These things, these things were here and but the beholder
Wanting

<div align="right">— Gerard Manley Hopkins</div>

RUSKIN
and the Art
of the Beholder

Elizabeth K. Helsinger

Harvard University Press
Cambridge, Massachusetts, and London, England
1982

Publication of this book has been aided by a grant from the
Andrew W. Mellon Foundation

Library of Congress Cataloging in Publication Data

Helsinger, Elizabeth K., 1943—
 Ruskin and the art of the beholder.

 Includes bibliographical references and index.
 1. Ruskin, John, 1819–1900—Criticism and interpretation. 2. Art criticism—
England. I. Title.
PR5264.H4 1982 828'.809 81–13428
ISBN 0–674–78082–5 AACR2

For my grandmother, Nina, who taught me her love of travel, and for Howard, who shares it with me

Acknowledgments

Ten years' immersion in a mind as capacious as Ruskin's has created more intellectual debts than I can trace. From John D. Rosenberg I acquired my first sense of Ruskin. He has continued to provide encouragement and a model of gifted and graceful criticism. George P. Landow, W. J. T. Mitchell, James Chandler, Stuart Tave, and Howard Helsinger read all or part of the manuscript; they will recognize how much I have benefited from their criticisms. The University of Chicago, through the deans of the Humanities Division and the College, Karl Weintraub and Jonathan Z. Smith, granted the research leave during which the first half of this book was written in 1977–78. To students, colleagues, friends, and members of the Laocoon discussion group at the University of Chicago I owe the largest but least assignable debt both for intellectual stimulation and for personal support. I would like to thank especially: Becky O'Connor Chandler, Joseph Connors, Robert A. Ferguson, Jerome McGann, Margaret Olin, Richard Shiff, Joel Snyder, Ellen Stauder, and Robert von Hallberg. Helen Vendler reminded me of the lines from Hopkins; the phrase "the beholder's share" I have borrowed from Ernst Gombrich. My sons Aaron and Alex cheerfully accepted the demands of my working life, which my husband Howard supported in every possible way.

Chapter 2 appeared in a slightly different form in *Studies in Romanticism*. I am grateful to the following institutions for permission to reproduce works in their collections: Abbot Hall Art Gallery, Kendal, Cumbria; Museum of Fine Arts, Boston; The British Museum; The Metropolitan Museum of Art; Monument Musei e Gallerie Pontificie, Città del Vaticano, Rome; The National Gallery, London; Ruskin Galleries, Bembridge School, Isle of Wight; and The Tate Gallery, London. Finally I am, as any student of Ruskin must be, thankful for the Library Edition of Ruskin's works edited by E. T. Cook and Alexander Wedderburn.

Contents

Illustrations

(following p. 182)

1. J. M. W. Turner, *The Fall of the Tees, Yorkshire.* Engraving from *Picturesque Views in England and Wales* (London, 1838).

2. John Ruskin, *Ariccia [La Riccia], near Albano*, 1841. Pencil, watercolor, and bodycolor. Abbot Hall Art Gallery, Kendal, Cumbria.

3. Turner, *Keswick Lake, or Derwentwater, Cumberland.* Engraving from *England and Wales*, 1838.

4. Turner, *Launceston, Cornwall.* Engraving from *England and Wales*, 1838.

5. J. D. Harding, *Benevento.* Engraving from William Brockedon, *Italy, Classical, Historical, and Picturesque* (London, 1842).

6. Samuel Prout, *Temple of Pallas.* Engraving from *Jennings' Landscape Annual for 1831.*

7. Turner, *Chain Bridge over the River Tees.* Engraving from *England and Wales*, 1838.

8. Ruskin, *Venga Medusa.* Engraving from *Modern Painters V (Works 7; 1860).*

9. Clarkson Stanfield and J.M.W. Turner, *The Picturesque of Windmills.* Engraving from *Modern Painters IV (Works 6; 1860).*

10 Ruskin, *Windows of the Fifth Order.* Engraving from *The Stones of Venice II (Works 10; 1853).*

11. Raphael, *The Liberation of St. Peter.* Fresco. Stanza di Eliodoro, Vatican (photo Musei Vaticani Archivio Fotografico).

12 Nicholas Poussin, *The Blind Orion Searching for the Rising Sun.* Oil. The Metropolitan Museum of Art, Fletcher Fund, 1924.

13. Turner, *The Slave Ship*, 1840. Oil. Museum of Fine Arts, Boston.

14. Turner, *Salisbury from Old Sarum Intrenchment.* Engraving from *England and Wales*, 1838.

Engravings were photographed by the author at The Joseph Regenstein Library, University of Chicago.

Introduction

M Y MOTHER FORCED ME, by steady daily toil, to learn long chapters of the Bible by heart; as well as to read it every syllable through, aloud, hard names and all, from Genesis to the Apocalypse, about once a year."[1] Recalling his early childhood in the first chapter of *Praeterita,* Ruskin passes by an unexplained logic from reading—the Bible, Walter Scott, and Pope's Homer—to seeing. In his Scottish aunt's garden, a door opens "to the water, which ran past it, clear-brown over the pebbles three or four feet deep; swift-eddying,—an infinite thing for a child to look down into." At his own home in Hunter Street, London, the windows, "fortunately for me, commanded a view of a marvellous iron post, out of which the water-carts were filled through beautiful little trap-doors, by pipes like boa-constrictors; and I was never weary of contemplating that mystery, and the delicious dripping consequent." Without so much as a new sentence, memory then leads him from Hunter Street to "the panoramic opening of the four windows of a post-chaise, made more panoramic still to me because my seat was a little bracket in front [from which] I saw all the high-roads, and most of the cross ones, of England and Wales; and great part of lowland Scotland" (35.15–16). In this carefully structured account of his childhood, Ruskin juxtaposes his patient study of words and syllables with his prolonged contemplation of eddies and streams or, a few pages later, of patterns in carpet and wallpaper (35.21). The yearly progress through the Bible has its parallel in the Ruskins' annual tours through England and Scotland. Looking matches reading.

The first three chapters of *Praeterita* return again and again to these and similar parallel experiences of reading and seeing. With each new instance, the logic that connects these memories becomes clearer. See-

ing and reading are not separable experiences for Ruskin; they are a single activity. His careful study — "at once so eager and so methodic" (35.51) — whether of texts or of moving water, carpet patterns, or passing landscapes, appears to the older Ruskin as the foundation of his future accomplishments. To his annual reading of the Bible, "that discipline — patient, accurate, and resolute — I owe . . . much of my general power of taking pains" (35.14); his "patience in looking, and precision in feeling, which afterwards, with due industry, formed my analytic power" (35.51).

The ties between reading and seeing go beyond the common discipline that both imposed. The same sensibility drew the fascinated child to contemplate words or moving water. He remembers, for example, that he especially loved the *visible* design of words: "in my own way, [I] learnt whole words at a time, as I did patterns . . . assisted by my real admiration of the look of printed type, which I began to copy for my pleasure, as other children draw dogs and horses" (35.23). The impulse to study words as graphic images, just as he studied the patterns in carpets or the trickle of water over pebbles, was equalled by the impulse to visualize the images suggested by words. The four-year-old Ruskin, sitting for his portrait, requests a background of "blue hills" because, Ruskin remembers, he thought of the words sung to him by his nurse:

> For Scotland, my darling, lies full in thy view,
> With her barefooted lassies, and mountains so blue. (35.22)

Ruskin's earliest dated efforts at composition, two pages of which he reproduces in chapter three, illustrate once again the strong instinct he believes he had to join reading and seeing: to apprehend words as, both graphically and semantically, images. At seven he produced a book of poetry and prose in which the varied size and style of the handlettering and the interspersed drawings are as carefully attended to as verbal style and content — of which, as Ruskin points out, they are remarkably expressive.

The instincts and habits thus presented in *Praeterita* are fully as important to Ruskin's later achievements as the unstated argument of his autobiography suggests. His criticism is particularly sensitive to temporal and linguistic aspects of visible design in paintings, in architecture, or in natural scenery. Early volumes of *Modern Painters* stress the

way landscapes or visual art are progressively experienced and require patient study of the beholder; later criticism points to the ways in which visual art can be "read" for symbolic meaning. Explaining how art can convey these temporal and linguistic experiences, Ruskin draws equally on literature, contemporary linguistic study, and the viewing habits of contemporary tourists. At the same time, Ruskin the reader is unusually alert to visual or spatial elements in literature. He looks not only at the physical aspect of books (print, illustrations, cover) but also at the design implicit in verbal style, at the recreation of visual experience through description, and at the power of polyvalent words or phrases to condense meaning in the manner of complex visual images. His reading extends to the perception of visible form on many levels. Conversely, his seeing is a temporal and often a linguistic activity. Few critics have done as much as Ruskin to demonstrate, in his own prose as well as in his criticism of art or literature, exactly where and how seeing and reading converge.

Ruskin is a writer, not an artist (though he was a gifted draftsman), but his verbal art teaches perceptual skills. Reading Ruskin can become learning to see with Ruskin: looking at nature or Turner or the Ducal Palace under his guidance, going back to the art and literature that shaped his style and formed his ideas, and examining his prose for the light it sheds upon his visual no less than his verbal habits. One can also turn the art of beholding that Ruskin teaches back upon Ruskin himself. The beholder he addresses, in *Modern Painters* or *The Stones of Venice,* can learn to combine seeing with reading because Ruskin is principally concerned with art or literature where seeing and reading overlap, where language is visible or images readable. Ruskin's own prose requires a similarly educated reader. Ruskin the art critic, teaching a Victorian audience how to look at Turner or Venetian architecture, can educate an audience for Ruskin the writer, one of the great masters of English prose.

Such an approach to Ruskin's verbal art is in some respects circular: a Ruskinian study of Ruskin. Ruskin's critics fall into two categories (neither side quite approves of the other): those who examine his mind, as it were, from the inside; and those who apply a systematic criticism that is not Ruskinian to his ideas. My own study begins from the inside. My aim has been to understand *how* Ruskin looks at nature and art, and how that activity shapes his prose style, critical practice,

and critical theory. In exploring Ruskin's visual habits and linguistic assumptions I have deliberately adopted some Ruskinian structures of thought and feeling in my own prose. My approach, however, is also historical. I have been equally concerned to define his relationship to English art criticism, to romantic psychology and poetics, and above all to English responses to landscapes in the preceding hundred years. Here neither my historical method nor, of course, my perspective is Ruskin's. Though I begin and end inside Ruskin's mind, I have necessarily stood outside it in the effort to locate his work in cultural history.

Ruskin is the last great figure in a century of intensive English interest in landscapes. An historical account of his criticism must also consider what happened to that interest in the first half of the nineteenth century, particularly in the years between 1825 and 1850. This period has been much less studied than the second half of the eighteenth century or the first two decades of the nineteenth. Ruskin, like his great contemporary Arnold, was concerned with the cultural health or disease of contemporary England reflected in contemporary reactions to the literature and art of the past. His redirection of landscape responses in the post-romantic years reflects a shared Victorian self-consciousness about how art, nature, and perception generally function, or fail to function, for the ordinary beholder or reader. Ruskin's specific focus on the *consumption* of landscape — to put it in the economic context on which he increasingly insisted — produces insights into the aesthetics of landscape quite different from those of the artist- or poet-oriented writers of the romantic period. In many respects Ruskin's approach to art is closer to that of twentieth-century writers on the psychology of perception in the visual arts or on visual art considered as symbolic or linguistic system. He examines art, in other words, from the perspective of the spectator or reader rather than (as in romanticism) from the perspective of the artist. Ruskin's views of how the spectator or reader perceives and interprets what he sees, essential to an understanding of his achievements in prose, are exciting in their own right. The "art" of this Victorian critic, created by and for the beholder, constitutes a revision of romantic explanations of art and literature, a revision to which we have, perhaps unwittingly, returned.

Ruskin's aesthetic and cultural criticism begins with the way he looks at landscapes. His visual habits were acquired from a particular histori-

cal experience of natural scenery, extended by him first to landscape painting and then to all forms of visual art. These visual habits are already evident in the descriptive prose of *Modern Painters I*. By the time Ruskin wrote *Modern Painters III*, they had become the basis for a conscious critical position and method, defined in part through an extended critique of romanticism. Between *Modern Painters I* and *Modern Painters III* he gained an historical perspective on contemporary attitudes toward landscape. He developed from the middle-class tourist's and reader's characteristic experience of scenery — as a succession of unfolding views offering opportunities for close study of details — a program for the perceptual reform of his Victorian audience. In place of awed confrontation with a romantic sublime, Ruskin urged the value of progressive discovery. In *The Stones of Venice,* a history written as a travel book, historical self-consciousness is extended to critical self-consciousness: the tourist's way of looking at landscapes becomes the avenue to reforming contemporary culture.

This program of perceptual and cultural reform also owes much to verbal habits. Though Ruskin consistently speaks of art as language, his interest in the spectator who "reads" develops more slowly. His earliest descriptions of Turner paintings (in *Modern Painters I*) modify associationist and romantic ideas about reading poems and looking at pictures. Between *The Stones of Venice* and *Modern Painters V,* he tries to reconcile romantic methods of reading the historical language of human imagination with religious exegesis of the transcendent language of nature and the Bible. Not until the last part of *Modern Painters V* are the method and theory of reading art fully worked out in his criticism and incorporated into new prose structures. There the iconographical tradition on which both artist and critic are presumed to draw is a fully historical language of art. The model for this last kind of reading comes from the new philology of the mid-nineteenth century rather than from romanticism or religion. The beholder's art of *Modern Painters* is also, by its last volume, a reader's art.

Ruskin's revised conception of the languages of art becomes a major influence on the language of his criticism in 1859 and 1860. The use of elaborate verbal emblems to structure writing and elicit a particular response from the reader is a characteristic feature of Ruskin's later prose. It reflects his new beliefs about the critic's relation to both artist and beholder. This critical prose belongs itself to a tradition: it is the most recent incarnation of an English tradition of emblematic litera-

ture. For those who look at landscape and art after Ruskin, his prose is also the first example of a critic's art. Ruskin himself, however, continued to regard his prose as the first — and perhaps the last — example of a beholder's art: the adequate expression of perceptual skills essential to cultural health.

The sequence of "Looking at Landscape" (Part I) and "Looking at Art" (Part II) in this study roughly follows the chronological development of Ruskin's critical ideas. The sequence of chapters, however, does not. I have approached Ruskin's looking and reading from several different perspectives. Ruskin's response to Wordsworth, for example, is a touchstone for a number of his critical ideas. I have considered that response from two successive points of view: Ruskin's highly critical attitude toward Wordsworth as a romantic poet of imagination (in Chapter 2) and his great admiration of him as a guide in reforming perception (in Chapter 3). The relationship between the two attitudes is more dialectical than contradictory.[2] This character of his thinking seems best preserved by taking his different approaches successively rather than attempting to reconcile them under a single embracing category or formula. Such a method of exposition has the disadvantage of making particular demands upon readers: that they suspend their expectations of a complete account of Ruskin's views for many chapters and that they read successive chapters as continually modifying and complicating those views put forth in earlier chapters. But the method has the advantage of avoiding misleading simplifications of Ruskin's ideas. The premise of his criticism is that comprehension for the ordinary spectator and reader depends on a flexible multiplication of meaning and point of view that can only occur as a cumulative experience. My method of exposition is close to Ruskin's own. I have tried in the course of my own study, however, to indicate not only where such cumulative exposition comes from, in Ruskin's case, but also why it works as it does and what the critical rationale behind such demands on impatient readers must be.

The overall structure of this book is excursive, a structure both Ruskin and Wordsworth would recognize. Like the educative pleasure journey, this one returns to its point of origin, the analysis of prose style, by what will at first appear a wandering route. Though its destination will not be immediately apparent, there are no major confusions or discontinuities obstructing the way. At its end, the point of

departure will be in view, though the conclusion will not, after all, leave you exactly where you began. An excursion is a progression, despite the intention to return. The progress between departure and conclusion should show the country covered to be more extensive and more interesting than any map I might offer as an introductory guide.

I Looking at Landscape

The Beholder's Share

The Poet–Painter

THE DESCRIPTIVE PASSAGES in *Modern Painters I* (1843) struck contemporary readers because they were beautiful and because they were unexpected. Visual description was not a common tool of the Victorian art critic, except as satire. The "elaborate richness of description and imagery," the "graphic power" of Ruskin's descriptions again and again evoked the comment that the work was not that "of a critic only, but of a painter and poet."[1] *Gentleman's Magazine* explained the descriptions as a "profuse display of examples and illustration" — illustration entirely verbal, for the first volume was published without plates.[2] Critics from the art establishment paid special attention to the author's descriptive style, too, ridiculing it as "eloquent skimble-skamble" and deriding him as a "whirling Dervish who at the end of his well-sustained reel falls with a higher jump and a shriller shriek into a fit."[3] The virtuoso descriptions of *Modern Painters I* stood out from their context like jewels in sand, poems and paintings illustrating expository prose. The first volume of *Modern Painters* was a success but not always, from Ruskin's later perspective, for the right reasons. Admiring readers for the next fifty years detached these gems for separate exhibitions of Ruskin the Painter or Ruskin the Poet of Nature, to the frustration of an older Ruskin who defined himself primarily as a critic.

Readers and periodical reviewers were right to single out these passages. They *are* presented as paintings, and through them Ruskin establishes his authority as an artist of vision. Yet there is more in them: indications of the aesthetic habits and assumptions that eventually shaped Ruskin's critical identity and formed the basis of his critical procedures. These descriptions are structured as exercises in a mode of

seeing accessible to every amateur. Their author indicates that he speaks not as an artist but as a teacher dedicated to popularizing art. The signals to the reader of *Modern Painters I* are plainly contradictory.

The uncertain rhetoric with which Ruskin begins his career at the age of twenty-four reflects an uncertainty about what that career is to be. Does he write as the simple beholder of nature or as the budding landscape artist? The distinction between artist and beholder which is missing in *Modern Painters I* becomes of crucial concern to Ruskin over the next decade. It lies at the heart of his criticism of English responses to landscape. Oscar Wilde's brilliant invention, "The Critic as Artist," would insist that the contradictions of *Modern Painters I* are unresolvable, and delight in the paradox. Ruskin did not agree. The descriptive prose of that initial volume is the basis for his different and less paradoxical critical art: the art of the beholder.

R USKIN'S comments on *Modern Painters I* suggest a confusion, or perhaps simply a plurality, of rhetorical aims behind the conflicting demands of his descriptive prose. The preface to the first edition warns the reader that what "was intended to be a short pamphlet, reprobating the manner and style" of periodical criticism of Turner, had already become "something very like a treatise on art" (3.3). Ruskin undertook *Modern Painters* as an occasional piece of writing, hardly intending to make it the beginning of a critical career. He rejected fairly quickly the polemics of the pamphleteer (many were removed from the revised edition, published in September 1846).[4] Other questions of intention and style took much longer to resolve. The identity of the author—his relationship to his audience and to the artists he wrote about—was very much in flux for the next six or seven years.

In the months following the publication of the first volume, Ruskin tried to clarify to several correspondents what he meant to do in the rest of the project. On the one hand he spoke of convincing the public "by the maintained testimony of high authority, that Turner is worth understanding" (3.653). As he wrote in the preface to the second edition (1844), he wanted "to attach to the artist the responsibility of a preacher, and to kindle in the general mind that regard which such an office must demand" (3.48). This part of his aim required that he establish his own "high authority" in order to awake the public to an ap-

propriate awe for the powers of art. Two years later the importance of convincing through high authority seems to determine the weighty tone and methodical approach of *Modern Painters II* (1846) — half treatise, half sermon, and modeled on the prose of Richard Hooker. He defines his critical object here as the elevation of art, a mission "to summon the moral energies of the nation to a forgotten duty, to display the use, force, and function of a great body of neglected sympathies and desires, and to elevate to its healthy and beneficial operation that art which, being altogether addressed to them, rises or falls with their variableness of vigour, now leading them with Tyrtaean fire, now singing them to sleep with baby murmurings" (4.28). In 1844, however, he also thinks of his project in quite different terms: "to spread the love and knowledge of art among all classes," to communicate not "technicalities and fancies" but "the universal system of nature," to make sensibility to the beautiful more universal (3.665). Where *Modern Painters II* is the voice of high (moral) authority, this is the voice of the popular educator. The high authority speaks to his public of a forgotten duty and holds up art and the artist as objects of awe, but the popular educator assures them, as Ruskin assured an 1843 correspondent, that if they try to understand Turner, they can (3.653). The two attitudes toward art and the public coexist in the letters and prefaces of 1843 and 1844, and indeed both continue to be important in Ruskin's later criticism. In *Modern Painters I* neither attitude is yet articulated, and the difficulty of combining them is further complicated by the author's reluctance to identify himself as a critic at all. The distinctive prose techniques of both the high authority and the popular educator are already there, but they work sometimes with and sometimes against the various guises the author of *Modern Painters* adopts.

The first and perhaps most important of these guises is that of the amateur. The title page of *Modern Painters I* presents the author simply as an anonymous "Graduate of Oxford," an educated gentleman. His authority, as the preface to the second edition explains, is defined in opposition to that of professional critics and historians of art. He is literally an amateur, a lover of truth and beauty, publishing his views at his own expense. He comes forward as the champion of the present against the past, portraying artistic convention as the impediment over which Turner has leaped to greatness. *Modern Painters I* deliberately rejects an historical approach to painting, just as it avoids the technical

language of the painter and connoisseur except to satirize the work of painters inferior to Turner. Ruskin was distinguishing himself both from an older group of periodical reviewers like the Reverend John Eagles of *Blackwood's* (whose attacks on Turner's late paintings had led to *Modern Painters*) and from a new group of museum experts like Sir Charles Eastlake, Keeper of the National Gallery, and Gustav Friedrich Waagen, Director of the Berlin Gallery.[5] The judgments of both groups, Ruskin argued, depended on precedent; men like Eagles judged quality by comparison with a particular canon, while Eastlake and Waagen established dates and authenticity through analysis of paints, canvas, style, and subject. Neither group could appreciate the work of a really innovative painter so well as "men of general knowledge and unbiassed habits of thought" who could recognize in it "a record and illustration of facts before unseized" (3.15). Through devotion and earnest study—not of artistic styles or conventions but of "the new truths [the painter] had discovered and recorded"—the educated amateur might prove a more valuable guide than the professional critic. As Ruskin wrote to a sympathetic reader in December 1843:

We are overwhelmed with a tribe of critics . . . well acquainted with the technical qualities of every master's touch; [who] when their discrimination fails, plume themselves on indisputable tradition, and point triumphantly to the documents of pictorial genealogy. But they never go *quite* far enough back; they stop *one* step short of the real original . . . Whatever, under the present system of study, the connoisseur of the gallery may learn or know, there is one thing he does *not* know,—and that is nature. (3.646)

This knowledge was Ruskin's one positive claim to authority. As a Graduate of Oxford, not an art critic, he claimed to be free of the biases of technical expertise and an historical approach; but he acknowledged something more than a general command of Turner's subject, natural fact.

Yet here too Ruskin stressed not the expertise but the means to acquire it: visual experience open to every diligent amateur. The descriptive passages in *Modern Painters I* were the proof of Ruskin's own love for and knowledge of natural fact—hence the chief grounds for his authority. They were also a demonstration to readers that they too could discover, with their own eyes, the facts that Ruskin and Turner had seen. Ruskin's descriptions were designed to convey not just speci-

fic knowledge about the physical behavior of light or water or rocks or foliage, but a new way of seeing. The description of a wooded bank, for example, works to sensitize the reader to effects of light by suppressing temporarily knowledge of the shapes of individual leaves:

The leaves then at the extremities become as fine as dust, a mere confusion of points and lines between you and the sky, a confusion which, you might as well hope to draw sea-sand particle by particle, as to imitate leaf for leaf. This, as it comes down into the body of the tree, gets closer, but never opaque; it is always transparent with crumbling lights in it letting you through to the sky: then out of this, come, heavier and heavier, the masses of illumined foliage, all dazzling and inextricable, save here and there a single leaf on the extremities: then, under these, you get deep passages of broken irregular gloom, passing into transparent, green-lighted, misty hollows; the twisted stems glancing through them in their pale and entangled infinity, and the shafted sunbeams, rained from above, running along the lustrous leaves for an instant; then lost, then caught again on some emerald bank or knotted root, to be sent up again with a faint reflex on the white under-sides of dim groups of drooping foliage, the shadows of the upper boughs running in grey network down the glossy stems, and resting in quiet chequers upon the glittering earth; but all penetrable and transparent, and, in proportion, inextricable and incomprehensible, except where across the labyrinth and the mystery of the dazzling light and dream-like shadow, falls, close to us, some solitary spray, some wreath of two or three motionless large leaves, the type and embodying of all that in the rest we feel and imagine, but can never see. (3.589–590)

What is being conveyed is not, of course, "the" truth of a bank of foliage in sunshine, but one kind of painterly vision, a way of seeing that can be learned and will then influence the way other scenes—real, painted, or described—are perceived. But in the first part of the nineteenth century, such seeing also had scientific status. The prevailing mode of scientific research was the observation and description of natural phenomena, under natural conditions and with the unaided eye. To Ruskin and his readers his particular painterly vision might be both a prerequisite for seeing a Turner and an instrument of scientific investigation.[6] Ruskin claimed that this way of seeing provided more "facts before unseized" than any previous painterly vision of landscape. His authority as the author of *Modern Painters I*, then, came neither from his knowledge of painting nor from his knowledge of natural

fact but from his ability to see in a certain way, and hence to acquire knowledge. That ability he tries to transfer to his readers through description. The implication is that Ruskin's readers, by the time they finish *Modern Painters,* may have as much authority as Ruskin himself lays claim to.

Still, no reader of *Modern Painters I* can overlook the equally strong indications that this amateur possesses an authority he is not offering to share. A number of Ruskin's remarks to his readers (many of them removed in the revised edition)[7] suggest the distance he put between himself and them, a distance further established by his assertive tone and by exaggerated attacks on the probable aesthetic preferences of his readers—the landscapes of Claude and Salvator and Gaspar Poussin. A sentence in the first edition, for example, read: "It will only be when we can feel as well as think, and rejoice as well as reason, that I shall be able to lead you with Turner to his favorite haunts" (3.468n). Although in later editions Ruskin evidently felt that this statement presumed too much for the Oxford Graduate, the division of "we" into an "I" who will lead and a "you" to be led, and the implied moral authority ("when we can feel as well as think") behind that division were characteristic of many passages he did not revise. A chapter that begins with the neutral observation, "It is a strange thing how little in general people know about the sky" modulates after a page into admonitory rhetoric full of echoes and rhythms from Job and the biblical prophets:

Who, among the whole chattering crowd, can tell me of the forms and the precipices of the chain of tall white mountains that girded the horizon at noon yesterday? Who saw the narrow sunbeam that came out of the south and smote upon their summits until they melted and mouldered away in a dust of blue rain? Who saw the dance of the dead clouds when the sunlight left them last night, and the west wind blew them before it like withered leaves? All has passed, unregretted as unseen; or if the apathy be ever shaken off, even for an instant, it is only by what is gross, or what is extraordinary; and yet it is not in the broad and fierce manifestations of the elemental energies, not in the clash of the hail, nor the drift of the whirlwind, that the highest characters of the sublime are developed. God is not in the earthquake, nor in the fire, but in the still, small voice. (3.344–345)

In passages like this Ruskin identifies himself by tone and diction as an evangelical teacher, a role that is familiar to and implies beliefs and at-

titudes shared with much of his middle-class audience but that establishes a distinction between writer and reader.

Ruskin further complicates his relationship with his readers by describing the activity of the artist in terms that fit the role he himself plays in *Modern Painters I*. The painter has "the responsibility of the preacher"; he must both "induce in the spectator's mind the faithful conception of any natural objects" and, more importantly, "guide the spectator's mind." The artist also

talks to him; makes him a sharer in his own strong feelings and quick thoughts; hurries him away in his own enthusiasm; guides him to all that is beautiful; snatches him from all that is base; and leaves him more than delighted, — ennobled and instructed, under the sense of having not only beheld a new scene, but of having held communion with a new mind, and having been endowed for a time with the keen perception and the impetuous emotions of a nobler and more penetrating intelligence. (3.133–134)

The reader is indeed snatched and hurried along by the quick and impetuous progress of his guide in the last long sentence of Ruskin's description of foliage. Preaching and communion similarly identify the elevated tone and diction Ruskin adopts in other passages. Ruskin's artist evidently shares something of the same ambiguous relation to his audience that Ruskin expresses toward his. At one moment he preaches to them and at the next shares his enthusiasms with an engaging familiarity. Ruskin apparently writes as the spokesman for this artist, articulating his sermons or, in a more familiar tone, giving his side of the conversation described in the passage above. The chief difference between criticism and creation suggested by this description of the artist would seem to be a difference of medium. The writer on art is a translator; he gives literal (verbal) substance to the pictorial speech of the painter.

The exalted status that Ruskin gives the great artist in this volume drives a further wedge between readers and the critic, who is closely identified with the great painter. The most hyperbolic of Ruskin's descriptions of Turner casts the painter as an angel out of Revelation: "Turner—glorious in conception—unfathomable in knowledge—solitary in power—with the elements waiting upon his will, and the night and the morning obedient to his call, sent as a prophet of God to reveal to men the mysteries of His universe, standing, like the

great angel of the Apocalypse, clothed with a cloud, and with a rain-
bow upon his head, and with the sun and stars given into his hand"
(3.254). When the passage was attacked by reviewers as excessive,
Ruskin left it out of later editions, but his vision of Turner as angel
and prophet standing in the sunlit clouds is in fact repeated in another
famous passage that was not deleted from the volume. "Of the Truth
of Clouds" concludes with an elaborate description of a day's sequence
of spectacular skies seen from a mountain top, a composite, according
to Ruskin's footnotes, of various Turner paintings. With every new
and more sublime scene the reader is reminded that he is standing
where Turner stood, before visions uniquely Turner's ("Has Claude
given this?" is the refrain that punctuates the description). Finally, as
"the whole heaven, one scarlet canopy, is interwoven with a roof of
waving flame, and tossing, vault beyond vault, as with the drifted
wings of many companies of angels," when "you can look no more for
gladness" and "are bowed down with fear and love of the Maker and
Doer of this," Ruskin asks, "tell me who has best delivered this His
message unto men!" (3.418–419) The ambiguous connection between
painter and writer is especially noticeable in these passages because the
descriptions are identified as verbal versions of Turner paintings. Rus-
kin's question at the end of the last passage ("who has best delivered
this His message") confirms the reader's perception of a kind of rivalry
between critic and artist by suggesting an answer that Ruskin surely
did not intend. Similarly, when Ruskin speaks specifically of the
unique nature of a great artist's imagination as only to "be met and un-
derstood by persons having some sort of sympathy with the high and
solitary minds which produced it—sympathy only to be felt by minds
in some degree high and solitary themselves" (3.136), the reader must
assume Ruskin speaks as one of those high and solitary few. Early in
the book Ruskin does try to explain the apparent contradiction be-
tween this statement of the *in*accessibility of great art and his claim
that "men of general knowledge" can learn to see as Turner saw. The
feeling and passion, he says, can be shared only by the few, but the
ability to perceive natural facts is possible for all, and this truth of rep-
resentation is a trustworthy index to the relative value of the full artis-
tic vision: "Truth is a bar of comparison at which they may all be ex-
amined, and according to the rank they take in this examination will
almost invariably be that which, if capable of appreciating them in

every respect, we should be just in assigning them; so strict is the connection, so constant the relation, between the sum of knowledge and the extent of thought, between accuracy of perception and vividness of idea" (3.138). The explanation, though it justifies Ruskin's initial concentration on natural fact, does not entirely prepare us for the alternating voices of *Modern Painters I*—the shifts from the contagious enthusiasm of the amateur educator to the high authority of the preacher or the painter-poet.

Ruskin's purple passages are instances of artful writing in the high romantic mode. Yet the verbal structure of his descriptions in fact presents visual experience as immediately accessible, the exploration of the excited amateur. Some signals direct us to understand these passages as instruction; others direct us to admire the verbal art. We may identify these conflicting verbal clues if we look at three passages where teaching seems progressively less important than virtuoso word painting. Most of the descriptions in *Modern Painters I* focus on some single effect that Ruskin wants to teach readers to see so that they can appreciate the triumph of Turner's painting. Description of sensible effect is usually accompanied by explanation of the physical or geological fact it indicates. To explain how Turner alone accurately expresses the force of falling water in a painting like *The Fall of the Tees* (ill. 1), for example, Ruskin contrasts what other painters have done with a description of how falling water behaves:

You will find nothing in the waterfalls even of our best painters, but springing lines of parabolic descent, and splashing shapeless foam; and, in consequence, though they may make you understand the swiftness of the water, they never let you feel the weight of it; the stream in their hands looks *active*, not *supine*, as if it leaped, not as if it fell. Now water will leap a little way, it will leap down a weir or over a stone, but it *tumbles* over a high fall like this; and it is when we have lost the parabolic line, and arrived at the catenary, when we have lost the *spring* of the fall, and arrived at the *plunge* of it, that we begin really to feel its weight and wildness. Where water takes its first leap from the top, it is cool, and collected, and uninteresting, and mathematical; but it is when it finds that it has got into a scrape, and has farther to go than it thought, that its character comes out: it is then that it begins to writhe, and twist, and sweep out, zone after zone, in wilder stretching as it

falls; and to send down the rocket-like, lance-pointed whizzing shafts at its sides, sounding for the bottom. And it is this prostration, this hopeless abandonment of its ponderous power to the air, which is always peculiarly expressed by Turner, and especially in the case before us. (3.553–554)

The animation of the water, the extended sentence, and the multiplication of metaphor through which Ruskin conveys the distinctive character of falling water are certainly artful. Yet the passage keeps its primary character as explanation. The descriptive passage is brief in comparison to the paragraphs of more analytical exposition preceding it. Ruskin concludes by returning us to Turner's painting. Finally, he does not try to present an entire scene or composition, animating instead only a single fact.

Longer passages of description can work differently. A paragraph like Ruskin's description of foliage is intended to convey a special visual fact, again in order to help the reader understand a Turner painting. The precision and profusion of detail presented as visual experience work to combat the myth of the artist's vision as inaccessible and incomprehensible, except as a sudden vague emotional impression, to the ordinary viewer. The passage focuses attention on a particular aspect of the scene—the effects of light—and does so by first taking us through a progressive examination of its visual space. The eye is led downward through a sequence of nine distinctive modulations of flickering light, from "the confusion of points and lines between you and the sky" to "the quiet chequers upon the glittering earth." The summary description of the effect of the whole ("the labyrinth and the mystery of the dazzling light and dream-like shadow") comes after a visual tour of the parts. The reader has seen how the final effect is constructed and can read a much more precise meaning into more than visual terms like "mystery" and "dream-like." By letting the reader discover and distinguish the variety of visual facts that make up the impression of labyrinthine light and shadow, Ruskin both alerts him to the presence of similar facts in other scenes—conveys a particular painterly way of seeing—and demonstrates the kind of orderly optical scanning by which a spectator fully sees a picture or scene. What the writer describes, in other words, is the scene as it is discovered by the spectator. Ruskin's descriptive procedure, where the order of descrip-

tion seems to be an order of experience, is a canny bit of educational psychology: he leads the student through a successful repetition of the kind of analysis he is trying to teach, demonstrating that the reader can in fact see what Ruskin sees. Every time we encounter a descriptive passage, we get a chance to practice the method of visual analysis, whether we simply visualize as Ruskin describes or whether we follow his advice and go directly to the country or to Dulwich Gallery.

Yet this passage of description is set off from the surrounding prose by a variety of formal and stylistic devices suggesting that it is itself an imaginative whole, a word painting conceived and structured as an independent design. In the preceding paragraph Ruskin instructs the reader, "Break off an elm bough three feet long . . . and lay it on the table before you, and try to draw it leaf for leaf." The description begins with an explicit shift away from this direct visual study. It is introduced as an exercise in imaginative rather than literal vision: "But if nature is so various when you have a bough on the table before you, what must she be when she retires from you . . .?" Similarly the experience is brought to a formal close, after it has been summed up in a final phrase descriptive of an overall impression (the labyrinth and mystery) by a return to the now emblematic image of the solitary bough. As experience, the description has a clearly marked beginning and end not unlike the framing of a visual artifact. Within the frame, the syntax and rhythm of the prose provide an internal order for the experience corresponding, by implication, to a compositional order in the visual scene. In the first two thirds of the single main sentence of the description, a clear sequence of clauses ("This . . . ; then . . . ; then . . . ; then . . . , then . . . ") describes an orderly progression from sky to earth through extremely complicated patterns of light and shadow. The narrative is accelerated by lengthening each successive stage and subdividing it into an increasingly complicated profusion of asymmetrically modifying phrases and clauses. In the last third of the sentence ("but all . . . "), where the description shifts to summary impression and then focuses on a representative detail, the rhythm slows and the syntax is simplified; pairs of balanced terms and frequent pauses, isolating a single noun or verb, prepare for a bare final clause that resolves the breathless complexity of the sentence ("all that . . . we feel and imagine, but can never see"). The effort to convey a coher-

ent visual space through orderly scanning reinforces the sense that the paragraph *is* the verbal equivalent of a painting. Like the painting it is an imaginative whole.

The passage is further marked as an independent composition because it is paired immediately with a satiric description of an actual painting.[8] The next paragraph instructs the reader, "Now, with thus much of nature in your mind, go to Gaspar Poussin's view near Albano, in the National Gallery." The juxtaposed passages place Ruskin's description in competition with Gaspar's painting, implying that the prose paragraph (or the modern painting for which it is a stand-in) is a painting to hang up next to Gaspar's, just as Turner wished two of his paintings to hang next to—and overwhelm—Claude's.

Is Ruskin writing as a prose painter or as an educator? Does he want to create a visual composition to dazzle us? Does he want to convey the beholder's experience (which becomes more than visual) in order to educate our perceptions? Both, probably. His descriptive style, translating visual effects rather than simply enumerating them, converting spatial forms into a dramatic narrative, may represent an attempt to rival painting in prose. But the description can also be read as a demonstration that painting is accessible and comprehensible because, like more ordinary visual phenomena, it can be studied and analyzed. The dazzling whole can be experienced part by part until even the unobservant spectator sees. Perhaps an attentive reader can accept Ruskin's description both as art in its own right and as part of the visual education his volume offers. Ruskin's experience with Victorian readers suggests that this was not usually the case. His description gave the reader an analytical method and far more visual information than any contemporary art criticism offered,[9] but its educative function was undercut by its verbal artfulness.

The prose medium itself creates a problem, one not limited to Victorian readers. We too may well expect critical prose to be self-effacing, instructive, and analytical. How then will we respond to the obvious virtuosity of Ruskin's descriptive style? Will we interpret it as inappropriate display, despite—or because of—its success in creating a verbal equivalent for perceptual experience? The problem always exists for descriptive literature about the visual arts. Here, though, Ruskin's contradictory clues to the reader exacerbate the generic difficulties.

The juxtaposition of visionary and satiric descriptions suggests rivalry, but it is also an effective way of bringing attention to stylistic differences in the paintings and winning the reader's assent to the teacher's judgment of their relative merits. (The paired slides of a lecture in art history work the same way, though there it is the oral commentary that determines whether the comparison is neutral or whether one painting is viewed as a caricature of or development from the other.) The immediate framing of the paragraph suggests we are to take it as a word painting, but in the larger context of the chapter and book, description is clearly meant to serve sight, not to rival it. Shorter descriptions, like that of falling water, do not call attention to themselves as independent dramatic narratives. Their function as explanation is never in doubt. Ruskin's statements about his rhetorical intentions and authorial identity do not resolve the ambiguities of his more elaborate descriptions. On the contrary, they indicate that he did not yet know whether he was primarily a poet-painter or a critic and, if he were a critic, exactly what his relationship to his audience should be.

The problem of how to take Ruskin's elaborate descriptions—and hence their place in the rhetorical structure of the book—is most acute in the handful of frequently anthologized pieces that attempt full-scale descriptions of Turner paintings (for example, *Snowstorm* and *The Slave Ship*) or of landscapes that other painters had rendered unsuccessfully, like Ruskin's versions of the Roman Compagna and La Riccia—paired, in *Modern Painters I*, with satiric descriptions of a Claude and a Gaspar Poussin.[10] The last two especially seem to have been intended primarily as finished, imaginative compositions, improvements on Claude and Gaspar, whatever their subsequent usefulness in teaching the public how to see. Both descriptions are based on Ruskin's diary record of a day's travel from Rome to Cisterna in January 1841; he returned in March to take a second look at La Riccia (the modern Ariccia), this time drawing the same view (ill. 2).[11] The two sketches and the finished prose versions in *Modern Painters I* show a process of composition much like that which Ruskin analyzed in *Modern Painters IV* (1856) as the way in which a great imaginative artist turns first impressions into a finished work of the imagination.[12] When Ruskin began, in 1845, the studies on which the analysis of 1856 was based, he used Turner's paintings as his examples of imaginative art. His own

drawings and notes, made on the same spots, were his references for judging the transformations Turner had made. Just two years after *Modern Painters I*, he was more concerned with distinguishing his descriptions and depictions from Turner's than with rivaling his effects in prose. But in 1843 and 1844, he felt no need to separate his own descriptions from Turner's finished paintings. The La Riccia description, where Ruskin makes no attempt to distinguish between prose description as art and prose description as a tool of criticism, is a useful point of comparison for Ruskin's later style and critical attitudes.

Ruskin himself noted that his impulse to describe came before any specific intention to teach. He felt this impulse to be his link with the geniuses of great art. As he wrote his father in 1852,

there is such a thing [as genius]—and it consists mainly in a man's doing things because he cannot help it, intellectual things, I mean: I don't think myself a great genius—but I believe I have genius . . . there is the strong instinct in me which I cannot analyse—to draw and describe the things I love—not for reputation—nor for the good of others—nor for my own advantage—but a sort of instinct like that for eating or drinking.[13]

In 1840, the month before his trip through the Campagna, he noted in his diary, "I was tormented with vague desires of possessing all the beauty that I saw, of keeping every outline and colour in my mind, and pained at the knowledge that I must forget it all."[14] And a few months later he noted his own often unsuccessful attempts to arrest "these strong distinctive impressions" in words.[15] His diary for 1840 and 1841 is filled with extensive descriptions of the landscapes he encountered and refers as well to drawings made of the same scenes. The description of his journey through the Campagna and the drawing of La Riccia made two months later belong to this group—records prompted by the impulse Ruskin then thought he shared with the great artist, "the strong instinct . . . to draw and describe the things I love."[16]

According to his diary remarks, Ruskin was interested in capturing two aspects of what he saw: "strong distinctive impressions," especially those of first sights, and "every outline and colour," the smallest discriminations of visual fact. Drawings were especially necessary as a supplement to verbal description for getting details. *Modern Painters I* is full of apologies for the inadequacy of language to convey sufficiently fine visual distinctions:

we shall be compelled to notice only a few of the most striking and demon-strable facts of nature. To trace out the actual sum of truth or falsehood in any one work, touch by touch, would require . . . a chapter to every inch of canvass . . . I can do little more than suggest the right train of thought and mode of observation . . . how difficult it is to express or explain, by lan-guage only, those delicate qualities of the object of sense, on the seizing of which all refined truth of representation depends . . . nothing but what is coarse and commonplace, in matters to be judged of by the senses, is within the reach of argument. (3.258,253)

At the end of the volume Ruskin explicitly disclaims any attempt to capture the finer visual facts of line and color in the descriptions of *Modern Painters I:* "I have been perfectly unable to express (and indeed I have made no endeavour to express) the finely drawn and distin-guished truth in which all the real excellence of art consists" (3.609). Yet following Ruskin's successive efforts to describe La Riccia, one may suspect that the description in *Modern Painters* is the culmination of the instinct to draw and describe so strongly evident in the 1840–41 diaries. Then, too, Ruskin's drawing style in the early 1840s was not capable of expressing the Turnerian effects of light and color to which he was becoming increasingly sensitive. Language was more flexible than drawing as a means of expressing the conflagration of color that overwhelmed him at La Riccia. The drawing and diary record of that spot are aids to visual memory, but the *Modern Painters* description comes closest to fulfilling Ruskin's desire to recreate a first impression while keeping every line and color.[17]

The diary entry for his trip through the Campagna is a running series of notes made from the constantly shifting perspective of the traveler.[18] There are no full stops, no comprehensive views. The ob-server is constantly attentive to details of interest to the amateur painter, geologist, botanist, and student of clouds and skies, but his record is a piecemeal notation of details as they strike a moving eye, not an organized composition. At one point Ruskin singles out an im-pression as especially remarkable—"three minutes of rapidly changing composition, absolutely unparalleled in my experience"—but while details are more numerous here, the attempt to record this as a single strong, distinctive impression is made by recalling his excitement and not by any attempt to create a coherent visual image.

Leaving Rome "in a pour of rain" Ruskin first describes various groups of ruins along the plain of the Campagna (notes used in the de

scription of the Campagna for the preface to the second edition of *Modern Painters I*):

Then came an ancient stone aqueduct, exquisite in colour and mass of form, and shattered throughout, yet keeping towards its mountain termination a continued line. Beyond it, the Apennines, with fresh snow, shone large through breaking rain-cloud, white fragments of it falling along the Campagna, and relieving in places its dark groups of ruin; the Alban mount looking high through drifting shower.

After the partial view through breaking rain clouds, the sky closes in again and Ruskin describes the desolation of the plain. In the distance an isolated villa and grove and the silhouette of the town of Albano appear against the sky. Beyond Albano he

descended into a hollow, with another village on the hill opposite—a most elegant and finished group of church-tower and roof: infinitely varied outline against sky, descending by delicious colour and delicate upright, leafless [sketch]s of tree, into a dark, rich-toned depth of ravine, out of which rose, nearer, and clear against its shade, a grey wall of rock—an absolute miracle for blending of bright lichenous colour. Our descending road bordered by bright yellow stumpy trees, leaning over it in heavy masses (with thick trunks covered with ivy and feathery leafage) giving a symmetry to the foreground—those trunks rising from bold fragments of projecting tufa, loaded with vegetation of the richest possible tone. The whole thing for about three minutes of rapidly changing composition, absolutely unparalleled in my experience, especially for its total independence of *all* atmospheric effect, being under a grey and unbroken sky with rain—as bright as a first-rate Turner. I got quite sick with delight; scrambled up a steep hill into the village, a bright light showing over the sea—clear amber—against which we got the outline again descending from us, on the other side, with a purple piece of marsh opening to the sea.

And so on through other villages, now under a clearing sky, into Cisterna.

With these notes and the drawing he made on his return in March to prompt his memory, he wrote the following description for *Modern Painters I*:

Not long ago, I was slowly descending this very bit of carriage-road [the scene of Gaspar Poussin's painting of La Riccia], the first turn after you leave

Albano . . . It had been wild weather when I left Rome, and all across the Campagna the clouds were sweeping in sulphurous blue, with a clap of thunder or two, and breaking gleams of sun along the Claudian aqueduct lighting up the infinity of its arches like the bridge of chaos. But as I climbed the long slope of the Alban Mount, the storm swept finally to the north, and the noble outline of the domes of Albano, and graceful darkness of its ilex grove, rose against pure streaks of alternate blue and amber; the upper sky gradually flushing through the last fragments of rain-cloud in deep palpitating azure, half aether and half dew. The noonday sun came slanting down the rocky slopes of La Riccia, and their masses of entangled and tall foliage, whose autumnal tints were mixed with the wet verdure of a thousand evergreens, were penetrated with it as with rain. I cannot call it colour, it was conflagration. Purple, and crimson, and scarlet, like the curtains of God's tabernacle, the rejoicing trees sank into the valley in showers of light, every separate leaf quivering with buoyant and burning life; each, as it turned to reflect or to transmit the sunbeam, first a torch and then an emerald. Far up into the recesses of the valley, the green vistas arched like the hollows of mighty waves of some crystalline sea, with the arbutus flowers dashed along their flanks for foam, and silver flakes of orange spray tossed into the air around them, breaking over the grey walls of rock into a thousand separate stars, fading and kindling alternately as the weak wind lifted and let them fall. Every glade of grass burned like the golden floor of heaven, opening in sudden gleams as the foliage broke and closed above it, as sheet-lightning opens in a cloud at sunset; the motionless masses of dark rock—dark though flushed with scarlet lichen, casting their quiet shadows across its restless radiance, the fountain underneath them filling its marble hollow with blue mist and fitful sound; and over all, the multitudinous bars of amber and rose, the sacred clouds that have no darkness, and only exist to illumine, were seen in fathomless intervals between the solemn and orbed repose of the stone pines, passing to lose themselves in the last, white, blinding lustre of the measureless line where the Campagna melted into the blaze of the sea. (3.278–280)

The finished version of Ruskin's La Riccia uses Turnerian light and color to achieve the heightened effect of ambitious, imaginative painting. More than half of the description elaborately recreates the "absolute miracle" of foreground color noted in much less detail in the diary. Ruskin also completely changes the "grey and unbroken sky" of his original experience to the more dramatic effects of sun on clearing clouds. He has made a painting out of an observant traveler's notes.

In Ruskin's landscape, space is also reorganized into a painterly

composition, as it was not in his diary.[19] The slope of La Riccia is presented as part of a single complete prospect. Above it the domes and trees of Albano show against the clearing sky, with the blazing sea in the far distance. Comparison with the diary account shows that the single view is achieved by making the narrative sequence a sort of flashback, an alteration the casual reader might not even notice. The finished account begins with the traveler's descent from the town of Albano with the opposite slope of La Riccia before him, but before describing that slope the narrative goes back to give impressions from the preceding hours: "when I left Rome," "all across the Campagna," and "as I climbed the long slope of the Alban Mount." The description of the domes of Albano he can see as he climbs is followed immediately by the description of the slope of La Riccia, which in fact he could not see until he had passed through the town and begun to descend the hill—the descent of the opening sentence. As the diary more accurately notes, it is the outline of Bernini's church in La Riccia, not the domes of Albano, which the traveler sees at the top of the slope. The diary record also makes clear that after he had seen the slope of La Riccia he had to climb it and enter the town before he could see the sea. The finished narrative simply omits the necessary second climb. The climb *to* Albano is the last mention of motion by the traveler before the description of the slope of La Riccia; the rest of the description implies motion by the eye only (penetration of the foreground, then the movement up and back into sky and distant horizon), as if it were a scene scanned by the spectator from a fixed point of view. By inverting the order of experience and omitting mention of further changes in point of view, Ruskin juxtaposes foreground slope, silhouette, and distant sky and sea to create an illusion of a single prospect, a Claudian subject organized as a regular recession of planes toward a bright, distant horizon.

But Ruskin's word painting, though it turns the experience of a moving spectator into a single landscape composition, is still a narrative. The finished version creates a narrative drama out of a presumably stationary scene. The paragraph is no longer structured on the experience of the traveler, though its unity does not depend solely on the coherence of the space it describes. Specifically literary techniques give Ruskin's paragraph a unity analogous to that of a finished landscape painting, achieved in quite different ways. Ruskin's analysis in *Modern*

Painters IV of how Turner transforms his visual experiences into an imaginative whole suggests a conception of imaginative unity equally applicable to his own prose version of La Riccia. In *Modern Painters IV* he distinguishes the imaginative landscape painter from the topographer, who faithfully records the visual facts of a given scene, choosing but not altering what he can see. The inventive painter, on the other hand, works not from the actual facts of the scene, but from the first impression it makes on his mind.

Now, observe, this impression on the mind never results from the mere piece of scenery which can be included within the limits of the picture. It depends on the temper into which the mind has been brought, both by all the landscape round, and by what has been seen previously in the course of the day; so that no particular spot upon which the painter's glance may at any moment fall, is then to him what, if seen by itself, it will be to the spectator far away; nor is it what it would be, even to that spectator, if he had come to the reality through the steps which Nature has appointed to be the preparation for it, instead of seeing it isolated on an exhibition wall. (6.33)

The first impression condenses into a single scene what has been seen previously in the course of the day, or in earlier experiences, and what could be seen of the surrounding landscape if the artist's point of view shifted. Turner's great imaginative paintings were composed, Ruskin goes on, "in a kind of passive obedience to his first vision, that vision being composed primarily of the strong memory of the place itself which he had to draw; and secondarily, of memories of other places . . . associated, in a harmonious and helpful way, with the new central thought" (6.41).

The description of La Riccia is precisely concerned with this foresightful power of imagination. Inverting the order of experience and omitting changes in point of view are one way of condensing different scenes and times into one. But a prose account of all that was or could be seen by a moving observer related as if from a single perspective would be bewildering to any reader trying to visualize it—a kind of Cubist landscape, with temporal as well as spatial shifts in point of view. For Ruskin it would lack that feature of Turner's vision which characterizes it as imagination: the gathering of disparate elements into a single compelling unity. The imagination organizes complex facts—more than can be seen from a single perspective—around a

central thought or image. That organization must not violate the reader's sense of the vision as a true view of reality. Many of Ruskin's readers traveled the road from Rome to Cisterna themselves; they knew what could and could not be seen from Albano. The sequence of "then" and "then" and "then" in the diary is not obliterated, but replaced by a carefully orchestrated crescendo of visual and emotional effects, using related metaphors and similes to bind an implicitly changing prospect into a narrative unity.

Some of the ways in which the order of travel becomes a drama are straightforward. Where the diary records a constant alternation of overcast sky with gleams of light, the finished description turns alternation into progression. "Wild weather" is interrupted by "breaking gleams," which give way to a clearing sky and fiery color, which in turn melts into a final blaze of light. The same pattern is expressed in the similes introduced, somewhat gratuitously for modern tastes, at intervals in the description: from "the bridge of chaos" through "the curtains of God's tabernacle" to the "floor of heaven" and beyond into the actual heavens, the "sacred" clouds. Patterns of imagery and simile like these unite the composite prospect without requiring the reader to visualize it as a single scene. They structure the account as a dramatic narrative, experience progressing to a climax, a sequence different from the original traveler's perception. They are additions to, not substitutes for, an account of the visual complexity and detail that Turner could convey in paint. They also suggest how the traveler's earlier experiences have shaped his responses here; the Campagna he has just crossed, in pouring rain, was a landscape of unrelieved ruin and decay: the chaos bridged by the aqueduct. La Riccia appears in that context as a glimpse of paradise, a revelation of the heavens.[20] Ruskin's decision to present it as literally revealed by the opening clouds underscores its effect on the traveler who has just crossed the wasteland of the Campagna.

If Ruskin's paragraph makes a single distinctive impression on the reader, however, it is an impression not of sudden revelation but of accumulating energy. How is this impression of energy achieved, and how does it transform the facts of the traveler's experience into a dramatic narrative with the imaginative unity of a painting? We are not encouraged to identify the energy of the prose with the physical activity of the traveler. He acts briefly in the opening lines of the paragraph

("I was descending," "I climbed"). But we get only an indirect reminder of his presence as spectator at the end of the passage, when the clouds are "seen" to melt into the sea. The spectator appears explicitly as narrator only once in the middle of the paragraph, interjecting his "I cannot call it colour." At first reading, neither traveler, spectator, nor narrator is presented as especially active. Nor is the scene one of violent motion: there are no moving people or animals, no waterfalls or rushing rivers, only a "weak wind" to give any motion to rocks and clouds and leaves. But the passage is dense with activity, most of it in the landscape itself. One in ten of its words are verbs or verb forms; of these nearly half are present participles, and all but eight are active. Variations in reflected light and color are presented as an activity of clouds, rocks, and trees. Motion, though extremely slight in any one object, is both constant and multiple: gleams are breaking and lighting up, every leaf is quivering, vistas arch, flakes of spray are breaking, fading, kindling, opening glades burn, foliage breaks and closes. Every element seems to vibrate or, more exactly, to shimmer and scintillate in a dance of light. The dance never collapses into a blur. Ruskin takes great pains to distinguish between leaves as they reflect and as they transmit sunlight, between autumn leaves and evergreens (*wet* evergreens), between flowers (arbutus) lifted or let fall by the wind. There are sixteen different colors, another eighteen distinct kinds of light or darkness, and six different atmospheric conditions affecting the reflection of light (clouds, rain clouds, aether, dew, rain, mist).

The sense of energy inherent in the scene is reinforced by the dominant metaphors of the passage: light as fire and light as moving water. Where the diary records visual information as details of outline, color, tone, depth, blending, symmetry, and composition—a painter's terms—the same information in the *Modern Painters* paragraph is organized into repeated or extended metaphors expressing the spectator's sense that light and color have acquired a life of their own. Color is a conflagration, a torch, a blaze, stars, or lightning that burns, fades, or kindles; and it is foam, mist, showers of light, waves of some crystalline sea, silver flakes of orange spray dashed, tossed, arching, and breaking over the gray walls of rock. Both metaphors identify the landscape's moving, changing patterns of light as the visible manifestations of a great inner energy, the energy of a raging fire or a surging

sea. The waves extending "far up into the recesses of the valley" provide specific visual information about the "rapidly changing composition" (we have a clear sense of the linear rhythms that organize the visual space) but they also identify visual patterns with the recurrent motion of a powerful natural entity, a great body of water. The metaphors express visual information important to the painter-topographer in the form of a strong distinctive impression, a central thought that is the mark of imaginative vision.

This central impression of an enormous energy within the landscape itself is quite consistent with Ruskin's known views. What is submerged in metaphor and purely verbal energy is suggested explicitly in *Modern Painters III,* where he marks as the most important feature of true landscape feeling a sensitivity to the alien life of things (5.340–341). The "dim, slightly credited animation in the natural object" is boldly proclaimed in the sixties and seventies as an animating spirit, a living force or power felt in all things.[21] Not only animals but trees, rocks, and clouds all seemed alive in varying degrees. Ruskin admitted no sharp division between animate and inanimate nature. Changes in aspect, throughout the natural world, indicated changes in structure, the growth or decay of organic entities. Light and color particularly marked the presence of energy. When Ruskin attributes an unexpected activity to an apparently still scene, he is expressing what he understands as a true fact about nature—a pervasive vitality extending from the animate through the vegetable to the apparently inanimate world of rocks and clouds. The spectator at La Riccia does not perceive this fact from the one scene viewed in isolation. His impression is shaped by his earlier experiences of nature, including the trip across the lifeless Campagna which led him to this vital, colorful spot.

At the same time, however, the energy conveyed by Ruskin's prose seems to come not only from the landscape but also from the eye and mind perceiving it. Some of the incessant activity in the paragraph comes from changes of light and color from moment to moment, small changes that even a weak wind can produce. But other motion—the sinking trees, the vistas arching far up the valley—is more accurately ascribed to the scanning eye[22] or to the collecting, ennumerating, and discriminating activity of perception. Complex syntax and rapid prose rhythms that add to the impression of energy attributed to the landscape are also signs of a great visual and verbal energy. As in

the paragraph on foliage, in the second half of this paragraph the sentences grow progressively longer while the syntax — a multiplication of clauses and phrases linked without symmetry — becomes more complex. But here within the longer clauses paired terms are repeatedly used to discriminate two subtly different effects (buoyant and burning, breaks and closes, to reflect or to transmit, first a torch and then an emerald, fading and kindling), setting up, as it were, a vibration of particulars between two possible states. The more sustained rhythm of the long sentences — like successive waves that flatten finally into a last long phrase, just when the metaphorical waves dissolve into a sea of light — is quickened by the accumulation of rapid, fine distinctions in the paired terms. Toward the beginning of this part of the description, a reference to the rejoicing trees suggests the emotional excitement behind the increased intensity of description. And the narrator himself interjects, as this section begins, "I cannot call it colour, it was conflagration." The interjection calls our attention explicitly to the linguistic character of the activity in the sentences that follow. It is seeing by naming.

Though we may be reminded that Ruskin's paragraph gives us not just the landscape but the landscape as it impresses an imaginative mind, it is important to note that the landscape remains, nonetheless, Ruskin's principal subject. The balance between natural and psychological truth that Ruskin maintains is not Wordsworth's: the "Mind of Man" is not the main region of Ruskin's prose description. The relationship between color and mind here is very close to what Ruskin defines in his famous chapter on the pathetic fallacy, thirteen years later. "Blue," he insists, "does *not* mean the *sensation* caused by a gentian on the human eye; but it means the *power* of producing that sensation: and this power is always there, in the thing, whether we are there to experience it or not" (5.202). Color is a fact about the landscape of La Riccia; to experience it, for an imaginative mind, is precisely to respond to it as a power of nature. The difference between Ruskin's diary and the *Modern Painters* description is the difference between the notation of color as a fact for the painter's eye (a painter with the particular technical skills Ruskin then possessed) and color experienced by the imagination as natural energy. The distinction between Ruskin and Wordsworth or Coleridge is that in Ruskin's imaginative description visual detail is not selected and sparing, but multi-

plied and lavish.[23] The impression of energy is conveyed through the presentation of visual abundance. The collecting and discriminating activities of the perceiver remain as important in the final description as the ability to impress upon it an organizing shape, a dramatic unity, a governing metaphor.

I have emphasized the various means by which Ruskin transformed his sketches of La Riccia into a finished imaginative work—creating an illusion of a single visual composition, adding a dramatic unity of climactic experience, using specifically verbal resources to convey a single impression, pairing his "painting" with Gaspar Poussin's. These aspects of the paragraph indicate to the reader that the author is a poet-painter writing in the romantic mode of the sublime. The response demanded by such a creation is certainly admiration, but not necessarily the kind of analysis I have just given it. Yet what we noted of descriptive passages where imaginative unity is less completely achieved is still true here: Ruskin's descriptive style can, and perhaps is intended to, encourage analytic attention. The methodical visual scanning and penetration of a scene, the accumulation of visual details, the constant process of discriminating subtle differences in light or color, the gradual discovery of larger patterns—visual, emotional, and symbolic—these techniques are an important part of all Ruskin's descriptions, including La Riccia. Engaging readers in the process of seeing, they not only direct our gaze at new visual facts, they also give us practice in a more critical approach to painting, and, just as important, manage to convey the excitement of the process of visual discovery they illustrate. In a highly finished passage like La Riccia, the effect of Ruskin's descriptive art on his readers becomes particularly problematic.

The educative function of his descriptive writing later came to seem paramount to Ruskin. He was increasingly troubled by readers' responses to his early descriptions. In 1874 he wrote a friend who was compiling a book of selections from *Modern Painters,* "I *was* a little scandalized at the idea of your calling the book 'wordpainting.' My dearest Susie, it is the chief provocation of my life to be called a 'word painter' instead of a thinker. I hope you haven't filled your book with descriptions" (37.136). Six years earlier he had spoken somewhat more bitterly of his reputation as a "fine writer": "I have had what, in many respects, I boldly call the misfortune, to set my words sometimes

prettily together; not without a foolish vanity in the poor knack that I had of doing so: until I was heavily punished for this pride, by finding that many people thought of the words only, and cared nothing for their meaning" (18.146). And in 1877, speaking at Oxford on *Modern Painters,* he devoted one lecture entirely to a criticism of his early writing style. His standard in 1877 was no longer, he said, the "masters of the art of language" where "art is always manifest," but a drawing of Turner's that "looks as if anybody could have done it." He is especially critical of the too careful effects of alliteration and balanced pairings in his earlier style, "putting my words in braces, like game," or exaggerating for the sake of an effective image. "Were I writing it now," he continues, "I should throw it looser, and explain here and there, getting intelligibility at the cost of concentration" (22.514–515). Though Ruskin is speaking here of a style he used as late as 1860, his words apply to the descriptions of *Modern Painters I.* In that early descriptive style, educating the reader through visual exploration takes second place to impressing him with an overall effect of imaginative vision. It is not that the necessary information is missing, but that the author of the passage seems to care more about his paragraph as dazzling creation than as instruction for the ordinary reader. This impression almost certainly reflects Ruskin's own unarticulated creative ambitions, not always in harmony with the amateur's enthusiastic lessons in how to see. In 1843 Ruskin lacked both the critical and the stylistic self-consciousness that might have enabled him to avoid being taken for a word painter instead of a thinker or critic.

T HE FORMATION of that self-consciousness over the next thirteen years is one subject of the next four chapters. By 1856, when the third and fourth volumes of *Modern Painters* were published, Ruskin had resolved much of the confusion between word painting and criticism. He defined his own roles as writer and critic more clearly and marked the distinctions as well as the kinship between himself and the romantic poet or artist. Ruskin's new critical self-consciousness affected his descriptive writing, but it did not lead to the wholesale rejection of purple prose which his later comments might imply. Ruskin became a conscious proponent of the habits of seeing and thinking exemplified in the descriptive prose of *Modern Painters I,* but he came to identify

those habits with a beholder's experience of nature and art. The effect on his prose style was not to eliminate description or even to alter style at the sentence level. Ruskin changed the larger structure of these passages and modified the uses to which they were put. These changes did eliminate some of the confusing signals to the reader about how such passages were to be approached. It may be useful to look briefly at some examples of description from later works.

After *Modern Painters I* Ruskin seldom offered finished descriptions as versions of Turner, improvements of Claude, or as paintings in their own right. He was much more likely to quote directly from his diary (noting that he was doing so) than to work up an imaginative whole. Framing devices like the juxtaposition of Turnerian and satiric descriptions, or admonitions to readers to imagine what they cannot see, largely disappear. When Ruskin does describe, he often describes the part and not the whole of a scene or painting. His descriptions are studies focusing our attention, for the purpose of analysis, on particulars. They do not attempt to present an imaginative structure or even to give a complete account of a visual design or literary form. This focus on particulars was not, as I shall argue, simply idiosyncratic; they were important historical models for this way of seeing which shaped both Ruskin's practice and the response of his readers. One change in the format of his books made it easier to avoid giving accounts of imaginative wholes. Beginning with *The Seven Lamps of Architecture* his books were illustrated. He could offer an engraving of a Turner to supplement his verbal studies of details. But even in his illustrations Ruskin most often gives details without the design of the whole.

In the full-scale descriptions that Ruskin does offer in later works, readers' expectations of painterly performance are sometimes a calculated part of the rhetorical effect. This is most obvious in passages like the descriptions of a mountain ravine in *Modern Painters IV* (6.386–387) or a Highland glen in *Modern Painters V* (7.268–269), when Ruskin deliberately leads us to expect a word painting and then introduces details that shock us with the contrast between aesthetic expectation and harsh reality. In the midst of a loving account of the Highland scene, the spectator-reader discovers that "the carcase of a ewe, drowned in the last flood, lies nearly bare to the bone, its white ribs protruding through the skin, raven-torn," and "a little butterfly

lies on its back, its wings glued to one of the eddies, its limbs feebly quivering; a fish rises, and it is gone." Further on we encounter "the green and damp turf roofs of four or five hovels, built at the edge of a morass," and finally "a man fishing, with a boy and a dog—a picturesque and pretty group enough certainly, if they had not been there all day starving." The excitement and energy of visual exploration are deliberately excluded here, and the shift from a picturesque to a Victorian view of "nature red in tooth and claw" is accomplished by means of a series of deliberate stabs at the reader's sensibilities and expectations.

At other times Ruskin undertakes full-scale description as an aid to comprehending what is not primarily visual—for example, the bird's-eye views of northern and southern Europe in "The Nature of Gothic" (10.185–188), the contrast between Giorgione's Venice and Turner's London in "The Two Boyhoods" of *Modern Painters V* (7.374–377), or that between St. Paul's in London and St. Mark's in Venice (10.78–85). In these instances Ruskin's paired pictorial descriptions are not introduced as paintings to be admired for their own sakes, but as illustrations of the cultural, social, and historical differences that art reflects. In the last two cases, as with the shock descriptions of mountain ravine and Highland glen, there is again a deliberate tension between the reader's expectations of aesthetic pleasure from the description and Ruskin's observations of poverty, cruelty, and insensitivity in present-day Venetians and Londoners. When he has painted the splendid vision of St. Marks, Ruskin describes the people who cluster at its base:

in the recesses of the porches, all day long, knots of men of the lowest classes, unemployed and listless, lie basking in the sun like lizards; and unregarded children,—every heavy glance of their young eyes full of desperation and stony depravity, and their throats hoarse with cursing,—gamble, and fight, and snarl, and sleep, hour after hour, clashing their bruised centesimi upon the marble ledges of the church porch. And the images of Christ and His angels look down upon it continually. (10.84–85)

The description is pictorial but not picturesque. The intruding Italian urchins constitute a criticism of picturesque expectations as well as of social realities. The more we approach Ruskin's descriptions as a picturesque verbal art, the greater will be our surprise (and sometimes,

indignation) at the unlovely realities Ruskin has included in his scenes—ugly truths about himself and his viewers and readers. This sometimes violent reversal of the reader's expectations is exactly the effect that Ruskin intends, concerned as he is, from *The Stones of Venice* on, with moving his readers to *do* something about decaying masterpieces or, more important, about intolerable living conditions in Scotland or Italy or England.

At the end of his life Ruskin discovered yet another way of using description. Descriptions of places are the real emotional centers of his autobiography, *Praeterita*.[24] His memories of them, not a series of dates or events or achievements, create its structure. The chapter on "The Simplon," describing Geneva and the Rhone, is the heart of a pattern of related landscapes that form Ruskin's earliest memories and to which he returns throughout the book. The distinctive characteristics of Ruskin's prose descriptions are all present in his extensive account of the Rhone. Seeing is presented as a progressive experience, with the reader led as spectator into the scene while the eye penetrates still further, scanning, discriminating, naming the finest details of a visually rich and complex landscape. The impression of the whole—an emotional as well as visual impression—is carefully built up through examination of the parts. Motion of the eye and energy in the prose seem to come directly from the response of the mind to the life of what it sees. But there are important differences between Ruskin's *Praeterita* description of the Rhone and his *Modern Painters* description of La Riccia. Concentration has indeed loosened. The burden of the sublime does not hang over the artist and his reader. There is no rush to revelation, to a climax of feeling or meaning, a summary vision. Looking is a more leisurely activity. The order of seeing seems less firmly fixed by the demands of dramatic narrative or educational analysis. The narrator, like the river, has followed its "eddied lingering" randomly or according to a very personal and perhaps discontinuous pattern. The prose reflects the movements of memory and personal association, not the movement of intensive visual analysis.

Waves of clear sea, are, indeed, lovely to watch, but they are always coming or gone, never in any taken shape to be seen for a second. But here was one mighty wave that was always itself, and every fluted swirl of it, constant as the wreathing of a shell. No wasting away of the fallen foam, no pause for

gathering of power, no helpless ebb of discouraged recoil; but alike through bright day and lulling night, the never-pausing plunge, and never-fading flash, and never-hushing whisper, and, while the sun was up, the ever-answering glow of unearthly aquamarine, ultramarine, violet-blue, gentian-blue, peacock-blue, river-of-paradise blue, glass of a painted window melted in the sun, and the witch of the Alps flinging the spun tresses of it for ever from her snow. (35.326–327)

The eye and mind seem free to wander in short drifting phrases and then to pause where all sense of coherent visual space, of surface and depth, is lost. In the final sentence of this passage Ruskin's usual long wave of phrases, clauses, participles, and adjectives does not convey the usual sense of compelling motion and energy. Movement and force are held perfectly balanced in the stasis of constant motion by the negated participial phrases—"no wasting . . . never-pausing . . . never-fading"—each of them followed by a pause but still continuing beyond the pause to the final "for ever from her snow." Weight and solidity are balanced against delicacy and fragility, the force and strength of waves of melted ice or glass flashing back the sun against the wreathing of cloud or shell, the fluted swirl, the spun tresses that whisper and glow. The absence of spatial boundaries (no surface, no bottom), the perfect balance of motion and pause, of weight and lightness, of mass and delicacy, result in a release into a sort of perpetual free fall, a condition of perfect physical freedom. That freedom could never be boring: it is born of total saturation in visual abundance, of an intricate, limitless, perpetual pattern of color and movement. The freedom is emotional, too. Just as there is no need to rise to a climax of appreciation, so there is no need to shock anyone into reforming action. Seeing is innocent gladness; there are no hidden depths, no unpleasant facts to be uncovered. Ruskin's description neither turns on the reader nor moves on to a conclusive vision or a framing distance. It hangs for an eternal moment in a field of snow, then begins again to follow the "eddied lingering" of the river.

The innocent way, too, in which the river used to stop to look into every little corner. Great torrents always seem angry, and great rivers too often sullen; but there is no anger, no disdain, in the Rhone. It seemed as if the mountain stream was in mere bliss at recovering itself again out of the lake-sleep, and raced because it rejoiced in racing, fain yet to return and stay.

There were pieces of wave that danced all day as if Perdita were looking on to learn . . . and in the midst of all the gay glittering and eddied lingering . . . the dear old decrepit town as safe in the embracing sweep of it as if it were set in a brooch of sapphire. (35.327–328)

The final embrace of the river itself is all the wholeness the vision needs.

The recurrent landscapes of *Praeterita* become metaphors of an individual mind, as Ruskin's other descriptions do not. That mind, and not the landscape itself, is the subject of Ruskin's last book. In this sense *Praeterita* is Ruskin's one great opus as a romantic artist and poet. Its descriptions are a private gallery of the author's paintings, such as Turner built; like Turner's, they demand to be taken together. These are episodes in the life of a mind, recurrent encounters with landscapes to which Ruskin returned, in fact and in memory, as often as Wordsworth to his "spots of time." Description is artifact in *Praeterita*. But the end of these descriptions is not the production of a painting, nor the production of an educated response in a reader-viewer. Seeing is an end in itself in *Praeterita*, needing no goal and no termination. The sensibility revealed through the *Praeterita* descriptions is not changed by what it sees; it *is* what it sees. The vitality that Ruskin finds and his prose creates is what keeps him alive, because his claim to identity comes not through the cumulated loves and events of time but through his sensibility. When he can no longer return through memory and his own words to recreate sights, he cannot continue the autobiography. He concludes his book by presenting a landscape where the process of seeing is finally brought not to a climax but to an impasse, as he loses himself in the lights of fireflies that forever close off familiar prospects of water, cities, mountains, and clouds.

The Victorian Critic in Romantic Country

BETWEEN THE WORD PAINTING OF *Modern Painters I* and the mental landscapes of *Praeterita* stretch the forty-five years of Ruskin's career. Within a decade after *Modern Painters I* he was certain that his vocation was to be a critic and not a poet or painter. The third volume of *Modern Painters* confronts us directly with Ruskin's choice. At the beginning of that volume he identifies himself firmly for the first time as a professional writer on art:

I have now given ten years of my life to the single purpose of enabling myself to judge rightly of art, and spent them in labour as earnest and continuous as men usually undertake to gain position, or accumulate fortune. It is true, that the public still call me an "amateur" . . . I have, however, given up so much of life to this object; earnestly desiring to ascertain, and be able to teach, the truth respecting art. (5.4)

Ruskin offered his ten years of study not only to show that he was not an amateur but also to ask that he no longer be read as a word painter. He defended his method and style as "the labour of a critic who sincerely desires to be just" (5.6). In fact Ruskin had put aside his ambitions as poet and artist shortly after *Modern Painters I* was published, but in the succeeding decade he went on to reexamine the whole notion of the romantic poet-artist. The second half of *Modern Painters III* is a sustained if often indirect criticism of Wordsworth in which Ruskin distinguishes for himself a vocation and a manner of seeing different from that represented by the great romantic nature poet.

Turner may be the professed hero of *Modern Painters,* but Wordsworth is his co-hero in *Modern Painters I.* In that volume Turner, Wordsworth, and sometimes Ruskin himself seem to share the same

mode of seeing and feeling, imaginative vision at its most sublime. This trinity has dissolved in *Modern Painters III*. What Ruskin set out to justify and emulate in the prose of *Modern Painters I*—the art of Turner and Wordsworth—is examined in *III* and *IV* from a perspective consciously distinct from theirs. Ruskin's criticism of Wordsworth is part of a larger critique of the romantic imagination as a privileged mode of perception. To romantic descriptions of the poetic imagination, Ruskin opposes his own versions first of imaginative and finally of critical perception. Though Ruskin identifies himself as a romantic, he defines a critical attitude—and with it, a prose style—formed in opposition to his romantic model. At the end of his chapters on romanticism in *Modern Painters III* Ruskin invites his readers to join him in his different mode of perception, the critical "science of aspects."

In his larger critique of romanticism, beginning with the chapter "Of the Novelty of Landscape," Ruskin questions the meaning and value of the nineteenth-century passion for landscape. Ruskin's chapters have for the most part been read piecemeal, either for his history of landscape representation, his theory of the pathetic fallacy, or his shift from aesthetic to social criticism—but not for his startling comments on Wordsworth.[1] The seven chapters seem to me to form a coherent argument against a particular kind of romantic vision which Ruskin identified with Wordsworth. Ruskin's case against his former hero is a convenient place to begin an examination of his critical approach to romantic art. The criticism of Wordsworth is also Ruskin's first sustained presentation of an alternative, beholder's point of view.

To read these chapters of *Modern Painters III* as a revaluation of Wordsworth puts Ruskin's most famous contribution to literary criticism, his theory of the pathetic fallacy, in a different light. This much debated concept has been read as Ruskin's response to romanticism by both Patricia Ball and Harold Bloom.[2] Ball rightly relates the pathetic fallacy to Ruskin's early prose descriptions, identifying both as a departure from romantic attitudes toward observation. But by using Coleridge as her reference point, she misses an important part of Ruskin's quarrel with his romantic models: his distinction between the imaginative perception of the romantic poet, exemplified by Wordsworth, and the critical perception Ruskin recommended to the Victorian reader and adopted as his own. Bloom, stressing the actions

and reactions of poetic influence, turns immediately to Wordsworth. For Bloom, however, the distance Ruskin discovered between himself and Wordsworth is the "terrible pathos" in Ruskin's critical art,[3] not, as Ball argues, an important shift in nineteenth-century attitudes toward description. Limited in focus to the pathetic fallacy, neither Bloom nor Ball looks closely at Ruskin's other objections to romantic poetry. Those objections are essential to my concerns: Wordsworth's role in Ruskin's self-definition as a critic and Ruskin's redirection of the nineteenth-century English response to landscape.

Ruskin was not the only Victorian in the 1850s to criticize romantic examples. Tennyson, Browning, and Arnold all did so before him.[4] Tennyson's *In Memoriam* (1850), subtitled "The Way of a Soul," can serve as a Victorian analogue to Wordsworth's *The Prelude, or Growth of a Poet's Mind,* published posthumously in the same year. Two of Wordsworth's earlier poems, "Tintern Abbey" and "Ode: Intimations of Immortality from Recollections of Earliest Childhood," provide a context for the comparison of romantic with Victorian experience as pursued both in *In Memoriam* and in *Modern Painters III.* Like Ruskin's critical prose, Tennyson's poem seems consciously to alter readers' expectations established by romantic conventions (for Tennyson, the long romantic lyric).[5] Arnold's "The Scholar Gypsy" and Browning's "Childe Roland to the Dark Tower Came" (1853 and 1855) similarly take a special romantic theme—the autobiographical quest—as an occasion for expressing their distance, in temper and style, from romantic models. In the same years both poets also attempted in prose to define and distinguish themselves from some aspect of romantic poetry: Arnold in the 1853 preface to his *Poems,* Browning in his 1851 essay on Shelley. For all three men these revisions of romantic attitudes and styles were not their first work, but marked the beginning of a distinctive personal style and a distinctively Victorian self-consciousness. Ruskin's 1856 volumes of *Modern Painters,* prefaced by his presentation of himself as a professional critic, occupy a similar position in the development of his critical attitudes and prose.

Unlike his contemporaries, however, Ruskin was assessing the romantic imagination through its art as well as its literature. In *Modern Painters I* he uses romantic poetry to illustrate, and elevate, landscape art; in *Modern Painters II* romantic poetics provide the primary model for Ruskin's theories of imagination; in *Modern Painters III* he reverses

the strategy of the first volume and uses landscape art to criticize romantic poetry. His criticisms amount to a further revision of romantic sister-arts theory, a departure from his own insistence in earlier volumes on the equality of Painting and her traditionally greater sister, Poetry. The judgments of *Modern Painters III* are specifically historical, however, as those of *Modern Painters I* and *II* were not. Ruskin approaches Turner and modern landscape painting from the new perspective provided by his recent venture into cultural history, *The Stones of Venice*. Where his first volume had simply assumed common modes of seeing and feeling in recent landscape art and literature, and his second volume had developed aesthetic theories in support of that assumption, the third volume of *Modern Painters* focuses on these modes of seeing and feeling as an historical phenomenon expressing and serving particular cultural needs. Writing now from the viewpoint of the cultural critic, Ruskin finds that landscape painting is and should be the dominant modern form of expression because it can better serve the needs of the culture. His criticisms of the romantic imagination have to be viewed in the context of this revaluation of poetry and painting in modern European culture—a revaluation that is as much political as it is aesthetic.

RUSKIN turns to Wordsworth at three different times in his critical career: in the 1840s, to illustrate Turner; in the 1850s, as a key example of modern landscape feeling; and in the 1880s, as a foil for his praise of Byron. The discussion of Wordsworth in *Modern Painters III* provides the fullest explanation for the dramatic shift in Ruskin's opinion between the 1840s and the 1880s, and the poet's role in *Modern Painters I* is the best index to what Wordsworth once meant to Ruskin. (There is another Wordsworth for Ruskin, whom he continued to admire. I shall return to this Victorian Wordsworth in the next chapter.)

Wordsworth occupies a more prominent place on the title page of *Modern Painters* than either Turner or the author. Every edition of every volume carries a long epigraph from *The Excursion* (IV.978–992):

> Accuse me not
> Of Arrogance . . .
> If, having walked with Nature . . .

And offered, far as frailty would allow,
My heart a daily sacrifice to Truth,
I now affirm of Nature and of Truth,
Whom I have served, that their Divinity
Revolts, offended at the ways of men

. . .

Philosophers, who, though the human soul
Be of a thousand faculties composed,
And twice ten thousand interests, do yet prize
This soul and the transcendent universe,
No more than as a mirror that reflects
To proud Self-love her own intelligence.

The Wanderer, who speaks these lines, affirms an authority based on the direct experience of nature. Ruskin seems to be adopting this claim as his own. The Wanderer contrasts the experience of a humble heart with the narrower intelligence of philosophers—for Wordsworth, as the larger context of the quotation makes clear, an attack on scientists and eighteenth-century rationalists like Voltaire. Ruskin's first volume is similarly offered as the testimony of an amateur observer of nature against the experts, in his case art reviewers, historians, and critics. Like Wordsworth, Ruskin claims for the amateur a direct access to knowledge of nature, soul, and God. And he endorses Wordsworth's attack on the "proud Self-love" of the experts, which both men counter with the nonprofessional's love of his subject for its own sake—the pure love of the Divinity of Nature and Truth. Ruskin does not attempt to distinguish between himself, Wordsworth, and Wordsworth's Wanderer—between the amateur critic, the poet, and the voice of traditional pastoral wisdom, Wordsworth's pedlar-sage. These identifications hold true throughout the first volume of *Modern Painters*. The tone and diction of Ruskin's prose sometimes identify the author as amateur observer, sometimes as exalted poet-seer, and sometimes as preacher or sage.

Wordsworth is also the poet whose descriptions Ruskin most frequently quotes in *Modern Painters I* to illustrate Turner's natural phenomena. Ruskin singles out three Wordsworthian qualities for special praise: his acute observation of visual detail, his penetration beyond surface detail to essential natural facts, and the balance of faculties, in

cluding feeling, which characterizes his perceptions. He quotes Wordsworth for "fine and faithful" descriptions (3.363), calls him "the keenest-eyed of all modern poets for what is deep and essential in nature" (3.307), and holds him up as model for the inferior English landscapists who "have not the intense all-observing penetration of well-balanced mind" or "anything of [Wordsworth's] feeling" (3.177). This praise is both romantic and Wordsworthian and, at the same time, unWordsworthian and even anachronistic in the 1840s: Ruskin sounds romantic when he uses the keen eye as a metaphor for the penetrating, feeling mind; anachronistic when he praises Wordsworth as a descriptive poet. The emphasis on penetration and the well-balanced mind follows Wordsworth's own correction of superficial picturesque attitudes to nature—"The repetitions wearisome of sense, / Where soul is dead, and feeling hath no place" (*Excursion* IV.620–621); the "tyranny" of the eye "Bent overmuch on superficial things" and insensitive "to the moods / Of Nature and the spirit of the place" (*The Prelude* [1805] XI.179, 161–162). Ruskin cites the same Wordsworthian qualities of intensity, penetration, and feeling as signs of imagination, "the highest intellectual power of man" in *Modern Painters II.* The theory of imagination developed there is largely based on romantic poetics (Wordsworth's prefaces are cited), but it serves as a theory for the visual arts as well. Ruskin calls the central mode of imagination for both painters and poets "penetrative"; it is above all intense, acts reciprocally with feeling, and pushes beyond surface detail to grasp essences:

It never stops at crusts or ashes, or outward images of any kind; it ploughs them all aside, and plunges into the very central fiery heart; nothing else will content its spirituality; whatever semblances and various outward shows and phases its subject may possess go for nothing . . . it looks not in the eyes, it judges not by the voice, it describes not by outward features; all that it affirms, judges, or describes, it affirms, from within. (4.250–251)

Although Ruskin follows Wordsworth in identifying the imagination with a mental eye, he nonetheless praises him primarily as a descriptive poet. The quotations in *Modern Painters I* are all examples where outward images are *not* plowed aside or outer detail made "obscure, mysterious, and interrupted" to better reveal inner nature (4.253). The Wordsworth of *Modern Painters I* is the man of acute observation and faithful description, not the poet for whom "the light of

sense / Goes out" (*The Prelude* [1805] VI.534–535) when the light of imagination dawns. When Ruskin praises Wordsworth in eighteenth-century terms as a pictorial poet, he departs from Wordsworth's understanding that accurate observation and description are only the first step toward imaginative creation. He departs also from the devaluation of purely visual description in poetry expressed by other romantics (Coleridge and Hazlitt, for example). Ruskin found in Evangelical typology a theoretical precedent for his conviction that outer detail and inner essence, visual and imaginative or spiritual truth, could coexist in equality.[6] But when he reexamined Wordsworth and romantic poetics in *Modern Painters III*, he discovered that they could not serve as literary examples of an art both pictorial and imaginative.

At the beginning of *Modern Painters III* Wordsworth is once again paired with Turner as an imaginative poet-artist, but halfway through the volume he is first condemned as a bad judge of painting, next put in a lower order of poets, and then replaced as the representative modern poet by Walter Scott. By the end of Ruskin's discussion of the modern temper, Turner stands alone as the great creative mind of nineteenth-century England. Even in Wordsworth's own territory, the Lake Country, Ruskin takes Turner for his guide (ill. 3). Turner alone is hailed as "the master of this science of *Aspects.*" What has happened to the co-hero of *Modern Painters I*?

This question, which must have struck many readers, Ruskin answers from a characteristically changing series of critical perspectives. He raises three major objections to Wordsworth's poetry in *Modern Painters III*. First, nineteenth-century poetry is peculiarly susceptible to the pathetic fallacy. As a poet, Wordsworth is not simply the humble student of Nature and Truth portrayed in *The Excursion*. A favorite device of modern poetry has led him to a serious failure of perception. Second, Ruskin argues that since painting conveys the emotion of landscape more effectively than poetry, visual description is more important than Wordsworth allows. Turner's art expresses and responds to the temper of the age better than Wordsworth's antipictorial poetry. Finally, according to Ruskin, Wordsworth's account of his landscape experience is inaccurate; thought is always an inseparable part of perception. Because he misrepresents his own act of seeing, Wordsworth is a misleading guide for modern readers who share his love of landscape.

Ruskin's chapter "The Pathetic Fallacy" is his first substantial quali-

fication of Wordsworth's greatness. The pathetic fallacy, as Ruskin defines it, is a device for expressing psychological truths in descriptive poetry. A distorted presentation of natural facts reveals the emotional preoccupations of the perceiver. Wordsworth, Tennyson, and Keats are "Reflective or Perceptive" poets (5.205n) for whom the pathetic fallacy is an effective strategy. Their poetry uses a speaker describing and meditating on nature "who perceives wrongly, because he feels, and to whom the primrose is anything else than a primrose: a star, or a sun, or a fairy's shield, or a forsaken maiden" (5.209). There is a contrasting mode of poetry, which Ruskin calls the creative; it is not primarily descriptive or meditative nature poetry and need not rely on pathetic fallacy to portray emotional responses. Though description is not its primary mode, it may contain passages of description; but (at least in the examples Ruskin gives) these descriptions of natural fact are introduced as comparisons or metaphors for some fact of human action or emotion. Unlike pathetic fallacy, such comparisons need not blur or distort differences between human and external nature. Dante can compare falling souls to falling leaves

without, however, for an instant losing his own clear perception that *these* are souls, and *those* are leaves; he makes no confusion of one with the other. But when Coleridge speaks of

"The one red leaf, the last of its clan,
 That dances as often as dance it can,"

he has a morbid, that is to say, a so far false, idea about the leaf; he fancies a life in it, and will, which there are not; confuses its powerlessness with choice, its fading death with merriment, and the wind that shakes it with music. (5.206–207)

Though Ruskin insists that both groups of poets must be "*first*-rate in their range" (5.205), he orders them in a definite hierarchy. Creative poetry is a higher mode than reflective or perceptive poetry because it gives equal weight to psychological truth and physical fact. Where poets and speakers are clearly distinct, the pathetic fallacy is, Ruskin says, a legitimate dramatic device (5.218). But if, as Ruskin sometimes (rather unfairly) assumes, poets' perceptions are often as distorted as their speakers', then they are inferior to creative poets who, though they too feel strongly, also "think strongly, and see truly" (5.209).

This way of putting the case identifies the poet's choice of the reflective or perceptive poetic mode with a serious flaw in perception. The following chapters of *Modern Painters III* apply this criticism to romantic poets in general and to Wordsworth in particular. In one sense Ruskin is extending a romantic criticism of nature poetry, following Wordsworth and Coleridge when he argues that a poet's perception of nature is inadequate if it does not involve all the faculties of a well-balanced mind. But where Wordsworth, thinking of the late eighteenth century, attacked the "mimic" rules of picturesque perception and the narrow rationalism of scientists and philosophers, Ruskin finds the greatest danger for poets of Wordsworth's and succeeding generations to come from the very feeling they had trusted to correct the distortions of rules and reason. Wordsworth's Wanderer accuses the self-reflecting intellect; Ruskin attacks the self-projecting heart. He continues to praise Wordsworth's "intense penetrative depth" in *Modern Painters III,* but his praise is repeatedly qualified by warnings that the feeling Wordsworth brings to his perception of nature has become a source of "proud Self-love." Ruskin makes this criticism of Wordsworth when he praises another romantic poet, Walter Scott.

When Ruskin looks for a representative nineteenth-century poet, he assumes that this poet will share the period's unusual love of landscape. We might expect, then, that the nineteenth-century poet would also use the pathetic fallacy. According to Ruskin, only Scott does not. Why then choose Scott, whose best work Ruskin himself believes to be his novels, rather than Wordsworth, whom Ruskin considers the greatest poet in the reflective or perceptive school of nature poetry? Ruskin says that Scott can represent the weaknesses as well as the potential strengths of landscape poetry, but it does not seem to be entirely for his faithlessness or sentimental attitude toward the past that Ruskin has chosen him. Scott seems to be important for Ruskin because his is the only example of a descriptive, reflective nature poetry which does not rely on the pathetic fallacy. Scott is representative not of what landscape poetry has been, but of what it could be—though Ruskin does not claim that Scott is himself the greatest landscape poet. The undercurrent of comparison between Scott and Wordsworth which runs through "Of Modern Landscape" constantly points to the fallacy of projected feeling as the chief difference between them. Scott alone of modern writers is humble and free of affectation. Words

worth's conversations reveal traces of "jealousy or self-complacency" and he is "often affected in his simplicity" (5.332). Scott is the greatest example of the "pure passion for nature," the "habit of looking at nature . . . as having an animation and pathos of *its own*." This attitude "is not *pathetic* fallacy; for there is no passion in *Scott* which alters nature," and consequently his "enjoyment of Nature is incomparably greater than that of any other poet I know. All the rest carry their cares to her, and begin maundering in her ears about their own affairs." Tennyson, Keats, Byron, and Shelley are particularly guilty:

Wordsworth is more like Scott, and understands how to be happy, but yet cannot altogether rid himself of the sense that he is a philosopher, and ought always to be saying something wise. He has also a vague notion that nature would not be able to get on well without Wordsworth; and finds a considerable part of his pleasure in looking at himself as well as at her. But with Scott the love is entirely humble and unselfish. (5.340–343)[7]

Ruskin's first objection to Wordsworth, then, is that he slights visual for psychological fact, preferring the subjective truth conveyed by the pathetic fallacy.

To this essentially romantic criticism of Wordsworth and romantic poetry, Ruskin joins a second, unromantic attack on poetry that undervalues visual imagery. His praise of Scott's narrative and descriptive poems over Wordsworth's more psychological ones is involved in this attack as well. In *Modern Painters I* and *II* and at the beginning of *Modern Painters III* Ruskin insists on the theoretical equivalence of painting and poetry as imaginative arts.[8] Though by doing so he sets himself against an antipictorial tradition of romantic poetics, which begins with Burke, enlists Coleridge and Hazlitt, and influences Wordsworth, Ruskin at first coopts Wordsworth as an example of his own position. He assumes that the art of Turner and the poetry of Wordsworth can be understood in the same terms. But later in *Modern Painters III* Ruskin argues that painting has a greater imaginative effect than poetry on the modern mind. In making that argument he establishes criteria to show that Wordsworth's antipictorial poetry works differently, and less effectively, than Turner's painting.

When Burke compared emotional effects in the literature and art of

the sublime, he argued that language affects emotional response more directly and powerfully than pictures. Burke was refuting the picture theory of language derived from Hobbes and Locke, which held that words act on the mind by evoking images. The picture theory had helped call into question the Renaissance view that painting was a lesser sister of the other major imitative art, literature. Burke observed that words are *not* very effective at evoking images. From this he went on to suggest new grounds for the superiority of literature to painting.

The truth is, all verbal description, merely as naked description, though never so exact, conveys so poor and insufficient an idea of the thing described, that it could scarcely have the smallest effect, if the speaker did not call in to his aid those modes of speech that mark a strong and lively feeling in himself. Then, by the contagion of our passions, we catch a fire already kindled in another, which probably might never have been struck out by the object described. Words, by strongly conveying the passions . . . compensate for their weakness in other respects . . . [They are] able to affect us often as strongly as the things they represent, and sometimes much more strongly.[9]

The contagion of passions that Burke described was elaborated into romantic theories of a sympathetic imagination. His suggestion that literature, because its "business is to affect rather by sympathy than imitation," should avoid merely pictorial description was taken up by Coleridge and Hazlitt, who also affirmed his speculation that literature might affect us more strongly than imitative art. Hazlitt writes that

the argument which has been sometimes set up, that painting must affect the imagination more strongly, because it represents the image more distinctly, is not well founded . . . Painting gives the object itself; poetry what it implies. Painting embodies what a thing contains in itself: poetry suggests what exists out of it, in any manner connected with it. But this last is the proper province of the imagination.[10]

Or again: "words are a key to the affections. They not only excite feelings, but they point to the *why* and *wherefore* . . . They are links in the chain of the universe, and the grappling-irons that bind us to it . . . they alone answer in any degree to the truth of things."[11] Both Hazlitt and Coleridge attack writers (Crabbe is a favorite target) who

seem to give descriptive detail for its own sake. Coleridge affirms: "images taken from nature and accurately described [do] not characterize *the poet.* They must be blended or merged with other images, the offspring of imagination, and blended, besides, with the passions or other pleasurable emotions which contemplation has awakened in the poet himself."[12] In a Burkean passage, Coleridge insists, "What are deemed fine descriptions, produce their effects almost purely by a charm of words, with which & with whose combinations, we associate *feelings* indeed, but no distinct *Images.*"[13]

Wordsworth's many references to the tyranny of the eye and the need for the imagination to escape it indicate his sympathies with this antipictorial approach. In the preface to his 1815 *Poems* Wordsworth lists accurate observation and description of "things as they are in themselves . . . unmodified by any passion or feeling existing in the mind of the describer" as the first power necessary to the poet, but he adds: "This power, though indispensable to a Poet, is one which he employs only in submission to necessity, and never for a continuance of time: as its exercise supposes all the higher qualities of the mind to be passive, and in a state of subjection to external objects, much in the same way as a translator or engraver ought to be to his original."[14] In Wordsworth's poetry, eye is again and again either opposed to heart, mind, and imagination or stripped of its usual sensory meaning in order that it may become a metaphor for mental action.[15] When Wordsworth remembers, in *The Prelude,* his early picturesque tour of the Alps, he says "the eye was master of the heart" and "held my mind / In absolute dominion"; imagination suffered under this tyranny of the eye (XI[1805].171,174-175). Only when "we are laid asleep / In body, and become a living soul" can sight return as a metaphor for an inward action of the mind. Then, "with an eye made quiet by the power / Of harmony, and the deep power of joy, / We see into the life of things" ("Tintern Abbey," 45-49).

In *Modern Painters I* and *II* Ruskin directly opposes the Burkean argument that poetry, as an imaginative art, is higher than painting, an imitative art. But as George Landow has pointed out, he opposes it with an interesting mixture of romantic and unromantic ideas about the imagination.[16] On the one hand, he extends romantic poetics to the visual arts when he insists that both poetry and painting are imaginative arts: they appeal to the same supreme faculty. On the

other hand, he defines imagination differently: the imagination works reciprocally with feeling, but it works *through* visual images—in literature, as in painting. This view of a primarily visual imagination, though common in the eighteenth century, was not shared by romantics. Ruskin admits that "in representing human emotion words surpass painting" (5.330), but he would not agree with Burke that visual imagery is irrelevant to the power of words to evoke an emotional response in the reader. He is committed to the belief that both words and paint evoke images in the imagination and by that route affect the emotions of readers and viewers. Hence a single definition serves for both literature and art: both are "poetry," "the suggestion, by the imagination, of noble grounds for the noble emotions." Still more explicitly, "the power of assembling, by *the help of the imagination,* such images as will excite these feelings, is the power of the poet" (5.28,29). By this definition, there is no distinction in kind between the imaginative effects of a Turner painting and a Wordsworth poem.

In "Of Modern Landscape," however, Ruskin changes his appraisal of the sister arts by shifting from a theoretical to an historical argument. Looking at the nineteenth century, Ruskin asks whether the new emphasis on landscape alters the equality of painting and poetry as imaginative arts. His criterion is a cultural historian's: he is comparing art and literature as expressions of the modern mind. At the same time, he is making an aesthetic judgment, but one intended to be historically limited: he is comparing the power of art and literature to appeal to a modern audience.

as the admiration of mankind is found, in our times, to have in great part passed from men to mountains, and from human emotion to natural phenomena, we may anticipate that the great strength of art will also be warped in this direction . . . and farther, because . . . in representing natural scenery painting surpasses words, we may anticipate also that the painter and poet . . . will somewhat change their relations of rank in illustrating the mind of the age; that the painter will become of more importance, the poet of less. (5.329–330)

Wordsworth's poetry may be doubly damned, but Ruskin's judgment of it must nonetheless be understood in the light of his belief that painting, not poetry, has greater power to express and move a modern

mind. Ruskin certainly criticizes Wordsworth's handling of nature in his poetry. By opposing feeling to sight, Wordsworth lets his own responses obscure certain truths of nature (the pathetic fallacy). Moreover, he does not sufficiently recognize what seems to Ruskin to be the fundamental importance of the eye to imagination and feeling. Yet Ruskin's attacks on Wordsworth, like his praise of Scott, are qualified by his belief that no landscape poetry has the imaginative power of the greatest landscape painting. Ruskin replaces Wordsworth with Scott not because Scott's poetry is greater, but because Scott's treatment of nature—joyful description for its own sake, otherwise "unmodified by any passion or feeling existing in the mind of the describer"—is closer to the pure landscape feeling that painting more successfully captures. In *Modern Painters III* Wordsworth remains for Ruskin the chief figure in nineteenth-century landscape poetry. But that poetry, with its emphasis on individual feeling at the expense of accurate description, misrepresents and perhaps misleads the modern mind.

In the last chapter of his critique of romanticism, Ruskin raises his third objection, this time to Wordsworth's account of perception. Ruskin challenges the authority of Wordsworth's personal experience of nature, the authority by which Wordsworth subordinates the eye to feeling and imagination. Where Wordsworth testifies that his youthful landscape response ("a feeling and a love, / That had no need of a remoter charm, / By thought supplied"; "Tintern Abbey," 80–82) became with age less vivid but more profound, Ruskin insists that sense is never separate from thought, even in the child. "There is not, however, any question but that both Scott and Wordsworth are here mistaken in their analysis of their feelings. Their delight, so far from being without thought, is more than half made up of thought, but of thought in so curiously languid and neutralized a condition that they cannot trace it" (5.355). The thought that more than half makes up their impressions is subordinated to the visual image, of which alone they are conscious. Taking as example a scene of many visual delights where what "impresses us most" is nonetheless "a thin grey film on the extreme horizon," because it "is known to mean a mountain ten thousand feet high, inhabited by a race of noble mountaineers," Ruskin notes that the identification of the thin film as mountain takes place at a level of perception below consciousness. It is not an articulated

thought: "the thoughts and knowledge which cause us to receive this impression are so obscure that we are not conscious of them; we think we are only enjoying the visible scene; and the very men whose minds are fullest of such thoughts absolutely deny, as we have just heard, that they owe their pleasure to anything but the eye" (5.356).

Relying, like Wordsworth, on his own experience, Ruskin finds that his earliest response to natural scenery "was never independent of associated thought" (5.365). Even as a child he possessed a frame of reference that governed his perception of visual beauty. Literary and historical associations suggested a contrast between his everyday experience of contemporary cityscapes and images of a more pastoral past. A particular set of emotions—joy, affection, sorrow, delight mixed with awe—were part of his frame of reference. According to Ruskin's account, he could never have seen landscape without a complex of individual and cultural associations.

Ruskin insists that there is no such thing as seeing without thought because he wants to deny the second part of Wordsworth's testimony: that there can continue to be landscape feeling—and for Wordsworth, more profound feeling—if the youthful delight in visual experience fades.[17] Ruskin maintains that thought is and must remain subordinate to visual experience.

And observe, farther, that this comparative Dimness and Untraceableness of the thoughts which are the sources of our admiration, is not a *fault* in the thoughts, at such a time. It is, on the contrary, a necessary condition of their subordination to the pleasure of Sight. If the thoughts were more distinct we should not *see* so well; and beginning definitely to think, we must comparatively cease to see. (5.356)

He describes the proper relation of thought to sight, characteristically, through a visual metaphor: a garland of thoughts and fancies grouped and fastened about a natural object (5.359). This act of seeing, more than half made up of dim and untraceable thoughts even in the child, is not a prelude to imagination; it *is* imagination, "the power of the imagination in exalting any visible object, by gathering round it, in farther vision, all the facts properly connected with it; this being, as it were, a spiritual or second sight, multiplying the power of enjoyment according to the fulness of the vision" (5.355).

Ruskin has in fact identified imagination as "the power of fully *per-*

ceiving any natural object." The process takes place not at the level of language but at the level of images. It is a kind of visual thinking. Though he distinguishes imaginative perception from simple visual sensation, it is clear that he does not believe such primary or innocent sight actually possible—even the child's sight is thoughtful or imaginative. As he later claimed, all seeing, properly understood, is imaginative; it is "second or spiritual sight" (22.195). The word "spiritual" is not just an exhortation to look for moral or religious significance in things seen (though Ruskin often uses it this way). His efforts to reform perception are based on an argument about the nature of perception as a psychological process. He is countering romantic psychology with his own. Coleridge, Hazlitt, and Wordsworth contend that, while images may imitate reality, only words convey feelings and associations, "the proper province of the imagination." For Ruskin, to perceive is to feel and think without language. To perceive is to imagine.

Ruskin's account of perception resembles both the associationist psychology important to Wordsworth and modern psychological explanations of perception, but differs from them in one important respect. Like the most widely known associationist, Archibald Alison, Ruskin stresses the role of association in even the child's response to natural beauty. And like gestalt and perceptual psychologists, whose ideas have been incorporated into art theory by Rudolph Arnheim and Ernst Gombrich, Ruskin insists that these associations are a necessary part of the act of seeing itself, operating below the level of consciousness and hence of language.[18] We see the gray film because we identify it as a distant mountain. It may sound strange to attribute this notion of perception to Ruskin who, after all, also invented the phrase "innocence of the eye" (15.27n). (Gombrich uses Ruskin as his straw man when he argues for the conventionality of all perception.) But it is worth remembering that the innocent eye is a notion Ruskin introduced in a handbook on drawing for amateurs; its principal function was to help his students shed a particular set of pictorial conventions. *Modern Painters III*, written a year before *The Elements of Drawing*, is the other side of the heuristic argument for an innocent eye. No eye, Ruskin argues in *Modern Painters III*, really comes innocent to the perception of landscape.

But Ruskin stops short of a belief in the complete subjectivity or

conventionality of perception. He is closer to Gombrich or Arnheim than to Alison or Wordsworth because he understands perception as a sort of visual thinking with association as a part of, and not subsequent to, the act of seeing. But he differs from both Alison and the later writers because he believes that the perceiver does register one image that corresponds to the object in front of him. The central image in the garland of thought-images retains its status as an objective fact, though its power as impression is enhanced by the cluster of associated images. Ruskin's metaphoric description of the perceptual process may be difficult to take literally, but it reflects his desire to distinguish his own account of perception from associationist accounts that make the response to landscape too personal. All perception may be imaginative, but imaginative perception is nonetheless, as Wordsworth's Wanderer testified, a road to the discovery of Nature and Truth. From that road, Ruskin feared, Wordsworth had strayed.

Why does Ruskin attach so much importance to correcting romantic accounts of imaginative perception? He places a heavy weight of cultural responsibility on the landscape poet and artist. Ruskin has moved from what Victorians understood to be a romantic emphasis on imagination as the province of literature (and art) to a more Victorian concern with imaginative perception understood as essential to cultural health. Perceptive poetry interests him less as poetry than as part of a broader historical phenomenon: changes in perception brought about by modern science and technology, to which the modern interest in landscape seems to be a reaction. Though Wordsworth, Keats, Byron, Shelley, and Tennyson write about a relationship with landscape to which perception is central, none of these poets, Ruskin believes, properly understands and values the act of perception.

Ruskin's argument, developed in the last few pages of "The Moral of Landscape," runs something like this. All perception may be imaginative, but not everyone is aware of the unconscious thoughts that constitute much of what is seen. For "nearly all persons of average mental endowment" the unconscious mental act of seeing is very quickly succeeded by a "wandering away in thought from the thing seen to the business of life . . . They see and love what is beautiful, but forget their admiration of it in following some train of thought which it suggested, and which is of more personal interest to them" (5.357–358). Distraction in the ordinary perceiver is not necessarily a

matter for concern, but it has changed in recent years from mere un-consciousness of aesthetic pleasure in landscape to careless disrespect for what is seen. Distraction and disrespect have been exacerbated by the declining belief in a spiritual life once associated with nature, and by technological and scientific conquests over nature. The railroad and the telegraph (Ruskin's two examples) speed up the process of seeing, change the appearance of the landscape, and hence profoundly affect the act of perception. The modern interest in natural scenery is a reaction against changed habits of perception, but the role of landscape feeling in contemporary culture is also a sign that these changes have already occurred. The landscape feeling indicates a healthy desire in ordinary men to recover aesthetic and spiritual pleasures of perception, but it is also commonly viewed as dreamy idleness or willful rebelliousness—in part because it is not valued by cultural authorities. Modern educators put all their emphasis on knowledge of words and the abstract sciences and neglect or dismiss disciplines that would teach people to look more attentively at their surroundings. The child's interest in natural history is "violently checked" or "scrupulously limited to hours of play," while drawing is taught as a social accomplishment by masters who encourage the substitution of a visual shorthand for first-hand observation and accurate depiction. The result is that those who do observe and draw landscape "are for the most part neglected or rebellious lads—runaways and bad scholars—passionate, erratic, self-willed, and restive against all forms of education; while your well-behaved and amiable scholars are disciplined into blindness and palsy of half their faculties" (5.376–377).

Perceptive poetry and landscape painting spring from just the kind of careful looking that doubt and progress are making eccentric or obsolete. Poet and artist can make the average person conscious that his own perception is richer than he knows. They can arrest and convey the fullness of imaginative perception, the natural object and its garland of thought and feeling that make up the fleeting first impression. They can educate people of average intelligence to value others' perceptions and to cultivate their own, and perhaps persuade them to make certain that the conditions for attentive perception are not irrevocably altered. At stake is not just the existence of art but the quality of human life. But if perceptive poetry and landscape art are to exemplify and make conscious the value of imaginative perception, they

cannot "wander away in thought from the thing seen"; they must *suggest* the garland of thought and feeling, while the experience conveyed remains immediate and visual. Reflection and philosophy have no part in the visual thinking that characterizes imaginative perception. Wordsworth remains for Ruskin an ideal perceptive poet when he keeps to description, as in the short poem "Yew Trees," which Ruskin quotes (5.358–359). But the Wordsworth of many of the "Poems of Imagination," and presumably of *The Prelude*,[19] betrays the heart that loves Nature. He has ceased to see, and hence to imagine.

Ruskin's changed attitude toward Wordsworth is thus also historical and political. Twenty-five years later when he again turned to Wordsworth, this character of his criticism is much more striking.[20] His worries about cultural health were far more urgent by 1880. The careless inattention to environment and the distraction that characterized modern perception by then seemed closely linked to the social woes of nineteenth-century England. Ruskin's judgment of Wordsworth was correspondingly harsher. In 1856 he still classed Wordsworth as a Seer, albeit a flawed one; by 1880 even his praise of the poet is devastating. By narrowing his focus, Wordsworth has achieved

A measured mind, and calm; innocent, unrepentant; helpful to sinless creatures and scatheless, such of the flock as do not stray. Hopeful at least, if not faithful; content with intimations of immortality such as may be in skipping of lambs, and laughter of children—incurious to see in the hands the print of the Nails.(34.320)

Wordsworth's rank and scale among poets were determined by himself, in a single exclamation:

> What was the great Parnassus' self to thee,
> Mount Skiddaw? ("Pelion and Ossa flourish side by side"; 34.318)

Behind Ruskin's attacks on Wordsworth lies his sense that Wordsworth is a traditionalist at a time when tradition is dying or dead.[21] To recover disappearing habits of mind it is no longer enough to evoke their continuing presence in remote rural areas or in a poet's memories. Recollected experience is not sufficient support for the present experience of the ordinary man or of the culture. Past and present are too sharply divided; only radical criticism and change will restore the habits of imaginative perception that Ruskin had praised as an essential human activity in 1856. Then he had written that "the greatest thing a

human soul ever does in this world is to *see* something, and tell what it *saw* in a plain way" (5.333). Already in *Modern Painters III* Ruskin was defending perception as both an absolute moral necessity and a contemporary political one. He identified changes in habits of seeing as a phenomenon of the nineteenth century and saw those changes as potentially destroying pleasures of perception important for human minds and societies. And he took responsibility as a critic for asking how landscape art and poetry met the threats to imaginative perception. From this point of view, Wordsworth's calm and measured mind would not do. By 1880 Ruskin had turned to a different perceptive poet. This poet also "never loses sight of the absolute fact"—but Ruskin has extended the meaning of fact to include not only the facts of a benign landscape (Wordsworth's pure mountain tarns) but also the facts of landscape altered by human thoughtlessness and cruelty (Carlyle's and Byron's rivers of blood and "seas of gore"; 34.322,328). And Ruskin is convinced now that clear sight of such facts will be accompanied not just by the selfless joy he had once praised in Scott, but also by emotions he had once considered personal and selfish: unrelieved melancholy, scorn, satire, and anger born of "an instinct for Astraean justice." By this more inclusive definition of visual fact and undistorting feeling, Byron, not Wordsworth, is "the truest, the sternest, Seer of the Nineteenth Century" (34.341–343, 397).

I suggested at the beginning of this chapter that Ruskin's criticism of Wordsworth and romantic nature poetry was a significant stage in his definition of himself as a critic. To evaluate the romantic achievement, he created an historical category that included himself (the modern temper, expressed in landscape literature and art, and often employing the pathetic fallacy) and then distinguished himself from both the poets and the artists he admired. I would like to turn now from Ruskin's arguments to the structure and metaphors of his prose, asking what it meant to write as a critic of romanticism.

The last pages of Ruskin's chapters on romanticism differ from conclusions to similar sections in *Modern Painters I* in two important ways. In the earlier volume, when he wishes to mark an ending by a change in rhetoric or some noticeable structural device, Ruskin characteristically shifts from explanation to praise and often ends (as he sometimes

begins) with a vision—a virtuoso descriptive passage that serves both to glorify Turner's vision and to identify Ruskin's own mode of seeing with Turner's.[22] In *Modern Painters III*, as in much of Ruskin's subsequent criticism, the rhetorical shift is from explaining art and nature to exhorting the reader. The concluding structural device does not illustrate or dramatize imaginative perception, but rather invokes the object of critical perception by alluding to it, through an image or phrase whose meaning depends on and recalls the constellation of thoughts articulated in the essay. Thus the seven chapters exploring landscape art and poetry conclude with attacks on the modern education and technology that seem to follow from the romantic misunderstanding of perception. And the last paragraphs of the section name Turner "master of this science of *Aspects*," completing the critique of romantic imagination by calling its greatest representative an instructor in a different kind of perception. Similarly, in "Of Kings' Treasuries" (1865), Ruskin shifts from advice on reading to a passionate attack on his audience for "despising literature, despising science, despising art, despising nature, despising compassion, and concentrating its soul on Pence" (18.84). The lecture ends by reiterating the phrase that is its title, now metaphorically extended to bring together the two concerns of the lecture. True kings' treasuries, Ruskin had begun by suggesting, contained not gold but books; and true kings, he ends by urging, should pave not their coffers but the streets of their cities with this gold—should, that is, make the wealth of knowledge part of the daily lives of their people (18.104–105).

The new rhetorical conclusions of the 1850s and 1860s seem to be directly related to his decision, first evident in *Modern Painters III*, to separate himself from the romantic art that was his first subject and to bring his readers to make the same separation. Concluding his arguments not by praising but by exhorting, and not by dramatizing imagination but by renaming his critical subject, Ruskin has abandoned the authority he invoked in *Modern Painters I*. There he concluded his explanations by writing like a painter or poet—a prose Wordsworth or Turner. In *Modern Painters III* he ends his chapters on romanticism instead with a demand upon his readers for engagement and social action. His new name for Turner recalls his arguments for the importance of sight to the imagination. It also reminds his readers that sight should, for them, be joined to thought by another route than that of

the romantic imagination—by the new *science* of aspects, a process of critical perception that Ruskin himself has demonstrated.

The move to accusation and exhortation asserts what was for Ruskin an essential—and always final—phase of critical perception. In *Modern Painters III* he moves through a bewildering variety of different kinds of criticism. Perceptive poetry, defined as a literary mode, later becomes an historical category: nineteenth-century landscape poetry. From literary criticism and cultural history Ruskin turns to arguments based on recent aesthetic theory and psychology. With each kind of criticism he moves from analysis to judgment, but judgment made from yet another perspective, that of the cultural critic. Cultural criticism is the last perspective from which Ruskin writes, because it is the perspective that leads beyond the imaginative perception of art to engagement and action. The critic follows the audience out the door and the reader from his study. Reversing an earlier hope, Ruskin concludes in *Modern Painters III* that neither landscape art nor perceptive poetry can directly effect reforms. Thus when he ends by exhorting his audience, he is separating himself, through subject and rhetoric, from even those artists whose imaginative perceptions he admires. Still, the judgments of the cultural critic, though they must come last, do not blot out any of the insights achieved by the critic in his other guises. The science of aspects—like the name by which Ruskin appeals to women at the end of "Of Queens' Gardens" (Maud or Madeleine, the Magdalen) or the abiding virtues he invokes at the end of a lecture on a cloud that vanishes, "The Mystery of Life and Its Arts"—works to multiply meaning and reinject complexity into the simplifying rhetoric of the call to reform. This final act of naming is thus faithful to the critic's rejection of reductive vision, as of reductive rhetoric, in favor of perceptual richness.

The distinction between romantic artist and critic suggested by these rhetorical changes is also expressed in two different metaphors for the way of seeing Ruskin adopts as his own. Ruskin's chapter "Of the Use of Pictures," introducing his examination of landscape feeling, takes as its special subject "imaginative power in the beholder" as that differs from imaginative power in the artist (5.178–186). The initial difference Ruskin notes is one of degree. The artist's imagination is readily aroused, even by the shapeless ink splash on the wall. The beholder's imagination is fragile, sluggish, "eminently weariable." The

difference in power is also a difference in method of comprehension or mode of seeing, however. This is most clearly brought out by the submerged metaphor governing Ruskin's description. His beholder's imagination is constantly compared to a traveler. It must be awakened and prodded into motion; its attention can be arrested, as the traveler's might be by an opportunity for a sketch. It tires easily, with "the weariness which is so often felt in traveling too much." It must be occasionally given a chance to "rest, and, as it were, places to lie down and stretch its limbs in; kindly vacancies, beguiling it back into action." Above all, like the traveler, the beholding imagination needs to be guided. Ruskin's comparison stresses the peculiar needs of the beholder, but it also suggests a fundamental difference in the way the beholder approaches a landscape or a painting. The beholder's experience, like the traveler's, is progressive. It takes time visually to explore a landscape or a painting. From the beholder's changing perspective, variation of pace and incident together with strongly marked compositional guideposts are as important as overall form or atmosphere, because he does not, like the man facing a broad prospect, take in the whole at a single glance. Form and meaning unfold progressively, as they do for the spectator moving *through* a landscape.

The artist's imagination, by contrast, works instinctively and instantaneously (5.187–188). His sight is marked by a "peculiar oneness" instantly achieved. The true artist holds his whole composition before the mind's eye from the start. His first impressions of landscape will exhibit the same unifying vision.

I know not if the reader can understand, — I myself cannot, though I see it to be demonstrable, — the simultaneous occurrence of idea which produces such a drawing as this [a Turner]: the grasp of the whole, from the laying of the first line, which induces continual modifications of all that is done, out of respect to parts not done yet. No line is ever changed or effaced: no experiment made; but every touch is placed with reference to all that are to succeed, as to all that have gone before. (7.243–244)

Ruskin comes back to the artist's unique power of instantaneous, comprehensive seeing again and again, as in this passage from *Modern Painters V*. He stresses the absolute difference between artistic vision and normal perception: "All noble composition of this kind can be reached only by instinct; you cannot set yourself to arrange such a sub-

ject; you may see it, and seize it, at all times, but never laboriously invent it" (15.210). We may see it, but only by tracing out the parts. If the beholder is a traveler, who can enlarge his limited perspective only by constantly changing his point of view, the artist stands stationary on an eminence, immediately taking in the whole in a single intense moment of perception. The prospect of the artist, however, is more extensive than any actual prospect, for it embraces distant times as well as distant places, fusing the past experience of both the individual and the culture into a single perception (6.33–42). The artist's vision transcends the limitations of both space and time with no apparent effort. The ordinary beholder, like the ordinary traveler, needs other methods and strategies to overcome his limitations and properly see a landscape or a painting.

Ruskin's science of aspects presents these methods and strategies under a different metaphor. The natural scientist replaces the tourist as a figure for the beholder. Or, rather, the scientist is the tourist who sees more accurately and more methodically, for the natural scientist also roams the countryside, climbing mountains, breaking open rocks, gathering and dissecting flowers. Ruskin's beholder, however, does not practice the ordinary, Baconian empirical "science of *Essence*" but a new science of perception: "there is a science of the aspects of things, as well as of their nature; and it is as much a fact to be noted in their constitution, that they produce such and such an effect upon the eye or heart (as, for instance, that minor scales of sound cause melancholy), as that they are made up of certain atoms or vibrations of matter" (5.387). Ruskin's wandering natural scientist, like his visionary artist, does not merely observe but perceives: his own responses, shaping his observations, are an admitted part of his subject. Just as an ideal art presents things as they *seem* to an imaginative perceiver, so too the beholder must concern himself with the "effect upon the eye or heart" of what he observes. But these perceptual facts, like the sensible facts at their core, must be accumulated gradually in the course of investigative experience by the average spectator. This activity is the beholder's science.

In light of Ruskin's repeated attempts to distinguish artistic from scientific perception[23] — attempts continued in the distinction between aspect and essence, perception and observation — it may be surprising to find him turning to science for a model for beholding. The term works here to remind us of the failure of Wordsworth and other poets

sufficiently to value observation. Wordsworth, as Ruskin earlier complains, does not appreciate the importance of natural science to those who do not have the poet's capacity for rich imaginative perception, instinctively and instantaneously achieved.[24] The observations of the natural scientist, like the slow progress of the traveler, can be another route to fuller perception. In place of the quick grasp of imaginative perception, the scientist labors to assemble perceptual data that will multiply the significance of the experience. The natural scientist also can discover, as Ruskin elsewhere writes, "the inner relations of all these things to the universe, and to man" and learn to perceive undreamt-of "natural energies" and "past states of being" (12.392).

The results will not be quite the same. Scientist and traveler still need the artist to provide the unifying visions at which they too hope to arrive. Without the artist, indeed, their laborious methods of covering ground may never bring them to unite their first impressions of aspects with their detailed subsequent knowledge into a single perception of the whole. "The man who has gone, hammer in hand, over the surface of a romantic country, feels no longer, in the mountain ranges he has so laboriously explored, the sublimity or mystery with which they were veiled when he first beheld them" (12.391–392). The sternly critical mind still needs its complement, the quick imaginative perception of the poet-artist. The natural scientist, Ruskin goes on, will look with gratitude on the man who

retaining in his delineation of natural scenery a fidelity to the facts of science so rigid as to make his work at once acceptable and credible to the most sternly critical intellect, should yet invest its features again with the sweet veil of their daily aspect; should make them dazzling with the splendour of wandering light, and involve them in the unsearchableness of stormy obscurity; should restore to the divided anatomy its visible vitality of operation, clothe the naked crags with soft forests, enrich the mountain ruins with bright pastures, and lead the thoughts from the monotonous recurrence of the phenomena of the physical world, to the sweet interests and sorrows of human life and death. (12.392–393)

The scientist gathers the natural facts; the scientist of aspects, or beholder, gathers natural facts as they are perceived by a human mind; the artist alone sees all these and instantly understands the connections between them.

Turner is Ruskin's master artist, the master of the science of aspects. He can both teach and surpass the natural scientist and the traveling beholder. But Ruskin in these chapters on romanticism is himself "the man who has gone, hammer in hand, over the surface of a romantic country." Constantly shifting his perspectives, he has indeed discovered much about the natural energies, past states of being, and inner relations of his romantic country "to the universe, and to man." The traveler's and the scientist's changing points of view are his characteristic method, too. As he announces when he begins "Of the Use of Pictures," his approach is "one of drawbacks, qualifications, and exceptions"; "useful truths . . . like human beings . . . are eminently biped." Multiplying one's point of view was for Ruskin the ordinary man's best route to comprehension, both visual and intellectual. So in his chapters on romanticism, he does not immediately arrive at the name of the method which his study of Turner has taught him. He constructs his epithet as the scientist of aspects himself constructs his garland of imaginative perception, by laboriously gathering and articulating the thoughts that the epithet conveys. He ends his critique of romanticism by offering as exemplar to his readers an image of the workings of his own mind, a phrase that points to a process of critical perception defined as the obverse of the romantic imagination. The "science of *Aspects*" is another name for the beholder's art.

Excursive Sight

Ruskin's beholder has a history. His critical spectator—
the traveler or the roving natural scientist—is a familiar figure in land-
scape art and literature of the late eighteenth and early nineteenth cen-
turies. He is the man on horseback riding into the middle distance of
Turner's *Launceston* (ill. 4) or the sketcher taking a view under *The
Fall of the Tees* (ill. 1)—plates from Turner's England and Wales series
of landscape engravings, which Ruskin greatly admired. The travel-
ing geologist is a figure for both author and reader in H. B. de
Saussure's *Voyages dans les Alpes,* Ruskin's favorite geology text. The
eponymous hero and the speaker of Byron's *Childe Harold's Pilgrimage*
are also traveling beholders, and so of course are both the speaker and
the Wanderer of Wordsworth's *The Excursion*—two poems that in-
fluenced Ruskin's own earliest efforts at landscape literature.

Ruskin himself learned to look at landscapes by following the foot-
steps of these travelers from literature and art. Beginning in the 1820s
and 1830s, he and his family took yearly excursions through England,
Scotland, France, Switzerland, and Italy, learning to see with Words-
worth, Turner, Saussure, and Byron. The visual habits Ruskin
displayed and encouraged in the descriptions of *Modern Painters I*—the
exploration of a scene or painting accomplished by moving through it,
gradually accumulating studied details—are those of the traveling be-
holders whose examples he had followed. Indeed, much that has been
described as idiosyncratic in Ruskin's way of looking at landscapes and
buildings is merely an intensified version of the traveler's progressive
perception.

Ruskin's experience was not unique. The pleasure tour in which
scenery, monuments of art or history, and nature itself were explored

67

was an increasingly common experience for middle-class English men and women in the early 1800s. If they did not travel themselves, they traveled vicariously, through the extensive literature of travel narratives, poems, descriptions, guidebooks, or volumes of illustrated views. Such works formed a staple of the book market from the late eighteenth through the mid-nineteenth centuries. Many characteristics of what Ruskin named, in *Modern Painters III,* the beholding imagination or the science of aspects were by 1856 familiar to his readers. Like Ruskin, they knew the traveler's episodic progress through unfolding, constantly changing scenery, or the desire to explore, recognize, and collect rocks, plants, artifacts, and views. They also knew the physical and imaginative exhaustion that this strenuous form of leisure activity could bring. Ruskin's "eminently weariable" beholder had plenty of counterparts among middle-class Victorian travelers. For Ruskin and his readers, there was nothing surprising about comparing the beholder's imagination to the traveler's, for their own viewing of scenery and paintings usually occurred in the context, actual or literary, of a tour.

When Ruskin identified beholding with traveling, however, he was using personal and cultural fact to say something about the peculiar nature of the viewing experience. As I noted at the end of the last chapter, he wanted to make a clear distinction between the way an artist might look at a landscape, as exemplified in his art, and the way in which an ordinary spectator saw scenery or paintings. The literature and art of landscape that Ruskin and his readers knew provides the basis for such a distinction in the contrast it offers between two kinds of spectators, or two ways of looking at landscapes. The first way presumes a spectator constantly changing his perspective, accumulating a series of views—the moving spectator of a landscape garden, a gallery, or a tour. Most writers on gardens and travel, like artists who drew for books of landscape views, assumed this would be their readers' normal way of seeing. The same artists and writers recognized a second mode of sight: the intense, sudden confrontation between an isolated, stationary observer and a single view of overwhelming power. This way of seeing was understood to be exceptional and difficult. Where the first kind of viewer was depicted as a traveler looking, sketching, botanizing, or geologizing, the second was a lone figure lost in awed meditation or caught up in the throes of inspiration—typically a hero or a poet. Gray's "The Bard" or his "Elegy

in a Country Churchyard," Wordsworth's Winander Boy in *The Prelude,* and John Martin's *The Bard* are all examples of this second figure, the viewer inspired to profound reflection or high imaginative vision by the landscape.

Though these two ways of seeing were often contrasted, more attention was paid to the psychology and circumstances of the second.[1] There are many terms for it—the imaginative, the grand, the poetic, the sublime—but no really adequate name for the first. The usual term for what the traveling spectator sees is "picturesque," originally meaning "like a picture" (specifically, like seventeenth-century Dutch and Italian landscape paintings). The term, later expanded to include particular picturelike qualities of landscapes, generally refers to the visual features of what is seen rather than to a mode of seeing.[2] Focusing on visual features instead of mental experience, "picturesque" acquired—for Wordsworth, among others—connotations of the superficial and unfeeling. It seemed to presume a merely visual response to landscape. By the time of *Modern Painters III* Ruskin had begun to build his own distinction between artist and ordinary spectator upon the older contrast between two kinds of landscape viewer, but he did so by applying to the spectator of the picturesque the serious analysis of mental activity that earlier writers had devoted primarily to the spectator confronting the sublime. Ruskin was concerned not only with the specific visual or associative qualities of landscapes but also with the mental, physical, and social habits of perception that middle-class English spectators brought to nature and art. His spectator is potentially as mentally, emotionally, and imaginatively active as the spectator of the sublime—but in a different manner. Wordsworth provides a term for this manner of seeing when he describes "the mind's *excursive* power" (*The Excursion* IV.1263)—a form of mental activity growing out of the traveler's unique approach to natural scenery. I have adopted Wordsworth's term for its dual connotations of leisurely travel for pleasure and mental or verbal digression. Where sublime, poetic, or imaginative vision produces exceptional landscape experiences, excursive sight—the play of eye or mind moving leisurely through a scene or subject—produces the pleasures that earlier writers associated with the picturesque and Ruskin defined as the particular experience of the ordinary beholder.

Turner's two engravings, *Launceston* and *The Fall of the Tees,* cap-

ture the distinction between the two ways of viewing landscape. The figure *in* the landscape, in each case, has a different perspective and a different way of looking at the scene from what the artist offers us as his own. The tiny man on horseback in *Launceston* is moving through the scene that the artist has comprehended in one larger view; the equally small sketcher in *The Fall of the Tees* studies and records a portion of what the artist has given as an emotionally and visually unified version of an impressive natural phenomenon. Turner may well be depicting himself as the traveler-sketcher in the landscape; he did in fact take sketching tours to produce books of views like the England and Wales series.[3] But in the completed pictures he has — literally — distanced himself from the traveler-sketcher to create the work we see. The distinctions Ruskin makes in *Modern Painters III* between the painter-poet and the beholder-critic, between Wordsworth's poetic imagination and the critical science of aspects, have their roots in this distinction between two modes of experiencing landscape.

We can read Turner's pictures in two ways. On the one hand, they can be taken as implicit criticism of the picturesque traveler's limited perspective and response, the attitude expressed by Wordsworth in *The Prelude*. On the other hand, Turner's figures provide an avenue into the pictures for the ordinary beholder. Their presence suggests Turner's concern with the different perception of his viewers. Like the viewers of his pictures, the figures in them can at any one moment react to only a part of what Turner has grasped. The rest of Turner's England and Wales series bears out this second interpretation, for his figures are not artists or poets or heroes, but ordinary anonymous individuals (ills. 14, 15). It is through their depicted or imagined reactions to the magnificent landscapes in which they find themselves that we feel the power of those landscapes.[4] This second way of interpreting Turner's picturesque figures, as indications of Turner's sympathy with ordinary men and ordinary beholders, was Ruskin's.

Ruskin's own most important encounters with scenery took place when he traveled. Moreover, the landscape literature and art that shaped his taste and influenced his first endeavors in poetry, prose, or sketching also reflected the traveler's experience. To some extent his personal and social expectations or those of his parents account for the

excursive nature of his early experience. Ruskin's parents strove to educate him as a gentleman.[5] Though they were proud of his precocious literary and artistic abilities and actively encouraged them, they did not see them as a potential vocation for their son. Most of Ruskin's exposure to and practice of art and literature took place within the framework of excursive, picturesque experience because that was appropriate to the gentleman who pursued art for pleasure. As a prosperous middle-class reader he would buy the popular illustrated travel literature of the day. As a leisured traveler he might produce sketches, journals, or poetic accounts of his tours, and as an amateur he might occasionally contribute poems or vignettes to literary annuals or send geological notices taken from his journal observations to natural history magazines. As a collector he might attend exhibitions of landscape watercolors recalling his travels and purchase some to hang on his walls. The young Ruskin did all these things with more than the usual energy and skill, but both the way in which he experienced landscapes and the models he followed for expressing his responses still identify his expectations as those of the amateur. The gentleman amateur took up his pen, but with a leisurely curiosity and limited ambitions toward imaginative invention. He was content to record what he saw, following picturesque and excursive models. He structured his accounts to reflect the experience of the traveler moving from detail to detail or view to view.

Expectations do not entirely account for the importance of excursive sight in Ruskin's early experience of landscape, however. In the 1830s, when Ruskin was growing up, landscapes still dominated much of the popular literature and art aimed at the middle class. The thirties were the great period for landscape illustrations in moderately priced books.[6] Steel engraving and lithography, the chief media for reproducing pictures, permitted high-quality illustrations in much larger editions and at lower cost than earlier methods of reproduction (the aquatint or the copper engraving of the late eighteenth and early nineteenth centuries). Landscape views made up the great majority of both the engraved and the slightly less popular lithographed illustrations — either as books of views, as illustrations to poetry or travel literature, or as the major attraction in the popular steel-engraved literary or landscape annuals. Almost all of these landscape views reflect and invite excursive looking, either by the manner in which they are

presented or by their style and subject. The Ruskins owned or knew most of the important examples of these illustrated books. John James Ruskin's account books for the 1830s list at least nine works in which engraved or lithographed landscape views represent the excursive experience of the traveler, and Ruskin refers to many more such works when he discusses contemporary landscape art in the first volume of *Modern Painters*.[7] In fact, the modern painters who are his subject in that volume were the major producers of the landscape views engraved and lithographed in the 1830s.

Context did much to identify these views as excursive. Many appeared as illustrations to travel notes or a traveler's narrative, or to poetry set in particular places in England or on the Continent. Others, like Samuel Prout's *Facsimiles of Sketches in Flanders and Germany* (one of Ruskin's favorites), were titled and arranged in geographic sequence to suggest the tour. Even where title, text, or arrangement did not specifically establish a context of travel for these views, the artist's treatment usually identified them as excursive and picturesque rather than as imaginative or sublime. In the first place, they were likely to be topographic, that is, recognizable representations of particular places. Though these artists increasingly borrowed techniques from Turner, Girtin, and others to render their landscapes more expressive, geographical representation, within certain conventions of composition and style, remained more important than the evocation of a particular emotional mood. In the second place, though most of these views include human figures, the figures are generally not used to further the emotional response of the beholder (ills. 5, 6). They provide a sense of scale relative to the beholder and give a vague idea of the costumes or occupations of local inhabitants, but they generally are not depicted reacting *to* the landscapes in which they are placed. There are almost no single figures in these views; these are social beings, typically talking, resting, or strolling. They are neither isolated meditators, poets, or heroes, nor even greatly moved ordinary beholders. Their presence works against intense emotional involvement of the beholder in the pictured landscape.

Moreover, these views tend to adopt perspectives and styles that invite the beholder to explore them visually, in imagination becoming a traveler through the landscapes they depict. In place of a selected focus on a single impressive natural phenomenon, deliberate obscurity, or

exaggerated recession—frequent characteristics of imaginative or sublime views—these pictures include a great variety of recognizable landscape features in an open composition, more or less distinctly represented in a fair degree of detail, without noticeable distortions of perspective. Either they are views of whole towns, important buildings, or natural phenomena taken from a point sufficiently distant to include a wide and varied landscape setting (ill. 5), or they are closer views that substitute detailed information about natural objects or local architecture (and often, local costumes and mores) for the more varied setting (ill. 6). In either case, they tend to suggest complexities, whether of large-scale geography or of foreground detail, which will reward a beholder's exploration. Comprehensive views often include a road with traveling figures, leading from the foreground toward a distant object of interest. There are always enough twists and turns in the road so that the viewer is simultaneously invited to explore and prevented from discovering, at one glance, all the information that travel down the inviting road might provide. Similarly, closer views may give glimpses down twisting side streets and alleys, or suggest the same explorable half-hidden intricacy through the texture of crumbling stone, sprouting weeds, and elaborately carved ornament, or the clutter of half-open windows, irregular Gothic projections, and hanging laundry. The more skillful of such pictures seem precisely designed for Ruskin's weariable beholding imagination (5.181–186). They do not try to overwhelm the viewer with strong impressions or jarring thoughts. They arouse his sluggish faculties, enticing him to visual or imaginary physical exploration by providing varied, intricate details or intriguing glimpses of further views. They give a weak imagination "something to do," but they are not so tightly organized into a single whole that they omit "kindly vacancies, beguiling it back into action." Above all, the best of these pictures provide Ruskin's "pleasant and cautious sequence of incident," for they invite and even require gradual discovery of their parts.

Ruskin's exposure to this excursive landscape art went beyond the illustrated book. From at least as early as 1830 he went to the annual exhibitions of the Old Water-Colour Society where he saw original watercolors by the artists whose work was engraved or lithographed—J. D. Harding, Copley Fielding, Samuel Prout, Clarkson Stanfield, David Roberts, and Turner. In 1832 his father bought the

first of many works from one of these artists (a Fielding); from then on, the walls of the Ruskins' home provided another place where Ruskin could daily encounter such landscapes. The same group of artists also shaped Ruskin's own drawings. His drawing masters and the major models for his drafting style, from his first lessons in 1831 through the early 1840s, included Fielding, Prout, Roberts, and Harding, as well as Turner's engraved views.[8] With the exception of Turner, these men were pen, pencil, and watercolor artists who avoided the grand imaginative conceptions of oil painters. Teaching amateurs like Ruskin, they provided lessons in the visual means of expressing, and inviting, excursive sight. Prout and Harding were perhaps the most important models for Ruskin of styles that encouraged visual exploration. Prout's linear style gave an impression of intricate texture and detail, though it was achieved by broken lines and dots that made accurate delineation of small details difficult (as Ruskin was later to object). Prout specialized in architectural scenes, particularly Gothic buildings of irregular shape set in enticing mazes of streets in the hearts of towns (ill. 6). Pedestrians in the foreground underlined the implied invitation to the spectator to explore the irregular spaces depicted. Harding, under whose influence Ruskin gradually abandoned his earlier Proutesque style in the early 1840s, was still linear; he concentrated not on outlines or textures but on the intricacies of structure, especially in trees and foliage (ill. 5). Harding (using Turner's *Liber Studiorum* as model) showed Ruskin how to use sinuous lines to trace natural patterns of growth without attempting to arrange them into complete compositions. The new style, with its insistence on natural design, was antipicturesque, but it was nonetheless excursive. Like the Proutesque style, it continued to treat each scene as an invitation to explore its parts. The intricacies of natural form-as-growth replaced the intricacies of irregular angles and textures arranged according to picturesque compositional rules.

The excursive approach to natural scenery was widespread in the verbal as well as the visual landscape art that Ruskin encountered.[9] Still the most popular form of landscape writing was the travel narrative, essentially an eighteenth-century genre.[10] The Ruskins owned several volumes of this type, including Joseph Forsyth's *Remarks on the Antiquities of Italy* (1802–03), William Rose's *Letters from the North of Italy* (1819), and Saussure's *Voyages dans les Alpes* (1779). These works

conveyed new historical, descriptive, or geological information about foreign sights through first-hand narrative accounts of actual tours. Books on foreign landscapes newly published in the thirties departed somewhat from this eighteenth-century narrative format, though they continued to use the fact or fiction of travel to instruct readers on a variety of subjects. Some, however, were more personal, even chatty, while others became much more factually detailed. The Ruskins bought many of these newer volumes, which tended to give more attention to medieval and Renaissance history, art, and architecture and to the Swiss Alps. Ruskin's interests followed the altered focus of the newer literature, though he remained more interested in natural scenery than in history or art history until the end of the decade. By the late 1830s, a new subgenre of travel literature, the guidebook, released the travel narrative from its increasingly heavy burden of facts. Most of Ruskin's travel in the thirties was made without the benefit of Murray's guides, however. His own landscape writing, though certainly highly personal, continued to provide much of the detailed description relegated by later writers to the guidebook.

The most important change in the landscape writing of the thirties for Ruskin, however, was the increased use of illustrations. From at least 1833, when he acquired Rogers' *Italy* with illustrations by Turner, he seems to have regarded landscape art as an integral and essential part of travel literature, or indeed of any landscape writing. All his own first efforts, from 1833 on, were illustrated—or where they could not be (as in the first two volumes of *Modern Painters*), his constant references to and descriptions of paintings, or views presented as paintings, provided verbal versions of the illustrated literature he knew. Physical or mental excursions through landscapes were always visual excursions, too—and Ruskin later demanded of his own audience that they not only read but look and, if possible, draw. The illustrations in the landscape books of the thirties did affect the accompanying texts, but not to alter their excursive approach. Where plates were numerous, narrative continuity sometimes disappeared from the text, to be sustained by the sequence of pictures; descriptive prose also diminished. Some authors digressed more readily into anecdote or personal reflection (as did Leitch Ritchie, who wrote texts for *Heath's Picturesque Annual* in the early 1830s), thus expanding the personal narrative elements of landscape writing. Others, however, provided extra historical or

picturesque information about the places depicted in the plates (as did Thomas Roscoe for *Jenning's Landscape Annual* or William Brockedon in his *Illustrations of the Passes of the Alps* or his *Italy*). Ruskin's own use of illustrations (or the verbal references and descriptions that were their substitutes) tended to follow the latter model. He used increased factual information to reinforce the invitation to explore. On some occasions he also used the fact or fiction of travel to structure his landscape writing (as in *The Stones of Venice* or in isolated passages in *Modern Painters*), but in most of his work the underlying experience of travel no longer takes narrative form. As in the book of views of the 1830s, excursiveness becomes a way of seeing implicit in the views themselves; the narrative is no longer necessary to support the experience of excursive sight and thought. One might almost say that *Modern Painters I* is a wholly verbal version of an 1830s book of landscape views: excursive pictures in prose, accompanied by informational rather than narrative text.

A second form of landscape literature was equally important to Ruskin in the thirties. Though the best new landscape poetry— Tennyson's first volumes appeared in 1830 and 1832—was not excursive, the Ruskins were reading an older generation of poets: Wordsworth, Byron, Rogers, and Scott. New editions of the work of all four were published in the thirties, the last three with landscape illustrations by Ruskin's favorite excursive artists.[11] We may not think of these poets as primarily excursive writers, but in fact all four use descriptions of landscapes experienced by traveling spectators as structuring features of major poems—Wordsworth's *The Excursion* and his several "tour" sequences, Byron's *Childe Harold,* Rogers' *Italy,* and Scott's narrative poems such as *Marmion.* All could and did serve the Ruskins as guides to travel in the Lake Country, Switzerland, Italy, or Scotland. The landscapes these poets described were, like those depicted by the topographical artists, recognizable named places. Even where their speakers were not explicitly travelers, they experienced scenery from a series of shifting viewpoints that could be duplicated by a real-life traveler.

Wordsworth's, Byron's, and Rogers' poems were late examples of the long descriptive-meditative poem, an eighteenth-century form descending from James Thomson's *The Seasons.* As Thomson's poem makes clear, excursive habits of perception had been at first closely tied

to the eighteenth-century garden.[12] The garden experience was still immediate for Wordsworth, who helped design one such garden, but so too was the extension of that progressive viewing experience beyond the boundaries of the garden into the surrounding countryside. For Byron, as for Ruskin and his readers, the excursive experience reflected in the long descriptive-meditative poem was that of William Gilpin's picturesque tours or of travel generally. Certain features of this kind of poem persist from Thomson through a host of followers to Wordsworth, Byron, Rogers—and into the prose descriptions of *Modern Painters I.*

Both the constant succession of different landscapes and the gradually unfolding aspects of any one view identify the approach to landscape in these works as excursive. Prose or poems are structured not by the single unified view—as the prospect poems of the late seventeenth and early eighteenth centuries had been[13]—but by the moving beholder's changing experience. Variety is more important than unity to their aesthetic. That variety almost always comes less through an eye scanning a complete distant view than through the leisurely progress of a beholder who must penetrate space—moving into and through landscape—in order to discover what it contains. Whereas the tightly structured meditative poem, the long romantic lyric, follows a strict emotional logic and tends to use descriptive detail quite selectively, the excursive poem or prose description may have a structure and an emotional logic that are not readily discernible to either beholder or reader, may digress frequently, and will probably be lavish of descriptive detail. The excursive poem progresses by constantly renewed expectation and surprise, and by continuous contrasts between successive experiences. Its outcome is never predictable: no particular conclusion is built into its meandering structure. The majority of long descriptive-meditative poems are disappointing. Mere visual succession, however richly elaborated, contrasted, and broken by meditative digression, is likely to end, as Ruskin realized, by exhausting or boring the reader. There is a monotony to continual surprise. But the examples of excursive poetry that Ruskin knew best, Byron's *Childe Harold* and *Don Juan* and Wordsworth's *The Excursion,* are also the most successful. They fuse unpredictable progress through landscapes with mental and emotional progress into a single action. Mind, eye, and body are exercised together, so that the wandering sage in *The Excursion* can serve as

both mentor and travel guide, and the traveler's exploration of landscape in *Childe Harold* become a model for the beholder's exploration of self and culture. For Ruskin these literary examples, read, reread, and imitated in the 1830s, were of the first importance as models of excursive writing. Yet as his comments in *Modern Painters III* make clear, Ruskin did not wholly adopt these literary models. Wordsworth and Byron transformed excursive sight into "the mind's excursive power." Ruskin never accepted this subordination of eye to mind. The mental and verbal energy of *Modern Painters I,* as we have seen, remains inseparable from the visual energy of perception — an energy that is inspired by and in turn expresses a vitality in the landscapes it explores.

The clearest evidence of how much the excursive approach to landscape influenced Ruskin's way of seeing in the 1830s comes from his own early literary and artistic efforts. The Ruskins did take up the invitation of the views and poems they examined, traveling frequently throughout England, Scotland, France, Switzerland, and Italy and returning to consult still more travel books.[14] Throughout the 1830s, Ruskin's most extensive writing and drawing were occasioned by these tours. At the age of eleven he kept a prose journal of his trip to the Lake Country and returned to write a long verse account. "Iteriad" describes a succession of views connected by a humorous running account of the trials and joys of travel. Wordsworth's *The Excursion* and his several tour poems were Ruskin's models for the more serious descriptive passages. He did not attempt the structures of mental action or the meditative passages of Wordsworth's poems, but even at eleven he recognized these as essential to the genre:

> Now were I, — oh, were I a proper lake-poet
> — Although you will say, " 'Tis in vain, that;" — I know it!
> But I cannot do what I know that I should, —
> Pop in an address to the nymph solitude. (2.309)

He knew, too, the excursive poet's temptation to vary endless description with digression: "I am digressive! Oh, pray do not blame me! / . . . You know that description alone, it would be, sir, / A tedious thing that would tire you and me, sir" (2.310). Two years later he turned to new models for his "Account of a Tour on the Con-

tinent" (1833-34): the illustrated books of the thirties, particularly Rogers' *Italy,* with vignettes by Turner. Like that volume, Ruskin's "Account" is a mixture of poetry and prose with carefully done illustrations imitating steel-engraved vignettes. Here the prose passages take some of the burden of sustained description from the poetry, and both the prose and the vignettes help to divide the poetic portions into manageable units and to introduce a further mode of variation. The format remains that of exploration. Most of Ruskin's attention is again given to visual description, but there is a new dimension of historical allusion for which he could have found precedents in both Rogers and Rogers' own immediate source, Byron.

In 1835 Ruskin went directly to Byron for his "Journal of a Tour through France to Chamouni," which he later described as "a poetic diary in the style of *Don Juan,* artfully combined with that of *Childe Harold*" (35.152). Ruskin's arrangement of his verse into stanzas and cantos is Byron's, and so is his tone, or rather tones, for the serious reflections on past and present of *Childe Harold* are oddly rather than artfully combined with the irreverent digressiveness of *Don Juan.* Visual and emotional responses are seldom fused in Ruskin's version of Byron's excursive styles. Buildings and monuments receive increased attention, but Ruskin's account is still predominantly concerned with the description of natural scenery. Like Byron's *Childe Harold,* Ruskin's excursive poem was written while he was actually traveling. At the same time, however, Ruskin also kept two additional accounts: a very full prose journal, with extensive, detailed descriptions of rocks and clouds; and a large collection of sketches, many of buildings and towns in a Proutesque style. Though Ruskin did not do so, these sketches might have been brought together to form a volume of views like that of Prout's which had so impressed the Ruskins (*Facsimiles of Sketches in Flanders and Germany*). Where his 1833-34 "Account" had tried to combine prose, drawings, and poetry into a single work, the 1835 journey prompted three separate records, each focusing on a different aspect of his experience. By 1835, then, Ruskin had acquired not one but three modes of recording his excursive experience of landscape: poetry, prose, and sketching.

Ruskin's major landscape writing in the thirties (and his first substantial published work) was a series of prose essays, illustrated with woodcuts made from his own drawings, on the relation of houses to

their landscape settings. *The Poetry of Architecture* (1837–38) was suggested by travel, but here for the first time Ruskin drops the first-person travel narrative, without discarding the excursive approach. In both their assumptions and their terminology these essays indicate his growing interest in an aesthetics and psychology of excursive viewing inherited from the eighteenth century.

Though Ruskin does not offer an account of an actual tour, travel is both a fact he assumes in his readers ("the reader who has travelled in Italy," "what every traveller feels to be") and a fiction he uses to move from one subject to another ("Let us now cross the Channel," "on leaving Italy"). Ruskin does not study landscape settings for the houses he describes from the inhabitant's perspective (inside looking out), but from the traveler's (the house seen as a distant feature in a landscape). The fact and fiction of travel are indications of fundamental visual assumptions that show up even when he describes the effect of mountain cottages or lowland villas on a stationary spectator. Describing the houses he finds most pleasing in their settings, he posits an "eye" that is introduced, attracted, conducted, or drawn, beguiled, and guided by a connected variety of shapes, lines, textures, colors, and emotional associations. Ruskin assumes, that is, that aesthetic pleasure comes through visual exploration: scenes that encourage and reward a moving eye. This processive vision is repeatedly captured in the structuring verbs of his descriptions. Before one exemplary landscape, "The glance of the beholder rises . . . it meets, as it ascends . . . till it rests" (1.98); before another "the eye passes over . . . it trembles . . . but it finds . . . it climbs . . . and there it finds" (1.110–111). The emphasis Ruskin initially places on unity of feeling, a single character for every landscape, and starting trains of meditation (1.5,8–9,67–72) — good associationist criteria pointing back to Archibald Alison — should not mislead us. For Ruskin, unity of feeling is achieved through a thoroughly picturesque variety of visual effect, because he consistently brings excursive habits of seeing to his experience of landscape and architecture.

The Poetry of Architecture is Ruskin's first systematic attempt to define the criteria for his aesthetic judgments. Not surprisingly, he seems to have gone back to prose discussions of excursive sight among late eighteenth- and early nineteenth-century writers. Ruskin's essays most obviously echo Wordsworth's one prose work on excursive

aesthetics, his *Guide to the Lakes.* He repeats not only Wordsworth's interest in the local character of natural scenery as it affects the mind and feelings, but also some of Wordsworth's specific opinions about the best color, materials, or locations for Cumberland cottages. Yet Ruskin's language and ideas also connect his essays with the earlier writers who first defined the particular pleasures of excursive seeing. For example, one essay discusses at length Hogarth's "line of beauty." The choice is interesting, since Hogarth set himself against the main current of eighteenth-century aesthetic preferences to advocate a version of progressive sight.

For most eighteenth-century writers on aesthetics, unity, simplicity, subordination of parts, and a single clear focus established by lighting, subject, and theme were essential ingredients of the highest kind of art: the grand style in painting or poetry, the beautiful, and of course the sublime. To some degree almost all the literature, from Addison through Reynolds to Alison and Hazlitt, also recognizes a second kind of aesthetic pleasure derived from variety, intricacy, and novelty, which are not subordinated to a unified impression. But this kind of pleasure, often associated with the picturesque, tends to be less highly valued by those who write about the fine arts of painting and poetry.[15] Alexander Gerard, for example, opens his *Essay on Taste* (1759) with a chapter on novelty but in the next chapter declares, "Grandeur or sublimity gives us a still higher and nobler pleasure."[16] Gerard's praise of novelty is tied to a discussion of the pleasure of exercising the mind by introducing "moderate difficulty" into what is conceived of as an extended *process* of perception. "Witness the delight with which antiquaries bestow indefatigable pains on recovering or illustrating ancient fragments . . . This is in general the cause of our pleasure in all inquiries of mere curiosity."[17] Gerard's discussion of the higher pleasure of sublimity, on the other hand, specifies simplicity and unity as necessary to what is viewed as a much more immediate experience: not the exercise of recovering parts or fragments, but the single full moment of an expanded mind: "filled with one grand sensation, which totally possessing it, composes it into a solemn sedateness, and strikes it with deep silent wonder and admiration."[18] Burke's *Enquiry* is almost wholly concerned with the aesthetics of the single impression, particularly the intense impression of the sublime. Lord Kames devotes considerable space to novelty and surprise, praising the

great pleasures of variety provided by natural landscapes, but reminds us, "A picture however, like a building, ought to be so simple as to be comprehended in one view."[19] Reynolds urges aspiring artists to imitate the simplicity and single impressions of Raphael's grand style, not the multiple distracting beauties of the ornamental style of Venetian colorists or northern realists.[20] Hazlitt prefers the ideal vision of Poussin, which "satisfies the mind" and "reposes on itself"—an art of "harmony and continuity of effect"—to the picturesque, which surprises the mind and induces a "progress" in the eye through discrimination and contrast.[21]

Hogarth is the one real exception to the consistent association between the "higher pleasures" of art and the unified impression or single point of view. While he recognizes the value of this appeal (especially in his discussions of light and shade), his *Analysis of Beauty* (1753) lays greater stress on the intricacy and variety of the serpentine line—the line of beauty that for Ruskin epitomizes the aesthetic pleasures explored in *The Poetry of Architecture.* Hogarth's description of the pleasure provided by intricacy and variety makes it quite clear that he has in mind experience in which immediate comprehension in one view is replaced by a gradual unfolding through multiple perspectives. He celebrates pleasures that come through process or pursuit, where difficulty and delay are relished more than immediate grasp.

[The] love of pursuit, merely as pursuit, is implanted in our natures, and design'd, no doubt, for necessary, and useful purposes. Animals have it evidently by instinct . . . It is a pleasing labour of the mind to solve the most difficult problems; allegories and riddles, trifling as they are, afford the mind amusement: and with what delight does it follow the well-connected thread of a play, or novel, which ever increases as the plot thickens, and ends most pleas'd, when that is most distinctly unravell'd?

The eye hath this sort of enjoyment in winding walks, and serpentine rivers, and all sorts of objects, whose forms . . . are composed principally of what I call, the *waving* and *serpentine* lines.

Intricacy in form, therefore, I shall define to be that peculiarity in the lines, which compose it, that *leads the eye a wanton kind of chace,* and from the pleasure that gives the mind, intitles it to the name of beautiful.[22]

The pleasures of pursuit are closely related to the pleasures of Gerard's antiquary, who loves the difficulty of putting together fragments that

do not immediately suggest a whole. Hogarth's relish for this kind of mental and visual pleasure, though it is uncommon in discussions of painting and poetry in the mid-eighteenth century, is characteristic of three genres or kinds of art mentioned in his examples: allegorical or emblematic art (not very highly regarded) and two new and rather popular, if "lower," art forms, the comic novel and the landscape garden.[23] The last of these was of particular importance for a group of eighteenth-century writers with whom Ruskin, in *The Poetry of Architecture,* has many ties.

Like William Gilpin, Uvedale Price, and Richard Payne Knight, Ruskin in 1837–38 concerned himself less with criteria for the artist or architect than with instruction in seeing and feeling for the amateur, the patron, or the beholder. The object, he reminded his readers, "is not the attainment of architectural data, but the formation of taste" (1.29). Like those authors, too, Ruskin focused not on the independent creations of painting or poetry, but on those "embellishments by which the efforts of man can enhance the beauty of natural scenery" (1.11). In this early essay Ruskin openly espouses the picturesque. He not only repeatedly invokes the term but also employs a whole vocabulary of other painterly terms to describe the properly embellished landscape—effect, composition, tone—terms that link him to the earlier picturesque writers. His interest in embellishing natural landscapes with buildings that will bring out their particular natural character is a version of the picturesque landscape gardener's—or the picturesque tour sketcher's—enterprise. Indeed, for all his professed allegiance to Wordsworth's mind and feelings over the more purely visual interests of Gilpin, Price, and Knight, Ruskin in these essays invokes the eye far more frequently than the mind or heart.

Though Gilpin, Price, and Knight do not make perception the basis for their definitions of the picturesque, they are aware of the connection between the picturesque garden or tour and a particular, excursive way of seeing. They describe their own mode of sight by contrasting it with the sublime or poetic encounter. The first and dominant source of pleasure that Gilpin finds in travel is pursuit, with the expectation of novelty that it encourages.[24] He distinguishes this pleasure, derived from the analysis or successive discovery of parts, from that of the comprehensive view in which we examine objects "under the idea of a *whole*"; "when some grand scene . . . strikes us . . . and every mental

operation is suspended" as we are stopped and caught up by some strong effect on the imagination.[25] Gilpin's decision to focus on the pleasures of pursuit, not stasis, is expressed as a real aesthetic preference by Price. He describes the pleasure of picturesque garden exploration by comparing it favorably with the experience of sublimity. Such exploration is like "the excitement produced by the intricacies of wild romantic mountainous scenes [where] curiosity prompts us to scale every rocky promontory, to explore every new recess . . . by its variety, its intricacy, its partial concealments, [the picturesque] excites that curiosity which gives play to the mind, loosening those iron bonds with which astonishment chains up the faculties."[26] Price makes the free play of excursive exploration permitted by the picturesque sound far more attractive than the iron bonds of astonishment imposed by the sublime. Knight repeats Gilpin's and Price's preferences for visual exploration excited by the picturesque, maintaining, unusually, that progressive sight can on occasion create effects as strongly imaginative as, but far less constricting than, the sublime.[27]

Like these picturesque writers to whom he seems to have turned for his essays on landscape and architecture, Ruskin too, and for the first time, consciously draws the distinction between two ways of seeing and chooses to employ picturesque or excursive sight. Defending English landscape, he notes: "I have always rejoiced in the thought, that our native highland scenery, though, perhaps, wanting in sublimity, is distinguished by a delicate finish in its details " (1.50). English hill scenery, he goes on to say, is picturesque. Unlike Wordsworth, who expressed a similar preference for English highland scenery over the sublimity of the Alps,[28] Ruskin does not restrict himself to English landscapes, but when he gets to the more rugged country of Europe he will not consider the possibility of fitting houses to sublime landscapes. The experience of sublimity, he reminds his readers, is incompatible with the progressive sight of the ordinary beholder:

it is a well-known fact that a series of sublime impressions, continued indefinitely, gradually pall upon the imagination, deaden its fineness of feeling, and in the end induce a gloomy and morbid state of mind . . . consequent, not upon the absence of that which once caused excitement, but upon the failure of its power. This is not the case with all men; but with those over whom the sublimity of an unchanging scene can retain its power for ever,

we have nothing to do . . . It is not of them, but of the man of average in-
tellect, that we are thinking throughout all these papers. (1.160)

By the time Ruskin wrote *The Poetry of Architecture* his increased fa-
miliarity with the aesthetics of excursive sight had introduced him to
the distinction that eighteenth-century writers constantly drew be-
tween excursive and imaginative or sublime sight. What had been, for
the younger Ruskin, an unconsidered exercise of excursive habits of
perception began to be a matter for deliberate choice.

Though Ruskin's visual habits are strongly excursive in the 1830s, this
was not the only way he could look at a landscape. Indeed, when he
wrote that there were those "over whom the sublimity of an unchang-
ing scene can retain its power for ever," he may well have considered
that he was just such an observer. We glimpse Ruskin's intense
responses to nature, and especially to mountains, throughout his early
years. Moments when his eye is arrested, fixed on a spot from which
he receives a sudden overwhelming impression, occasionally interrupt
the flow of his excursive verse. In these moments the expectation of
movement or change is forgotten, and Ruskin (in the jingling rhymes
of age fourteen) can "look on the Alps by the sunset quiver / And
think on the moment thenceforward for ever!" (2.367) Yet for most of
the decade he makes little effort to express these moments of intense
vision in any way that distinguishes them from the succession of other
sights presented in his travel narratives. From the late thirties until
1845, however, sublime views inspire ambitious new efforts in all three
of his expressive media: in poetry, where he uses landscapes to evoke
and express strong emotions; in drawing, where he imitates the ex-
pressive exaggerations of Turner's more imaginative landscapes to il-
lustrate his poetry; and in prose, where he begins in 1840–41 to record
in his diaries not only daily observations of rocks or clouds but also
emotionally charged landscape experiences.

These new efforts testify less to a new way of looking than to
Ruskin's expanded creative ambitions. In *The Poetry of Architecture* he
accepts an inherited distinction between "the man of average intellect"
and the man who can sustain an encounter with the sublime. That dis-
tinction apparently encourages him to try his own hand at a sublime,
imaginative landscape art. Ruskin may also have been responding to

what had become a common myth of poetic maturation: that excursive sight is the youthful prelude to the sublime vision of the romantic artist or poet. To take an early and minor example (but one important for Wordsworth), in James Beattie's poem "The Minstrel" (1771–1774) a young poet, still in a formative stage of sensibility and fancy, is described as a voracious wanderer:

> Meanwhile, whate'er of beautiful, or new,
> Sublime, or dreadful, in earth, sea, or sky,
> By chance, or search, was offered to his view,
> He scanned with curious and romantic eye.
> . . . still keen to listen and to pry.[29]

The prying, visual curiosity of the sensitive observer in pursuit of the novel, sublime, or beautiful is replaced in the second half of the poem, where the poet reaches maturity, by the metaphorical ascent of the "comprehensive mind" to a truly sublime bird's-eye view, from which the poet arranges the beauties of nature "to frame / Those forms of bright perfection" "in one form sublime."[30] Wordsworth gives a similar account of poetic maturation in "Tintern Abbey" (and again in Book XII of *The Prelude,* though Ruskin could not have known that poem before 1850). Ruskin himself later understood Turner's early artistic development in the same terms, tracing his emergence from picturesque work before 1800 to the sublime oils of the first decades of the nineteenth century.[31] In the late thirties and early forties, Ruskin seems to have considered that he himself might evolve from the excursive observer of nature to the imaginative poet or artist of sublime vision.

For his new poems and drawings Ruskin turned to different models: in art, to Turner's oils; in poetry, to the romance and the romantic lyric, particularly those of Shelley and Coleridge. In later years Ruskin looked back to Turner's vignettes for Rogers' *Italy,* which he acquired in 1833, as a revelation of the power of landscape art. But neither Turner's vignettes nor Ruskin's early imitations of them suggest that Ruskin then thought of Turner as someone who saw landscapes differently from other picturesque and topographical artists. Ruskin found another Turner when he looked at the oils exhibited in the Royal Academy. By 1836, when he defended these paint

ings against the attacks of the Reverend Eagles, he makes a distinction between them and the watercolors or engravings he had previously known. The oils, he claims, are not representations of nature at all. Turner paints not nature but imagination (3.637). The vignettes with which Ruskin illustrated his own romantic lyrics in the early 1840s, with their focusing swirls of light and cloud and dizzying recessions, imitate Turner's grander oil landscapes far more than they do his excursive illustrations or books of views.[32]

Ruskin also thought of the poetry that these vignettes of sublime landscapes were intended to accompany as imaginative rather than descriptive. His 1836 defense of Turner's oils compares them to "the finest works of imagination of our poets" — specifically (for modern examples) Coleridge's "Christabel" and "The Ancient Mariner" and Shelley's "Prometheus Unbound" (3.637). His own "The Broken Chain," begun in 1836 in imitation of Scott's *Marmion,* was completed in 1841 and 1842 on the model of "Christabel." Between 1843 and 1845 Ruskin composed seven shorter landscape poems in the sublime mode, all set in the Alps and strongly recalling Coleridge's and Shelley's poems on Mt. Blanc.[33] In this last group of poems especially, Ruskin abandons a poetry of excursive sight for poems based on a single, immediate, and powerful impression. Like much of the most successful landscape poetry of the late eighteenth and early nineteenth centuries, Ruskin's poems employ the topos of the stopped traveler — *siste viator* — or invoke a "spirit of place" to which his own poetic energies respond.[34]

Neither Ruskin's landscape lyrics and romances nor his illustrations in the sublime mode are successful. The feeling in both seems forced and flat; the poet or artist does not convince us of any more intimate connection between himself and the spirit of place than that of the dutiful (and well-read) traveler. Ruskin himself quickly realized his failure: by 1842 he had stopped trying to be a Turnerian artist of imagination, and in 1845 he relinquished his poetic ambitions as well. His letters to his father from Italy during that year accept, though somewhat reluctantly, what he sees as a significant change in his mental habits, a reversal of the evolution from critical curiosity to imaginative vision experienced by Beattie's minstrel or by Wordsworth: "my mind is strangely developed within these two years, but it is developed into something more commonplace than it was, into a quiet, truth-

loving, fishing, reasoning, moralizing temperament—with less passion and imagination than I could wish, by much."[35] "The habit of criticising hardens one," he notes. The habit of criticizing that he consciously employed as he traveled through Italy was an extension of his old excursive habits. He tried above all to get details and proportions correctly, from which he could build an accurate version of the whole.[36] He climbed on ladders to explore sculpture and frescos from as close as possible, moving, when he could, not only around but up and down and through the buildings he was observing and sketching. He went from building to building and town to town, "writing as I go, all I can learn about the history of the churches, and all my picture criticism," not stopping to turn the running narrative of his discoveries or his careful sketches of architectural details into unified impressions. "I am getting far too methodical," he concluded, "to write poetry."[37]

Yet Ruskin had not simply returned to the excursive looking of the amateur poet and sketcher, nor even to the systematic excursive explorations of *The Poetry of Architecture*. *Modern Painters I* has more passion and imagination than any of his earlier work, even though it rejects poetry and drawing—excursive or sublime—for prose. Part of this, of course, is a result of the confusions of identity and intent discussed in Chapter 1. The juxtaposition of his own work with Turner's or Claude's, the careful framing of his more elaborate descriptions, the rearrangement of experience to create full Claudian compositions, the introduction of his own controlling metaphors, the implied similarity between great artists or poets and those who fully understand their work—all these indicate that in 1842 and 1843 Ruskin had not given up his ambition to rival the great imaginative poets and painters, in prose if not in their own media. But there is something else going on in the descriptive prose of *Modern Painters I*. More than in any of his earlier excursive writing, Ruskin expresses a visual and emotional excitement and demonstrates an imaginative activity evoked by progressive, methodical examination of details. The expressiveness comes less from Ruskin's attempt to rival Turner or the poets in sublime sight than from a new conviction that passion and imagination are not incompatible with excursive sight. Once again it was Turner's work, understood now in a different way, that precipitated this change in style.

Ruskin records in *Praeterita* two experiences of 1842 that renewed

his delight in visual exploration (35.311–315). At Norwood and again at Fontainbleau, he set out to draw, without any imaginative ambition, stray bits of natural detail (ivy twisting around a thorn, an aspen tree) only to discover an unlooked-for pleasure. As he records ivy or aspen, line by line, he finds an unexpected beauty in the pattern of leaf and branch. His initial languor is replaced by a growing energy and enthusiasm, as he pursues the design unfolding before him. Ruskin remembers these experiences as revelations of a new beauty, but surely they are also rediscoveries of an old pleasure. Ruskin himself links his discovery closely to his mistaken efforts to create imaginary Turnerian landscapes "out of my head" during the preceding several years (35.302). The more humble efforts at Norwood and Fontainbleau are not just a turn from imagination to nature; they are also a return from imitating sublime conceptions of unified views to his earlier excursive habits, to the pleasures of gradual discovery expressed in the travel poems, diaries, and sketches of his youth.

The renewed pleasure in unambitious, excursive sight is only half the revelation of 1842. Ruskin's pleasure is also legitimated as an imaginative activity. He discovers that Turner does not paint his sublime landscapes out of his head. Two events lead Ruskin to this perception. First, he begins, late in 1841, to take lessons from a new drawing master, J. D. Harding, whose specialty is trees (35.308–09). Harding insists that intricate branchings are in themselves beautifully designed and have no need of picturesque embellishment. It was, presumably, as a result of Harding's tutelage that Ruskin began his drawing exercises at Norwood and Fontainbleau. Harding used Turner's *Liber Studiorum* to enforce his point about naturally pleasing ramification. Ruskin's experiments at Norwood and Fontainbleau, then, convinced him that Harding was right, at the same time that they recalled his earlier pleasure in faithful exploration of rocks or clouds or changing views. They also suggested that the careful patterning of foliage or rocks or water in Turner's work might be nature's design, not Turner's.

A second event confirmed Ruskin's suspicions: he saw the water-color sketches of Swiss scenes — including some of Turner's grandest conceptions — which Turner had prepared in 1842 as preliminary drawings. This examination of first sketches convinced him that Turner's grand imaginative landscapes were indeed "straight impressions from nature — not artificial designs" (35.310). If Turner follows nature, and

natural design can be discovered by progressive looking, then the visual habits Ruskin had acquired through travel and the imitation of picturesque landscape artists will be, after all, a rewarding way of looking at even Turner's grand landscapes. Though Ruskin had to acknowledge that his own efforts at sublime composition were not successful, the experiences of 1842 provided compensation for the disappointment of his artistic ambitions. The prose descriptions of *Modern Painters I* reflect both his rediscovered pleasure in excursive looking and a new confidence that such looking constitutes an adequate and legitimate response to Turner's sublime landscape art.

The descriptions of *Modern Painters I* imitate Turnerian landscapes in excursive prose. Yet Ruskin does not claim that Turner's grand landscapes are themselves built up through excursive sight. He does not fully work out the relation of excursive to sublime sight until *Modern Painters IV* ("Of Turnerian Topography"), though he begins to explore this issue as early as 1845, when he studies his own topographic sketches of various Turnerian subjects to try to discover what Turner has done. But the conclusion Ruskin reached in *Modern Painters IV* — that Turner relies on his phenomenal memory to include material discovered through excursive looking in the instantaneous imaginative visions on which his works are based — confirms an assumption already implicit in *Modern Painters I.* Turner was for Ruskin of unique importance among landscape artists because he exemplified sublime vision while encouraging excursive looking in his viewers. He created unified, impressive views, altering or exaggerating literal facts to express his sustained encounter with the sublime. Yet he was nonetheless so true to the principles of natural structure, change, and growth in foliage, rocks, water, clouds, or light and color, grasped down to the least detail, that he must be approached by a beholder in exactly the way nature itself must be approached by anyone of ordinary imaginative powers: excursively. Turner's work thus combined the virtues of excursive or picturesque landscape art — inviting and rewarding careful, progressive study by the beholder — with those of the great imaginative art he had recognized in Turner's oils — awing the beholder with his unified, emotionally charged vision, his "wildly beautiful imagination."

The artist who could accomplish both these ends of landscape art in the same works could serve not only as exemplar of the sublime

response to landscape but also as a guide for the ordinary, excursive beholder. Turner the teacher is an important figure in *Modern Painters I*, where Ruskin is himself trying out the new role of teacher and critic. Indeed, though Ruskin praises Turner in almost apocalyptic language for his godlike vision, he spends relatively little time giving examples of it (the descriptions of *The Slave Ship* or *Snow Storm* are exceptional, and even there, of course, Ruskin unfolds Turner's sublimity to us only gradually). Much more frequent are progressive descriptions of isolated passages in works which, if we actually go back and look at them, are likely to strike us at first more for their grandeur of conception than for their detailed truth to nature. *Chain Bridge over the Tees,* for example (ill. 7), is one of Turner's more impressive images of natural sublimity in the England and Wales series. The minute figures of a hunter and his prey, a nest of ducks, are overwhelmed by the enormous sweep of the mountain waterfall that separates them. Ruskin makes no direct attempt to tell or show us the effect of the whole picture. Instead, in discussions scattered throughout the volume, he uses three different passages in the picture, cited as "standards" of rock, water, and foliage drawing, to teach readers to see the significant lines of structure, growth, movement, or change—nature's design—in these phenomena. His descriptions of "the properties and forms of vertical beds of rock" around the stream (3.489), or the "passiveness and swinging of the water" expressed in undulating lines (3.554–557), or "the complexity, entanglement, and aërial relation" of the thicket in the lower right-hand corner (3.587n) do acknowledge Turner's imaginative achievement, but only indirectly, through the excitement, even passion, that Ruskin's prose conveys. This excitement is partly the pleasure of surprised discovery from moment to moment, but it also suggests Ruskin's anticipation of what there is still to find. Excursive looking, in the case of Turner's landscapes like *Chain Bridge,* can carry the beholder very far indeed, eventually leading him to a comprehension of greatness. But for large parts of *Modern Painters I* Ruskin concentrates on a more immediate task, and uses Turner for a different purpose—as an instructor in the beholder's, not the artist's, mode of seeing.

Ruskin's discovery, in 1842, that both nature's and Turner's compositions could be explored excursively led naturally to the particular argument that Ruskin made about Turner in *Modern Painters I,* begun

later the same year: the defense of Turner's truth to nature. But joined to Ruskin's disappointment at his own efforts to imitate Turner's imaginative art, these discoveries apparently had a still more important effect — to precipitate a decision to write about Turner, rather than simply to imitate him. Ruskin's original impulse to defend Turner as a great imaginative artist goes back to 1836, but in *Modern Painters I* that has been supplemented with another intention. Turner's work, as Ruskin had discovered, requires of the beholder a more active, energetic, and emotionally responsive version of excursive sight. Displaying this kind of seeing in his prose descriptions of Turner's work, Ruskin joins imitation to a new aim, to teach Victorians how to see both nature and Turner. This educative enterprise was not very well articulated, and Ruskin had not yet accepted criticism as his permanent vocation, but the impulse to teach is already strongly there.

B ETWEEN 1843 and 1856 Ruskin grew much more sure of his critical vocation. In 1845 he gave up his remaining poetic ambitions. When he returned to *Modern Painters* after a ten-year break, he took the beholding imagination as one of his principal subjects, carefully distinguished his own way of seeing from that of the romantic nature poet as exemplified by Wordsworth, and continued to invoke Turner, whose sublimities could instruct and satisfy the excursive beholder. But Turner was not Ruskin's only teacher in this period. Ruskin's attacks on Wordsworth in 1856 hide a debt he elsewhere acknowledges freely. There is a line in *The Excursion* that Ruskin quotes, directly or indirectly, on at least a dozen separate occasions: "We live by Admiration, Hope, and Love" (IV.763).[38] In 1875 he cites it as "my literal guide, in all education" (28.255), but he has already quoted it in crucial passages in *Modern Painters II* and *III, Unto This Last,* and on numerous occasions in the 1870s, and will cite it again in *Praeterita.* The particular interpretation Ruskin puts on the line is less important than the debt he repeatedly expresses to its author as his "guide, in all education."

Unlike Turner, Wordsworth did not serve Ruskin simultaneously as an example of imaginative vision and an instructor in excursive sight. Ruskin saw these two aspects of Wordsworth's endeavor as distinct and even contradictory. Wordsworth himself offered considerable sup-

port for this view. It is not surprising that Ruskin chose to express his own decision to give up poetry for critical prose through a critique of Wordsworth's poetry, for Wordsworth, as Ruskin knew him, seemed also to have decided that he could only instruct and reform his readers by exchanging his identity as a poet of sublime encounters for the role of the wandering sage. In this role, as the principal character in *The Excursion,* Wordsworth became Ruskin's second important teacher, guiding his efforts to encourage and reform the excursive power of the beholding imagination.

The Wordsworth Ruskin knew was not the Wordsworth we know. Both Coleridge and Hazlitt encouraged the view—which has become ours--that the Wordsworth of stopped encounters and sublime experience is the true Wordsworth, the poet of imagination.[39] Ruskin's Wordsworth was both a poet of sudden, imaginative encounters and a poet of excursion. Moreover, he was a poet who apparently had concluded by 1815 that the vision of the former was not a model for ordinary men, and henceforward adopted excursion as his preferred mode. *The Prelude,* written early but continually revised throughout Wordsworth's lifetime, reaches a contrary conclusion: the "spots of time" that interrupt excursions or the ordinary progress of time and the poet's narrative turn out to be the hidden sources of his mental power. What is more, *The Prelude* offers the poet's mind as a model for all minds, his experiences of nature as those to be sought by all men. But Ruskin, of course, did not know the unpublished *Prelude* in the thirties and forties when his conception of Wordsworth was formed. If we subtract *The Prelude* from Wordsworth's works, we are left with a poet who writes in two modes, exemplifying two kinds of experience very like the imaginative and ordinary perception described by Ruskin. On the one hand, Wordsworth records intense encounters with rural landscape and rural inhabitants, encounters transformed by memory and imagination into poetry. This is the poet of "Resolution and Independence," "The Highland Reaper," "Nutting," "Tintern Abbey," "The Thorn," "The Simplon Pass," and "There was a Boy"—all "Poems of the Imagination" in the editions Ruskin knew. On the other hand, Wordsworth also records the experiences of the spectator on tour and, in his most ambitious published poem, represents the education of wandering spectators by a wandering sage.

This is the youthful author of *Descriptive Sketches* and *An Evening Walk,* but it is especially the mature poet of the tour poems, the prose *Guide,* and *The Excursion.*

Moreover, the Wordsworth Ruskin knew indirectly encouraged the association between intense encounters and a privileged, poetic perception, on the one hand, and excursive experience and ordinary sight, on the other — apparently deciding to give up the one for the other partway through his career. In his 1800 preface to *Lyrical Ballads* Wordsworth wants to abolish the sharp distinction between poetic and ordinary modes of seeing, but the 1815 preface and supplementary essay suggest that he has changed his mind. In the earlier preface Wordsworth's stated purpose is "to illustrate the manner in which our feelings and ideas are associated in a state of excitement."[40] The project is presented as a response to a contemporary threat to ordinary perception. Modern art and events provide "gross and violent stimulants" that "blunt the discriminating powers of the mind . . . unfitting it for all voluntary exertion [and] reduce it to a state of almost savage torpor."[41] Wordsworth characterizes the poet's habits of perception in this early preface in order to contrast them with this corrupted perception. He concludes that the difference can be overcome if the poet, through poetry, can reshape the perceptual habits of readers. When the poet's mind is rightly disciplined, it can "describe objects and utter sentiments of such a nature and in such connection with each other, that the understanding of the being to whom we address ourselves, if he be in a healthful state of association, must necessarily be in some degree enlightened, his taste exalted, and his affections ameliorated."[42] The discipline that should form the minds of both poet and ordinary perceiver is, Wordsworth insists, the same. The high imaginative experience of the arrested spectator and the traveler's digressive experience are two aspects of the mind's interaction with nature, but both are available to people of healthy perception. Because this faith in a single mental discipline is the faith of *The Prelude,* too, we see this as a continuing, fundamental basis of Wordsworth's poetry. But without *The Prelude,* the essays of 1815 would indicate that Wordsworth gave up that faith.

In 1815, Wordsworth was far less optimistic about his effect on readers. The preface of 1815 is almost exclusively concerned with poetic powers, with no indication that these are to become the reader's habits.

The distance between the "original imaginative genius" of the poet (a phrase frequently repeated in varying forms in the supplementary essay) and the usually unresponsive reader seems all but unbridgeable. Like Ruskin, Wordsworth insists that good readers must be active readers ("without the exertion of a co-operating *power* in the mind of the Reader, there can be no adequate sympathy" with poetry[43]). But when Wordsworth analyzes the potential audience for the poet of imagination in the supplementary essay, he finds that youth will be easily deluded, the middle-aged out of practice, the religious-minded receptive but narrow in their sympathies, and even those who have made a life study of poetry—the one fit audience—often too full of their own prejudices to make good readers. Thus he concludes:

in everything which is to send the soul into herself . . . wherever life and nature are described as operated upon by the creative or abstracting virtue of the imagination; wherever the instinctive wisdom of antiquity and her heroic passions uniting, in the heart of the poet, with the meditative wisdom of later ages, have produced that accord of sublimated humanity, which is at once a history of the remote past and a prophetic enunciation of the remotest future, *there,* the poet must reconcile himself for a season to few and scattered hearers.[44]

Ruskin, who drew on Wordsworth's prefaces for his own chapters on imagination in *Modern Painters II,* had come by 1856 to share his concern with contemporary threats to ordinary perception and his desire to counter them through modern culture. For Ruskin, Wordsworth's 1815 pessimism about the reforming power of sublime landscape encounters would be directly expressed in his poetic practice. Though Wordsworth continued to add a few poems to those "of the Imagination," most of his published work between 1814 and 1850 is in a different mode. In particular *The Excursion,* the major published poem of this period, concerns itself explicitly with the perceptual problems of ordinary people who are instructed by someone who is not a poet; the form of both instruction and poem is explicitly excursive. *The Excursion* was Ruskin's constant favorite among Wordsworth's poems.[45] In 1843, when Ruskin wrote to his old teacher comparing Coleridge and Wordsworth, he praised that poem above all, but he wrote that its author was perhaps not so great an imaginative poet as Coleridge, though infinitely greater as a man.[46] On the evi-

dence of both published poetry and prose, then, Wordsworth was to a reader in the 1840s a poet dedicated to reforming ordinary perception who decided that such reform could best be accomplished, not by encouraging the reader to share the poet's vision, but rather, as in *The Excursion* or the *Guide,* by taking a distinctive reader's or spectator's mode of perception as subject and attempting to reform that. This of course is the approach Ruskin had chosen by the 1850s. When he criticized Wordsworth in *Modern Painters III,* he criticized the poet of imagination. The Wordsworth of *The Excursion,* who spoke not as the imaginative poet but as the Wanderer, continued to be Ruskin's guide.

Wordsworth's handling of the imaginative poet of place, the arrested spectator, and above all the ordinary traveler spoke directly to Ruskin's concerns in the 1840s and 1850s. Wordsworth apparently shared Ruskin's conviction that the habits of the beholder differ from those of the poet. The poetry of Ruskin's Wordsworth offers models both for the poet's distinctive experience (the instantaneous grasp of wholes) and for the beholder's (the progressive unfolding of parts). I would like to look in some detail at representative examples of Wordsworth's poetry in the sublime and the excursive modes. Whether or not Ruskin ever read *The Prelude*—there is no evidence in the published works and diaries that he did—he probably knew the twenty lines from Book VI that recount Wordsworth's passage through Gondo Gorge, for these were published separately as "The Simplon Pass" under "Poems of the Imagination" in 1845. "The Simplon Pass" has become the favorite passage for modern critics writing on the Wordsworthian imagination. What sets this passage apart from passages with which Ruskin could compare it—like those recounting the traveler's experience in Books I and IV of *The Excursion?*

Nature in Gondo Gorge is first perceived as an "intense unity" and then reduced to essential "characters," literally linguistic signs. Both the intense impression of unity and the reduction to significant characters are common features in Wordsworth's poetry of encounters with nature or rural characters where imagination has subsequently been at work. Neither is an aspect of landscape experience in *The Excursion.* In Gondo Gorge sensory contrasts are heightened but held in a dynamic stasis. The familiar passage is always worth quoting:

> The immeasurable height
> Of woods decaying, never to be decayed,

The stationary blasts of waterfalls,
And everywhere along the hollow rent
Winds thwarting winds, bewildered and forlorn,
The torrents shooting from the clear blue sky,
The rocks that mutter'd close upon our ears—
Black drizzling crags that spake by the wayside
As if a voice were in them—the sick sight
And giddy prospect of the raving stream,
The unfettered clouds and region of the heavens,
Tumult and peace, the darkness and the light,
Were all like workings of one mind, the features
Of the same face, blossoms upon one tree,
Characters of the great apocalypse,
The types and symbols of eternity,
Of first, and last, and midst, and without end.[47]

The contrasting elements in this passage are not presented as a simple sequence of opposites, like those in the picturesque *Descriptive Sketches,* for example. The conflicting natural forces—unending corruption, stationary blasts, winds thwarting winds—contribute to a final impression not of contrast but of unity, the unity of a locked struggle of matched powers.[48] The mixture of sensory perceptions, sight and sound especially, reinforces the impression of an experience whose parts cannot be separated or analyzed. The perceiver is bewildered, giddy, even sick with the unsuccessful effort to separate these mingled natural powers. It is just this kind of experience that Wordsworth characterized as sublime in a prose fragment written about 1811 or 1812 (intended as a preface to his *Guide to the Lakes*). "For whatever suspends the comparing power of the mind and possesses it with a feeling or image of intense unity, without a conscious contemplation of parts, has produced that state of the mind which is the consummation of the sublime."[49] In the same fragment he distinguishes three components of the sensation of sublimity: "a sense of individual form or forms; a sense of duration; and a sense of power." In the natural sublime, Wordsworth says, the sense of form and duration must be combined with "impressions of power, to a sympathy with and a participation of which the mind must be elevated—or to a dread and awe of which, as existing out of itself, it must be subdued."[50] In the Simplon description, form and duration are in fact negated even as they are expressed,

in order to convey a unified impression of power. There is no attempt to establish a sense of continuous physical space, no sense of the perceiver's location in the passage; almost every visual element is plural, and the spectator is somewhere in the midst of woods, waterfalls, winds, torrents, rocks, crags, clouds. The balance of opposed forces creates an indefinite moment when the effects of physical action seem suspended and time is abolished — the woods decay always and never, the water falls forever and not at all. As Wordsworth explains in the prose fragment, the conflicting elements are "thought of in that state of opposition and yet reconcilement, analogous to parallel lines in mathematics, which, being infinitely prolonged, can never come nearer to each other; and hence . . . the absolute crown of the impression is infinity which is a modification of unity."[51] The first movement in this passage, then (the first twelve lines), is a grasp of unity where visible form and duration are perceived only to be reduced to a timeless, formless monotone (quite literally, as sound gradually replaces sight). This process is characteristic of other famous Wordsworthian passages of emotionally charged landscape experience, including those where natural power is less in evidence — for example, the opening lines of "Tintern Abbey," where the individual forms of cliffs and hedgerows are finally replaced by the single column of the hermit's smoke: a reduction of many details to the significant one.[52] This comprehensive mode of seeing is identified in the prose fragment with the sublime; in "Tintern Abbey" (and *The Prelude*), with the imaginative responses of the poet's rightly disciplined mind.

The second movement in the Simplon passage is also associated, elsewhere in Wordsworth's work, with a valuable poetic way of seeing. The power in this passage is primarily nature's until the last five lines, when the reader must recognize the power of mind that has rendered the inarticulate mutterings of rocks, winds, and water as legible signs, the written characters of the ancient Book of Nature, an apocalypse. After the mind has grasped the scene as an intense unity, some of the definite elements of sight or sound are endowed by the mind with a new power, the power of written language. They become mnemonic signs that tell a story of personal or collective experience now connected with the particular place. The same term, "characters," recurs in Wordsworth's accounts of other extraordinarily impressive landscape experiences, always to indicate the final status

of visual detail that has become mnemonic sign. After the skating episode in Book I of *The Prelude,* for example, the poet talks about how these haunting experiences "Impressed upon all forms the characters / Of danger or desire."[53] The first of the spots of time in Book XII presents a kind of allegory of this movement of the mind—transforming visual details into linguistic signs—though the young Wordsworth does not yet recognize the process as a mental one. The lost boy comes on the place where a murderer had once been hung. All visible signs of the deed have disappeared: "The gibbet-mast had mouldered down, the bones / And iron case were gone." The scene is emptied in Wordsworth's description of it, except for the "monumental letters" of the murderer's name carved in the turf. "The characters were fresh and visible" ("to this hour," Wordsworth had first written, putting the line in the present tense).[54] In what happens next the same process is shown operating in the mind of the boy: only three visual details from the scene he next perceives remain with him, the repeatedly invoked pool, beacon, and girl. The mind invests them with the power to serve as just such "fresh and visible characters" to remind him, in later years, of the incident and emotions felt by the boy. The pool, the beacon, and the girl are not simply the chief objects in one visual scene; as characters they recall not a single visual composition but the whole story of the boy's wandering.[55]

Wordsworth's "Essay on Epitaphs" describes another instance when "visible characters" recall an emotionally affective history to the spectator, a gloss on the characters of "The Simplon Pass" which Ruskin would have known. The epitaph carved on a gravestone is visible character in two senses: to read the written signs should be, Wordsworth says, to read the character of the buried man.[56] Wordsworth's description of how the dead should be commemorated in a good epitaph corresponds closely to the way, in his poetry, selected details of an emotionally affecting scene become mnemonic signs by which scene and emotion are recalled. The situation of the spectator in the graveyard is very like that of the spectator of the sublime: the epitaph ought to evoke "sublimity of sentiment" and "awful thoughts," the grandeur of "the most serious and solemn affections of the human mind"—religion, time, eternity. The occasion should be one of intensity; the writer of epitaphs ought "to give to universally received truths a pathos and spirit which shall re-admit them to the soul like revelations

of the moment."[57] To convey this sublimity of sentiment, to create the intensity of immediate revelation, the epitaph must avoid a detailed comparison and analysis of its subject's virtues and faults. A "balance of opposite qualities or minute distinctions in individual character . . . will, even when they are true and just, for the most part be grievously out of place" because "the understanding having been so busy in its petty occupation, how could the heart of the mourner be other than cold?"[58] The epitaph should not appeal to the curiosity of those who love to trace "the intricacies of human nature." In the epitaph, as in the sublime experience of landscape, what is desired is an intense unity of impression, not a conscious contemplation of the parts. Wordsworth describes the unifying perception that the epitaph reflects, and evokes, in a significant visual metaphor:

The character of a deceased friend or beloved kinsman is not seen,—nor ought to be seen, otherwise than as a tree through a tender haze or luminous mist, that spiritualizes and beautifies it; that takes away, indeed, but only to the end that the parts which are not abstracted may appear more dignified and lovely; may impress and affect the more.[59]

Affection here, like imagination in *The Prelude* and the *Guide,* is thought of as an "unfathered vapour" that helps to create an independent, unified impression of its subject by suppressing many individual details.[60] The mist or "medium of love" also enables the mind to isolate a few details and turn them into mnemonic signs—the commemorative epitaph, visible characters of a more inclusive history. The epitaph, Wordsworth insists, is not a portrait—just as the landscape description, in "The Simplon Pass" or "Tintern Abbey," is not a landscape painting.[61] The relation of characteristic or visual detail to the unified impression is not that of parts to a whole so much as it is of signifiers to a signified. The details have become "types and symbols" of a temporal experience, the mourner's affectionate relationship with the dead or the spectator's imaginative relationship with a place. These visible characters are an important part of the extraordinary sublime or imaginative experience in "The Simplon Pass" or "The Essay on Epitaphs" (the lofty forms or the hermit's smoke in "Tintern Abbey" serve a similar function) because it is through them that Wordsworth arrives at the act of poetic creation. By means of his transformation of

sensory detail into linguistic sign, Wordsworth calls up memory, establishing both for himself and for his readers his roots in the place with which his poetic genius is to be identified, and where it must return in order to act. The visible characters are both mnemonic signs for Wordsworth himself and public signs, inscriptions that testify to Wordsworth's presence, in the past of his childhood and in the present of his poetic maturity.[62]

There is one further indication that "The Simplon Pass" is an encounter with the sublime: its form. To Ruskin it was a fragment, published as a poem. It recounted experience identified as the traveler's, but presented as the prolongation of an intense moment rather than the unfolding of sequential scenes. Its form—the fragment—was yet another method of marking the different quality of the experience it recounts from what the ordinary traveler might find. (When Wordsworth published the passage as part of an excursive account of a walking tour, in Book VI of *The Prelude,* he had to substitute various strategies of narrative disruption for the fragment form to mark its character as extraordinary, sublime experience.[63])

Ruskin's descriptions of the power of natural scenery in *Modern Painters I* impress us very differently from Wordsworth's. There are some similarities, which may help to explain the ambiguous status of the observer depicted in those descriptions: they stand out from the surrounding prose both by their careful internal structuring and by their greater excitement, intensity, and energy; they are also deliberately framed as separable pieces of experience. Yet Ruskin's descriptions do not share two of the most important features that distinguish Wordsworth's sublime spots: Ruskin's reflect a progressive mode of experience, not a single prolonged moment of intense unity, and they exhibit none of Wordsworth's efforts to turn visual detail into mnemonic and public signs of a poetic observer's presence. Indeed, Ruskin's visual details resist reduction to linguistic sign, and Ruskin's narrator is hardly there at all. The powerful impression of an isolated, imaginative observer is largely absent. When the observer is present, as in the view of the Alps at the end of the cloud chapter, he is not alone. The crowd on top of the mountain includes Turner, Ruskin, and the reader whom Ruskin explicitly invites along. As we saw, Ruskin specifically criticizes Wordsworth, in *Modern Painters III,* both for his lack of respect for purely visual detail and for the too oppressive

presence of the poet himself in his landscape. At a much later period (beginning at the end of the 1850s) Ruskin did become interested in the inscriptions that artists and poets left upon landscape, and eventually found a way to leave his own. But these later inscriptions deliberately avoid the Wordsworthian sublime fusion of poet and place.

If Ruskin did not follow, in *Modern Painters I,* Wordsworth's *siste viator* encounters with landscape in "Poems of the Imagination," he did apparently learn from Wordsworth's different procedure in *The Excursion.* In "Tintern Abbey" (or *The Prelude*) the speaker is identified as Wordsworth, the poet; "The Simplon Pass" is also a first-person poem. In *The Excursion* the spectators are not identified with Wordsworth; they are not poets but simply travelers. The landscape experiences in *The Excursion* do in fact differ in several important respects from those extraordinary experiences recounted by the arrested traveler or the poet-spectator of the Sublime.

The title of Wordsworth's poem puts it firmly in a familiar context for the reader in the early 1800s. Between the early seventeenth and the mid-nineteenth centuries, according to the *OED,* not only the noun "excursion" but also the now obsolete adjective "excursive" carried both a literal and a figurative sense: literally, a leisurely ramble—for health or pleasure—away from a fixed point or a direct route, always undertaken with an intention to return; figuratively, an extended digression, play, or variation in the direction of thought or interests. "Excursive" seems to have not only described a frequent and familiar experience for middle- and upper-class English consumers (the tour of a garden, gallery, or region), but also referred to a recognized *mode* of experience that might be mental and verbal as well as physical and visual. Wordsworth's poem is about a literal excursion—a walk through the Lake Country; it is also an excursion in relation to the planned poem, "The Recluse"; but above all it is a celebration of "the mind's *excursive* power" for which the Wanderer's movement and the poet's digression are the enabling occasion. The mental action into which the Wanderer draws the speaker (in Book I) and the Solitary (in Book IV) retains connotations of a valued experience attached to the literal term: this going out from the self is a progressive experience undertaken for health and pleasure.

When Wordsworth took excursion, in all its senses, as his subject,

he apparently focused directly on the nature of the spectator's or reader's perceptions. Where "Tintern Abbey" invites the reader to follow the growth of one poet's mind, *The Excursion* offers the examples of four minds, three of them engaged in an archetypal spectator's or consumer's experience, and two of these—the speaker and the Solitary—in the reader's own position, needing excursion for the sake of mental and moral health. In this poem Wordsworth does not try to transform his spectators into poets or fixed genii of place. He offers a different kind of sublime experience, more compatible with excursive seeing, and he also demonstrates how purely picturesque seeing can be deepened into more significant experience without altering the distinctive progressive movement, focus on details, and changing perspectives of the excursion. The Wanderer is indeed described as one of the many "Poets that are sown / By Nature" (I.77–78), but even he differs from the poet of "Tintern Abbey"; such natural poets as he do not write poetry, nor do they ever "take unto the height / The measure of themselves" (I.87–88), and self-consciously proclaim their imaginative power in the places they visit. And the Wanderer, despite his undoubted roots in the country he visits, *is* a visitor, one who passes through but does not remain. Imaginative and sublime experience have a place in *The Excursion,* but whether for the speaker, the Wanderer, or the anonymous shepherds of ancient Greece or recent Cumberland, such experience does not end with the transformation of sensory detail into linguistic sign and hence the writing of poetry.

A passage from Book IV illustrates the difference between the poet's and the ordinary perceiver's imaginative experience of sublime landscape. The speaker interrupts the Wanderer, who has just been urging the Solitary to "Quit your couch—/ Cleave not so fondly to your moody cell . . . climb once again, / Climb every day, those ramparts" (IV.481–482,493–494). The Wanderer urges the Solitary to exchange the taper of his solitary self-regarding intellect ("unseasonably twinkling . . . like a sullen star / Dimly reflected in a lonely pool") for the "unconsuming fire of light," imagination and feeling turned outward (IV.485–488,1065). The implicitly social use of imagination to which the Wanderer encourages the Solitary already suggests that the high poetic sublime is not in question here. At this point the speaker breaks into the Wanderer's very long speech with the following description of a sublime experience:

Oh! what a joy it were, in vigorous health,
To have a body (this our vital frame
With shrinking sensibility endued,
And all the nice regards of flesh and blood)
And to the elements surrender it
As if it were a spirit! — How divine,
The liberty, for frail, for mortal, man
To roam at large among unpeopled glens
And mountainous retirements, only trod
By devious footsteps; regions consecrate
To oldest time! and, reckless of the storm
That keeps the raven quiet in her nest,
Be as a presence or a motion — one
Among the many there; and while the mists
Flying, and rainy vapours, call out shapes
And phantoms from the crags and solid earth
As fast as a musician scatters sounds
Out of an instrument; and while the streams
(As at a first creation and in haste
To exercise their untried faculties)
Descending from the region of the clouds,
And starting from the hollows of the earth
More multitudinous every moment, rend
Their way before them — what a joy to roam
An equal among mightiest energies;
And haply sometime with articulate voice,
Amid the deafening tumult, scarcely heard
By him that utters it, exclaim aloud,
"Rage on, ye elements! let moon and stars
Their aspects lend, and mingle in their turn
With this commotion (ruinous though it be)
From day to night, from night to day, prolonged!"

(IV.508–539)

Some features of the passage correspond with the account of Gondo Gorge: the description follows an interruption of sequence; in fact it is not something seen in the course of the three men's walk. The distinctive forms perceived by the spectator are notably elusive, the "shapes and phantoms" called out by "flying, and rainy vapours." Those shapes and streams, coming at the spectator in their midst from

all directions, convey an overall impression of multitudinous energies gathered into a single roar—a tumult or commotion the observer can imagine, and desire, as extending indefinitely: "From day to night, from night to day prolonged." The narrator-observer is also alone, roaming among unpeopled glens. But instead of converting some details from this intense, unified impression of nature's power into visible characters, to be recalled by the poet and read by the reader in future times, the speaker simply adds his own voice—albeit an articulate one—to the uproar. He is one among the many after all, and one scarcely heard even by himself. The speaker demonstrates what the Wanderer, in passages to follow, characterizes as an imaginative perception of supernatural presence in nature, but that perception-through-participation does not lead to mnemonic inscription and hence to an explicitly creative and poetic act. In *The Excursion* version of sublime experience, there is no added dimension of mental time; we do not see the spectator withdrawing from experience, turning it into writing, and later reading that writing and creating poetry from it. The spectator makes no claims to the spot. This immediate, participatory, almost self-forgetful experience was, as we shall see, closer to Ruskin's experiences of sublimity and to the versions of sublimity he eventually discussed for both spectators and readers.

The chief emphasis in *The Excursion,* however, is not on such extraordinary moments. The Wanderer notes that the Solitary probably does have such momentary revelations (and the speaker tells us, in Book I, that the Wanderer has known such moments too, I.125–162), but the Wanderer is a sage primarily because he can use the picturesque, scientifically observant, excursive mode of experience to make "living things, and things inanimate, / . . . speak, at Heaven's command, to eye and ear, / And speak to social reason's inner sense, / With inarticulate language" (IV.1204–1207). Inarticulate speech, not writing or poetry; the speech of things, not of the poet himself; speech addressed to the social reason, not overheard by the solitary reader. The first words the Wanderer utters in the poem are addressed to a speaker who has already revealed himself, through his description of the scene, as a picturesque observer. The Wanderer tells him, "I see around me here / Things which you cannot see" (I.469–470)[64] and proceeds to show the speaker, and through him the reader, how to reform picturesque perception. The Wanderer tells a

story that gives the picturesque details encountered by the spectator a particular human and social meaning. His story is a further verbal digression from the physical excursion. Like the picturesque mode of seeing itself, the story, especially because it is oral, unfolds its meaning gradually (the listener, in the poem at least, can't skip to the end). Its effect on the listener-speaker's perception in the poem, as we see at the end of Book I, is not to allow him to look at the scene and comprehend it as a visual whole, but to give him an additional perspective from which to view its parts. Before he listens to the Wanderer, the speaker sees the cottage garden and spring this way:

> It was a plot
> Of garden ground run wild, its matted weeds
> Marked with the steps of those, whom, as they passed,
> The gooseberry trees that shot in long lank slips,
> Or currants, hanging from their leafless stems,
> In scanty strings, had tempted to o'erleap
> The broken wall. I looked around, and there,
> Where two tall hedge-rows of thick alder boughs
> Joined in a cold damp nook, espied a well
> Shrouded with willow-flowers and plumy fern. (I.453–462)

The close-up focus on detail, the emphasis on a primarily foreground wildness and visual intricacy, visual richness directly connected to the abandoned and decaying state of the garden, are quite conventionally picturesque observations. The Wanderer, when he first looks at the same scene, is no more comprehensive in his view, but the picturesque detail on which he focuses—"The useless fragment of a wooden bowl, / Green with the moss of years, and subject only / To the soft handling of the elements" (I.493–495)—directly speaks to him of Margaret's history and its effect on him. At the end of the book, the speaker-listener can see what the Wanderer saw in the picturesque details that earlier caught his attention:

> Then towards the cottage I returned; and traced
> Fondly, though with an interest more mild,
> That secret spirit of humanity
> Which, 'mid the calm oblivious tendencies
> Of nature, 'mid her plants, and weeds, and flowers,
> And silent overgrowings, still survived. (I.925–930)

There is one more dimension to the deepened mode of picturesque or excursive perception. To this reading (the Wanderer's term) of "the forms of things" as reminders of Margaret's death, the Wanderer juxtaposes another reading from the past:

> I well remember that those very plumes,
> Those weeds, and the high spear-grass on that wall,
> By mist and silent rain-drops silvered o'er,
> As once I passed, into my heart conveyed
> So still an image of tranquillity,
> So calm and still, and looked so beautiful
> Amid the uneasy thoughts which filled my mind,
> That what we feel of sorrow and despair
> From ruin and from change, and all the grief
> That passing shows of Being leave behind,
> Appeared an idle dream . . . (I.942–952)

The Wanderer's memory serves what, to Ruskin, would be an important function: it corrects the tendency to a simply pathetic—and fallacious—reading of nature. The plumes and weeds still remind him of Margaret's story and his uneasy thoughts of sorrow and despair, but they also have an independent voice; they convey an image of tranquillity. Here again, as in the Wanderer's earlier perception of the scene and in the speaker-listener's perceptions, the mode of seeing is the same: the perceiver is tracing out details in a close view of a foreground; he is not taking in a comprehensive impression from huge forms, a wide prospect, or a monotone voice of natural-poetic presence. Book I works to reform picturesque perception by multiplying perspectives on visual details through additional excursions, first into the more public past of the Wanderer's tale and then into the personal past of the Wanderer's memory. These additional excursions provide a context in which detail becomes meaningful—in which, that is, it suggests a whole. But the whole is neither a visual composition nor a poetic one: sensory details "speak" but with inarticulate voice, and about their life and a stranger's. They do not become linguistic signs and cannot be made to serve as inscriptions testifying to the poet's presence.

The lesson in perceiving in Book IV is essentially similar to that of Book I, and I will not examine it in detail. The kind of perception that

is being reformed is, however, somewhat different: it is scientific perception, associated with the Solitary's exposure to the kind of rationalism that also produced the French Revolution. Like picturesque perception, the scientific observation Wordsworth attacks examines details comparatively or analytically; it pries and pores, "Viewing all objects unremittingly / In disconnection dead and spiritless; / And still dividing, and dividing still, / Break[s] down all grandeur" (IV.960–964). Scientific perception is for Wordsworth a much more dangerous perversion of the nonpoetic mode of seeing than the picturesque to which it is clearly related, but it too can be reformed, and the cure is the same. In fact the attack on scientific perception was originally joined to the attack on picturesque perception in Book I. Passages celebrating the healthy excursive power of the mind which would cure both were taken from earlier versions of Book I ("The Ruined Cottage") and used in Book IV.[65]

> But descending
> From these imaginative heights . . .
> Acknowledge that to Nature's humbler power
> Your cherished sullenness is forced to bend . . .
> Then trust yourself abroad
> To range her blooming bowers, and spacious fields,
> . . . be our Companion while we track
> Her rivers populous with gliding life . . .
> Roaming, or resting under grateful shade
> In peace and meditative cheerfulness;
> Where living things, and things inanimate,
> Do speak, at Heaven's command, to eye and ear,
> And speak to social reason's inner sense,
> With inarticulate language. (IV.1187–1207)

The habitual (a key term) contemplation of these humbler forms under the varying perspectives provided by personal and collective human experience—memories and traditionary tales (I.163–164)—will, the Wanderer confidently expects, reform scientific perception so that the perceiver will remember that "its most noble use, / Its most illustrious province, must be found / In furnishing clear guidance, a support / Not treacherous, to the mind's *excursive* power" (IV.1260–1263).

The Wordsworth of *The Excursion* apparently addressed Ruskin's chief concern: teaching the ordinary spectator how to see. The Wanderer sets out to reform picturesque and scientific perception, not to convert readers to a specifically poetic way of seeing. It is the mind's excursive power that picturesque and scientific perception— Ruskin's traveler and natural scientist—support. Wordsworth's 1815 preface and essay, as we have seen, encourage a distinction between this kind of mental power, accessible to ordinary readers and spectators, and the mental powers of the poet, "the creative or abstracting virtue of the imagination" which only the few will comprehend. Coleridge's assessment of Wordsworth's strengths and weaknesses, in chapter 22 of the *Biographia* (which Ruskin probably read between 1843 and 1846), reinforces this distinction—though Coleridge does not value Wordsworth's experiments with ordinary perception as Ruskin did.

Coleridge praises "the natural *tendency* of the poet's [Wordsworth's] mind . . . to great objects and elevated conceptions" and claims for Wordsworth, as poet, "the gift of IMAGINATION in the highest and strictest sense of the word."[66] He accepts without question Wordsworth's apparently reluctant conclusion, that his audience must be fit but few. But Coleridge's sense of the word imagination does not extend to all the powers displayed in *The Excursion*; it is *The Excursion* from which Coleridge quotes when he objects to Wordsworth's "matter-of-factness," a "laborious minuteness and fidelity in the representation of objects," and when he censors Wordsworth's choice of a common and unpoetic character like the Wanderer (whose history must be extensively described to explain his speaking abilities) as his mouthpiece. Coleridge objects, too, to a "prolixity, repetition, and an eddying" of thought which he attributes to strength of feeling operating through the unpoetic minds Wordsworth perversely chooses as his characters.[67] In both style and point of view, according to Coleridge, Wordsworth strays from his proper domain in *The Excursion*. Coleridge isolates with precision just those characteristics of the poem which, I have been arguing, would be familiar to the reader as signs of a picturesque or excursive mode of experience, and which interested both Ruskin and Wordsworth in their common enterprise to reform ordinary perception. Coleridge's account of the effect on the reader of progressive description-by-detail is just what Knight relishes and what Wordsworth and Ruskin take as the starting point of their own excursive styles:

Such descriptions too often occasion in the mind of a reader, who is determined to understand his author, a feeling of labor, not very dissimilar to that, with which he would construct a diagram, line by line, for a long geometrical proposition. It seems to be like taking the pieces of a dissected map out of its box. We first look at one part, and then at another, then join and dove-tail them; and when the successive acts of attention have been completed, there is a retrogressive effort of mind to behold it as a whole.[68]

But Coleridge does not recognize this mode of experience as legitimate in art. "The poet should paint to the imagination." In one respect, of course, Coleridge was right: Wordsworth wrote better poetry when he illustrated the workings of a poetic imagination. Here Ruskin may have profited from Coleridge's comments. When Wordsworth took the reader's mind as his subject, he created for Ruskin a model not of poetry but of criticism.

The Ruskinian Sublime

MORE THAN ANY OTHER VICTORIAN, Ruskin retained a romantic taste for sublimity. Yet the "beholding imagination" he described is not well suited to cope with the romantic or Burkean sublime. His beholders have the picturesque traveler's limitations: they must gather and compare many partial views before they can comprehend or fully respond to what they see. Have these beholders any access to the emotional intensity of the romantic sublime? The beholder's limitations of sight and understanding govern two kinds of aesthetic response which Ruskin discusses at length, the "grotesque" and the "noble picturesque." The noble picturesque uses excursive exploration to evoke strong feelings, while the grotesque, though it is a response to a single impression, consists of fragmented images like those acquired by excursive seeing. The grotesque and the noble picturesque are nonetheless versions of sublime experience. Both the fantasy or fearful symbolism of the grotesque and the active sympathy of the noble picturesque are equal in emotional force to the experience of the Burkean sublime. Ruskin presents them, moreover, as alternative responses to sublime situations. In point of view or mode of comprehension and composition, they are closer to an ordinary way of seeing, the excursive and not the sublime. But in feeling and imagination, they lay claim to the power, and hence presumably the satisfaction, associated with extraordinary, sublime vision. Both responses are carefully distinguished from the full imaginative grasp of the artist or poet. We might call these categories of aesthetic response a spectator's or reader's sublime.

The significance of the two Ruskinian categories may be clearer if we look again at the usual meaning of the sublime for the traveler.

Sublimity may have been increasingly associated with poetic vision, but this did not mean that it was inaccessible to the ordinary viewer. Quite the opposite, as writers from Gilpin through Wordsworth agree. Sublimity was a challenge, requiring a sudden, difficult, but rewarding shift in the mode of perception. The example of the poet's response was a model for imitation by less privileged spectators. The results might sometimes be more ridiculous than sublime, but the challenge of a poetic way of seeing, to feel an immediate impression of sublimity before the Alps or St. Peter's, was widely felt by the most ordinary of picturesque travelers. Ruskin too defines a sublime mode of seeing that poets and artists exemplify. But that mode of seeing, the inventive or imaginative, is, he insists, not imitable by every spectator. Poetry and art command awe but not imitation. The artist's sublime grasp of total form and meaning cannot be a model for the spectator's experience. Ruskin's grotesque and noble picturesque can best be taken as different responses to the challenge—or burden—of sublimity, to what Byron earlier called "All that expands the spirit, yet appals."[1] They describe other ways of attaining comprehension, based on the spectator's own habits of perception and not on an assumed identification with the artist's privileged way of seeing.

In this respect the Ruskinian sublime is a major departure from the romantic sublime and its imperatives. Although Ruskin may well have found suggestions for his antipoetic approach to sublimity among the romantics themselves, particularly the later Wordsworth and Byron and Turner, his rejection of the poetic sublime as a model for spectators is both more explicit and more sweeping. The spectator's leisurely way of seeing and partial, fragmented views become in Ruskin's criticism a representative human experience, as the sublime grasp of the artist, though it does and should continue to command awe, is not. In a significant alteration of romantic priorities, Ruskin puts the beholder before the artist as his model for the reform of perception that he saw as essential for the nineteenth century. The beholder's share and, particularly, the beholder's sublime are at once a description of and a prescription for a new way of seeing.

Most romantic examples of sublime experience provide a sense of exaltation derived from the confrontation with greatness. We

might distinguish two kinds of sublimity in romantic landscape experience, a positive and a negative, according to the absence or presence of terror and difficulty in the confrontation with awesome natural power.[2] To each kind of sublime experience there are several possible resolutions. When the confrontation with greatness is not very terrifying or difficult, the experience may conclude either with an unselfconscious participation in that greatness or with a self-conscious identification of the admired greatness as (or as like) our own. The passage from Book IV of *The Excursion* discussed in the last chapter is an example of unselfconscious participation concluding a positive experience of sublimity. This seems also to have been Ruskin's characteristic response to mountain sublimity in his youth, as we shall see later. Wordsworth's ascent of Snowden (in *The Prelude*) is an example of the second resolution to positive sublimity. The poet discovers in the natural landscape an image of the power of his own imagination.

In the negative or terrible sublime, we may move from fear to exaltation by several routes. We may successfully resist the felt threat of an external power. Resistance brings a sense of our own mental and emotional strength. Or we may do no more than recognize the feared power. The recognition, especially when it involves naming or articulating that power, is also a form of mental mastery. The Burkean sublime is a negative sublime: terror and fear are indispensable parts of the experience. The notion of resistance is also implied in the connection Burke draws between sublime response and the instinct of self-preservation. Wordsworth's passage through Gondo Gorge is another example of the negative sublime. Wordsworth, however, gives two resolutions to this experience: that of simple recognition or naming (the fearful shapes and sounds as types and symbols of apocalypse) and a second, in the preceding apostrophe to his imagination, in which successful resistance is implied and the types and symbols very nearly appropriated as an image of imaginative power. To the extent that we believe the appropriation, the experience seems positive—though terror remains in other aspects of the account.[3] Despite Wordsworth's efforts to transform this particular experience of the negative sublime, however, the difficult or terrible sublime is probably the most common form of romantic sublimity.

My simplified account is partly designed to bring out one common assumption, shared even by recent writers on the subject: the only al-

ternative to a successful attempt to comprehend greatness at the moment of confrontation is failure. When we cannot identify with natural power, or fail to subdue or comprehend it through resistance or recognition, we must give up the challenge. We return to an ordinary mode of perception and feeling without the sense of exaltation that comes from the successful attempt at comprehension. The sublime experience has not occurred. Actually, neither Wordsworth nor Byron nor Turner accepted this restricting view of sublime experience. Turner provides access to his sublime landscapes through figures of ordinary beholders with limited or partial comprehension. In *The Prelude* Wordsworth portrays fearful confrontations as sublime even when comprehension is delayed. Imagination works in and through memory to master natural power. More important for Ruskin, however, is the apparent lesson of *The Excursion*. Terrible or negative sublimity is not an issue for the wandering spectators in that poem. Positive sublimity, resolved by unselfconscious participation, remains a possible experience, but it is far less important than the reformed picturesque or scientific sight of Books I and IV. Wordsworth seems to offer these modes of experience as alternatives to the emotional satisfactions of sublimity, replacing the more difficult achievements of the negative sublime.

Byron introduces negative sublimity explicitly as a problem for the traveling spectator in *Childe Harold*. The challenge of greatness—Napoleon or the Alps—is finally resolved at the end of Canto IV in a confrontation with St. Peter's:

> Thou seest not all; but piecemeal thou must break,
> To separate contemplation, the great whole;
> And as the ocean many bays will make,
> That ask the eye—so here condense thy soul
> To more immediate objects, and control
> Thy thoughts until thy mind hath got by heart
> Its eloquent proportions, and unroll
> In mighty graduations, part by part,
> The glory which at once upon thee did not dart,
>
> Not by its fault—but thine: Our outward sense
> Is but of gradual grasp—and as it is

That what we have of feeling most intense
Outstrips our faint expression; even so this
Outshining and o'erwhelming edifice
Fools our fond gaze, and greatest of the great
Defies at first our Nature's littleness,
Till, growing with its growth, we thus dilate
Our spirits to the size of that they contemplate.

Byron does not give up the attempt to comprehend a difficult great-ness, as Wordsworth may seem to do in *The Excursion*. He substitutes for immediate mastery a "gradual grasp" or piecemeal approach, ap-plied even to traditional sublime subjects. His preference for the piece-meal approach is reflected in the open-ended, digressive structures of both *Childe Harold* and *Don Juan*. In the earlier poem, this approach de-velops directly out of the needs and habits of the traveler. St. Peter's is a "fountain of sublimity" which can draw the mind of man toward greatness (stanza 159), but only when it is experienced excursively, by a spectator who takes it in gradually as he explores it physically. To stand in front of it expecting to be overwhelmed and then exalted is to doom oneself to failure. The great dome cannot in fact be seen from this position. More important, the spectator has imaginative as well as physical limitations which can be overcome only by replacing confron-tation with progressive exploration.[4] For Byron this is not giving up the challenge of the sublime, but meeting it in another way.

Ruskin, of course, knew the Byron passage as well as he knew *The Excursion*. His diary for 1840 and 1841 records his own repeated and un-successful attempts to see the Renaissance grandeur of St. Peter's as sublime in the conventional manner: to find some point of view from which to be overcome by the massive whole.[5] We cannot know that Ruskin had Byron's and Wordsworth's recommendations to the trav-eling spectator specifically in mind when he began to formulate his own notions of a beholder's sublime, eight years after his failure to re-spond to St. Peter's. Yet like the two poets, Ruskin responds to the burden of negative sublimity for the traveler neither by urging imita-tion of more gifted observers nor by giving up the challenge, but by proposing alternative routes to comprehension and emotional satisfac-

tion. His grotesque substitutes a reduced but single image for the grandeur of sublime vision. His noble picturesque, like Byron's gradual grasp or Wordsworth's excursive power, substitutes progressive for immediate response—and lays claim to a different kind of emotional power located in conventionally picturesque as well as in sublime scenes.

Like Byron's traveler, Ruskin was initially reluctant to take up the challenge of the romantic sublime. When he wrote *Modern Painters I* he wished both to exalt Turner's art as awesome and unapproachable and to insist that readers could understand Turner's greatness if they would only try. The former attitude would ordinarily have meant presenting Turner's art as sublime; the latter, approaching it as one approached landscape encountered on one's travels: analyzing, comparing, tracing out details, and even drawing them. Ruskin did both—but when it came to explaining the aesthetic theory behind his praise of Turner, he avoided using either of the conventional terms "sublime" or "picturesque." Sublimity, he explained, was not a separate aesthetic category: "the sublime is not distinct from what is beautiful, nor from other sources of pleasure in art, but is only a particular mode and manifestation of them" (3.130). He does not even discuss the possibility of a special picturesque source of pleasure. As Landow has demonstrated, Ruskin excludes these categories, particularly the sublime, because he wants an objective definition of aesthetic value, predicating a single human aesthetic response. The sublime and picturesque have been since Burke described more often in terms of contrasting psychological responses than of the objective qualities of external objects.[6] Another way of stating Ruskin's procedure in *Modern Painters I* (and for the most part, *Modern Painters II*) would be to say that he suppressed those aesthetic terms associated with a specific point of view or special conditions of seeing. "Beauty"—the only term of the conventional triad he retains—implied no such limitations. Where the sublime was understood as a single impression of unity, without conscious recognition of parts, and the picturesque as a progressive perception of parts, without an immediate comprehension of unity, the beautiful was frequently described as the conscious perception of both the whole and its parts, of unity in multiplicity.[7] The beautiful, in these terms, seems to imply a neutral perceptual norm, subject to none of the special conditions demanded by the sublime or the picturesque.

All aesthetic experience, Ruskin maintains, can be described as the experience of beauty; variations in point of view produce no significant alteration of what is essentially a single aesthetic response.

By 1853 Ruskin had quietly changed his earlier position. *Modern Painters II* already contained references to sublimity as a different kind of aesthetic experience—primarily as the experience of awe. The drafts for *Modern Painters II* contain notes for a separate section on the sublime in which Ruskin recognizes it as a distinct aesthetic category. There is no formal discussion of the sublime in the published volume, but Ruskin included chapters on sublime style and on the picturesque in *The Seven Lamps of Architecture* (1849). In 1853, for *The Stones of Venice III,* he briefly described a different kind of sublimity, the sublimity of terror. Throughout the 1850s Ruskin apparently continued to plan a full, formal discussion of the sublime for a later volume of *Modern Painters,* but though notes survive, no chapter was included in the published volumes. Ruskin's planned discussion of the sublime is replaced, in the last volumes of *Modern Painters,* by renewed discussions of the grotesque and noble picturesque, and of the artist's power of invention.

These alternatives to the romantic sublime address problems of contemporary perception Ruskin had not recognized in 1843. For the beholding imagination, differences in physical and psychological perspective were critical, as Ruskin gradually realized. His personal encounters with the sublime contributed to his change of mind. Accounts from 1842 and 1853 suggest that he found sublimity newly terrifying by the early 1850s. The grotesque and the noble picturesque resolve difficulties for the doubting romantic spectator that Ruskin himself experienced.

Ruskin originally intended his account of an evening at Chamounix in 1842 as an illustration of the theory of Typical Beauty in *Modern Painters II.* John Rosenberg compares the passage with Wordsworth's Simplon,[8] thereby pointing to what does indeed strike the reader familiar with landscape literature. Ruskin's revelation of Typical Beauty would be, in conventional terms, an experience of sublimity. We might take this, then, as an example of the kind of sublime experience that Ruskin in 1843 felt was not distinct from the beautiful. Ruskin has been lying by the Fountain of Brevent on a July evening "dark with storm": "So it had been throughout the day—no rain—no motion—no light." The darkness is profoundly oppressive:

It was as if the sun had been taken away from the world, and the life of the earth were ebbing away, groan by groan.

Suddenly, there came in the direction of Dome du Goûter a crash—of prolonged thunder; and when I looked up, I saw the cloud cloven, as it were by the avalanche itself, whose white stream came bounding down the eastern slope of the mountain, like slow lightning. The vapour parted before its fall, pierced by the whirlwind of its motion; the gap widened, the dark shade melted away on either side; and, like a risen spirit casting off its garment of corruption, and flushed with eternity of life, the Aiguilles of the south broke through the black foam of the storm clouds. One by one, pyramid above pyramid, the mighty range of its companions shot off their shrouds, and took to themselves their glory—all fire—no shade—no dimness. Spire of ice—dome of snow—wedge of rock—*all* fire in the light of the sunset, sank into the hollows of the crags—and pierced through the prisms of the glaciers, and dwelt within them—as it does in clouds. The ponderous storm writhed and moaned beneath them, the forests wailed and waved in the evening wind, the steep river flashed and leaped along the valley; but the mighty pyramids stood calmly—in the very heart of the high heaven—a celestial city with walls of amethyst and gates of gold—filled with the light and clothed with the Peace of God. (4.364)

Ruskin' paragraph goes on to drive home the essential fact about his own response to the dramatic revelation of fiery peaks through dark clouds: his complete loss of self-consciousness, which led to exaltation.

With all that I had ever seen before—there had come mingled the associations of humanity—the exertion of human power—the action of human mind. The image of self had not been effaced in that of God. It was then only beneath those glorious hills that I learned how thought itself may become ignoble and energy itself become base—when compared with the absorption of soul and spirit—the prostration of all power—and the cessation of all will—before, and in the Presence of, the manifested Deity. It was then only that I understood that to become nothing might be to become more than Man;—how without desire—without memory—without sense even of existence—the very sense of its own lost in the perception of a mightier—the immortal soul might be held for ever—impotent as a leaf—yet greater than tongue can tell—wrapt in the one contemplation of the Infinite God. It was then that I understood that all which is the type of God's attributes—which in any way or in any degree—can turn the human soul from gazing upon it-

self— . . . this and this only is in the pure and right sense of the word
BEAUTIFUL.

Like Wordsworth at Gondo Gorge, Ruskin experiences a shift in
modes of perception. Wordsworth's publication of "The Simplon
Pass" as a separate fragment implied the isolation of the sublime mo-
ment. In *The Prelude,* interruption in the traveler's account is rein-
forced by an intervening apostrophe to Imagination. Ruskin's passage
begins with a long description of the valley and fountain; he has al-
ready stopped traveling, but lying by the fountain he remains a minute
observer of visual and aural detail, until the crash of thunder makes
him look up and begin to see differently. The shift in modes of vision
is much less marked. There is a transitional phase of stationary obser-
vation, but no disruption of sequence. Once Ruskin has begun to see
differently, however, he, like Wordsworth, goes on to convert an in-
tense visual impression of natural power into a religious language of
divine types. For Ruskin, this language is not his own: recognizing it,
he recognizes a mental power not his own. Natural power and divine
mental power are the same. The experience is wholly positive. Ruskin
attributes his pleasure to his complete self-effacement, and, as Landow
points out, it is much more complete than in Wordsworth.[9] But of
course there is an eventual return of self-consciousness in Ruskin, too.
His account of his exaltation locates it in the *perception* of the tempo-
rary annihilation of self, a perception that requires self-consciousness: I
learned, I understood. "To become nothing" is followed by "to be-
come more than Man." This is a sublime of participation in which
there is an eventual recognition of self that comes through an initial
complete self-absorption in external power. The scene presents no
difficulties. Ruskin is able to shift to an exceptional way of seeing and
successfully grasp the scene imaginatively. He feels no resistance or
fear when he then sees the forms of natural power as visible characters
in a divine language.

The Wordsworth passage is much less clear on both these points.
Not only is the shift first felt as an unwanted interruption, but Words-
worth's attitude toward those types and symbols is not unambigu-
ously presented. The description itself makes a simple comparison:

natural sounds and forms were all the workings of one mind, types and symbols of Eternity. There is no direct expression of exaltation through participation here. In fact, without the lines to imagination, the whole experience is introduced as one of dejection, "a deep and genuine sadness"; the sleep of the immediately following night was melancholy, the lodging dreary. There are some grounds, then, for Weiskel's reading of the passage as an example of the negative sublime: a submerged record of difficulty in confronting the sublime or making the shift to another way of seeing, and fear or resistance at identifying with the divine mental power, the symbolic language of natural forms.[10] The positive version of this experience, according to the text itself, came later and involved a reinterpretation in which the exaltation did not come from participation in natural-divine power, but from the recognition of the imaginative power of the poet's own mind. The types and symbols have been appropriated as Wordsworth's own linguistic signs, the mnemonic signs that inform the imagination, and allow it to inform the world, of the presence of Wordsworth's shaping genius at that place. In the finished poem the negative and positive versions of the experience are juxtaposed but not reconciled.[11] The emotional tone of the Simplon Pass can be variously interpreted according to whether one takes as context the lines on imagination or the description of the preceding and following parts of the experience. The tone of Ruskin's passage, however, like that of the passage quoted earlier from Book IV of *The Excursion,* is clearly positive. In this respect Ruskin's experience is quite consistent with the kind of sublimity he had renamed the beautiful in *Modern Painters I*: a sublimity limited to the apprehension of greatness *without* fear. "There is no sublimity in the agony of terror," he wrote, in flat contradiction to Burke and to the testimony of Wordsworth's poem (3.129).

Eleven years later, however, Ruskin's response to a thunderstorm is markedly different. In the last volume of *The Stones of Venice* there is this description of the "scenery of storm," generalized now as "our" response:

the preparation for the judgment, by all that mighty gathering of clouds; by the questioning of the forest leaves, in their terrified stillness, which way the winds shall go forth; by the murmuring to each other, deep in the distance,

of the destroying angels before they draw forth their swords of fire; by the march of the funeral darkness in the midst of the noon-day, and the rattling of the dome of heaven beneath the chariot wheels of death; — on how many minds do not these produce an impression almost as great as the actual witnessing of the fatal issue [someone struck by lightning]! and how strangely are the expressions of the threatening elements fitted to the apprehension of the human soul! The lurid colour, the long, irregular, convulsive sound, the ghastly shapes of flaming and heaving cloud, are all as true and faithful in their appeal to our instinct of danger, as the moaning or wailing of the human voice itself is to our instinct of pity. It is not a reasonable calculating terror which they awake in us; it is no matter that we count distance by seconds, and measure probability by averages. That shadow of the thundercloud will still do its work upon our hearts, and we shall watch it passing away as if we stood upon the threshing-floor of Araunah. (II.163–164)

Ruskin's passage stresses and restresses the central fact of terror. The expression of terror, however, is prefaced by what is actually the resolution to this experience of negative sublimity: the identification, from the opening phrase, of the terrible phenomena as an intelligible divine language. The importance of the spectator, the intended reader of this language, is indirectly reaffirmed to resolve the moment of unreasonable terror. The passage is actually closer than the Chamounix to Wordsworth's Simplon Pass. Both describe a sublime experience in which fear is the predominant emotion, and in both natural forms have been interpreted as apocalyptic language. (Ruskin goes on to refer explicitly to a "language" by which "in the utmost solitudes of nature, the existence of Hell seems to me as legibly declared . . . as that of Heaven" II.164.) In both passages, but particularly in Ruskin's, something of the exhilarating effect of the terrible sublime is lost in the move from terrifying forms and sounds to apocalyptic language. Wordsworth's retrospective response (the apostrophe to Imagination) is quite convincingly exciting, but, as Hartman and Weiskel both point out, the excitement is not part of the first or negative version of the experience. It does not dispel the depressing memory of the Pass. This ambivalence is apparently canceled out, in Ruskin's case, by his commentary. Before and after his description he asserts the paradox of terrible sublimity as a fact of human nature, a necessary part of a divinely ordered natural world.

Two great and principal passions are evidently appointed by the Deity to rule the life of man; namely, the love of God, and the fear of sin, and of its companion—Death . . . it has not, I think, been sufficiently considered how evident, throughout the system of creation, is the purpose of God that we should often be affected by Fear . . . the merely pleasurable excitement which [we] seek with most avidity is that which rises out of the contemplation of beauty or of terribleness. We thirst for both . . . Thus there is a Divine beauty, and a terribleness of sublimity coequal with it in rank, which are the subjects of the highest art. (11.163,165–166)

This is the same explanation of sublimity that Ruskin offered for the positive experience at Chamounix. Self-effacement there was pleasurable because it revealed the "peace of God"; self-effacement before destructive natural forces in 1853 is pleasurable (though terrifying) because it reveals the might of a potentially wrathful God, the awfulness of sin and death.

But this does not alter the relative flatness of Ruskin's later passage. The resolution of the sublime experience may be the same—the revelation of a divine language—but the emotional facts are not. What was effective as a conclusion to one kind of experience (Chamounix) is not so effective for another. The terror that characterizes response to the sublime here presents a difficulty not present in Ruskin's response to Chamounix. We may get some indication of why this change of emotion makes the resolution of sublimity more difficult if we look back at another passage on the sublime in *Modern Painters II*. Ruskin has already shifted his position somewhat from *Modern Painters I*; he speaks of sublimity as though it were distinct from the beautiful. But he is just as adamant that Burke's "agony of terror" has no part in the awfulness of sublimity. He makes susceptibility to such terror the sign of religious doubt:

when fear is felt respecting things sublime, as thunder, or storm of battle, the tendency of it is to destroy all power of contemplation of their majesty . . . And so among the children of God, while there is always that fearful and bowed apprehension of His majesty . . . yet of real and essential fear there is not any . . . whereas, on the other hand, those who, if they may help it, never conceive of God . . . are by real, acute, piercing, and ignoble fear, haunted for evermore. (4.199–200)

Expressed far more sympathetically, the connection between pleasure in terror and an absence of firm faith becomes, in *Modern Painters III,* part of Ruskin's characterization of the modern temper — the love of clouds and darkness. In *Modern Painters II* those who experience the sublime as terrible are rudely cast out as "atheistical, brutal, and profane" (4.200).[12] By 1856 the emotional fact of pleasure in terror is recognized as the common contemporary condition, a condition in which, Ruskin acknowledges, he himself shares. It is a sign not of atheism but of doubtful faith. In the passage from *The Stones of Venice* Ruskin seems to be somewhere between these two positions. He clearly recognizes the element of terror in the response to the sublime, a response "we" share, but he identifies that response neither as absolutely atheistic nor as an historically particular manifestation of doubt. He argues that the terrible sublime *is* after all consistent with belief. Ruskin's letters from the same period (1850–1852) confirm what one might suspect from examining the sequence of terror denied as atheistical, affirmed as faithful, and sadly acknowledged as doubtful. Ruskin writes of his own triumph over doubt, achieved with difficulty — and, it should be added, not lasting.[13]

One can, then, read Ruskin's recognition of a terrible sublime as an indication of his own increasing difficulty with comprehending sublime scenery in the theological terms by which he had understood it at Chamounix. The difficulty of the sublime way of seeing is not, in this case, visual or imaginative. The explanation of terrible sublimity as the divine language of apocalypse offered in *The Stones of Venice* is the assertion of the will to maintain belief. The stress on terror points to a new sense of dfficulty encountered and overcome.

W E HAVE BEEN looking at Ruskin's example of the terrible sublime — nature read as the language of fearsome apocalypse — as if it were an independent exposition of sublimity. It is time to return that passage to its context. Ruskin describes the terror of natural imagery of sin and death in order to distinguish from it what he treats as a far more common and important response to awesome or fearful subjects, the state of mind that produces the grotesque. Here we find an alternative, effective resolution of the terrible sublime. The grotesque is an elastic category that seems, in the course of Ruskin's discussion, to be

continually expanding until in retrospect it may even include his own illustration of the terrible sublime. The true sublime, by contrast, shrinks to a hypothetical point, a limiting term for the expanding category of the grotesque. Thus, although Ruskin begins by defining the grotesque as inferior to sublime perception, he ends by exalting it until it becomes the highest humanly possible response to sublimity. "And thus in all ages and among all nations, grotesque idealism has been the element through which the most appalling and eventful truth has been wisely conveyed . . . No element of imagination has a wider range, a more magnificent use, or so colossal a grasp of sacred truth" (5.134). If we look closely at the terms by which Ruskin distinguishes between the grotesque and the sublime, and at those he describes as the perceivers in each category, we can connect Ruskin's personal reaction to sublimity to his attempt to reform nineteenth-century habits of viewing art and landscape.

Ruskin defines grotesque art in terms of the state or condition of mind that produces it: he recognizes what he had denied in *Modern Painters I,* the importance of point of view. The opposed states of mind that produce grotesque or sublime art are described in phrases remarkably similar to those used to make the contrasts between excursive and sublime modes of seeing, or between the beholder's and artist's approaches to art. Ruskin attributes to the grotesque state of mind such positive qualities as curiosity, capability of surprise, delight in variety, and a certain waywardness (11.154,157). Minds in such a state "gather, as best they may . . . various nourishment." They exhibit partial attention, making a "playful and recreative" application of fancy and imagination to serious subjects. Leisurely recreation, curiosity, expectation of surprise, pleasure in variety, gathering or collecting with no fixed plan or design — in all of these characteristics of the grotesque we can recognize the traveling spectator's pleasures as described in landscape literature. The connection becomes at one point explicit: Ruskin names this playful grotesque "the art which we may call generally art of the wayside, as opposed to that which is the business of men's lives." Such art is a "stretching of the mental limbs," a "leaping and dancing of the heart and intellect, when they are restored to the fresh air of heaven" from the imprisonment of work. The common identification between leisure and travel persists in Ruskin's metaphors.

The grotesque, then, is produced by a condition of mind closer to

that of the ordinary contemporary viewer than to that of the imaginative artist. The negative aspects of this state of mind, brought out through comparison with the mind that produces a really sublime art, make clearer the presence of a familiar distinction. The sublime state of mind is notable for "the scope of its glance," the breadth or depth of its grasp, its apprehension of highest truths, its compass of human sorrow, its power of contemplating things in their true light, as if reflected in a mirror; such a mind is raised above the playful distraction of the grotesque mind. It presents truths seen in wholeness (II.152,156, 178–81). The grotesque mind by comparison exhibits a narrowed vision, some shortening of the power of contemplation, a failure to grasp the highest truths; it does not "enter into the depth of things"; it is "imperfect, childish, fatigable" (like the "eminently weariable" imagination of the spectator). Its imagery is like that seen through a broken, distorted, and dim mirror—which seems partial, fragmented, with parts separated and out of proportion, apparently the product of no overall imaginative design (II.178–181). Thus the state of mind that produces the grotesque is not only connected with that of the picturesque traveler; it is also specifically described as inferior to another state of mind: the raised and fixed perception of contemplation, where large design or meaning is grasped or comprehended by the imagination.

Though the grotesque is associated with the leisurely and limited perception of the beholder, it is nonetheless different from what the spectator ordinarily perceives in the course of excursive looking. The grotesque *is* an attempt to see and express a large whole in a single image. In this sense it is the spectator's sublime: it is what one sees when one is arrested by an encounter with something that exceeds ordinary comprehension. It is a reduced or partial version of its subject. The relationship between grotesque image and sublime subject may be playful, witty, satiric, or seriously symbolic, but there is always an obvious disproportion between the grotesque image and what it stands for. Despite the inadequacy of the image, measured against the standard of a full imaginative grasp, the grotesque is a valued perception. Furthermore, the reduced sublimity of grotesque perception has one great advantage: it can be subsequently expanded by excursive methods. The imagery of wild dream or biblical prophecy, or of satiric or humorous grotesques, can be interpreted. The connections between grotesque image and sublime subject are there to be discovered by readers and

critics. The possibility of interpretation brings the grotesque a step closer to the true sublime. Thus Ruskin can introduce the grotesque as a lesser sublimity. Just as "there is a Divine beauty, and a terribleness of sublimity coequal with it in rank, which are the subjects of the highest art," so there is also

> an inferior or ornamental beauty, and an inferior terribleness coequal with it in rank, which are the subjects of grotesque art. And the state of mind in which the terrible form of the grotesque is developed is that which, in some irregular manner, dwells upon certain conditions of terribleness, into the complete depth of which it does not enter for the time. (II.165–166)

When the beholding imagination pauses and "dwells upon certain conditions of terribleness," it produces grotesque perceptions. The complete depth of the terrible greatness it confronts may be drawn out of the partial image at some later time.

Ruskin extends the meaning of grotesque along lines already laid down by romantic writers, but his grotesque has finally a very different relation to sublimity. Burke paired the sublime and the grotesque for purposes of contrast: the serious with the trivial.[14] The same pairing was also used in the mid-eighteenth century to contrast the serious with the comic. Hogarth begins the growing tendency to take the grotesque more seriously. For him, caricature, a bridge between the grotesque and the sublime, was a serious comic art.[15] German romantic writers like Friedrich Schlegel and Jean Paul Richter stressed the common ground between the grotesque and the sublime while maintaining their opposition.[16] The distorted and hieroglyphic imagery of the grotesque possessed both the terrifying power and the obscure significance of the sublime, but the grotesque alone was diabolic. Some continental romantics discovered a connection between the somber, comic-tragic deformities or limitations of the grotesque and a general modern or human condition. Victor Hugo, for example, paired the grotesque with the sublime as the two great poles of human experience: the grotesque, bestial, infernal, and inhuman at one end, the spiritual or sublime at the other.[17] But Walter Scott, reviewing E.T.A. Hoffmann's stories, objected to the link between the grotesque and the diabolic. Hoffman's grotesque tales, he complained, were too horribly fantastic, the wild imaginings of an uncontrolled or

diseased imagination, without moral point.[18] Ruskin's grotesque preserves the association with the sublime and exhibits all of the romantic tendency to take the grotesque seriously, especially to take the grotesque as representative of human limitations. But his discussion of the grotesque might be read as a response to Scott's objections, for Ruskin deliberately strips the "true" grotesque of its connection with the bestial, the satanic, the inhuman, and the immoral. His grotesque is the attempt of the limited imagination to come to grips with sin and death, but if it is true grotesque it reveals not moral corruption but moral aspiration in the perceiver. In this sense too Ruskin's grotesque is a version of the sublime.

Ruskin's elevation of the romantic grotesque toward the sublime should remind us that the relation he posits between beholder and artist is not a simple opposition either. The grotesque is not a category of aesthetic consumption. It embraces a range of productive activity, from the rough humor of the working man at play, through the witty, ornamental, and often amateur art of a more educated and leisured class, to the fantasies of Shakespeare; or from the dreams of ordinary people to the symbolical imagery of Dante and the apocalyptic visions of the biblical prophets. The true sublime, by contrast, is a class that may have no members at all. Ruskin gives no examples. It is, at any rate, a very rare state of mind, the condition of completely clear and comprehensive vision, of absolutely governed imagination, of an obviously godlike grasp of visual design and metaphysical order. What is important, though, is not so much the shrinking sublime as the expanding grotesque. Ruskin's intent here seems to be to establish a continuity between crude humor and visionary art — and to place the amateur art of the middle-class excursive spectator within that spectrum of active imaginative response.

In this effort Ruskin sets himself against the tendency to regard art and aesthetics as exclusively constituted by two sharply divided groups: imaginative artists and middle-class consumers, those who can create and those who can "taste." I do not mean to suggest that Ruskin is advocating a democratic art. He continues to be concerned principally with middle-class spectators and with artists, and to insist on maintaining some absolute distinctions between them. He describes the activity that produces the grotesque, as we have seen, quite traditionally in terms of the leisure activities of a middle class: travel. The

comprehensive grasp associated with the true sublime in this chapter is identified as the exclusively artistic power of invention in the later volumes of *Modern Painters*. The unlettered worker is represented only by a figure from the past, the medieval stone carver (though that, Ruskin argues, indicates a larger problem in contemporary art). Ruskin's emphasis on the grotesque does not indicate any desire to abolish a hierarchy of vision based both on imaginative ability and on social class. It does, however, put a new stress on the active, imaginative nature of the response possible from, and indeed required of, the spectator. Taste, acquired passively through traveling and reading, is not enough. Ruskin is interested in a response to landscape and art somewhere between picturesque taste and sublime comprehension or poetic invention. Failure to rise immediately to the challenge of the sublime in art or nature need not mean spectators must give up — or reduce what they see to a superficial collection of interesting textures and shapes. Artists and poets and those of *no* taste as well as ordinary educated spectator-amateurs employ an alternative mode of seeing. This mode is not a function of social class and imaginative ability, although Ruskin is primarily concerned that it be adopted by his middle-class readers. Dreams, visions, fantasy, wit, humor, satire, Gothic grotesques — all are examples of this alternative way of seeing, given concrete expression as a form of art.[19] The picturesque landscape sketching of amateurs, one might argue, could be another — if, as in some of Ruskin's own later drawings, it suggests the visual exploration, by a narrowed and broken vision, of what is sensed but not fully seen as vast, significant, and complexly ordered. It is tempting to see Ruskin's own criticism as a form of grotesque art: the concrete expression of an active and imaginative mind approaching the difficulties of landscape or great art by suggesting, and then expanding, partial images.

Ruskin's 1853 description of the terror of thunderstorms is not an impressive example of his prose. The terror is there, but the comprehension, through a consistent apocalyptic imagery, is too easily and quickly attained — much more easily and quickly than in Wordsworth's Simplon Pass description. I would like to repair the injustice of my first choice by offering here two much finer examples of what could be called Ruskin's grotesque art. The first is a drawing, *Venga Medusa* (ill. 8), which condenses the terror of the thunderstorm into a single fragmentary but emblematically titled image. The second

is a passage from Ruskin's manuscript chapter on the terrible sublime, probably written between 1856 and 1860, when its closing sentence was incorporated into a different passage in the published version of *Modern Painters V*. The manuscript version is appropriate here because it introduces the impressive imagery of the last sentence at the end of a paragraph confessing an inability to see and understand. Terrifying description is offered not as imaginative grasp but as an expression of a partial and distorted vision, as terrible facts described but not mastered. Such vision, though not ordinary, is not privileged either. It is a mode of seeing in which the ordinary spectator can and should sometimes share, an alternative to the comprehensive grasp of a hypothetical true sublime.

I pause as I write—long and resultless. Unless one were oneself all that one should be, how can one say, or imagine, what the thoughts of others should be? I cannot tell, of any pain that I have felt, of any delight that I have enjoyed, how far I grieved or rejoiced rightly. But this at least I know,—that whether we rejoice or grieve, we ought all of us to strive more and more to gain insight into the facts of the life around us; and that those facts are, to our human sight, more than terrible. Assume what theory you will about the world;—and still, so far as the vision of the world so constituted is granted to *you*, it must be a frightful one:—and the best that you can believe is that in compensation for the evil of it, there shall one day be greater good; but believing this, still the good is unseen, evil is seen. Try at least to see it. Whatever is to be the final issue for us there ought surely to be times when we feel its bitterness, and perceive this awful globe of ours as it is indeed, one pallid charnel house,—a ball strewed bright with human ashes, glaring in its poised sway to and fro beneath the sun that warms it, all blinding white with death from pole to pole. (4.376)

There is no rationalization of the bitterness or terror, and no balanced composition. Ruskin suggests a single image for the world's evil, the pallid charnel house, initially reducing the awful globe to a grotesque. In Ruskin's grotesque prose, however, the single image is not the end. The rest of his sentence step by step expands that image until it regains, finally, the grandeur he could at first only urge us to imagine ("Try at least to see it"). Pallor grows bright, then glaring, then blinding white. The house becomes a ball that is put in majestic motion and set in the vastness of space beneath the sun. The limited death of the charnel house breaks out into those human ashes strewn over

the ball, which finally engulf the earth "with death from pole to pole." The confessions of difficulty and limited imagination that form the first part of the paragraph are the prelude to this alternative response to the challenge of sublimity: the grotesque image progressively expanded until it approaches the terrible sublime.

Ruskin's terrible grotesque assigns to the spectator the role of a lesser artist—the amateur, the workman, the critic. But Ruskin also approaches the problem of sublimity from another direction. There is, he suggests, a way to achieve the emotional exaltation of sublime experience without interrupting excursive progress and producing grotesque images. His noble picturesque is explicitly introduced, in *The Seven Lamps of Architecture,* as another version of sublimity—a "parasitical sublime" (8.236–237). In fact it invades unannounced even Ruskin's discussions of the true sublime in *Seven Lamps,* as it does again in the manuscript chapter on terrible sublimity written between 1856 and 1860.

"The Lamp of Power" is a discussion of sublime style in architecture. The notion of sublimity at work is not the terrible or difficult but the awesome: "a severe, and, in many cases, mysterious, majesty, which we remember with an undiminished awe, like that felt at the presence and operation of some great Spiritual Power" (8.100). When Ruskin says that sublime buildings depend on a sense of magnitude proportionate to their surroundings and to the human figure; or that they "have one visible bounding line from top to bottom, and from end to end" (8.106); or that they often rely on breadth of plain wall surface to achieve an effect of weight and massiveness; or that "after size and weight, the Power of architecture may be said to depend on the quantity . . . of its shadow" (8.116)—he is in every instance judging the effect upon a spectator presumed to be standing in one place receiving an impression of the whole. But partway through the chapter there is a change. When Ruskin takes up the importance of shadow, he explains it not as conveying the awe felt before a supernatural power, but as expressing "a kind of human sympathy, by a measure of darkness as great as there is in human life . . . the truth of this wild world of ours . . . the trouble and wrath of life . . . its sorrow and its mystery . . ." (8.116–117). The identification is not with power but with human powerlessness; the emotion is not exaltation but sorrow

and sympathy. Similarly, the discussion of shadow that takes up the major part of the chapter pays constant attention to the mass and breadth of the whole, but as he explains how that effect is achieved, Ruskin moves into closer focus, illustrating by details. "A noble design may always be told by the back of a single leaf" (8.124). The drawings with which he illustrates his text are all of details, parts of a facade drawn from close up, from a point of view quite different from that assumed by the spectator trying to take in the whole at one glance. There is an unannounced change in both emotional and physical perspective within this chapter on the sublime. Comprehension of the visual whole or of the power it expresses is being achieved by an examination of parts, by a sympathetic understanding of how power or overall design is expressed in details.

This focus on expressive details is properly that of the chapter on "The Lamp of Memory." Picturesqueness or parasitical sublimity is there defined as "characters of line or shade or expression" productive of sublimity but "found in the accidental or external qualities" of an object (8.237). Picturesqueness is expressed in independent details; true sublimity in the design or power of the whole, to which the parts of course contribute. Picturesqueness and sublimity are then versions of each other, as Ruskin's alternative term suggests. The difference between them implies a different visual perspective or focus: "the picturesque direction of their thoughts is always distinctly recognizable, as clinging to the surface, to the less essential character" (8.240). As Ruskin writes elsewhere, the picturesque way of seeing involves not so much composition—the artist's power to immediately imagine a whole—as *de*composition, breaking a whole into unrelated parts (12.313). Though the parts may be gathered together, they are not reintegrated into the kind of wholeness that the sublime spectator looks for. The concentration on accidental surface detail also is a mental characteristic of picturesque spectators. They do not concentrate on the "centre of thought" (8.236) of the objects they regard. To become a picturesque spectator is, in one sense, to give up the challenge of the sublime.

Nevertheless—and this is the essential point about Ruskin's picturesque—the decomposing method of seeing can also be emotionally valuable. Ruskin describes a complicated response of sorrowful sympathy to the marks of age:

[The greatest glory of a building] is in its Age, and in that deep sense of voicefulness, of stern watching, of mysterious sympathy, nay, even of approval or condemnation, which we feel in walls that have long been washed by the passing waves of humanity. It is in their lasting witness against men, in their quiet contrast with the transitional character of all things, in the strength which, through the lapse of seasons and times, and the decline and birth of dynasties, and the changing of the face of the earth, and of the limits of the sea, maintains its sculptured shapeliness for a time insuperable, connects forgotten and following ages with each other, and half constitutes the identity, as it concentrates the sympathy, of nations: it is in that golden stain of time, that we are to look for the real light, and colour, and preciousness of architecture; and it is not until a building has assumed this character, till it has been entrusted with the fame, and hallowed by the deeds of men, till its walls have been witnesses of suffering, and its pillars rise out of the shadows of death, that its existence, more lasting as it is than that of the natural objects of the world around it, can be gifted with even so much as these possess, of language and of life. (8.234)

This passage is a remarkable illustration of a transformation of emotional response linked to a change in visual focus. At the beginning of the passage the building is a single personified presence that bears "witness *against* men." It seems a stern and judgmental power in which the spectator hardly participates. Awe, or more likely fear, is the unexpressed emotional attitude the spectator adopts. But as the passage goes on, the building seems to be opposing not human beings but "the transitional character of all things" — a perpetual natural flux and change to which we are also subject. Viewed this way it becomes, in a fine reversal, not a witness against us but a point of identity for us. It now serves to evoke a humanistic sympathy binding us with people of "forgotten and following ages."

That there has also been a change in the way the building is seen is suggested by a subtle shift in metaphor. The building that bears witness against men is immediately a living power; it is above all a voice. The building that can "half constitute the identity" of nations is a set of walls and pillars differing from "the natural objects of the world around it" only when it has acquired the visible marks of age, "that golden stain of time." When it has assumed this character it acquires language, a language written on its walls. The building is no longer a living power, impressive simply as "voicefulness" (not yet articulated

into "approval or condemnation"). It is instead a record to be read, a history of human fame and suffering. In becoming a reader, the observer must shift attention from the building's overwhelming and unified presence to the scattered individual marks of passing time on its surface, the stains and cracks and rents in aging masonry. The change of metaphor implies the shift from immediate grasp of a whole to the linear or progressive attention to details we have been discussing as characteristic of the excursive and the picturesque.

In this passage, as throughout the two chapters on power and memory, the alteration in emotional response seems wholly satisfying. Awe or fear of an alien unknown becomes an expanded human sympathy. The noble picturesque provides an aesthetic response that is emotionally and morally desirable—perhaps more so than that of the true sublime. Ruskin's manuscript chapter on terrible sublimity, written mostly in the late 1850s, further explains this preference. In the draft passages for this chapter published by Cook and Wedderburn, the terrible sublime is discussed as a problem, as it is not in the published volumes of *Modern Painters*. Ruskin starts with the difficulty hedged in *The Stones of Venice* and taken up again in *Modern Painters III*: if, as he had once asserted, the sublime is never terrible to the believer, must we understand the terrible sublime simply as a symptom of faithlessness in the perceiver? In the language of *Modern Painters III*, has the modern love of cloudy landscapes any positive value? Ruskin's answer in the draft passages is close to that of *Modern Painters III*: pleasure in terror, in any age of disbelief, is initially a sign of a valuable sensitivity to natural and supernatural power. But the continued pursuit of pleasure in terror is more suspect. The sanest people will turn away from terror as they discover beauty, except under conditions of unusual stress. When we do return to pleasure in terror, we can do so nobly or basely; the difference turns on the nature of the emotional resolution of the experience. In the base sublime, pleasure comes from active identification with the absolute strength of a terrible power and extends even to "actual enjoyment of the idea of pain"—a pleasure that Ruskin rejects completely (4.377). The perceiver in the noble sublime begins by opposing a terrible supernatural power and ends by sympathizing with the human objects threatened by that power. Sympathy may be turned inward: a bad conscience or physical weakness makes the observer unusually attracted to manifestations of destructive

powers, in order to resist them. The pleasure of terror comes in the affirmation of the human against a sweeping but fearsome power. The affirmation is, however, purely personal. But the movement of sympathy may also be outward. Then it is compassion for a collective humanity, the most valuable version of the dubious pleasure of the terrible sublime: "a noble, but doubtful and faithless compassion for the agony of the world" (4.380).

In Ruskin's discussion of the emotional responses to terrible sublimity, point of view is, in a purely metaphorical sense, the crucial issue. He insists on a rejection of the comprehensive divine perspective on moral and humanistic grounds: to identify with a terrifying destructive power is to take pleasure in causing pain. But he warns of the dangers of substituting for this supernatural perspective the single, limited view of the isolated spectator. To merely rejoice that one can resist the power that attracts and threatens is selfish. His solution, offered as the best alternative in a world where the divine point of view *is* terrifying, is a multiplication of limited perspectives, an expansion, through compassion, of a deliberately partial but stubbornly human point of view.

Ruskin's grotesque and noble picturesque present what had been simply a spectator's way of looking at pictures or landscapes as a mode of perception equal in epistemological importance, and in emotional and imaginative satisfaction, to the privileged category of the sublime. These altered versions of excursive seeing are alternatives to a conventional sublime which tend actually to replace it. His grotesque and noble picturesque are in part a solution to a personal difficulty. But Ruskin has identified the difficulty as a general cultural one as well—a new terror and fascination at the appearance of destructive natural power, which cannot be enjoyed as the manifestation of a benevolent natural or divine order. In *Modern Painters III* and *IV* the general cultural difficulty with the sublime affects the artist, too. First grotesque and then picturesque art become a cooperative effort between artist and spectator to comprehend greatness and enlarge sympathies.

The grotesque is examined in *Modern Painters III* not primarily as the rough humor of ordinary people, but as the symbolical or allegorical vision of the artist or poet. In this form it is capable of "giving the highest sublimity even to the most trivial object . . . No element of imagination has a wider range, a more magnificent use, or so colossal a

grasp of sacred truth" (5.133–134). The sublimity, the grasp of sacred truth, is nonetheless achieved through a grotesque way of seeing by the artist, and it generates as well a somewhat different kind of grotesque perception in the spectator. Grotesque vision is the most colossal grasp of sacred truth because it is the only way in which such truth *can* be comprehended—with the distortions and fragmentations resulting from a limited point of view. The artist's vision, faced with the challenge of a particular kind of knowledge, is as piecemeal as the spectator's. His grotesques, though capable of giving sublimity, need to be expanded or interpreted like the spectator's. Much of Ruskin's chapter on the grotesque ideal in *Modern Painters III* is devoted to examples of the interpretive process, the reader's and beholder's roles in multiplying the limited perspective of the artist by gathering together connected examples of allegorical imagery from the artist's and from other texts in order to arrive at sublime comprehension. This process is, in art or literature, what Ruskin calls "reading." It is the ordinary person's way of using linear to arrive at comprehensive perception, a reader's sublime—an extension of excursive seeing. The sublimity constructed by the reading process is never more than potentially present in the artist's vision. In this last description of the grotesque or symbolical sublime, reader and artist together use the partial or excursive way of seeing to arrive at an otherwise unattainable knowledge.

In Ruskin's chapter on the noble or Turnerian picturesque in *Modern Painters IV* there is a similar sense of cooperation between artist and spectator. Here, however, the emphasis is less on necessary limitations to sublime vision in the artist than on the artist's responsibility to make the aesthetic and human values of picturesque vision available to the spectator. Ruskin focuses not on the accidental marks of age in buildings, but on the intentional and sympathetic portrayal of incidental detail in painting.

He had, of course, always delighted in an intricate variety that invited leisurely progress and changing perspectives for an excursive eye. In *Modern Painters I* he praised the purely visual pleasures of an excursive way of seeing and, by implication, placed the responsibility for creating pictures to be seen this way on the artist.

Often as I have paused before these noble works, I never felt on returning to them as if I had ever seen them before; for their abundance is so deep and various, that the mind, according to its own temper at the time of seeing, per-

ceives some new series of truths rendered in them, just as it would on revisiting a natural scene; and detects new relations and associations of these truths which set the whole picture in a different light at every return to it. And this effect is especially caused by the management of the foreground: for the more marked objects of the picture may be taken one by one, and thus examined and known; but the foregrounds of Turner are so united in all their parts that the eye cannot take them by divisions, but is guided from stone to stone and bank to bank, discovering truths totally different in aspect according to the direction in which it approaches them, and approaching them in a different direction, and viewing them as part of a new system every time that it begins its course at a new point. (3.492).

The artist in this passage is not necessarily one who sees excursively or picturesquely, but one who creates landscapes that allow a picturesque or excursive way of seeing in the beholder. Pictures possess unity, but the unity is not single. There are as many different systems or wholes as there are possible points of view. The spectator is enabled and encouraged by the strength of the connections between the parts to discover the multiple truths "totally different in aspect according to the direction" from which the parts are approached in an excursion through the picture space.

Ruskin's praise of Turner in the *Modern Painters IV* chapter on the noble picturesque is similar. There the way of seeing is explicitly identified as picturesque, and Ruskin emphasizes the accompanying emotional movement of sympathy as much as purely visual movement. But the artist's role is the same: to enable the beholder to discover new sympathies as well as new sights while the beholder moves from point to point. The beholder learns and takes pleasure from the process of movement through the picture rather than from an immediate impression of a whole. What Ruskin praises in the Turnerian picturesque is a breadth of sympathy that is conveyed to the spectator by the artist's treatment of intricate detail. The artist is praised in this chapter not for exemplifying a different and extraordinary vision, but for encouraging the development of the spectator's way of seeing.

Clarkson Stanfield's ordinary or "lower picturesque" painting of a decaying windmill (ill. 9) has an inviting variety of visual features: "its roof is nearly as interesting in its ruggedness as a piece of the stony peak of a mountain, with a châlet built on its side; and it is exquisitely varied in swell and curve . . . the clay wall of Stanfield's mill is as

beautiful as a piece of chalk cliff, all worn into furrows by the rain, coated with mosses, and rooted to the ground by a heap of crumbled stone, embroidered with grass and creeping plants" (6.16–17). Even this surface picturesque is not to be despised, but "ought to be cultivated with care, wherever it exists: not with any special view to artistic, but to merely humane, education" (6.22). But Turner's noble picturesque is still more effective in encouraging that simultaneous movement of sympathy which makes the visual explorations of the spectator so valuable as a means of humane education. Ruskin notes that Stanfield depicts a mill too fragile to function, whose decrepitude he enjoys aesthetically; he has made the mill the principal light of his picture and elaborated the textural interest of its decay. Turner's mill, though also worn, still functions; moreover he underlines its functional purpose through the mill stones he has propped against it. Turner treats the mill as a symbol of the value and the drudgery of work. His mill is a stark, proud object on a hill, cast in shadow to express his sympathy with the continual sorrow of labor (6.16–19). The picturesque way of seeing can encourage sympathy in the spectator even when the artist has not felt it, but the greatest paintings will be those where the artist demonstrates a power of sympathy through his treatment of picturesque visual detail. As with the symbolical grotesque, the spectator can complete the extension of the picturesque from a mode of visual to a mode of moral perception.

Reading and picturesque viewing are a long way from the romantic imagination as celebrated by Wordsworth or Coleridge. Yet these apparently prosaic activities are the models for the sight whose central epistemological importance Ruskin praised in a much-quoted passage from *Modern Painters III*: "The greatest thing a human soul ever does in this world is to *see* something, and tell what it saw in a plain way . . .To see clearly is poetry, prophecy, and religion, — all in one" (5.333). He was praising Turner and Scott as the representative modern seers: representative because of the perfect ease with which they had mastered and could teach a knowledge of the aspects of things. Ruskin's terms imply the kind of perception we have been tracing as the excursive. "Aspect" carries with it the meaning of looking from a particular direction at one side of a thing. The science of aspects is a body of facts — visual, emotional, and imaginative — consisting of more than

one aspect, facts gathered by changing one's point of view. In the last three volumes of *Modern Painters* Ruskin praises Turner not as the painter of nature, or of truth, or of beauty, but as the master of a new mode of perception, of the way in which nature, truth, and beauty will be approached by a modern spectator. The roots of that new mode of perception, we have seen, reach not to the sublime but to the excursive and picturesque.

Readers and critics of Ruskin have not, I think, recognized Ruskin's prescriptions on art and sight for what they are: a program of reform based on an insight into changes in habits of perception. Those changes he linked to a combination of mechanical inventions, new economic and social patterns, and an altered religious and philosophical outlook. His exhortations, his prophecies, his criticisms, his projects for reform assume the future importance of a new way of seeing. That new way was to be distinguished from another way, the sublime grasp he located somewhere in the distant past, or attributed to great poets and artists, or described at other times as an impossible ideal. To a remarkable extent Ruskin accepted the change in seeing he described. I say remarkable because it is equally clear that Ruskin was not happy with this change.

In many ways his attitudes are parallel to those of the twentieth-century critic, Walter Benjamin. Professedly a Marxist, Benjamin described a similar alteration in the way spectators and readers experience art, pointing to technological and economic changes of the same sort that Ruskin had identified seventy-five years earlier. Yet Benjamin's work is, like Ruskin's, permeated with a profound nostalgia for a lost way of seeing—what he calls the "aura" of a work of art[20] and what Ruskin called "awe." Both men accept what they see as an irreversible historical change, but the reforms they urge within this new mode of seeing are conceived in terms of a displaced romantic art. Ruskin's grotesque and picturesque are defined by the sublime; the imaginative and emotional satisfaction to be found in an expanded excursive experience must equal the promise of the privileged romantic moment. Ruskin increasingly realized that this was not going to happen. Like Benjamin, he could see that awe or aura was on its way out. But neither man ever really rejoiced in this fact. For this reason both have appealed more to readers who share their nostalgia and romantic context than to those whom they took as their subjects and sought as their audience

— those ordinary modern readers and viewers who can look at art or landscape only distractedly, who feel no awe for the kind of vision they do not possess, whom sublimity leaves, as Byron put it, cold.

History as Criticism

Historical consciousness plays a larger role in Ruskin's criticism than is usually acknowledged. Ruskin called *The Stones of Venice* a history, but as history it has had few defenders.[1] The account of Venetian architecture in *Stones* is shaped throughout by an extrahistorical intention: to celebrate medieval art and values and to condemn, on moral as well as aesthetic grounds, Renaissance Italy and nineteenth-century England. Ruskin's history, even more than Carlyle's, seems to have few connections with nineteenth-century historicism, hence with the history of history. But this judgment is not itself sufficiently historical. Looking back at contemporary models and sources for *The Stones of Venice*, I find that Ruskin's term "history" had meanings for early Victorian readers with which his own work is in complete accord. In *Stones* and the large body of contemporary literature to which it is most closely related, history is approached through travel, and travel experienced as history. Ruskin's book, shaped to meet a traveler-reader's practical needs and formal expectations, belongs to a loose genre of travel histories that reflected and shaped the historical attitudes of a good many English readers in the first part of the nineteenth century. Common to all these works is an implicit identification between the activity of the reader exploring history and that of the tourist exploring landscapes: the facts of the history book are the artifacts encountered by the traveler. Ruskin calls the stones of Venice his archives; the metaphor reflects the experience of the traveler-reader for whom *Stones* and many popular history and travel books were intended.

But *Stones* is of course more than history presented as travel. Ruskin's readers, tourists in search of the picturesque, become his subjects

no less than Gothic workmen. His central chapter, "The Nature of Gothic," begins with an attack on contemporary modes of producing and consuming art. One can read this shift from past to present as a shift from history to criticism, a shift that thereby distorts the historical accuracy of the book. But in many respects this chapter is the book's greatest historical achievement. Ruskin's sharply critical attitude toward the Victorian manufacturer-consumer results in an idealization of the middle ages, but it also permits the historicization of contemporary attitudes toward history and art. The confrontation between a contemporary traveler and a foreign past becomes a means for presenting an historicized view of the present and, particularly, of the traveler's habits of perception. Ruskin was not the first Englishman to use the travel-as-history trope to explore the perceptual limitations of the traveler-reader; he recognized Byron, Turner, Prout, and Carlyle as his predecessors. But *Stones* is at once closer to the popular literature it resembles and more consistently critical of the perceptual habits of the traveler-reader it addresses.

"The Nature of Gothic" has traditionally been cited as the beginning of Ruskin's social criticism,[2] and so it is. It is the historical self-consciousness cultivated in that chapter as much as the economic and social analysis, however, which seems to mark the transformation of the amateur writer on art into the cultural critic. Ruskin's writing before *Stones* is remarkably ahistorical. The stones of Venice and the English travelers who see them are historical entities as the subjects of Ruskin's earlier books—the truths of nature and art or the lamps of architecture—are not. The full title of the first volume of *Modern Painters* (*Their Superiority in the Art of Landscape Painting to the Ancient Masters*) points to the discontinuity between Claude and Turner which Ruskin repeatedly asserts there. In the three volumes of *Modern Painters* that follow *Stones*, however, Ruskin takes a very different approach, tracing changes in perception, taste, and belief. Claude appears as one of Turner's teachers, not simply as the negative pole of a comparison between false and true landscape painting. *Stones* gave Ruskin experience with modes of historical thought prevalent in the early nineteenth century, and these continued to shape his work, even though he wrote no more histories.[3] The book seems to have showed Ruskin that his proper work, though not history, was criticism based on historical self-consciousness. I take it that this view of the place of *Stones* in his work

became clear to Ruskin as he wrote. Volumes two and three, increasingly critical of the cultural attitudes of Victorian readers, explicitly point to a critical, historical treatment of the present as the proper approach to the subject of Turner and landscape art—a program carried out in Ruskin's next major books, *Modern Painters III–V*. The shift of focus from Gothic workman to Victorian reader is an exercise in historical perception as well as an act of criticism. With this shift in focus, Ruskin extends his historical perspective from art to contemporary attitudes to art; at that point, history becomes a necessary part of Ruskin's efforts to reform the perceptual habits and cultural attitudes of his readers.[4] To understand this development in Ruskin we need to look more closely at the way in which *Stones* combines tourism with historical narrative and puts these to critical use.

But are either popular travel histories or critical juxtapositions of past and present very significant in the history of history? Neither of these Victorian versions of history makes historical explanation and reconstruction a primary goal. Although they may lead to a more historical consciousness of the present, they do not assume that all truths are historical and relative. They accept the possibility of absolute and ahistorical judgment that may transcend the limitations of the moment, and then proceed to make such judgments—like Ruskin's violent condemnation of the Renaissance—an integral part of their historical accounts. These procedures have long been regarded as completely opposed to the objectivizing tendency of nineteenth-century historicism. Recent critics, however, have suggested that the objectivity pursued by the historicists was born of the same assumptions as the nostalgia and the sweeping judgments expressed by romantic—and many Victorian—writers.[5] The historicist's search for an objective, scientific method might be regarded as an impossible attempt to cancel the historicity of interpretation no less than the romantic's assumption of absolute moral or religious values as criteria for judgment. Such criticism calls into question the common distinction by which romantic history, like Carlyle's and Ruskin's, is seen as less central to the development of modern historical methods than scientific historicism. If one accepts this criticism as a (negative) correction to the current view, then the travel histories and cultural criticism of the English Victorians acquire a greater interest for the history of history. Though these Victorians, like the scientific historicists, were unwilling to historicize all truth,

they were often more concerned to explore the historical dimensions of contemporary perception and judgment. In this history of history, Ruskin's *Stones* occupies a modest but highly interesting position.

R̲USKIN'S own experience will illustrate the close connection between travel and history which existed for the early nineteenth-century reader. In the excursive literature on which Ruskin was raised, travelers were never allowed to forget the histories of the places they toured. Byron's *Childe Harold* and Rogers' *Italy*, for example, interweave historical narrative or meditations on the past with descriptive accounts of places visited; Wordsworth's *The Excursion* begins by stopping a traveler to make him listen to a tale, a piece of local history; Prout's *Sketches* focuses on Gothic buildings; Brockedon's *Passes of the Alps* recounts historical crossings from Hannibal to Napoleon; Saussure's *Voyages dans les Alps* is a work of natural history presented as a travel narrative. When Ruskin made his first solo trip to Italy in 1845, he took along as guides not only Murray's *Handbook for Travellers in Northern Italy* but also Simonde de Sismondi's *Histoire des Republiques Italiennes*. And when he embarked on a serious course of historical reading preparatory to *Stones*, the book he found most valuable was a history of Venetian architecture specifically designed "per servire di Guida estetica"—arranged, illustrated, and intended, like Ruskin's own work, to guide the traveler.[6] Finally, Ruskin's constant companion in Italy was, as Murray's *Handbook* recommended, Dante—whose poem, after all, is presented as a traveler's narrative and guide to both an extraterrestial geography and the contemporary history of Italy. The books that served Ruskin first as stimulus and then as preparation and companions for his continental tours ranged from prose travel narratives, books of engravings presented as travel records, and poems structured as tours to guidebooks and histories; what all these books had in common was the assumption that travel was a primary means of learning about the past. So Ruskin's experience followed a fairly common pattern among the early nineteenth-century English middle class. Sir Francis Palgrave, who wrote the first edition of Murray's guide to northern Italy, had specifically recommended that the traveler use both Sismondi's history and F. T. Kugler's history of Italian painting (the English edition, edited by Sir Charles Eastlake).[7] When the latter book,

which had both "history" and "handbook" in its original title, was revised in 1874, Lady Eastlake referred to it as "the chief guide of the English traveller in Italy" for the last thirty years.[8] Similarly, Alexis Rio's art history, which Ruskin used, was introduced by its English translator in 1854 as a work that would provide "interest and information to the traveller who makes it the companion of his wanderings through the Italian cities."[9]

The popular travel book of the eighteenth century was narrative in form, like the history, and like the history it deflected attention away from the narrator to an external subject.[10] But the story was the traveler's, not that of the countries described. The book was organized according to the sequence of places visited by, or recommended to, the traveler. The narrator, though striving to maintain a universal rather than a strikingly personal identity, usually wrote in the first person and often addressed a specific contemporary audience. Within the narrative of the trip, of course, historical digressions might play a lesser or greater part. Trips to Italy for the English had long been travel in time as well as space, and the eighteenth-century English travel narratives amply recognized this. Italy displayed the visible reminders of a classical past—reminders that the English gentleman of the time incorporated as allusions and objects of meditation into the gardens or poems that served as small-scale equivalents to travel.[11] The trip to Italy, as presented in the travel literature, was, like the poetic landscape garden or the long descriptive poem, a planned tour in the course of which unexpected vistas into past time as well as distant space surprised the traveler with a constant variety of imaginative excursions. And just as the gardens, in the latter part of the century, began to place less emphasis on classical allusions and more on the suggestive power of the landscape itself, so the later travel narratives are less concerned with invoking historical associations through the artifacts encountered than with evoking, through description and engraving, the sublime or picturesque pleasures of the landscapes in which those artifacts are set.

After Waterloo, changes in the identity of the English traveler altered the character of travel literature. Picturesque views were still essential, but there was a renewed recognition that travel, especially to Italy, was also travel to the past.[12] The new English audience for travel books seems to have included a much higher percentage of readers—

like the newly wealthy Ruskins — who could afford more than vicarious travel. These new travelers wanted precise information not only about routes and moneys and hotels but also about the historical significance of what they were seeing. A demand for hard facts spawned a new kind of travel writing. The guidebooks of Murray and Baedeker, begun in the late 1830s, aimed at the middle-class traveler through a systematic presentation of practical and historical information.

The same demand also led would-be travelers to use histories as travel reading, and it stimulated attempts, of which *The Stones of Venice* was one of the most successful, to combine the history and the travel book. Rogers introduces his poem *Italy* as not only describing a beautiful country but also appealing "to those who have learned to live in Past Times as well as Present"; in a note he added his wish to "furnish my countrymen on their travels with a pocket-companion" to the monuments of Italy's past and present history.[13] In his poem sections of description alternate with sections of narrative relating either historical and legendary events or encounters with contemporary customs and inhabitants. The same interweaving of past and present, narrative and description, characterizes the text of the popular landscape annual published in the 1830s by Robert Jennings. One model for both Rogers and the landscape annuals — a model that Ruskin knew well enough to imitate in 1835 — was Byron's *Childe Harold's Pilgrimage*.[14]

The past to which the nineteenth-century traveler was directed in the '30s and '40s was not, however, the classical past but the middle ages. This shift from one past to another partly accounts for the new interest on the part of traveler-readers in factual historical information. As Anna Jameson — whose *Sacred and Legendary Art* sold well despite what Ruskin regarded as its author's lack of aesthetic judgment — pointed out in her introduction, the subject matter of medieval art was unintelligible to the average English traveler: "We find no such ignorance with regard to the subjects of Classical Art, because the associations connected with them form a part of every liberal education."[15] The nineteenth-century traveler to medieval Italy lacked the education to interpret its monuments, as the eighteenth-century gentleman taking the classical grand tour had not. The travel narratives in prose, poetry, or engraving include expanded, more informational historical digressions. But they also acknowledge a greater need for facts than can be supplied within the limits of the genre. Byron adds notes,

Heath's Picturesque Annual refers the reader to guidebooks, Murray's sends the traveler off with histories in his pocket, and Ruskin writes a three-volume history to guide the new middle-class English tourist to a more than picturesque view of medieval Venice.

We can see the influence on *Stones* of this conjunction of history with travel both in the structure of Ruskin's volumes and in the identities he assigns to his readers. The titles of the three volumes, as Ruskin pointed out to his father,[16] recognize and play upon the doubled function of his work. The sequence of "The Foundations," "The Sea Stories," and "The Fall" suggests an historically ordered narrative of the rise and decline of Venice. At the same time, both the foundations and the sea stories also refer to the physical divisions of the buildings. ("Sea Stories" was Ruskin's term for the first floors of the old palaces.) Ruskin is describing the architecture of Venice from the ground up, as it could be found by the present-day traveler. The double meaning of the titles is an accurate index to the narrative structure: the sequence of buildings considered in volumes two and three is intended to work both as an order of visit for the traveler and as a chronology of styles. Ruskin specifies that the order is historical in his introductory chapter. His instructions to the reader in the course of volumes two and three, however, are directed to the traveler who should "visit in succession, if possible" the particular buildings he describes (11.149). He also included more detailed descriptions of particular buildings in special appendices for travelers and, in 1879, issued an abbreviated "Traveller's Edition."

Though the general organization of these two volumes is that of the narrative which is both travel and history, the conjunction of the two is actually achieved through a series of small juxtapositions of the traveler's present with the historical past. We are, at one moment, invited to look at what we could see now in Venice; at the next, we are listening to an account of past events or of legends about these events; a few pages later we are back in a traveler's present, this time to compare Venice, past or present, with contemporary London. Still later, we are imagining what Venice would have looked like, were we the very different spectators for whom the buildings were originally intended. Rogers' *Italy* and Jennings' landscape annual use a similar interweaving of present description and historical narrative, but in Ruskin's travel history the alternation between present and past is much

more frequent and unexpected. The traveler-reader is constantly sur-
prised to be returned to the present. This pattern accomplishes some-
thing different from the aims of the travel history, as Ruskin makes
clear in "The Nature of Gothic" and his conclusion.

The structure of volume one, however, differs from that of volumes
two and three in ways that complicate a description of Ruskin's travel-
history. "Foundations" in fact refers not just to the founding of the
Venetian empire or to the stone foundations of the buildings the
traveler examines, but also to the "canons of judgment" (9.8) on
which Ruskin's subsequent historical and aesthetic interpretations of
Venetian architecture are founded. Volume one is arranged as a
systematic presentation of principles of construction and decoration il-
lustrated by the history of Western architecure from Greece to nine-
teenth-century England. There are precedents for this kind of prelim-
inary essay in eighteenth-century travel literature and in the histories
Ruskin read. Though the first-person narrative was the indispensable
heart of an eighteenth-century travel book, a separate section of "Gen-
eral Reflections" was not uncomon[17] — as, for example, in Arthur
Young's *Travels in France* or James Boswell's *Account of Corsica.* Gib-
bon, too, supplements his historical narrative with a section of General
Reflections.[18] This two-part structure continues into the nineteenth
century in Murray's guidebooks (where, however, the general com-
ments were usually rather brief).

The two-part structure was also a feature of some contemporary
histories. Lord Lindsay's *Sketches of the History of Christian Art*, which
Ruskin reviewed in 1847, was the most immediate available model of
an English history of Italian art that exalted the middle ages at the ex-
pense of the Renaissance, and did so on moral and religious grounds.
Lord Lindsay's book begins with a very long essay on the general char-
acter of Christian art — actually a statement of the beliefs that shape his
schematic "General Classification of Schools and Artists," which fol-
lows the essay and precedes the narrative proper. Ruskin's first chapter
("The Quarry") does very much the same thing. The two-part struc-
ture of both men's books reflects a procedure exactly opposed to a sci-
entific or objective method. They begin with their beliefs about the
history of the period and with an outline of history interpreted accor-
ding to those beliefs; the narrative that follows then reads not as
evidence to prove their conclusions, but as illustrations for convictions

whose authority does not depend on historical facts. Thus Lindsay opens his book:

The perfection of Human Nature implies the union of beauty and strength in the Body, the balance of Imagination and Reason in the Intellect, and the submission of animal passions and intellectual pride to the will of God, in the Spirit.

Man was created in this perfection, but Adam fell . . .

Nevertheless the Moral Sense . . . still survives . . . and the struggle between Imagination and Reason . . . still reveals . . . the Ideal . . .

So long as we keep the Ideal in view, we rise — from Sense to Intellect, from Intellect to Spirit . . .

This is an universal law of humanity . . . the history of Man . . . affords the most striking and instructive *illustration* of it.[19]

Ruskin's movement from conviction to its illustration in "The Quarry" is far subtler, but the procedure is similar. As Ruskin himself explained in the preface to the first edition: "In many cases, the conclusions are those which men of quick feeling would arrive at instinctively; and I then sought to discover the reasons of what so strongly recommended itself as truth. Though these reasons could every one of them, from the beginning to the end of the book, be proved insufficient, the truth of its conclusions would remain the same" (9.7). The preliminary statement of extrahistorical truths serves an important methodological and rhetorical function for this kind of history. It sets up the historical (or the travel) narrative that follows as illustration or example of truths it need not prove. Putting the conclusions before the evidence informs the reader that for the author history is serving figuratively and literally as an illustrated guide to a way of seeing.

But the rest of Ruskin's first volume, though it continues to set forth introductory principles, is presented as a narrative — separate from but related to the travel-history narrative that follows. Here another travel history is the probable model. Saussure's *Voyages dans les Alpes* was Ruskin's introduction, and remained his primary guide, to the geological exploration of the Alps. Saussure's book, like Ruskin's, narrates simultaneously a history (the natural history of the mountains) and a tour (complete with maps, first-person narration, and illustrated views). When Ruskin traveled in Italy, he spoke of his study of Gothic architecture there as an alternative to his prior study of

natural history in the Alps.[20] The title of his volumes on Venice seems similarly to evoke that other study of "the historical language of stones" (11.41) in which Saussure was his guide. The ghost of the geologist hovers over the preface, too, where Ruskin uses analogies drawn from natural science to describe his methods.[21] Near the end of his volumes, the analogy appears again, but this time the terms are reversed. Reminding his readers that there is also a natural history of stones, he describes that history in terms drawn from the procedures of the political historian:

[The colours of marble] record the means by which that marble has been produced, and the successive changes through which it has passed. And in all their veins and zones, and flame-like stainings, or broken and disconnected lines, they write various legends, never untrue, of the former political state of the mountain kingdom to which they belonged, of its infirmities and fortitudes, convulsions and consolidations, from the beginning of time. (11.38)

In Saussure's book the narrative proper (tour and natural history) is preceded by an introductory section on the composition and formation of stones in the Geneva area, the traveler's presumed point of departure. Saussure indicates that this section will provide the traveler-geologist with the necessary analytical tools.[22] This first section is an exercise in practical analysis through which some fundamental principles can be established. It does not violate the identity of traveler assigned to the reader even though it does not actually form a part of the narrative. After a first chapter laying out convictions and an historical schema, Ruskin, like Saussure, lays his analytical foundations by taking the reader through an imaginary practical application of them in the twenty-nine chapters on construction and decoration which form the remainder of the first volume. In this case, the reader is invited to participate in a fictive exercise in building:

I shall endeavour so to lead the reader forward from the foundation upwards, as that he may find out for himself the best way of doing everything, and having so discovered it, never forget it. I shall give him stones, and bricks, and straw, chisels and trowels, and the ground, and then ask him to build . . . And when he has built his house or church, I shall ask him to ornament it. (9.73)

This presentation of the preliminary "Reflections" as a narrative of the reader's fictive experience is not a common feature of travel narratives, travel histories, or guidebooks, and here it seems likely that Ruskin was thinking of Saussure. In both books the effect is a more complete assimilation of the reader of history into some identity proposed by the book. Once the reader becomes a character in the book, the book can dramatize the conditions under which perceptions and judgments are made.

For Saussure this self-consciousness never becomes an end in itself. Ruskin, however, uses the identity he creates for readers to involve them, as both travelers and readers of history, in new responsibilities toward their own culture. When Ruskin identifies his audience, its attitudes and assumptions become the explicit focus of attention. He never loses sight of the fact that he is addressing readers; "the reader" is a recurring figure throughout the three volumes. Ruskin's reader is more specifically described in his preface as a "general reader," probably "little versed in the subject" and including "the most desultory" (9.9). In the same preface, however, Ruskin ascribes to this general reader some knowledge of recent developments in historical method. He offers his stones as facts and his observations of them as a return to original sources, a return that will correct the inaccuracies of earlier histories. The stones have the status of historical documents. Thus Ruskin makes it clear that both he and his reader are modern readers of history in primary sources: Niebuhrs in Venice.

As early as the end of his first chapter, though, Ruskin offers the fiction of another identity to his readers. His "Come . . . come, and let us know, before we enter the streets of the Sea city" (9.59) holds out the promise of history as travel. The promise is fulfilled at the end of the "Foundations" volume: "And now come with me, for I have kept you too long from your gondola: come with me, on an autumnal morning, through the dark gates of Padua, and let us take the broad road leading towards the East" (9.412). In this fiction, the stones of Venice are physical objects to be experienced, not documents to be read. The reader is in their presence, with Ruskin as guide. The fiction of travel is maintained in long passages of description in the second volume and in briefer passages in the third. It is also supported in some of the illustrations. Although the majority of the plates are simplified line drawings, two-dimensional analyses of the ac-

tual stones arranged to reveal a chronology of style, some are pictur-
esque versions of actual buildings. These drawings imply not only a
particular spatial point of view but also, through details like crumbling
stone or stray tufts of grass, a specific temporal perspective in the pre-
sent (ill. 10). Picturesque details support the fiction that the reader is
not just following the analysis of the critical historian but also sharing
the experience of the traveler.

Fiction is implicitly recognized as fact, too. When Ruskin refers to
the traveler, he means more than the fictional experience he has
created. He assumes that his reader has traveled and will travel—be-
longs, as a comfortably middle-class Victorian, to a class that travels.
From the beginning of the second volume Ruskin begins to play upon
this cultural fact in such a way as to make his readers critically self-con-
scious of the ways in which their reading and their traveling are re-
lated. The first volume ends with a present-tense description of travel
to Venice; the second opens with an immediate historical distancing
from the travel experience: "In the olden days of travelling, now to re-
turn no more" (10.3). The effect of this distancing is not simply to
evoke nostalgia for a pre-railroad Venice, as Ruskin first does, but also
to make the traveler's experience of Venice itself a subject with a his-
tory. In those olden days—before the mid-1840s—"it was no marvel
that the mind should be so deeply entranced by the visionary charm of
a scene so beautiful and so strange, as to forget the darker truths of its
history and its being" (10.6). This romantic view of Venice is still
what the English tourist sees, but both the physical aspect of Venice
and the historical understanding of its stones have changed:

although the last few eventful years . . . have been more fatal in their influ-
ence on Venice than the five hundred that preceded them . . . there is still so
much of magic in her aspect, that the hurried traveller, who must leave her
before the wonder of that first aspect has been worn away, may still be led to
forget the humility of her origin, and to shut his eyes to the depth of her des-
olation . . . But for this work of the imagination there must be no permis-
sion during the task which is before us. The impotent feelings of romance,
so singularly characteristic of this century, may indeed gild, but never save,
the remains of those mightier ages to which they are attached like climbing
flowers; and they must be torn away from the magnificent fragments, if we
would see them as they stood in their own strength. Those feelings [are]
always as fruitless as they are fond . . . The Venice of modern fiction and

drama is a thing of yesterday, a mere efflorescence of decay, a stage dream which the first ray of daylight must dissipate into dust. No prisoner, whose name is worth remembering . . . ever crossed that "Bridge of Sighs," which is the centre of the Byronic ideal of Venice. (10.7-8)

The "Venice of modern fiction and drama" is the Venice that Ruskin and his traveler-readers, thanks to Byron, saw when they visited the city: the product of a particular time and culture. Not the city but the perception of it — as beautiful but corrupt, an enchanted city appearing from nowhere in the high Renaissance, Byron's "fairy city of the heart," Rogers' dreamlike "City in the Sea," risen "like an exhalation from the deep."[23] The coming of the railroad makes such a view of Venice visually anachronistic, as recent historical research makes it conceptually out of date.

Not one but two different kinds of traveler-readers are invoked in Ruskin's second volume: one, the distracted and hurried traveler who reads Byron and turns "impotent feelings of romance, so characteristic of our century" on the now incompatible visual and historical facts of Venice; the other, the reader of history as Ruskin would create him, the traveler he guides, as he does at the end of the first volume, past rows of crumbling stucco Renaissance villas and the intrusive railroad bridge, through clouds of smoke, to the all but invisible remains of medieval Venice. The first kind of reader-traveler Ruskin presents as historical fact — a portrait of his audience and their habits (which are, or were, his own). The second kind of traveler-reader is an identity Ruskin would like to create in fact through his fictions. Both the actual and the created audience, however, are in one respect the same, and this is a point that Ruskin's book tries to drive home: for both, traveling, reading, and seeing are nearly synonymous terms for a way of consuming cultural artifacts. That coincidence of roles is, as Ruskin later makes clear, itself an historical phenomenon rooted in specific beliefs and forms of social organization.

General readers who turn to Ruskin's book for history and use it as a guide to actual or vicarious travel discover very early that Ruskin has in mind a more onerous identity for them. The concluding words of the preface direct his book "to the men of London," as members of a mercantile community like Venice, men who have "influence on the design of some public building," or buy or build their own houses

(9.10,9). It is not only as consumer but also as patron of art and architecture that Ruskin addresses his traveler-reader. And that identity carries with it the responsibility not just to be pleased wisely, but to employ the powerful influence of the consumer toward the production of architecture that will wisely please. "And it is assuredly intended that all of us should have knowledge, and act upon our knowledge, in matters with which we are daily concerned, and not be left to the caprice of architects, or mercy of contractors" (9.10). Toward this larger identity, the reader as patron, the fiction of Ruskin's first volume directly contributes. The imaginary experience of building and decorating—and, unlike the experience of travel, it is never more than a fiction—is less relevant to travelers or students of history than to those who will influence, as patrons, the civil or domestic architecture of their own cities. Travel in space or time, though they are modes of consumption, are also modes of education which will prepare Ruskin's readers, for good or ill, to influence the art they are most likely to patronize. In the "Conclusion" to *Stones*, Ruskin returns wholly from Italy to England and from the past to the present—and returns to lay the responsibility for "the revival of a healthy school of architecture in England" (11.226) before his readers. He does not ask them to become, literally, builders or artists. His readers remain modern spectators, travelers and consumers, not artists. But as consumers they are no less the creators of historical documents, of stones that can be read. The historically new power of the consumer—a power Ruskin recognizes but does not praise—is one subject of the central chapter of his history, "The Nature of Gothic."

THAT CHAPTER draws not only on the double function of the narrative and the double identity of the audience in the travel history, but also on the increasingly self-conscious confrontation of present with past which an experience of history through tourism implied. For Ruskin the most important models for this double focus on past and present come not from travel histories but from writers and artists who, like him, drew on contemporary travel experience as a general modern mode of perception and judgment. Ruskin found Turner, Byron, and Carlyle each using the picturesque tour of ruins to deepen consciousness of modern cultural perspectives.[24]

Turner and Byron are of obvious importance for *Stones* since they take Venice as their subject; they provide influential perceptions of Venice and—especially in the case of Byron—reflect on the process of perception in the contemporary traveler. Carlyle, though his subject is never Venice, was evidently no less important in drawing Ruskin's attention to the problems a contemporary reader-traveler faced in adequately responding to a distant past. I focus here on Carlyle's *Past and Present* because that book, like Ruskin's, employs the trope of the reader as traveler in a work that is primarily not travel but history. And, like Ruskin's book, Carlyle's is both history and criticism—criticism not of the observing individual (as in Byron's poem) but of culture and society.

Past and Present begins with the familiar situation of the traveler visiting ruins. "The picturesque Tourist [Carlyle himself, collecting material for his *Cromwell*], in a sunny autumn day, through this bounteous realm of England, descries the Union Workhouse on his path."[25] These ruins are, ironically, not dead stones but discarded humans, the inhabitants of St. Ives Workhouse. With this cruelly inadequate instance of touristic looking, Carlyle juxtaposes an apparently more appropriate example:

The *Burg*, Bury, or "Berry" as they call it, of St. Edmund is still a prosperous brisk Town . . . Here stranger or townsman, sauntering at his leisure amid these vast grim venerable ruins, may persuade himself that an Abbey of St. Edmundsbury did once exist; nay there is no doubt of it: see here the ancient massive Gateway, of architecture interesting to the eye of Dilettantism . . . And yet these grim old walls are not a dilettantism and dubiety; they are an earnest fact . . . Gauge not, with thy dilettante compasses, with that placid dilettante simper, the Heaven's-Watchtower of our Fathers, the fallen God's-Houses, the Golgotha of true Souls departed! (46–48)

The picturesque traveler, who fails to perceive the spiritual facts about present *or* past, is equated from the beginning of this section with the modern reader of historical documents. Carlyle dwells on the utter foreignness of the *Jocelini Chronica*—despite its English subject—implying related failures of perception in traveler and reader. The chronicle is "exotic, extraneous; in all ways, coming from far abroad" (40). Carlyle's historical enterprise is introduced both as an act of proper reading and as an act of proper seeing—seeing within an assumed con-

text of travel. His invitation to the reader is very much like the one Ruskin was to use seven years later: "But it is time we were in St. Edmundsbury Monastery and Seven good Centuries off " (46). "Readers who please to go along with us . . . shall wander inconveniently enough" but at last come face to face with "some real human figure" (50).

From this point, however, Carlyle's and Ruskin's histories diverge. The identities of the reader as traveler and of the historian as guide drop out of sight in *Past and Present* as they never do in *Stones*. The travel analogy works against Carlyle's rhetorical aims, whereas it is essential to Ruskin's. The divergence in rhetorical aims needs tracing with some care, because at first sight Carlyle's and Ruskin's conceptions of history as criticism seem extremely close (Ruskin himself, in later years, repeatedly asserted his debt to Carlyle).[26] One might say that for both men history is presentational and didactic. Both seem to aim first at reviving the temporally and culturally distant past for the reader by giving it the immediacy of present experience. Causal explanation and sequential narration are of secondary importance to the lively presentation of multiple aspects of a given moment or action. According to Carlyle's dictum, "Narrative is *linear,* Action is *solid.*"[27] Adequate history, Carlyle goes on to indicate, is pictorial and scientific in the rather old-fashioned sense that Ruskin understood: the observation and description of natural phenomena as they appear to the unaided eye. At the same time, both Carlyle and Ruskin acknowledge that the historian works not just to describe but also to reform the perceptions of contemporary readers so that this living past will be intelligible to them. Carlyle is explicit about his didactic or reforming aim in the introduction to *Cromwell*: "We have wandered far away from the ideas which guided us in that Century . . . we have wandered very far; and must endeavour to return, and connect ourselves therewith again! . . . The Age of the Puritans is not extinct only and gone away from us, but it is as if fallen beyond the capabilities of Memory herself; it is grown unintelligible, what we may call incredible."[28] The historian must operate not only on the past but also on his readers. His presentation must be persuasive as well as factual and lively.

This dual aim may sometimes lead to deliberate distortion, as when Carlyle manipulates his historical source to present Abbot Samson as the hero he needs. Persuasion may also mean a variety of fictive exer-

cises into which the reader is led. Sometimes these are announced, like that of travel in Carlyle, or of travel or imaginary construction in Ruskin; at other times they are unannounced. In *Past and Present,* for example, Carlyle first introduces Jocelin as a total stranger, a dim and hardly understandable figure, then calls him a Boswell, and shortly after begins simply to refer to him in that familiar guise: Bozzy. At the same time, it becomes increasingly difficult to tell when we are listening to the Editor's translation of Bozzy-Jocelin and when to the Editor's own voice paraphrasing and interpreting him. The reader has been led by some tricky transitions to experience Jocelin's report as if it were contemporary, as believable as the familiar present. (Of course the Editor also repeatedly interrupts this process to point out the illusion. The present is still extremely different from that past which has come to seem so credible and comprehensible.) Insofar as both Carlyle and Ruskin accept this dual historical aim, to present and to reform, history is inseparable from cultural criticism. The historian tries to make readers conscious of the difference between their own values and beliefs and those of the past they are confronting, by leading them to experience a past judged differently from the way they normally conceive it, but repeatedly jolting them back to a recognition of the distance between past and present. Ruskin's descriptions of Torcello or St. Mark's work in a similar fashion.[29] Travelers, securely located by Ruskin in a diminished present, find that they have insensibly come to share the perspective of the original readers of the stones of Venice—but find that out only at the moment when they are reminded by Ruskin that contemporary Venice and, worse, contemporary London do not look the same as medieval Venice. For Carlyle and Ruskin, the fictive exercises and the destruction of those fictions together work to develop an historical self-consciousness and to persuade readers to alter their beliefs.

For Carlyle, however, persuasive description depends on the voice, whereas for Ruskin it depends on the eye. This difference in style means that they have quite different attitudes toward the modes of perception that their readers normally exercise. Carlyle asks his readers to listen to the "authentic utterances,"[30] the lively speech of Jocelin (or Cromwell or the women of Paris). Where much of the verbal energy of Ruskin's *Stones* comes in his visual descriptions, that of *Past and Present,* like most of Carlyle's books, comes in passages of simulated

speech, distinctive voices he creates or assumes. And for Carlyle this amounts to an explicit rejection of modern modes of confronting the past. He opposes history as living voice to both reading and picturesque seeing. Carlyle repeatedly attacks a history that overvalues mere scholarly reading of printed documents ("dry rubbish," "Dryasdust," "The Paper Age"[31]); the picturesque tourist, as we have seen, is closely linked with the modern historical reader. Reading and picturesque seeing obstruct the memory of a culture. To these modern historical modes Carlyle contrasts the truer memory of oral cultures. "Truer memory, I say: for at least the voice of their Past Heroisms, if indistinct, and all awry as to dates and statistics, was still melodious to those Nations . . . the Greeks had their living Iliad."[32]

There are several consequences of Carlyle's opposition of history as living voice to reading and picturesque seeing. First, the fiction of history as travel, like the identification of the reader *as* a reader, is not useful to Carlyle in his efforts to persuade his audience to respond more adequately to the past. Quite the reverse: he would rather have them throw out the dilettante eye altogether. Though Carlyle does continue to use visual metaphors to describe the relation of present to past that he is trying to effect (the "eye of the Dilettante" should become "the true eye for Talent"; the historian is, in his most exalted form, an Artist and a Seer), these metaphors have no connection, as they do for Ruskin, with the ways in which contemporary middle-class Englishmen literally see the past by looking at ruins and reading books. There is thus a major difference of emphasis in the strictly critical parts of *Past and Present* and *The Stones of Venice.* The historical self-consciousness both men cultivate as a means to contemporary social reform always and indeed primarily includes, for Ruskin, contemporary habits of seeing and reading. Carlyle, though he initially recognizes those habits as modern, rejects them outright.

Carlyle's preference for voice over sight also suggests a curiously antihistorical bias, which occasionally surfaces in his history-as-criticism. A history that aspires to the condition of oral traditional poetry is, at some fundamental level, nostalgic for a culture where historical consciousness has not yet arrived. And indeed Carlyle, in *The French Revolution,* allows some truth to the proposition that historical unconsciousness is a state of blessedness, and history a record of "some disruption, some solution of continuity . . . an irregularity, a disease.

Stillest perseverance were our blessedness; not dislocation and altera-
tion, — could they be avoided."³³ The last phrase is, of course, a crucial
reservation. Carlye sees quite clearly that the traditionalist society is
gone, as it was not for Burke. The attempt to reestablish a sense of
continuity so that events will not disrupt it would be a truly heroic
undertaking. And it is in such terms that Carlyle does in fact envision
the historian's role: as Artist, Poet, Seer, Hero. His own identity is the
more modest one of Editor; yet one understands that the persuasive
editor must in fact already be something of a poet and seer, too.
Whether an effective seer is another problem. Will he really abolish
the distance between past and present, turn the confrontation of pres-
ent readers with past heroes into that face-to-face meeting Carlyle en-
visions at the beginning of *Past and Present,* where "we look into a pair
of eyes deep as our own, *imaging* our own" (50) — because we too have
acquired heroic minds? Carlyle does not claim so much for his Editor:
"Certainly, could the present Editor instruct men how to know Wis-
dom, Heroism, when they see it, that they might do reverence to *it*
only, and loyally make it ruler over them, — yes, he were the living
epitome of all Editors, Teachers, Prophets, that now teach and proph-
esy; he were an . . . *effective* Cassandra. Let no Able Editor hope such
things" (38).

If in Carlyle we sometimes glimpse a vision of history that will
make history irrelevant, in Ruskin we do not. Ruskin draws back
both from abolishing the distance between past and present and from
efforts to convert us all to one heroic, poetic mind. He does not sug-
gest — as, in one way or another, Byron, Turner, and Carlyle all
do — that the ideal solution to the problem of adequately perceiving the
past may lie in acquiring a poetic imagination as an avenue to an ex-
tratemporal perspective. We remain quite firmly, as Carlyle in his role
as editor is always reminding us, where we still are: in the prosaic
present. From this perspective, which Ruskin identifies very con-
cretely with that of the modern English traveler and reader, cultural
criticism is closely tied to an historical self-consciousness.

"The Nature of Gothic" is the crucial chapter for any argument
about the relation of history to cultural criticism in *Stones.* Ruskin
criticizes contemporary England more directly and extensively there
than in any other chapter of his book. As has long been recognized,
"The Nature of Gothic" is not primarily about Venetian Gothic as an

historical style. Ruskin's subject is "the universal or perfect type of Gothic," which insofar as it is drawn from real buildings refers to northern, not Italian, architecture. On the face of it, then, this is simply not an historical chapter. In fact it has tended to be read as an independent critical essay ever since Furnivall had it separately reprinted for the Working Men's College in 1854. If, however, we read *Stones* as travel history, keeping in mind how Byron and Carlyle, especially, turned the traveler-reader's confrontation with history into a critical consideration of both past and present, "The Nature of Gothic" takes on a different relation to the rest of Ruskin's book. Gothic architecture is not an historical entity in this chapter, but the reader is.

As Ruskin himself points out, his subject is the reader's image of Gothic: "the idea which I suppose already to exist in the reader's mind . . . this grey, shadowy, many-pinnacled image of the Gothic spirit within us" (10.182). Reader-travelers who have been frequently referred to and even portrayed in Ruskin's history tour are quite clearly told that their guide will now take them through an examination of their perceptions of Gothic. These perceptions are quite probably based on English and French examples. The "grey, shadowy, many-pinnacled image" is recognizably that of much romantic literature, landscape painting, and picturesque drawing—not at all like the brightly colored and highly detailed buildings Ruskin has been describing. At first Ruskin builds on the image he has attributed to his reader-travelers in quite comforting, even flattering fashion. In two pages of elaborate description he approves the reader's image as an accurate expression of northern and Christian (Protestant) character—the reader's own. He also ties that image of Gothic to a political system the English reader would be glad to recognize: Gothic ornament expresses a constitutional, not a servile (Greek) or revolutionary (Renaissance) organization of labor. His readers' pleasure in a picturesque Gothic, then, seems to be quite harmonious with national, political, and religious characteristics they can be proud to claim.

At this point, however, there is a major shift in the rhetoric: "But the modern English mind has this much in common with that of the Greek" (10.190). For the next fifteen pages all sense of comfort is dispelled. Ruskin brings up, one after another, aspects of modern taste and attitudes—recognizably "ours" too—which seem to contradict

this pleasure in a picturesque Gothic. He ties modern English prefer-ences for order and for finished workmanship to contemporary social and economic organization: the division of labor in mass production and the social distinctions between manual and nonmanual laborers. The reader's own image of Gothic now serves to condemn contempo-rary attitudes. After Ruskin's first seductive presentation of that "grey, shadowy, many-pinnacled Gothic" and the kind of person who loves it, how can we possibly "esteem smooth minuteness above shat-tered majesty" (10.191) — and go on buying glass beads or erecting neo-classical buildings? We must convict ourselves on the evidence of our own perceptions, that view of Gothic we were glad to own.

The self-awareness and reflection that Ruskin's rhetorical strategy in this chapter seems meant to provoke do not stop there. Though these condemnations of an English taste for mechanical perfection may make readers squirm, they do at least seem to applaud an original attraction to Gothic. At one point Ruskin specifically appeals to the evidence of this taste against the stress on order and finish that the English allow to guide their buying habits:

All the pleasure which the people of the nineteenth century take in art, is in pictures, sculpture, minor objects of virtù, or medieval architecture, which we enjoy under the term picturesque: no pleasure is taken anywhere in mod-ern buildings, and we find all men of true feeling delighting to escape out of modern cities into natural scenery: hence, as I shall hereafter show, that peculiar love of landscape, which is characteristic of the age. (10.207)

Yet if the reader has followed Ruskin's analysis carefully, this pleasure in the picturesque will seem by no means a wholly trustworthy guide. Pleasure, in Ruskin's analysis, takes on a peculiar meaning. In Vic-torian society it has been artificially separated from work and equated wholly with leisure — leisure and money. "It is not that men are ill fed, but that they have no pleasure in the work by which they make their bread, and therefore look to wealth as the only means of pleasure" (10.194). The attitudes of workmen are, Ruskin goes on to point out, fully shared by their middle-class employers — who, like them, con-sider manual labor degrading and unpleasant, surround themselves in their own work with objects and buildings in which they take no pleasure, and escape to find their pleasure as travelers and spectators of

natural scenery and medieval ruins, as distant as possible in both place and time from the modern cities where they normally live and work. From this perspective, the English pleasure in Gothic—that shadowy image—is as closely tied to particular modern social and economic arrangements as the contrary demand for finish and order we have just agreed to condemn. If we follow Ruskin this far, we should be very uncomfortable indeed. For not just "The Nature of Gothic" but all of *Stones* is addressed to the traveler-reader with a love of picturesque ruins. What does Ruskin do with the unpleasant self-consciousness into which he has led us?

Quite remarkably, he does not ask us to reject our picturesque pleasures. Indeed, the rest of Ruskin's chapter continues to define a Gothic that is not inconsistent with the many-pinnacled image with which he began. Picturesque Gothic is imperceptibly universalized until it comes to express universal human attitudes and aspirations. At the same time, the spectator's pleasure in picturesque Gothic is appealed to not as a specialized and suspect form of modern consumption, but as an instinctive recognition of self-evident truths. In this part of the chapter, then, neither Gothic nor modern perception of Gothic is treated as historical fact. But the reader reassumes an historical identity in the chapter's closing pages. Ruskin draws up a list of guidelines for "the general reader," assumed to be a spectator examining an Italian or French or English building. The reader is once again a modern traveler, for whom looking is leisure activity. Ruskin instructs us to judge the building for its success at conveying an adequate conception of the whole through views that are partial and changing because we are travelers, in both space and time. Yet what we as spectators see and do may also have changed.

First, See if it looks as if it had been built by strong men . . .

Second, Observe if it be irregular, its different parts fitting themselves to different purposes, no one caring what becomes of them, so that they do their work . . .

Thirdly, Observe if all the traceries, capitals, and other ornaments are of perpetually varied design . . .

Lastly, *Read* the sculpture . . . Thenceforward the criticism of the building is to be conducted precisely on the same principles as that of a book; and it must depend on the knowledge, feeling, and not a little on the industry

and perseverance of the reader, whether, even in the case of the best works, he either perceive them to be great, or feel them to be entertaining. (10.268–269)

The looking enjoined on us here is much more difficult. It is active and imposes responsibilities: to know, to feel, to work, to persevere—and to judge. Ruskin's readers have not been asked to abandon a touristic way of seeing; indeed, like Ruskin himself, we cannot. Seeing *is* an expensive form of consumption for us, and travel is the manner in which we indulge it. We can condemn but cannot simply put off our mode of experiencing gothic buildings, or the social and economic relationships determining that mode. But we can nonetheless improve our perceptions. There is one kind of picturesque travel that produces only vague, shadowy images of either visual or historical facts, and there is another that offers, despite necessary limitations in perception, the possibility of real insight into art or the past. Indeed—and this is Ruskin's final, perhaps too comforting conclusion—the limitations of picturesque travel, that peculiarly modern mode of seeing and reading the past, are themselves an image of natural human limitations in seeing and understanding. Travelers have very little chance of seeing something "whole." They must infer from the present state of a building what it was intended to look like and mean. They must also—especially with Gothic buildings—infer a visual whole by walking around and through something that is irregularly complex in shape and decoration and can never be completely seen from any one point of view. So, Ruskin suggests, our understanding of history or of the providential design of the world is, like the traveler's, necessarily partial and progressive. In this sense picturesque perception, like the Gothic architecture that seems specially suited to it, is more than just a modern way of seeing.

But this is not the only truth the modern reader must keep in mind. The paradox of picturesque perception which Ruskin sets up (and the paradox is that of historical perception in general) is that it transcends historical relativity to become a natural, human, representative way of understanding and seeing only when we remember the specific historical conditions that limit our perception. Ruskin's cultural criticism, though it appeals to extrahistorical truths self-evident to any reader, at the same time insists that we keep ourselves constantly aware of how

bound to our culture and society our perceptions are. Ruskin himself became acutely aware of how closely his readers' habits of seeing and reading about the past were connected to the consumerism of the picturesque tourist—a product of a particular historical development in social and economic relations. Unfortunately, as he was later to conclude, such a difficult kind of awareness does not necessarily lead to changing the society he so vigorously criticized.

II Looking at Art

Spectators and Readers

The Romantic Reader and the Visual Arts

T HIS BOOK SEEMS TO GIVE ME EYES," wrote Charlotte Brontë of *Modern Painters.*[1] She was not alone in her opinion that to read Ruskin is to see with a new intensity—to look at both natural and painted landscapes in a different way. The claim could as easily be reversed, however: to see intensely with Ruskin is to learn to "read" what we see—to consider landscape, natural or painted, as art, and visual art as a language requiring interpretation to yield its various kinds of meaning.[2] *The Stones of Venice,* where the reader is assumed to be a tourist, may be a special case of seeing as reading. The genre of travel history that Ruskin adopts deliberately collapses the distinction between spectator and reader. But the interaction between beholder and building or landscape or painting is reading in other senses. Ruskin himself begins *Modern Painters* by asserting that painting is a language; in *Stones* he constantly makes metaphorical connections between buildings and books; in much of *Modern Painters* he speaks of a divine language of nature that art should use; at the close of *Modern Painters* he offers a series of elaborate readings of Turner's symbolic art. Although the sense in which we can speak of Ruskin as a reader of visual art is different in each of these instances, the close connection between seeing and reading remains real.

One recent critic has set out to rescue Ruskin's reputation as a visually astute observer by deliberately avoiding "the shoals of Ruskinian metaphysics" encountered when one crosses the line between seeing and reading art.[3] I don't think we need be embarrassed to follow this potentially fruitful inquiry, particularly since Ruskin's various methods of reading visual art are rather extensions than betrayals of his more purely visual insights. It is, in fact, next to impossible to decide

where seeing becomes reading in his work—or, indeed, in almost any critical response to a work of art. I have treated as "reading" three aspects of his response to visual art. Each of these can be directly connected with methods of reading literary texts of demonstrable importance to Ruskin: the imaginative participation of the romantic reader, scriptural exegesis, and historical philology. Just why Ruskin should have wished to bring the activities of reading and seeing closer together for his Victorian audience is a question that needs asking at several points in the development of his critical practice. I shall be concerned in this chapter primarily with Ruskin's claim in *Modern Painters I* that painting is a language and with the ways in which his discussions of Turner there and in *Modern Painters III* suggest a deliberate revision of romantic ideas about the difference between looking at paintings and reading poems.

To CALL PAINTING a language has traditionally been to argue that it is a mental and not merely a mechanical art. Ruskin claims, near the beginning of *Modern Painters I*: "Painting, or art generally, as such, with all its technicalities, difficulties, and particular ends, is nothing but a noble and expressive language, invaluable as the vehicle of thought, but by itself nothing" (3.87). This claim puts him in a long line of defenders of painting going back all the way to Simonides ("painting is mute poetry"). The defense of painting as language is not a continuous theme in English art criticism, but it is made by England's first important art critic, Jonathan Richardson, and again by Ruskin more than a century later. Richardson's rather different understanding of the language of art illuminates both what is old and what is new in Ruskin's.

For Richardson, self-advertised as the first Englishman to write—in 1719—of the "science" of beholding the visual arts, "Painting is another sort of Writing."[4] Ruskin's and Richardson's defense of painting as a language may at first seem quite different from a second traditional defense stated by Leonardo da Vinci: "The imagination is to reality as the shadow to the body that casts it and as poetry is to painting, because poetry puts down her subjects in imaginary written characters, while painting puts down the identical reflections that the eye receives, as if they were real . . . [Poetry] does not, like painting, impress the consciousness through the organ of sight."[5] Leonardo argues

that sight gives us the most immediate impression of what is real, and hence direct appeals to sight in the visual arts possess a nonlinguistic (and nonimaginative) power that poetry cannot claim. John Locke's theories, however, made it possible for writers on art from the early eighteenth century on to argue both that art was a language *and* that it possessed an advantage over literature because of its closer connection with the sensations produced by an external reality—sensations that were the source of the mind's ideas. Leonardo contrasted the "darkness of the mind's eye" in which the verbal imagination must work with the light of the real eye admitted by painting. Locke's mind might be, in its newborn state, a dark closet or *tabula rasa*, but as soon as the senses began to function it was neither dark nor blank but filled with ideas. "Ideas of Sensation" became the primary material of language.[6] Painting, according to the Lockean view adopted by both Richardson and Ruskin, deals not only with sensations as "the identical reflections that the eye receives" but also with sensations apprehended by the mind as ideas—images used as mental conceptions. Painting could therefore both reflect reality and communicate ideas.

Ruskin makes this claim when, in *Modern Painters II*, he contrasts ideal with unideal or realistic art, and gives all his preference and attention to the former: "Any work of art which represents, not a material object, but the mental conception of a material object, is, in the primary sense of the word, ideal. That is to say, it represents an idea and not a thing. Any work of art which represents or realizes a material object is, in the primary sense of the term, unideal" (4.165–166). Ruskin's eloquence on behalf of "truth to nature" makes it easy to overlook his insistence throughout *Modern Painters* that art is concerned not with truth but with ideas of truth: "it represents an idea and not a thing." Though he insists that visual art be accurately representational, he dismisses imitation as a secondary source of aesthetic pleasure, and maintains that even imitative art, to convey pleasure, must not actually deceive (3.99–103). However closely the images of art may approximate our visual images of nature, they remain signs. Early in *Modern Painters I* Ruskin even goes on to suggest, cautiously, that resemblance may not be necessary to the signifying function:

Truth may be stated by any signs or symbols which have a definite signification in the minds of those to whom they are addressed, although such signs be themselves no image nor likeness of anything. Whatever can excite in the

mind the conception of certain facts, can give ideas of truth, though it be in no degree the imitation or resemblance of those facts. If there be—we do not say there is,—but if there be in a painting anything which operates, as words do, not by resembling anything, but by being taken as a symbol and substitute for it, and thus inducing the effect of it, then this channel of communication can convey uncorrupted truth, though it do not in any degree resemble the facts whose conception it induces. (3.104–105)

Denotation is, at least theoretically, more important than resemblance, though Ruskin is reluctant to admit the possibility of a nonrepresentational visual art.[7]

Like Ruskin, Richardson moves from writing to reading in his discussion of painting: "To consider a picture aright is to read." The analogy between painting and books is, however, only half the story: "In Respect of the Beauty with which the Eye is all the while entertain'd, whether of Colours, or Figures, 'tis not only to read a Book, and that finely Printed, and well Bound, but as if a Consort of Musick were heard at the same time: You have at once an Intellectual, and a Sensual Pleasure."[8] This description of reading is not so Lockean. The intellectual pleasures of finding ideas or verbal allusions are separate from—not based on—the sensual pleasures of colors and figures. Furthermore, Richardson, like most English critics later in the century, tended increasingly to disapprove of the intellectual pleasures of painting if verbal allusions were difficult to read.[9] The effect of a good painting should be immediate. Overly literary intellectual pleasures should not interfere: "And the Ideas thus convey'd to us [in painting] have this advantage, They come not by a Slow Progression of Words, or in a Language peculiar to One Nation only; but with such a Velocity, and in a Manner so Universally understood that 'tis something like Intuition, or Inspiration."[10] The primary pleasures of the imagination, according to Addison, have this immediacy and intensity.[11] Shaftesbury specifically warns against including "any thing of the emblematical or enigmatic kind" in painting; what is too learned, humorous, or witty will make it harder "for the eye, by one simple act and in one view, to comprehend the sum or whole."[12] Reynolds, defining the difference between painting and poetry in 1778, reiterated what had become the rule: "What is done by Painting, must be done at one blow."[13] The "reading" required by elaborate emblems and cluttered

compositions, relished in the century before, was perceived as incompatible with the new emphasis on visual immediacy. Skill in reading emblematic art did not of course disappear, but the defense of painting as a language to be read, perhaps because it suggested the difficult pleasures of emblematic compositions, is not often made between Richardson and Ruskin.

Why does it reappear in Ruskin? Not, in *Modern Painters I*, because Ruskin is referring to an emblematic art. Ruskin's conception of the language of art and of the kind of response it requires from the beholder is in fact quite different from Richardson's, despite their common Lockean heritage. If art is, for Ruskin personally at least, more powerful than literature, it is not because literature, like the shadows in Plato's cave that Leonardo's figure suggests, is less real. The language invoked by Ruskin in *Modern Painters I* is not primarily realistic —a language coincident with the world of things that its images resemble—but psychological: "an expressive language." Ruskin was, as George Landow has pointed out, the first important English writer on art to formulate a theory of art based on romantic theories of an expressive literature.[14] Just what does this mean for Ruskin as a beholder or reader of visual imagery? In the early volumes of *Modern Painters* Ruskin assumes that art communicates not only ideas but the individual mental process that converts sensation into perception and perception into art. The *Modern Painters II* passage quoted above goes on to define ideal art not only as a representation of ideas but as "the result of an act of imagination." Painting is described in the second preface to *Modern Painters I* as more than the vehicle of thoughts; it is a vehicle of thinking, of expression and emotion, ideas as they are connected by feeling and imagination (3.36). The kind of response an expressive language of art implies is neither the intellectual pleasure of reading emblematic images nor the sensual pleasure of immediate sensation, but a combined activity of discovering both sensations and ideas together with the movements of mind that produced them. This was not an unfamiliar conception of reading in 1843—the romantics had written extensively of it—but it was a conception they had explicitly denied to the beholder's response to visual art.

The differences between Richardson's and Ruskin's response to the language of art may be clearer if we look at three descriptions of paint-

ings: one by Richardson, one by Hazlitt, and one by Ruskin. Hazlitt, Ruskin, and the Richardsons, father and son, are perhaps the principal critics, with Reynolds, in the first two centuries of English art criticism. All write for lay readers (as Reynolds, addressing art students, did not); though each also painted or drew, their criticism of pictures is primarily intended for connoisseurs, amateurs, and laymen. Jonathan Richardson the senior writes self-consciously about the novelty of his attempt to instruct English viewers. His is not a theory of art, but an "Art of Criticism," the first "Science of the Connoisseur."[15] The Richardsons maintain their status as leading English art critics throughout much of the eighteenth century. William Hazlitt's criticism, written between 1814 and 1830, continues their nonprofessional approach. Though Hazlitt reminisced about the pleasures of painting from a former art student's point of view,[16] he is primarily concerned with the pleasures of viewing. Hazlitt was better known as a drama critic, general essayist, political writer, and lecturer on literature during his lifetime, but from the time of his death in 1830 there was a growing chorus of voices calling attention to his art criticism. Its republication in 1838 and 1843 helped to establish his reputation in the thirties and early forties as the leading English art critic of the nineteenth century. In April 1843—one month before the first volume of *Modern Painters* appeared—the reviewer in *Tait's Edinburgh Magazine* announced that there is "no English critic on works of Art to be compared with Hazlitt."[17] With the publication of *Modern Painters*, Hazlitt's reputation as an art critic was almost immediately eclipsed by Ruskin's. Ruskin continued to dominate the field well into the next century. Swinburne, Pater, Symonds, Henry James, and later Clive Bell, Roger Fry, Herbert Read, and even Ernst Gombrich had to come to terms with—or challenge—Ruskin's shaping influence on the tastes and viewing habits of his English audience.

Ruskin, Hazlitt, and the Richardsons share several assumptions: art criticism should provide descriptions, not just catalogues or biographies, to help the viewer to see; their viewers are not painters; the greatest art is ideal, in Ruskin's primary sense (it communicates ideas or thoughts). Hazlitt and the Richardsons can further agree that Raphael is *the* ideal painter. But there the resemblances end. Their choice of paintings to describe, their modes of talking about paintings, their thoughts about what visual qualities in painting render it ideal,

and how those qualities are perceived and understood by viewers are a useful index to important shifts in theory, in taste, and in the practice of art criticism between 1720 and the 1840s.

The Richardsons' most extended descriptions of paintings occur in their guidebook to art in Italy (1722). Hazlitt and Ruskin, though both write guidebooks, deliver their most memorable accounts of paintings outside that format. The difference is significant because the reader of a Richardson description is in fact always a spectator standing in a fixed position before a canvas in a particular room. The prose description *locates* the reader in a picture-viewing situation; it does not *transport* him to the place and time of the picture's subject or of the painter's mind. One of the most striking accounts in their book describes Raphael's fresco *The Liberation of St. Peter* in the Vatican (ill. 11). Richardson (the son) has already described the room in which the fresco appears, and he begins his detailed account of the picture: "'Tis over a Window, and (as the rest of those in these Apartments that are so) of an Odd Shape; what That is has been said heretofore. Over this Window is the Prison, which does not appear to consist of any more than One Room, the Walls of which are very thick, and continue the Perpendicular Line of the Window 'till they end in an Arch a-top, very near the greater Arch of the Out-line of the Picture; which Room is seen into through a large Iron Grate, which reaches from Side to Side, and from the Top to the Bottom."[18] The space of the picture as Richardson describes it is very nearly continuous with the space of the Vatican room; it is a space we see into but are kept out of by the massive iron grate that Raphael has painted across the central prison scene of the painting. The prison and its steps are a kind of triple stage framed by the window and arch of the room itself, below which we stand. The description here is particularly apt, perhaps even required, by the fresco—but it is Richardson's procedure even when he is dealing not with a fresco but with an oil painting whose space does not particularly suggest a stage built into the room. Of Raphael's *Madonna della Pescia*, for example, Richardson begins by noting not only the spatial relationships of the figures within the painting, but also the physical size and construction of the surface on which it is painted.[19] He is much more concerned with delivering in prose a vicarious experience than his continental predecessors or his English followers are. Thus he frequently refers to prints and drawings available in England,

suggesting that his book is intended as much for stay-at-homes as for those who actually make the grand tour. His careful accounts of physical locations and relationships between paintings, buildings, and spectator seem designed to allow English readers at home to imagine themselves walking the galleries and palaces of Italy.

Besides Richardson's greater attention to the physical conditions of spectatorship, there are further significant differences between him and the two later critics in the choice of visual elements to be read and the notion of the spectator's role. Richardson, for example, considers light primarily as a means of enhancing or defining ideas conveyed through figures and actions. In his commentary on *The Liberation of St. Peter*, he proceeds from the physical conditions of viewing to the "several distinct Actions" in the painting (the figures, where they are on the stage set, what they are doing), and finally to the most striking and controversial aspect of the picture, "the Particularity, and Variety of its Lights." Although some believe these lights — two angels, a torch, and the moon — violate the accepted rule of a single principal light, Richardson compares them with other examples of "Night-Pieces" and concludes: "Those great Masters owe their Fame in this Particular chiefly to the Unity of Light, surrounded by Darkness; Here all is Night, but all Shines; with such a due Subordination however, that One does not hurt Another, or torment the Eye in the least, which at ease can consider the Whole, and every Part; and not at Ease only, but with Delight." This passage is a fine and rare example of Richardson's attempt to convey a visual effect, what his father called the sensual pleasure of painting as opposed to the intellectual pleasures of identifying ideas, but it is at the same time revealing to find that what pleases him is a management of light that permits a particular kind of reading. The eye can "at ease consider the Whole, and every Part" — as Richardson has just done three times, with respect to setting, figures, and light. The clear and easy articulation of parts and their relationships to a whole informs both the intellectual and the sensual pleasures of viewing an ideal painting.

But Richardson has still more to say: the final judgment of a picture must be principally by means of the expression of the historical figures. In this case, expression too is greatly enhanced by the management of light.

Had *Raffaele* done This only to show his Art in the Management of the *Clair-Obscure*, had it been a pure *Jeu d' Esprit*, in Painting it had been much less considerable; but That moreover contributes vastly to the Expression, That fierce Flash of Light given by the Angel in the Centre of the Picture, together with the Horror of a Prison strikes forcibly upon the Imagination: The Iron Grate thro' which those Figures appear is plac'd there very Art- fully, it immediately gives you the Idea of a Jail, and those Dark Lines cut- ting the Brightness behind into so many small parts gives a Flickering, and a Dazzle that nothing Else could possibly have done. And though it must be confess'd the Angel with the Apostle Deliver'd breaks the Unity of the Ac- tion [St. Peter is shown first in prison, then outside the prison on the right], yet one cannot wish this Picture was without this Fault; it is Enrich'd by it, and you have one of the Finest Pictures in the World of two Figures as it were flung into a spare Corner of This; for these two Figures are exquisite: Nor are they without their farther Use; the Mind is something reliev'd from the Concern 'tis in upon seeing the Abject Condition of the Apostle in Chains: Here he is seen as we should Wish him; at Liberty, and under the Conduct, and Protection of his Heavenly Guide.

The effects of light to which Richardson responds so attractively show most clearly his assumptions about how paintings are perceived and understood. Light, enhancing action, strikes the imagination and "gives you the Idea of a Jail"; the second action then relieves the mind by giving a second idea of the apostle "as we should Wish him." The spectator here is a passive mind receiving ideas; those ideas are distinct and relatively clear, visually articulated in the painting and verbally ar- ticulable in Richardson's prose. This language, of course, is Locke's, and Richardson the senior uses it throughout his preface: "As every Picture, Statue, or Bas-relief, besides what it was intended to exhibit, leaves upon the Mind of him that sees it an Idea of its Self, distin- guished from every Other of its Kind; he that would describe them should endeavour to communicate such Distinct Ideas."[20] The clear divisions of a unified picture space, the separable but related actions, the illuminating but not distracting variety of lights, all work together to produce a visually realized idea of St. Peter's release from prison by angelic intervention. This distinct idea, it should be noted, is not real- ized in the mind of the spectator; it is already fully realized in the painting, given to or left on the spectator's mind where it can be

judged. The spectator needs only to bring to the painting his attention and some information (he needs to know the story). Richardson's prose account tries to give the reader a sense of what such a viewing experience would be, to "put a Reader Almost upon a Level with him that Sees the thing," and further, to enforce the attention that makes seeing into perceiving, or reading, the painting's visual ideas.

Though Hazlitt's essay "On a Landscape of Nicolas Poussin" (1821) is equally concerned with giving the reader the experience of the painting (ill. 12), his description is not, like Richardson's, an analysis of the visual image and the ideas it realizes, but a description of the idea—by no means wholly visual—evoked in the mind of a responsive spectator by light itself. The essay opens without any preliminary stationing of the spectator:

Orion, the subject of this landscape, was the classical Nimrod; and is called by Homer, "a hunter of shadows, himself a shade." He was the son of Neptune; and having lost an eye in some affray between the Gods and men, was told that if he would go to meet the rising sun, he would recover his sight. He is represented setting out on his journey, with men on his shoulders to guide him, a bow in his hand, and Diana in the clouds greeting him. He stalks along, a giant upon earth, and reels and falters in his gait, as if just awaked out of sleep, or uncertain of his way;—you see his blindness, though his back is turned. Mists rise around him, and veil the sides of the green forests; earth is dank and fresh with dews; the "grey dawn and the Pleiades before him dance," and in the distance are seen the blue hills and sullen ocean. Nothing was ever more finely conceived or done. It breathes the spirit of the morning; its moisture, its repose, its obscurity, waiting the miracle of light to kindle it into smiles: the whole is, like the principal figure in it, "a forerunner of the dawn." The same atmosphere tinges and imbues every object, the same dull light "shadowy sets off" the face of nature: one feeling of vastness, of strangeness, and of primeval forms pervades the painter's canvas, and we are thrown back upon the first integrity of things. This great and learned man might be said to see nature through the glass of time: he alone has a right to be considered as the painter of classical antiquity.[21]

Though there are references to remind us that we are spectators before a painting (it is a "landscape," "conceived and done" by Poussin; Orion, its "principal figure", "is represented" in a certain situation); yet the main pull of Hazlitt's description is to make us forget that we are looking at a canvas and imagine the same scene appearing directly

before the mind's eye. Even what he tells us we see must in fact be inferred or imagined—Orion's blindness. The felt moisture of the mists, the spirit of morning breathed by the landscape, the "feeling of vastness, of strangeness, and of primeval forms" are rather impressions evoked in the spectator than clear and distinct ideas visually realized on the canvas. Hazlitt's ideal painting can "fill the moulds of the imagination."[22] The picture is completed not on the canvas but in the mind of the imaginative viewer.

Like Richardson, Hazlitt identifies the figures and tells the stories in which they appear, but even his telling of the story is an example of an active and personal response. His Orion is immediately associated with Nimrod and then given the Homeric epithet which, in fact, strongly colors Hazlitt's—and perhaps Poussin's—perception of him. Phrases from Keats, Pope's Homer, Shakespeare, Milton, the Bible, Spenser, and Wordsworth are similarly sprinkled throughout Hazlitt's essay; they are not identified or used as explicit comparisons, but as the verbal associations or memories, of unexplained connection, which might occur to a literate English viewer whose mind was stimulated by the Poussin painting.

Hazlitt's impression may not be given as a visually precise description, let alone a visual analysis, but it is by no means unrelated to the painting. Here, as with Richardson, the visual effects to which Hazlitt responds are instructive. Though he begins traditionally enough with the action of the principal figure, his interpretation even of that figure, "himself a shade," seems guided by a visual quality that figure shares with landscape: "the same dull light," "the same atmosphere," a gray mistiness "which tinges and imbues every object, [and] 'shadowy sets off' the face of nature." The actual gray, misty light of the painting is almost obscured in Hazlitt's account by the ideas it metaphorically suggests. The pre-dawn light implies Orion's blindness, soon to be dispelled. Hazlitt also associated it with the prerational perception of a mythological nature: the "glass of time" has colored Poussin's representation. Hazlitt's Orion, like Keats's (in the essay's epigraph), is "hungry for the morn" in all its senses: the light of dawn, of recovered sight, and of post-mythological rational thought.

Richardson praises Raphael's light because it aids in the clear articulation of the actions and more forcibly impresses on the spectator's mind the ideas visualized in distinct but related actions. Hazlitt focuses

on the light in Poussin's painting because it suggests to a literate and active mind ideas that cannot be articulated by actions. Richardson is impressed by light that distinguishes and makes clear, Hazlitt by light that unifies and suggests. Both critics might be said to read their respective paintings. They articulate ideas as the meaning of visual images. But their habits of seeing, ideas of what can be read, and understanding of the perceptual process of reading differ widely.

Before I examine the associationist views of mental process that lie behind Hazlitt's reading of the Poussin, I want to draw some further distinctions between Hazlitt and Ruskin. In many ways, of course, the two critics are much closer than Richardson and Hazlitt. Both attacked Reynolds for equating the ideal with generalized nature—probably the most important nineteenth-century challenge to Reynolds and the academic ideal of the preceding three centuries. The similarities of their modes of describing paintings, or the spectator's experience, are equally great, as we can see if we juxtapose Hazlitt's greatest set piece, the opening of the essay on Poussin's *Orion*, with Ruskin's— the description of Turner's *The Slave Ship* (ill. 13) in *Modern Painters I*. Like Hazlitt, Ruskin interweaves literal description and metaphoric evocation; unlike the romantic critic, Ruskin pays closer attention to purely visual details.

It is a sunset on the Atlantic, after prolonged storm; but the storm is partially lulled, and the torn and streaming rain-clouds are moving in scarlet lines to lose themselves in the hollow of the night. The whole surface of sea included in the picture is divided into two ridges of enormous swell, not high, nor local, but a low broad heaving of the whole ocean, like the lifting of its bosom by deep-drawn breath after the torture of the storm. Between these two ridges the fire of the sunset falls along the trough of the sea, dyeing it with an awful but glorious light, the intense and lurid splendour which burns like gold, and bathes like blood. Along this fiery path and valley, the tossing waves by which the swell of the sea is restlessly divided, lift themselves in dark, indefinite, fantastic forms, each casting a faint and ghastly shadow behind it along the illumined foam. They do not rise everywhere, but three or four together in wild groups, fitfully and furiously, as the under strength of the swell compels or permits them; leaving between them treacherous spaces of level and whirling water, now lighted with green and lamp-like fire, now flashing back the gold of the declining sun, now fearfully dyed from above with the undistinguishable images of the burning

clouds, which fall upon them in flakes of crimson and scarlet, and give to the reckless waves the added motion of their own fiery flying. Purple and blue, the lurid shadows of the hollow breakers are cast upon the mist of night, which gathers cold and low, advancing like the shadow of death upon the guilty† ship as it labours amidst the lightning of the sea, its thin masts written upon the sky in lines of blood, girded with condemnation in that fearful hue which signs the sky with horror, and mixes its flaming flood with the sunlight, and, cast far along the desolate heave of the sepulchral waves, incarnadines the multitudinous sea. (3.571–572)

†She is a slaver, throwing her slaves overboard. The near sea is encumbered with corpses. [Ruskin's note]

Ruskin too abandons the analytic procedure of Richardson together with that barrier between spectator and painting which Richardson is constantly aware of. The two later critics synthesize their observations of setting, action, light, and the painting's ideas into a single continuous account of a viewing experience which is simultaneously interpretive. Both men suggest that meaning is implicit in the visual facts of the painting. They articulate that meaning not by naming ideas represented but by giving visual terms—the gray tone of the Poussin, the scarlet hues of the Turner—a weight of metaphorical meaning, with the help of literary quotation or allusion. This kind of description implies, as Richardson's does not, that the painting is completed by the spectator's response. Hazlitt states this quite clearly: "What looks," he exclaims of *Orion*, "which only the answering looks of the spectator can express!"[23] For all his stress on active seeing, however, Ruskin does not make Hazlitt's claim that seeing, and by extension a verbal account of imaginative seeing, completes a picture by expressing what the painting cannot.

The pleasure of viewing that Hazlitt describes is the pleasure of reverie, where seeing passes into metaphorical thinking. The spectator both sees what is there and is transported to "the regions of imagination": "it is to dream and to be awake at the same time; for it has all 'the sober certainty of waking bliss,' with the romantic voluptuousness of a visionary and abstracted being."[24] Waking bliss or romantic voluptuousness seems to be equally removed from vigorous engagement, judging by the tone of Hazlitt's prose. From the first suggestion of a certain lazy, pleasant imprecision ("having lost an eye in some affray") to the lulling repetition of the painting's dominant effect ("the

same atmosphere . . . the same dull light . . . one feeling, of vastness, of strangeness, and of primeval forms") to the final imaginative transport ("and we are thrown back upon the first integrity of things"), Hazlitt's prose suggests that looking is a kind of seduction of the imagination. The process is something like what Coleridge traces as the effect on a spectator of the opening acts of Shakespeare's plays, in which the imagination participates in its own enchantment by the gradual "willing suspension of disbelief."[25]

Ruskin's seeing, by contrast, is charged with undreamlike energy. That energy, as I suggested in Chapter 1, is conveyed by such things as participial forms and lengthening sentences of piled-up, assymmetrical phrases; it is an energy ascribed to the landscape itself, but reflecting equally the energy of looking. Reading the Hazlitt and the Ruskin together we find that the impression of greater energy in Ruskin's description does correspond to a considerably more active and excited visual experience. Hazlitt makes a single progress through the painting: from figures to foreground (mist, forests, earth), then back through gray dawn and Pleiades to the distant hills and ocean. Ruskin begins with the scarlet clouds streaming off the left and into the distant horizon of the picture, then moves back and forth between sea and sky reflected in it; finally he reverses his opening, following the mist of the night as it converges on the ship seen against the sky, whose light spreads across the water. In the course of all this moving around (corresponding to the much less simple spatial structure of the painting), Ruskin goes into considerably greater detail, especially about color and light as they play against the multiple forms of the sea. (This description is the climax of Ruskin's section on the "truth of water.") Much as painter and context seem to require the kind of description he gives, the important fact is that this is the kind of looking Ruskin always finds most satisfying. With *The Slave Ship* Ruskin actually puts off mentioning the ship itself until the last sentence of his description, as if to give himself time to look around first. What seduces Ruskin into this protracted description is not his own metaphoric imagination, stimulated by the subject's literary associations, but its visual richness. That richness draws him into a characteristically delighted, slow visual exploration. Admiring the foreground of Turner's *The Fall of the Tees* (ill. 1), Ruskin noted: "The articulation of such a passage as the nearest bank . . . might serve us for a day's study

if we were to go into it part by part . . . you are everywhere kept upon round surfaces, and you go back on these you cannot tell how, never taking a leap, but progressing imperceptibly along the unbroken bank, till you find yourself a quarter of a mile into the picture, beside the figure at the bottom of the waterfall" (3.490–491). If Ruskin's eye is drawn into intense exploration by the foregrounds of drawings, it is at first bewildered and then ecstatically lost in the visual abundance of ideal paintings like *The Slave Ship*: "how shall words express or follow that which to the eye is inexhaustible?" (3.492n) Hazlitt's spectator breaks the boundary between spectator and painting by imaginatively entering into the conception of the painting; Ruskin's by tracing the visual details of the composition until he imaginatively enters its space. "The eye . . . is guided from stone to stone and bank to bank, discovering new truths totally different in aspect according to the direction in which it approaches them" until "you find yourself a quarter of a mile into the picture, beside the figure at the bottom of the waterfall."[26]

Ruskin's method of reading *The Slave Ship* corresponds to his pleasure in visual exploration. Hazlitt's paragraph is an expansion and explication of the painting's principal figure as stimulated by the line from Pope's Homer quoted in Hazlitt's opening sentence: "a hunter of shadows, himself a shade." The description of the painting demonstrates how not only the painted Orion but also the landscape itself suggests the verbal figure. For Ruskin too landscape is more than the stage setting that Richardson sees (one can imagine how Hazlitt or Ruskin would have used those thick walls and barred grate of St. Peter's prison). But in Ruskin's description the fiery hues of sun and water only gradually come to express the guilt and punishment of the slave ship. Once we get to "the guilty ship . . . girded with condemnation in that fearful hue," all the previous references to water fearfully dyed with fiery, bloody color fall into place as part of a reading of the meaning of the painting. In the echo from *Macbeth* with which Ruskin closes his description, as in the phrase from Pope's Homer, the metaphoric meaning of color is fully contained. But Ruskin, putting figure, story, and literary allusion last instead of first, makes the interpretive process quite different: meaning does not emerge easily or at once; it seems to come only out of energetic visual exploration. Ruskin's description even ignores much more obvious signs: the legs,

chains, and sharks in the foreground and, of course, Turner's own verses. The effect of both strategies is not, certainly, to deny a readable meaning, but rather to locate it in its most impressive visual effects. These effects, lavishly explored and described, are never restricted to any simple signifying function.

We are used to tracing, in the period between the early eighteenth and the early nineteenth century, a complicated shift in aesthetic and poetic theory. The correspondent shift in theory and habits of reading visual art is roughly represented by the distance between the Richardsons, in 1722, and Hazlitt and Ruskin, in 1821 and 1843. For the Richardsons visual images are ideas given to the mind through the eye, but for the later critics visual effects suggest meaning by an associative process; spectator and critic need not judgment but sympathy and a participating imagination. This change in reading habits may seem to follow quite naturally from the new primacy of sympathy and imagination in theories of artistic and poetic creation, and no less from changes in contemporary poetry and painting themselves: new kinds of verbal and visual allusion, a different use of figurative language and iconography, a new idea of poetic and compositional unity, and a different logic—the looser associational connections that affected syntax as well as semantics in verbal and visual arts. In fact, however, the changes in creative theory and practice were not always reflected, at least immediately, in ideas about how reader and spectator respond. The lag is particularly noticeable for painting. As we have noted, Hazlitt reads Poussin's painting by first introducing a literary version of its guiding metaphor. His roundabout method of reading a painting as expressive language is not surprising in light of what eighteenth-century and romantic critics have to say about the new way of reading imaginative creations. Though they can almost all be shown to respond to painting much as they respond to poetry, they nonetheless go out of their way to state that painting is necessarily less satisfying than literature according to the new criteria for imaginative aesthetic response. Hazlitt achieves the full imaginative response to Poussin's painting by first turning it into a poem. For Ruskin no such translation is necessary. But he broke with romantic practice when he included the visual arts in the new notion of reading.

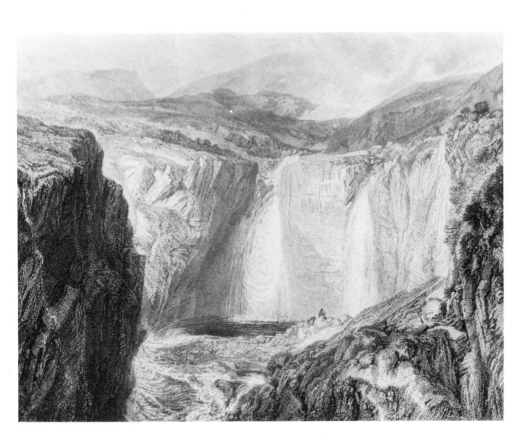

1. Turner, *The Fall of the Tees, Yorkshire.*

In fact, the great quality about Turner's drawings which more especially proves their transcendent truth is, the capability they afford us of reasoning on past and future phenomena, just as if we had the actual rocks before us; for this indicates not that one truth is given, or another, not that a pretty or interesting morsel has been selected here and there, but that the whole truth has been given, with all the relations of its parts; so that we can pick and choose our points of pleasure or of thought for ourselves, and reason upon the whole with the same certainty which we should after having climbed and hammered over the rocks bit by bit. With this drawing before him, a geologist could give a lecture upon the whole system of aqueous erosion, and speculate as safely upon the past and future states of this very spot, as if he were standing and getting wet with the spray. (3.487–488)

The articulation of such a passage as the nearest bank . . . might serve us for a day's study if we were to go into it part by part . . . observe how the eye is kept throughout on solid and retiring surfaces, instead of being thrown, as by Claude, on flat and equal edges. You cannot find a single edge in Turner's work; you are everywhere kept upon round surfaces, and you go back on these you cannot tell how, never taking a leap, but progressing imperceptibly along the unbroken bank, till you find yourself a quarter of a mile into the picture, beside the figure at the bottom of the waterfall. (3.490–491)

2. Ruskin, *Ariccia [La Riccia], near Albano, 1841.*

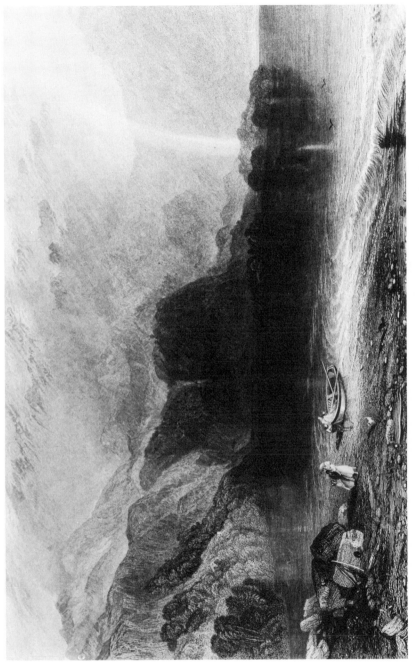

3. Turner, *Keswick Lake, or Derwentwater, Cumberland.*
Turner in Wordsworth country.

4. Turner, *Launceston, Cornwall.*

5. J. D. Harding, *Benevento*.

6. Samuel Prout, *Temple of Pallas.*

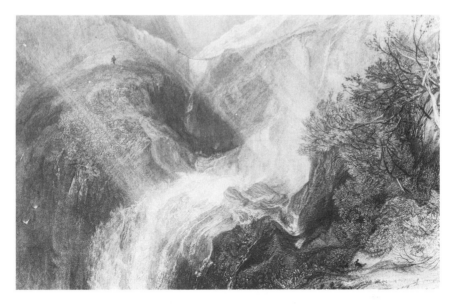

7. Turner, *Chain Bridge over the River Tees.*

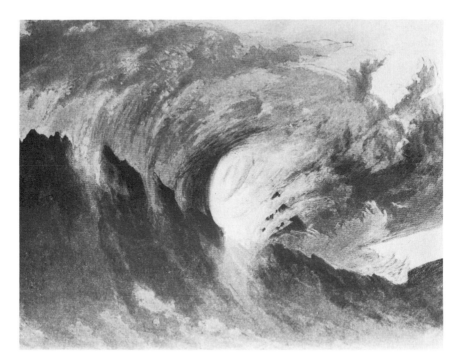

8. Ruskin, *Venga Medusa.*
An illustration to a discussion of stormclouds: the grotesque sublime.

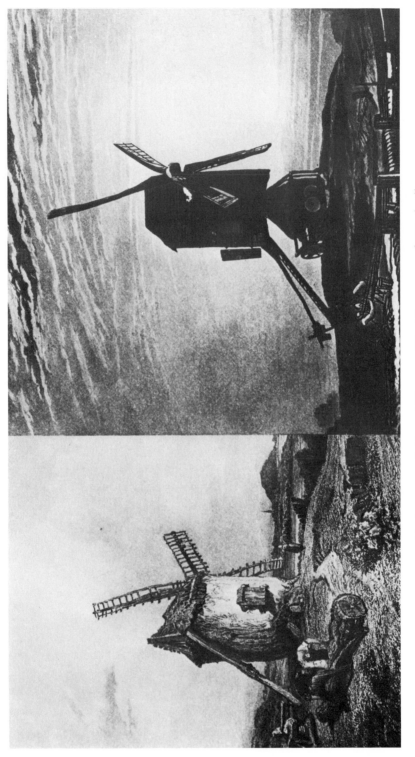

9. Clarkson Stanfield and Turner, *The Picturesque of Windmills.*

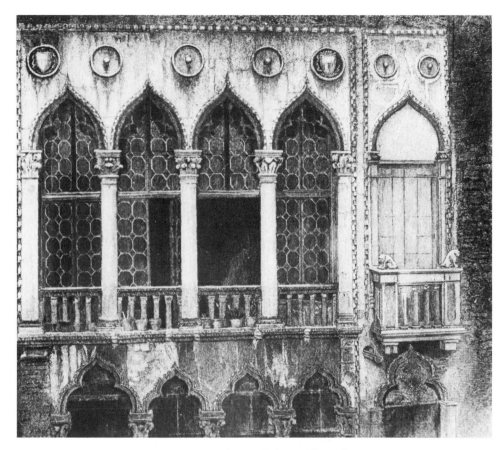

10. Ruskin, *Windows of the Fifth Order.*

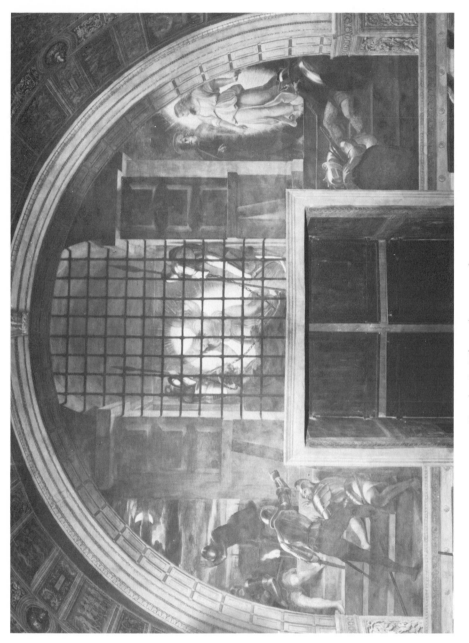

11. Raphael, *The Liberation of St. Peter.*

12. Nicholas Poussin, *The Blind Orion Searching for the Rising Sun.*

13. Turner, *The Slave Ship*, 1840.

14. Turner, *Salisbury from Old Sarum Intrenchment.*

To him [Turner], as to the Greek, the storm-clouds seemed messengers of fate. He feared them, while he reverenced; nor does he ever introduce them without some hidden purpose, bearing upon the expression of the scene he is painting.

On that plain of Salisbury, he had been struck first by its widely-spacious pastoral life; and secondly, by its monuments of the two great religions of England— Druidical and Christian.

He was not a man to miss the possible connection of these impressions. He treats the shepherd life as a type of the ecclesiastical; and composes his two drawings so as to illustrate both.

In the drawing of Salisbury, the plain is swept by rapid but not distressful rain. The cathedral occupies the centre of the picture, towering high over the city, of which the houses (made on purpose smaller than they really are) are scattered about it like a flock of sheep. The cathedral is surrounded by a great light. The storm gives way at first in a subdued gleam over a distant parish church, then bursts down again, breaks away into full light about the cathedral, and passes over the city, in various sun and shade. In the foreground stands a shepherd leaning on his staff, watching his flock;—bareheaded: he has given his cloak to a group of children, who have covered themselves up with it, and are shrinking from the rain; his dog crouches under a bank; his sheep, for the most part, are resting quietly, some coming up the slope of the bank towards him.

The rain-clouds in this picture are wrought with a care which I have never seen equalled in any other sky of the same kind. It is the rain of blessing—abundant, but full of brightness; golden gleams are flying across the wet grass, and fall softly on the lines of willows in the valley—willows by the watercourses; the little brooks flash out here and there between them and the fields. (7.189–190)

15. Turner, *Stonehenge.*

The Stonehenge is perhaps the standard of storm-drawing, both for the overwhelming power and gigantic proportions and spaces of its cloud forms, and for the tremendous qualities of lurid and sulphurous colours which are gained in them. All its forms are marked with violent angles, as if the whole muscular energy, so to speak, of the cloud were writhing in every fold: and their fantastic and fiery volumes have a peculiar horror, an awful life, shadowed out in their strange, swift, fearful outlines which oppress the mind more than even the threatening of their gigantic gloom. The white lightening, not as it is drawn by less observant or less capable painters, in zigzag fortifications, but in its own dreadful irregularity of streaming fire, is brought down, not merely over the dark clouds, but through the full light of an illumined opening to the blue, which yet cannot abate the brilliancy of its white line. (3.413)

[The Stonehenge], also, stands in great light; but it is the Gorgon light—the sword of Chrysaor is bared against it. The cloud of judgment hangs above. The rock pillars seem to reel before its slope, pale beneath the lightning. And nearer, in the darkness, the shepherd lies dead, his flock scattered. (7.190–191)

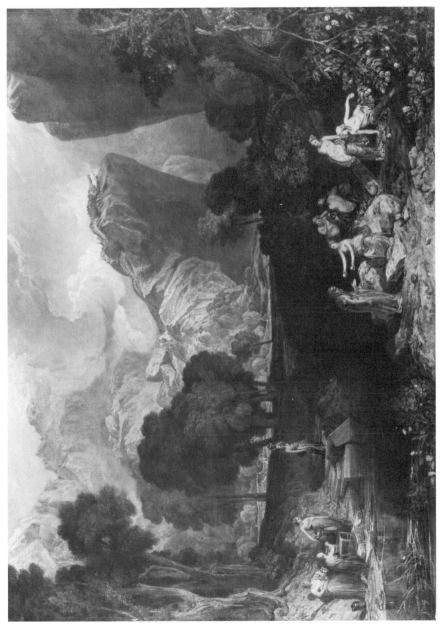

16. Turner, *The Goddess of Discord Choosing the Apple of Contention in the Garden of the Hesperides*, 1806.

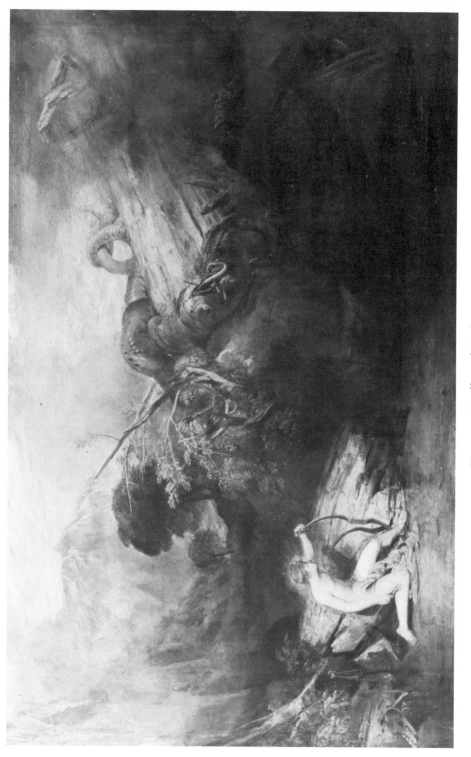

17. Turner, *Apollo and Python*, 1811.

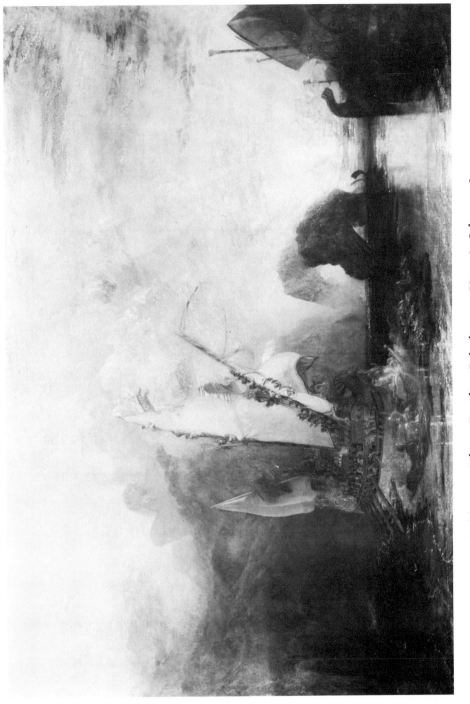

18. Turner, *Ulysses Deriding Polyphemus – Homer's Odyssey*, 1829.

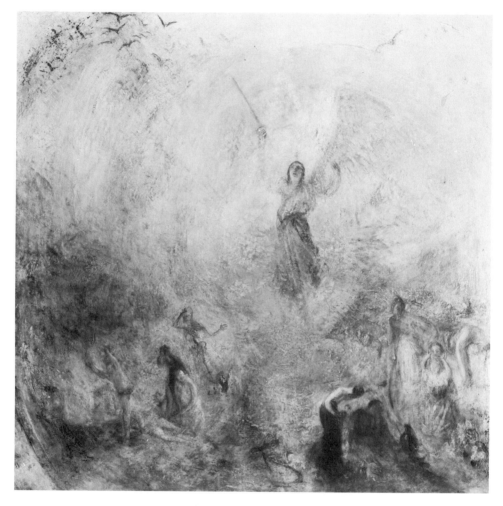

19. Turner, *The Angel Standing in the Sun*, 1846.

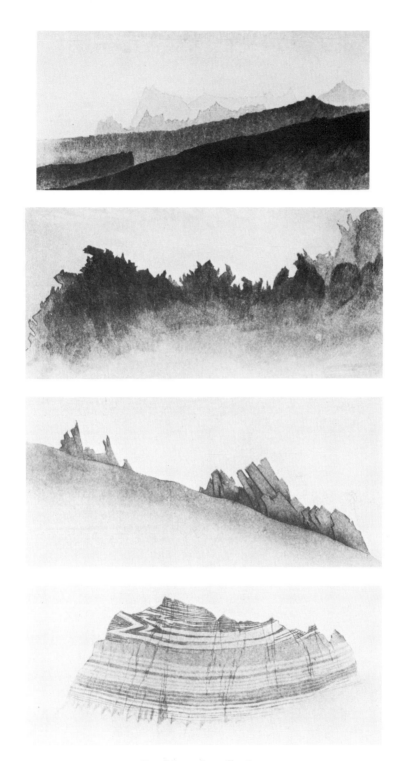

20. Ruskin, *Aiguille Structure*.

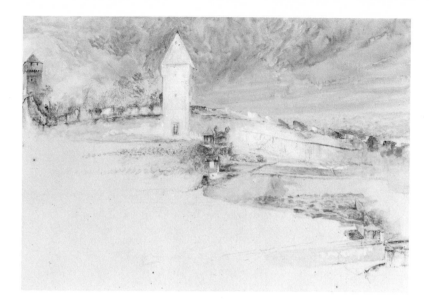

21. Ruskin, *The Walls of Lucerne, c.* 1866.

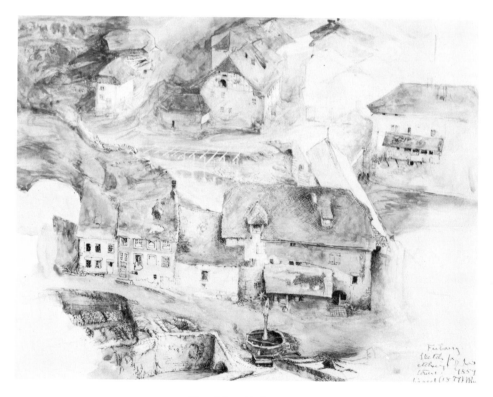

22. Ruskin, *Fribourg,* 1859.

23. Ruskin after Turner, *Quivi Trovammo.*

24. Ruskin after Giorgione, *Hesperid Aeglé*.

25. Turner, *The Golden Bough*, 1834.

26. Ruskin, *Monte Rosa. Sunset.* The last plate in *Modern Painters*.

Rᴏᴍᴀɴᴛɪᴄ critics have most to say about the differences between reading and seeing when they consider the drama. One can either read or see a play, and Lamb, Coleridge, and Scott agree that it is better to read than to see. They argue that the direct appeal to the senses, especially sight, of stage performance inhibits action of the imagination essential to the adequate realization of a great play. Lamb is vehement: *Lear, Othello,* or *The Tempest* cannot be acted. "When the novelty is past, we find to our cost that instead of realizing an idea, we have only materialized and brought down a fine vision to the standard of flesh and blood. We have let go a dream, in quest of an unattainable substance." To see a play performed is to give up "that vantage ground of abstraction which reading possesses over seeing"; "the imagination is no longer the ruling faculty, but we are left to our poor unassisted senses."[27] Coleridge comes to the same conclusion: "For the principal and only genuine excitement ought to come from within, — from the moved and sympathetic imagination; whereas, where so much is addressed to the mere external senses of seeing and hearing, the spiritual vision is apt to languish, and the attraction from without will withdraw the mind from the proper and only legitimate interest which is intended to spring from within."[28] And Hazlitt, when he is writing on drama, assumes a similar opposition between sensation and imagination: "Poetry and the stage do not agree together . . . The *ideal* has no place upon the stage; the imagination cannot sufficiently qualify the impressions of the senses."[29]

If the ideal has no place on the stage, what place can it have in painting? Hazlitt's attitudes as art and drama critic are not actually contradictory. The advantage he and his contemporaries assign to words is relative: though reading a play more successfully arouses the imagination than watching one, the response to visual art is also, but to a lesser degree, active and imaginative. The imaginative activities of seeing and reading can be difficult to distinguish in critical practice, but romantic critics agreed that there should be a difference. Literature, they argued, directly presents a certain train of associations. Its order is essentially the order of an imaginative mind, first the poet's, then the reader's. Looking at a painting merely stimulates such a train of associated ideas. Its order is that of space, not of mental process. It can provide the occasion for imagination, dream, abstraction, reverie, but

such imaginative activity actually takes place in the mind of the spectator only when he stops seeing. For Hazlitt an ideal painting makes an immediate impression, but "the imagination must qualify the impressions of the senses." The order of his paragraph on *Orion* is not the spatial order of the painting or even the temporal order of a visual experience of it, but an order of literary association and verbal metaphor. Coleridge would approve such a reading: "It is the nature of thought to be indefinite; — definiteness belongs to external imagery alone. Hence it is that the sense of sublimity arises, not from the sight of an outward object, but from the beholder's reflection upon it; — not from the sensuous impression, but from the imaginative reflex."[30] Hazlitt's prose passage records the more valuable imaginative reflex. For the viewer of a painting or play, seeing and imagining are temporally separable and potentially conflicting activities, but for the reader of a literary text they need not be so. Sensuous impressions may be conveyed through the mental response they elicit in a speaker. Literature alone can both portray and evoke the imaginative reflex.

The basis for this distinction between imaginative reading and imaginative seeing can be found in the most widely read of the associationist aestheticians, Archibald Alison. Alison, like the romantic critics who are indebted to him, insists above all that aesthetic pleasure, "the emotion of taste," is dependent on the activity of the imagination in the reader, listener, or spectator.

Whatever may be the nature of that simple emotion which any object is fitted to excite, whether that of gaiety, tranquillity, melancholy, etc. if it produce not a train of thought in our minds, we are conscious only of that simple emotion. Whenever, on the contrary, this train of thought, or this exercise of imagination is produced, we are conscious of an emotion of a higher and more pleasing kind; and which [we] distinguish by the name of the emotion of taste . . . The emotions of taste may therefore be considered as distinguished from the emotions of simple pleasure, by their being dependent upon the exercise of our imagination; and though founded in all cases upon some simple emotion, as yet further requiring the employment of this faculty for their existence.[31]

Alison's account posits an initial simple emotion and a subsequent activity of the imagination. This activity is a succession of ideas distinguished from a nonimaginative train of thought in two ways. It is

composed of "ideas productive of emotion," and it exhibits a greater than normal unity — a unity not of logic but of some form of resemblance cemented by the simple emotion that provoked it. This division into simple emotion or impression and train of thought or imaginative reflex is parallel to Coleridge's. Put together with the century's insistence on immediacy of effect in paintings, this line of thinking leads to a location of the impression in the painting, and the imaginative train of thought in the spectator's mind. Applied to literature, however, Alison's model of aesthetic response yields a different description of the reading process: the imaginative reflex can be located in the text itself, as well as in the mind of the active reader.

The closer kinship between literature and mental process is argued on several grounds. First, as Burke held, words can raise ideas of emotion directly, without necessarily first calling to mind a sensuous image.[32] Hence language can directly present that train of emotionally connected ideas that the picture can only hope to stimulate in the viewer. This advantage of words over visual images, as argued in later eighteenth-century associationist aesthetics, is reflected in Hazlitt's often quoted dictum, "Painting gives the object itself; poetry what it implies. Painting embodies what a thing contains in itself: poetry suggests what exists out of it, in any manner connected with it. But this last is the proper province of the imagination."[33] Behind Burke's, Hazlitt's, and Alison's belief in the unique power of words lies an important assumption about the nature of verbal language: that it is itself a form of association. Literary language especially seemed to combine ideas in a typically associative fashion, building up trains of thoughts and images linked by emotions. Visual art, however, was not considered as an associative language — or, more often, not considered as language at all.

To this argument Alison adds a second: the painter operates under a disadvantage in evoking either the initial simple emotion or the succeeding imaginative train of ideas because he cannot be as selective as the poet. Painting is at the same time both too limited and too inclusive to achieve the kind of emotional unity that governs imaginative association. Too limited, because it can appeal to a single sense and evoke a single moment of time only; too inclusive, because the painter is hampered in his efforts to bring out the "expressive character" of a place by the demands of imitation. A painting, by its very nature as a

representation, must maintain unity of place, time, and action from which literature is freed. Thus, Alison argues, the poet is subject to the most rigorous demands for associational unity of composition precisely because he, of all artists, can best achieve it.[34]

The assumption that unity of expression or character is essential for imaginative response is very much in evidence in Hazlitt's description of the Poussin painting. It necessarily exists in some tension with Hazlitt's other, and very strong, conviction that ideal nature cannot be Reynolds' generalized nature; it depends for its imaginative power on "specific character." Hazlitt in fact credited painting with changing the way his contemporaries saw nature and read poems. Painting demonstrated the importance of specific character in evoking the ideal. But Hazlitt, like Alison, noted that the poet can be far more selective in his use of detail to establish specific character than the painter, who is obliged to maintain some consistency in the finish or degree of detail of his representation. Thus visual realization, despite its salutary influence on modern seeing and reading, could not serve Hazlitt as a model for ideal imaginative art.[35]

The understanding of reading that emerged between 1750 and 1820, supported by associationist psychology, opened new possibilities to critics of the visual arts.[36] The distinction between an expressive literature and an imitative painting that persists in Hazlitt and others is misleading. In fact, romantic critics and associationist aestheticians approach paintings as if they were an expressive art—though less expressive than literature. Viewers of pictures may reach imaginative response differently from readers of poems, but imagination in poet and artist is the same. Rather than a simple opposition between seeing and reading, Kames, Alison, Hazlitt, and Coleridge set up a hierarchy of the arts as they are able to exhibit the imaginative process that created them and to evoke imaginative response in an audience.[37] In this hierarchy painting is always lower than literature, higher than sculpture or gardening. Literature fully embodies imaginative process; painting stimulates it. But the praise of painting that associationist criticism fostered could seem back-handed. When a critic like Kames, Alison, or Hazlitt wished to give the highest possible compliment to a painter, he was likely to call him almost a poet: "Poussin was, of all painters, the most poetical."[38] Romantic critics remained quite reluctant to speak of "reading" a picture—to equate the imaginative response to painting with that of the reader to poetry.

The exception to this general rule is Charles Lamb's 1811 essay on Hogarth, a work that in many respects anticipates Ruskin's praise of Turner. Lamb specifically praises Hogarth as a painter to be read: "His graphic representations are indeed books: they have the teeming, fruitful, suggestive meaning of *words.* Other pictures we look at,—his prints we read."[39] This statement might not at first seem surprising. Lamb describes Hogarth as a painter who works not by creating an immediate impression but by unfolding a complex meaning through the use of multiple images and verbal and visual allusions—a plethora of detail directly or metaphorically related to the subject of the print. He notes that Hogarth's prints have in fact "no central figure or principal group . . . nothing to detain the eye from passing from part to part, where every part is alike instinct with life" even down to "the dumb rhetoric of the scenery" and extending as well to "witticisms that are expressed by words, (all artists but Hogarth have failed when they have endeavoured to combine two mediums of expression, and have introduced words into their pictures), and the unwritten numberless little allusive pleasantries that are scattered about."[40] For this highly verbal art the term "reading" would be appropriate without implying anything about the imaginative activity of the viewer. Lamb, however, also praises Hogarth as a great imaginative artist—greater, even, than Hazlitt's favorite Poussin:

I think we could have no hesitation in conferring the palm of superior genius upon Hogarth, comparing this work of his [*Gin Lane*] with Poussin's picture [*Plague at Athens*]. There is more of imagination in it—that power which draws all things to one,—which makes things animate and inanimate, beings with their attributes, subjects and their accessaries, take one colour, and serve to one effect.[41]

The crowded clutter of Hogarth's prints does not, for Lamb, preclude imaginative unity. Hogarth's prints may not exhibit visual unity, but they do possess associative unity. To read a Hogarth is not simply to decode its imagery, the exercise that Shaftesbury and other eighteenth-century critics found to detract from the unified effect of a painting; it is also, for the spectator, to participate in the imaginative process embodied in the painting. It is, Lamb says, what Shakespeare meant by "*imaginary work,* where the spectator must meet the artist in his conceptions half way; and it is peculiar to the confidence of high genius

alone to trust so much to spectators or readers."[42] Lamb recognizes no difference here between the unity of Hogarth's visual composition and the unity of a literary work of associative imagination; there can be, therefore, no real difference in the manner in which spectator and reader respond to visual work like Hogarth's and to an imaginative poem. Indeed, throughout his essay Lamb compares Hogarth's work with Shakespeare's.

Hazlitt begins his lecture on Hogarth (1818) by referring with approval to Lamb's essay, particularly to his praise of Hogarth as a painter to be read. But in the course of the lecture Hazlitt completely transforms Lamb's criteria for judging Hogarth's excellence and ends by strongly qualifying Lamb's praise. Hazlitt will not call Hogarth an imaginative painter, reproves Lamb for comparing him to Shakespeare, and goes on to distinguish sharply between Hogarth and Poussin. Hogarth's cluttered prints are full of "circumstantial detail" and reference to everyday events, while the ideal art of Raphael or Poussin, using subjects far from familiar or everyday, renders them in detail sufficiently selective to produce the visual and conceptual unity necessary to stimulate the associating imagination of the viewer. "Hogarth only transcribes or transposes what was tangible and visible."[43] Hazlitt drastically reduces the notion of reading, as Lamb applied it to Hogarth, until it no longer carries the romantic sense of imaginative activity produced in the reader as he follows the text. Although Hazlitt gives greater praise to Poussin than to Hogarth, he does not praise him as a painter to be read. Poussin's effect on the imagination comes not through multiplying suggestive imagery, so linked as to lead the imagination by associative steps, but through unifying, by tone and selective imagery, a single suggestive ideal subject that will act as the starting point for reverie (Hazlitt's term) or imaginative reflex (Coleridge's)—a chain of associations in the mind of the viewer.

Hazlitt, contradicting Lamb on Hogarth, maintained the distinction between poem-as-process and painting-as-stimulus even in his highest praise of Poussin's ideal art. In the early volumes of *Modern Painters* Ruskin rejects this distinction outright. The kind of looking Ruskin advocates as necessary for the beholder of Turner is in fact much closer to what romantic critics meant by imaginative reading of great poetry than it is to Alison's or Hazlitt's conception of how one responds to ideal painting. Like Lamb, Ruskin found a painter for

whom Hazlitt's distinctions between reading and seeing did not seem to apply; unlike Lamb, Ruskin based his case on a fully romantic painter who was not, at least in the pages of *Modern Painters I,* particularly literary. Where Lamb focused on the emblematic nature of Hogarth's prints, Ruskin concentrated almost exclusively on visual composition in his first discussions of Turner. In his account of *The Slave Ship,* as we have seen, the visual impression is neither simple nor immediately grasped; the relation of ship, sea, and sky to each other is visually complex. Relationship, primarily expressed through color, does exist, but must be traced from touch to touch and color to color by the eye. That process of following out visual connections not immediately comprehensible is, in Ruskin's prose description, made identical with the process of following out an imaginative train of ideas (the flight of the clouds, the torture and relief from the storm, the bath of blood, the valley of the shadow of death, fearful dye, reckless waves, guilty ship, the ineradicable stain of crime). Thus for Ruskin the Turner painting does not convey emotion through visual unity of impression, stimulating dream or reverie. Rather it guides the mind through a temporal process of imaginative association which is inseparable from a temporal experience of tracing formal visual relationships, especially of light and color. Painting, like poetry, has become not just the occasion for mental process but also the embodiment of it.

We can see now, I think, how the impression of energy and intense visual exploration conveyed by Ruskin's description, in contrast to Hazlitt's, is directly related to his argument in *Modern Painters I* and *III* that painting is a parallel experience of equal value with literature. That Ruskin is consciously revising the romantic and associationist view of painting is strongly suggested by both the language and the content of his definitions of great art. When he talks of the importance of conveying the specific character or expression of a place, or speaks of the imagination suggesting related images that expand a simple poetical feeling, he is using Alisonian terms and an Alisonian model of mental activity.[44] Ruskin's definition of great art in *Modern Painters I,* however, contradicts the associationist demand that painting express a *single* powerful idea or emotion to stimulate imaginative association in the mind of the viewer: "But I say that the art is greatest which conveys to the mind of the spectator, by any means whatsoever, the

greatest number of the greatest ideas" (3.92). The revised definition offered in *Modern Painters III* uses more romantic terminology to make essentially the same point. Here Ruskin uses the single term "poetry" to define both verbal and visual art. Both are "the suggestion, by the imagination, of noble grounds for the noble emotions" (5.28). The emphasis on painting and poetry as arts of imaginative association is repeated a few lines later: what is required is not just simple poetical feeling but the assembling, by the poet's imagination, of "such images as will excite these feelings" in the mind of spectator or reader (5.29). Ruskin's definitions express a conviction that painting, as much as poetry, does more than provide a mood conducive to reverie. Its images also provide the content of that reverie, conveying ideas or exciting feelings in an "exercise of imagination." The corollary to this definition is that seeing a painting will require as much continuous attention to suggestive detail as reading a romantic poem. Further, the relationships between visual details may be as difficult to predict as the logic of metaphor, the twists and turns of associative thinking in Shelley or Keats or Wordsworth. This is, of course, what Ruskin says of Turner's paintings.

WHAT Ruskin praises as unique about Turner's landscape painting in *Modern Painters I* nicely indicates the visual grounds he found in Turner for extending the concept of active response from poetry to painting. In some of his most acute comments on Turner, Ruskin calls particular attention to his use of tone, color, and light to depict space.[45] Ruskin argues that Turner's conception of space is fundamentally different from that of the great landscape painters of the seventeenth century, Claude and Poussin. Turner's space requires an active viewing that is a form of associative thinking, as the space of his predecessors, according to Ruskin, does not. Space is represented by Turner not as possessing measurable extension, providing the means of estimating the size, position, and relationship of three-dimensional figures, but as filled with precisely significant light and color resolved into figure and distance by the activity of the spectator's eye and mind. Ruskin points out that the classical system expresses extension and relationship of objects in space by three means: linear perspective, which enables the viewer to tell at a glance the relationship of objects by

locating them at a given point in a preconceived space; tonal or color gradation, particularly tonal contrast; and aerial perspective, the gradual blurring of line and elimination of detail from foreground to background which expresses intervening space. Turner's space, expressed in very different ways, makes greater demands on the spectator's powers of visual discrimination and associative combination.

Linear perspective, as conceived in the Renaissance, is relatively less important for Turner than aerial perspective, which requires closer visual attention. Tonal contrast is also less important than gradation. Turner, Ruskin points out, extends the tonal scale upward; the result is not just the more dramatic contrasts of light and dark then available, but the wider range of intermediate gradation. Through these intermediate gradations, Ruskin argues, the impression of space is most effectively conveyed.

[The old masters] chose those steps of distance which are the most conspicuous and noticeable, that for instance from sky to foliage, or from clouds to hills; and they gave these their precise pitch of difference in shade with exquisite accuracy of imitation. Their means were then exhausted, and they were obliged to leave their trees flat masses of mere filled-up outline, and to omit the truths of space in every individual part of their picture by the thousand . . . Turner starts from the beginning with a totally different principle. He boldly takes pure white . . . for his highest light, and lampblack for his deepest shade; and between these he makes every degree of shade indicative of a separate degree of distance, giving each step of approach, not the exact difference in pitch which it would have in nature, but a difference bearing the same proportion to that which his sum of possible shade bears to the sum of nature's shade . . . Hence where the old masters expressed one distance, he expresses a hundred, and where they said furlongs, he says leagues . . . the very means by which the old masters attained the apparent accuracy of tone which is so satisfying to the eye, compelled them to give up all idea of real relations of retirement, and to represent a few successive and marked stages of distance, like the scenes of a theatre, instead of the imperceptible, multitudinous, symmetrical retirement of nature. (3.262–263)

Turner also uses indistinctness in a radically different fashion. As critics had been objecting for forty years, Turner tended to blur his foregrounds as much as or more than his middle and backgrounds—a practice just the reverse of normal procedure. Ruskin argues for the

effect of this procedure by pointing to the fact of selective focus: if the background is in focus, the foreground cannot be. Turner's habit of throwing the foreground out of focus tends to pull the viewer farther into the painting and so to enhance the experience of depth and distance. "The spectator was compelled to go forward into the waste of hills; there, where the sun broke wide upon the moor, he must walk and wander; he could not stumble and hesitate over the near rocks, nor stop to botanize on the first inches of his path" (3.324).[46] Turner gets greater suggestion of extensive space by giving less distinctness in both his fore- and his far backgrounds, *without* diminishing the amount of detail suggested. Ruskin insists on this point as a central part of Turner's technique of representing space. Compared to previous landscape painters, Turner is both less distinct in his depiction of objects and more precise in his visual indication of them—making, consequently, greater demands on his viewers. That is, Turner uses line, light, and color more suggestively. He does not realize objects with a high degree of definition, but neither does he leave the viewer free to associate at will from empty spaces in his painting. Fore- and backgrounds may be equally indistinct, but both remain "full." There are no empty spaces in Turner's paintings. "Hence, throughout the picture, the expression of space and size is dependent on obscurity, united with, or rather resultant from, exceeding fulness. We destroy both space and size, either by the vacancy which affords us no measure of space, or by the distinctness which gives us a false one" (3.339).

Ruskin's account of Turner's full but indistinct space is a visual version of the familiar romantic interest in the unfinished or incomplete; in both cases, readers and viewers are called upon to participate in creation. Ruskin's version of romantic incompleteness, however, places particular emphasis on the precise directions for imaginative activity which paintings and texts can provide. He does not praise the suggestiveness of vaguely depicted space that appears to be, in fact, simply empty. His praise of Turner's *Mercury and Argus*, for example, dwells on the abundance, variety, and precision of every indefinite stroke of the brush:

Abundant beyond the power of the eye to embrace or follow, vast and various beyond the power of the mind to comprehend, there is yet not one atom in its whole extent and mass which does not suggest more than it represents;

nor does it suggest vaguely, but in such a manner as to prove that the conception of each individual inch of that distance is absolutely clear and complete in the master's mind, a separate picture fully worked out: but yet, clearly and fully as the idea is formed, just so much of it is given, and no more, as nature would have allowed us to feel or see; just so much as would enable a spectator of experience and knowledge to understand almost every minute fragment of separate detail, but appears, to the unpractised and careless eye, just what a distance of nature's own would appear, an unintelligible mass. Not one line out of the millions there is without meaning, yet there is not one which is not affected and disguised by the dazzle and indecision of distance. No form is made out, and yet no form is unknown. (3.335)

As this passage makes clear, Ruskin defended Turner's suggestive representation of space not as a purely artistic device but as a closer approximation to the facts of normal perception. Turner, he claims, departs radically from ideas of space perception that had been the norm since the Renaissance to move closer to the truths of space and light and color as they appear to the human eye. Turner's lectures on perspective (the notes for which Ruskin had not seen in 1843), together with the evidence of his paintings, suggest that Ruskin's claim is consonant with Turner's own view of what he was doing—although in 1843 Ruskin's polemical intentions, his ahistorical approach, and his concentration on Turner's work of the late thirties and forties made him exaggerate the break with Claude and Poussin. Linear perspective, the triumphant rationalization of vision achieved in the Renaissance, does seem to have been considered by Turner as well as Ruskin as an inadequate representation of visual experience. Turner was not only more interested in aerial perspective, as Ruskin points out; he was also attracted by the mimetic and expressive possibilities of an elliptical field of bifocal vision with more than one vanishing point, where complicated patterns of curves or vortices not only suggest motion in air and water but also encourage movements of the eyes which Turner may have regarded as a neglected aspect of normal perception.[47] He was attracted too by the doubling or echoing of objects (noted by Ruskin, 13.73–74; 15.167–169), perhaps because it seemed characteristic of bifocal vision. These picture structures contrast with the simple avenues of recession through an orderly succession of planes that indicate continuous, consistent space in a Claude—an illusion based on our acceptance of fixed, single-point per-

spective as an equivalent to normal vision. Turner seems to have been increasingly unwilling to accept that convention, judging from his experiments with vortical compositions. Ruskin does not call explicit attention to the elliptical and vortical structures in Turner's paintings, but his own descriptions trace out similar visual movements in his explorations of paintings or actual landscapes. Some of the tremendous energy of motion in Turner's vortex paintings is reflected in the verbal energy and movement of Ruskin's prose descriptions. For both painter and critic, the energy of motion may have been intended as an accurate imitation of perception itself.

Turner's departure from tradition in the organization and representation of space, especially in some of his later work, could in itself account for much of that increased energy of perception which sets Ruskin apart from Hazlitt. Where the indications of distance and spatial relationships are unfamiliar, the painting as a depiction of natural space may simply give an impression of confusion, as Turner's critics again and again testify. The kind of point-by-point interpretation that Ruskin employs was probably necessary to make Turner's light and color comprehensible as spatial representation. But I don't think it is simply the problem of unfamiliarity that leads Ruskin to advocate careful visual readings as opposed to immediate impressions for the spectator of Turner's paintings. The conception of visual space ascribed by Ruskin to Turner seems to imply a different kind of seeing—one that is both excursive, in the sense traced in Chapter 3, and associative, in the sense prescribed by Alison and the romantic critics for the reading of poems.

It may help to explain how Turner's depiction of space could evoke excursive seeing and associative reading if we begin by noting some connections between Turner's practice and George Berkeley's *New Theory of Vision* (1709), with which Turner was certainly familiar.[48] Berkeley reasserted the medieval belief that we see only light and color, contradicting Locke's argument that figure and extension are primary qualities of objects, and color only secondary. This much of Berkeley's theory had begun to have a considerable impact on art theory by the early nineteenth century. Uvedale Price attributed a similar position to Payne Knight in 1801; Goethe reannounced the fact in his "Theory of Color," which Turner read and commented on extensively after it was translated into English by Eastlake in 1840.[49] Berke-

ley's explanation of how, if all we see is light and color, we think we see figure, distance, and so forth, is of particular interest. Berkeley argues that light and color suggest, represent, or signify these tangible qualities, as words signify ideas. We see figure, distance, or direction only through our common and accumulated experience that particular patterns of light and color correspond to tangible experiences of figures in particular spatial locations. The most immediate of these tangible experiences associated with visual experience, according to Berkeley, is that of the movements of the eyes themselves as they explore the visual field, shift focus, and so forth. Turner might be said to employ Berkeley's new theory of vision in several ways: in his increasing emphasis on light and color as the primary visual effects of painting, and in his interest in the eye movements generated by light and color as the means to express the structure of space and spatial relationships. Though there is no evidence that Ruskin read Berkeley's *New Theory* (he knew and strongly disagreed with others of Berkeley's works),[50] he certainly responded to these elements in Turner's practice, particularly the visual experience of space as that of the eye moving through a field of light and color. Furthermore, there are two points in Berkeley's *New Theory* which, from what we know of Turner, would have been likely to interest him and which recur in Ruskin's criticism. Berkeley presents his notion of how distance and direction are perceived as an explicit criticism of the Renaissance system of linear perspective; he also describes light and color as a conventional language (his term) based on associative connections between signifier and signified.[51] Berkeley's insistence that light and color constitute a language would make "reading" an appropriate term for seeing, although Berkeley would argue that we are not conscious that seeing is reading. His belief that vision is not a real language (whose words are things) further implies that reading involves something like the continuous process of association through suggestion which was to constitute the romantic notion of response to poetry. According to Berkeley's argument, if we believe that we see figure and space directly, then visual images will appear to be more or less direct presentations of "real" things. Positing that we see only light and color, for Berkeley, makes visual imagery not a presentation of any objective reality, but simply a language for expressing, through one order of mental and sensory experience (sight), another order of mental and sensory experi-

ence (touch). Thus visual signs become indeed analogous to verbal signs and not, as most later eighteenth-century writers who did not follow Berkeley held, an imitation of reality that could not closely reflect mental process. Neither Ruskin nor Turner, of course, would have accepted Berkeley's claim that visual language was not true to our perceptions of nature, but they do seem to have believed that visual language was quite capable of reflecting the same mental processes displayed in romantic poetry. And both men, like Berkeley, were interested in new ideas of space perception which helped to make explicit the function of visual imagery in painting as a suggestive language.

Like Berkeley, Ruskin attaches an attack on Renaissance conceptions of space to his defense of the new Turnerian version of spatial perception. In *The Stones of Venice* Ruskin censures Renaissance pride in perspective, denying that rationalization of space can provide truth of aspect — phenomena as they appear to a human perceiver. The artist must rely on his eyes. The contrast here is between a space that is rational and scientific, and one that exhibits no consistency of relationships such as might be expressed by mathematical formulas (11.57–58, 71, 115, 117). In *Modern Painters I* Ruskin describes a Renaissance space that is empty and impoverished, composed of "dead spaces of absolute vacuity" or of figures rendered with false distinctness, "staring defiance at the mystery of nature" (3.334). Turner's space is not impoverished but rich, not empty but full, not overdistinct but mysterious (3.246,341). All of these qualities are characteristics of the imagination (or the imaginative poem) as described by associative literary critics. Similarly, Ruskin's criticism of the pre-Turnerian landscapists is parallel to Alison's or Hazlitt's discussions of painting in general, as distinguished from poetry. Though Hazlitt finds Poussin's *Orion* poetic, he sees light and color as bringing suggestive atmosphere to what is essentially an art of figure and extension, of things governed by rational spatial relationships, not of ideas or mental images joined by the strong "chemistry" of the associating imagination (4.234–235; a phrase of Ruskin's adopted from that line of associationist psychology which literary critics found most congenial).

The climax to Ruskin's associationist criticism of Renaissance space comes in his parody of Claude's *Il Mulino* (*The Marriage of Rebecca and Isaac*) in the second preface to *Modern Painters I*. Ruskin ridicules the

belief that painting can be ideal if it relies solely on orderly spatial arrangements and ignores or violates associative connections.

The foreground is a piece of very lovely and perfect forest scenery, with a dance of peasants by a brook-side; quite enough subject to form, in the hands of a master, an impressive and complete picture. On the other side of the brook, however, we have a piece of pastoral life; a man with some bulls and goats tumbling head foremost into the water, owing to some sudden paralytic affection of all their legs. Even this group is one too many; the shepherd had no business to drive his flock so near the dancers, and the dancers will certainly frighten the cattle. But when we look farther into the picture, our feelings receive a sudden and violent shock, by the unexpected appearance, amidst things pastoral and musical, of the military; a number of Roman soldiers riding in on hobbyhorses, with a leader on foot, apparently encouraging them to make an immediate and decisive charge on the musicians . . . This is, I believe, a fair example of what is commonly called an "ideal" landscape; *i.e.* a group of the artist's studies from Nature, individually spoiled, selected with such opposition of character as may insure their neutralizing each other's effect, and united with sufficient unnaturalness and violence of association to insure their producing a general sensation of the impossible. (3.41–42)

He also attacks Claude for simplifying and clarifying figures so as to bring out formal relations at the expense of truth of expression or character:

The descending slopes of the city of Rome, towards the pyramid of Caius Cestius [Claude's setting], supply not only lines of the most exquisite variety and beauty, but matter for contemplation and reflection in every fragment of their buildings. This passage has been idealized by Claude into a set of similar round towers, respecting which no idea can be formed but that they are uninhabitable, and to which no interest can be attached, beyond the difficulty of conjecturing what they could have been built for. (3.44)

The simplifications justified by the criterion of visual unity are mocked by Ruskin, not only because they are untrue but also because they destroy the interest such a scene can have for the imaginative and sympathetic spectator: "It cannot, I think, be expected, that landscapes like this should have any effect on the human heart, except to harden

or to degrade it" (3.44). The true ideal unity is a unity of thought achieved by *including* all the "lines of the most exquisite variety and beauty" which provide "matter for contemplation and reflection" — and so combining them that each painting is "founded on a new idea . . . developing a totally distinct train of thought" (3.48). Ruskin is claiming both that Claude is false to nature and that his compositions do not exhibit the kinds of connections between ideas which characterize imaginative perception in thinking *or* seeing.

Ruskin may have exaggerated the differences between Turner and Claude, but that exaggeration allowed him to proclaim the possibility of painting where the sensory profusion resulting from visual truth to nature directly contributes to imaginative effect. The emphasis on Turner's unique representation of space in *Modern Painters I* is complemented by this criticism of Claude and defense of Turner in the second preface, conducted in strongly associationist terms. In fact, Turner's manner of filling space, demanding the moving eye and the active mind of the spectator, is the means by which spatial unity becomes identical with ideal or imaginative unity. Thus Ruskin can claim for Turner's painting the kind of associationist complexity and unity that Alison and Hazlitt found better achieved in literature.[52] At the same time, he necessarily changes the recommended approach to painting by stressing not a single impression of comprehensive space as the prelude to reverie, but the active exploration of relationships among images as the means by which the spectator will experience simultaneously the painting's spatial and its mental and emotional unity. Seeing is an excursive movement through a visual field by means of which the imaginative spectator reads the suggestions of figural detail and recreates the painting's double truth of space and mental process.

Ruskin's argument for associative unity in painting is developed more fully in *Modern Painters II* (in the chapters on imagination) and in *Modern Painters III*, where he describes imaginative perception as the "clustering" of ideas around a visual object. His chapter on "Turnerian Topography" in *Modern Painters IV* is an expanded explanation of Turner's spatial composition in terms of this model of imaginative sight. Similarly, the description of the beholder's imagination in *Modern Painters III* is a more explicit version of the manner of seeing already assumed in *Modern Painters I*. To rephrase Ruskin's perceptions in *Modern Painters I* in the terminology of *Modern Painters III* and *IV*, if

we see Turner's landscapes rightly we will be exercising imaginative sight—that process of associative thinking which, Ruskin claimed, was not separate from sight, as Wordsworth and Scott (or Alison and Hazlitt) believed, but indissolubly part of seeing. For Turner this sight would be instantaneous, the clustering of images. For the spectator, as for the reader, the process is more gradual: we must let our imaginations be guided from image to image and idea to idea by a painting or poem. For spectator or reader, imaginative sight is something more like the traditional train of associated ideas—though "train" was not a word that Ruskin, by the time of *Modern Painters III*, would use to describe the leisurely and unpredictable traveling of the excursive eye and mind. The Ruskinian sublime and the Ruskinian picturesque can also be seen as later attempts to work out, more elaborately, aspects of the kind of imaginative sight posited in *Modern Painters I*. Both grotesque and picturesque are also, as I have already argued, dependent on the excursive eye and mind of the spectator. The associative imagination and the excursive eye are consistently joined in the mode of seeing that Ruskin advocates.

Perception fascinated Ruskin, as it did his predecessors, Alison and Coleridge. Each understood perception not as the passive reception of sense impressions but as the active mental interpretation of that information. Insisting that all seeing is just such active perception, Ruskin extended to art what the associationist psychologists and romantic critics had claimed for literature: its power to engage, embody, and guide the whole mind, including the imagination. Excursive sight and associative reading were not Ruskin's inventions—they come out of the landscape experience, the psychology, and the literature of the previous century—but he brought them together and applied them where they had not been thought relevant. In so doing he effectively raised the status of the viewer of landscapes or paintings. He also presented seeing as a far more demanding activity than his predecessors had assumed. In his five-volume response to England's greatest romantic painter, Ruskin created the romantic spectator of painting.

There is historical irony in Ruskin's achievement. Claude and Poussin, after all, were a major source of inspiration for the eighteenth-century English landscape garden and hence for an approach to landscape reflected in gardens, on travels, and in poetry. The paintings were

equally important for early poetic gardens and meditative-descriptive poems full of emblematic devices, and for later ones where excursive approaches to landscape were combined with explicitly associationist demands for expressive scenery. Ruskin was, in a way, only bringing back to landscape painting what the English had derived from it: an excursive, associative mode of imaginative visual experience. If romantic critics treated painting as a relation who had outlived her usefulness to poetry, Ruskin reinstated her as the landscape movement's best child.

Best—but also last. Ruskin's closing of the cycle of influence carries an ominous suggestion of finality, a finality recognized and resisted in his own writing from the late fifties. By the time his audience has learned how to see and read landscapes, the colors of Turner's paintings will be irrevocably faded, English gardens converted to coalfields, distances filled with soot and smoke instead of light and color, and leisurely travel supplanted by steam and speed. (Turner might grasp the last with imaginative sight, but not the ordinary beholder.) In Pre-Raphaelite painting, truth to nature and truth to imagination are certainly not achieved through truth of space. By the mid-fifties, real and painted landscapes suited to the romantic spectator were increasingly difficult to find.

But Ruskin's ideas about perception did not disappear with the landscapes he loved. His insistence on active imaginative seeing even for the consumer is ultimately the strongest link between his art and social criticism. Seeing as he describes it is indeed an activity of the whole mind, as that mind was conceived by contemporary psychology. One can see how, if healthy perception typifies human mental activity, Ruskin could conclude that unfeeling or inaccurate response to the visual arts—to Venice, to Turner, to the Pre-Raphaelites—might be the sign of a culture-wide loss of mental and emotional health. Disease is one of Ruskin's pervasive metaphors for social as well as perceptual flaws. His remedies for cultural ill health in the second half of his career were often social and economic, but his criticism continued to address the failures of perception which seemed both symptom and cause of the disease. Reading was a major concern of this later perceptual criticism. By precept and example, Ruskin sought to teach his audience to read explicit symbolism in visual art, and to understand how that symbolism affected verbal language, including his own.

CHAPTER SEVEN

Symbolic Language

THE EXERCISE OF IMAGINATIVE PERCEPTION does not exhaust
the experience of visual art for Ruskin. The perceptual process I have
compared to romantic reading Ruskin refers to simply as "seeing,"
"seeing and feeling," or "perception." But aspects of both real
landscapes and paintings or buildings began by the early fifties to elicit
from him a further mental activity, which he called "reading." This
kind of reading is not the perception of light and color as figure and
space or even the comprehension of it, in a given composition, as
"mental expression." That comprehension is an inseparable part of the
perceptual process of imaginative sight, by Ruskin's definition. "The
Nature of Gothic" deals with the Gothic as an object of perception,
discussing material form and mental expression or mental character;
but at the end of the chapter the spectator is enjoined to look for some-
thing more. We must also "*Read* the sculpture."

In *The Stones of Venice* the text read by the spectator is, in most
cases, a particular iconography common to much medieval and early
Renaissance art and literature, with both scriptural and classical
sources. We pass from perceiving to reading when we encounter an
explicit symbolic language employed by artist, sculptor, poet, or
workman, "that great symbolic language of past ages, which has now
so long been unspoken" (11.205). Reading, as Ruskin exemplifies it in
Stones, is the interpretation of figures whose probable meaning is ar-
rived at through comparison with related figures in other texts or
works of art and reference to nature and to relevant scriptural pas-
sages. It is clear that such reading can contribute to the perception of
mental expression, but that perception does not depend on reading.
Ruskin makes reading a subordinate part of the total visual activity of

exploring a building.[1] He repeatedly insists that a good building must make aesthetic sense at *any* distance; this is the corollary to the assumption that a spectator will shift perspective and move around, up to, and through a work of art—a movement of the eyes only, in the case of a painting, but of the whole body in the case of buildings or actual landscapes. The iconography of a building will not of course be readable at all distances. It is, then, no part of much of the visual experience of architecture.

Yet Ruskin does give increasing importance to the interpretation of figure or icon, beginning with *The Stones of Venice.* Why does he become interested in adding reading to seeing at this time? How does he reconcile this new stress on interpretation with his earlier approach to Turner? His two models for reading the language of art are not at first glance compatible. As Ruskin readers well know, the interpretation of visual iconography, however justified by the work of art in question (and it usually is), can be weighed down with a burden of significance disproportionate to the role it plays in the spectator's response. That significance is often indicated in language that is not psychological or aesthetic but religious. Iconography acquires its special importance through its resemblance to or coincidence with symbolic language of quite a different nature—the Real or divine language of the Bible and of a significant universe. So much verbal emphasis does Ruskin give to the religious reading of symbolic languages that the role of his ideas on perception has often been lost sight of. Moreover, the shift from a psychological to a religious terminology to describe the reading of symbolic language in art has made it difficult for modern readers to see what common ground might exist between these two aspects of Ruskin's response to art. Ruskin devoted a good part of *Modern Painters IV* and *V* to an elaborate attempt, through an argument from metaphor, to reconcile religious reading with the romantic reading of Turner he had advocated in *Modern Painters I.* Without, I hope, minimizing the philosophical difficulties posed by Ruskin's yoking two different conceptions of language, I would like to reexamine his use of scriptural exegesis as a model for reading art.

ALTHOUGH Ruskin was thoroughly familiar with figural interpretation from his religious training when he began *Modern Painters,* there

is no real place for symbolic language or explicit "reading" in the first two volumes. (He uses typological allusions in his descriptions of paintings or landscapes, but does not instruct his readers to do so.) In part the exclusion was planned: Ruskin from the first intended to treat "ideas of relation" in a later volume. But his study of Gothic architecture in the late 1840s and early 1850s seems also to have changed his attitude toward the role of reading in the perception of visual art. He changes his mind about the extent to which the ordinary spectator can read the symbolism of art, and he formulates for himself a critical identity to which reading is central.

Ruskin's interest in the use of symbolic languages in art develops together with his conviction that all visual perception must be active and imaginative. When he calls art a language at the beginning of *Modern Painters I* he presents it as a language of painted line and color, signifying the visual aspect of things while expressing mental process. The notion of language, however, is chiefly useful as a way of stressing the second, expressive function of visual art. Ruskin's own descriptions in *Modern Painters I* may suggest that visual language requires a great deal of active seeing on any spectator's part, but as we have already seen, when he discusses the effect of paintings on spectators he does not stress this activity. The response of the ordinary spectator is limited to perceiving painted line and color as natural objects, which, Ruskin implies, is not commonly felt to be very demanding. Expressive or imaginative art does involve spectators in the "active exertion of the intellectual powers" at the instant of perception (3.115). But this kind of active seeing is limited in *Modern Painters I* to the very few, to "minds in some degree high and solitary themselves" (3.136). It seems to be a form of poetic or artistic activity and not a part of the ordinary perception of aesthetic objects. Only for the small and privileged group of active seers does art function as a language to express mental process. The ordinary spectator, Ruskin implies, will be conscious of art simply as faithful representation, not as a system of signs.

The situation is not much different in *Modern Painters II*. There too Ruskin seems to conceive of sight as separable into a hierarchy of perceptive responses: the merely sensory, the emotional-sensory ("moral" or "theoretic" perception), and the intellectual. Only intellectual perception is an active exertion of the mind, but this exertion is a usually quite unnecessary, at most very minor part of the effect of beauty on

the spectator. The volume is divided into a discussion of the two fac-
ulties concerned with beauty, the theoretic and the imaginative. Imag-
ination, "the highest intellectual power of man" (4.251), is always
described as active; in it the mind is exercised in combining, regarding,
or penetrating (4.36,228). The extended description of imagination in
Modern Painters II, probably based on Wordsworth's supplementary
essay of 1815, develops a concept of active thinking-as-seeing very close
to the imaginative perception of *Modern Painters III* — but ascribed, in
the earlier volume, to artists and poets only. The theoretic perception
of the normal spectator is, by contrast, more or less passive sight; it is
instinctive feeling (joy, love, and gratitude) aroused by beauty
(4.47–49,211). Here, as in *Modern Painters I*, Ruskin deemphasizes the
symbolic character of aesthetic objects insofar as that might imply that
aesthetic perception is intellectual. When he is talking about imagina-
tion in the artist, however, he readily admits the symbolic function of
visual imagery in art. Just as every word of an imaginative poet carries
"an awful under-current of meaning" (4.252), so even the naturalist-
ically painted objects in a Tintoretto are put to "symbolical use"
(4.269). Ruskin is here, as in *Modern Painters I*, very cautious about
symbolic modes of representation (exaggeration, abstraction, reduc-
tion to simplified character), but he wholly accepts symbolical use or
intent as a sure sign of a powerful imagination (4.297–313,261–278).

The ideas of natural beauty to which the theoretic faculty responds,
however, though many of them are in fact symbolic, do not constitute
a "language" or — with one exception — elicit interpretation. Formal
qualities that appear beautiful (varied curvature, bright horizons) do
signify, typify, or suggest divine attributes, Ruskin maintains, but
this moral meaning is "only discoverable by reflection" that plays no
part in the instinctive emotional response of the spectator (4.211). Ideas
of vital beauty (complementing those of typical beauty) are for the
most part not symbolic at all; "the felicity of living things" and their
"perfect fulfilment of their duties and functions" are directly perceived
by the theoretic faculty (4.210). Sympathy, or sympathy plus some
natural history, is sufficient. There is one respect in which ideas of
vital beauty do function as language, or at least seem to require inter-
pretation: images of living things can serve as "the record of con-
science, written in things external" (4.210) or as a lesson that must be
rightly read (4.147). Except for this one aspect of vital beauty, how-

ever (and Ruskin does not spend much time discussing it in *Modern Painters II*), response to beauty does not require active or intellectual perception; nor is the notion of art as symbolic language relevant to the kind of spectator response that Ruskin is concerned to establish.

But this treatment of aesthetic response is incomplete, as Ruskin himself admits. The theoretic faculty responds to natural beauty and to art insofar as it represents that beauty faithfully. The imaginative faculty of artist or poet works on natural beauty (or rather on the visual aspects of natural objects) and gives it expressive or symbolic significance. What is the spectator's response to imaginative art? Here, as in *Modern Painters I*, Ruskin gives two answers: the implied example of his own perceptions, this time in the interpretive descriptions of Tintoretto's paintings, and a brief explicit discussion of a privileged spectator. The Tintoretto descriptions exhibit the same visual exploration and verbal energy of the Turner descriptions in *Modern Painters I*, joined with an increased attention to deliberate allusion and symbolic intention. For the *Annunciation* in the Scuola di san Rocco, for example (4.264–265), Ruskin begins by focusing on the setting—a ruined palace—insisting on the almost grotesque detail of "the central object of the picture . . . a mass of shattered brickwork, with the plaster mildewed away from it, and the mortar mouldering from its seams." Carefully leading the spectator from that unlovely object along "a narrow line of light" connecting the brickwork with discarded carpenter's tools beneath it—a crucial compositional line—Ruskin finally identifies the symbolic significance of those elements that the spectator, guided by visual elaboration and composition, has been led to explore. "The ruined house is the Jewish dispensation; that obscurely arising in the dawning of the sky is the Christian; but the corner-stone of the old building remains, though the builders' tools lie idle beside it, and the stone which the builders refused is become the Headstone of the Corner." As in the earlier volume, the progressive unfolding of imagery and meaning here implies that both are accessible to Ruskin's spectators, if they will only look more carefully.

Ruskin must acknowledge that this kind of looking requires something more than the instinctive theoretic response. He does acknowledge it, but when he does so he again suggests that this more active, intellectual response, and hence the whole range of imaginative symbolism to which it gives access, will be possible only for a very few

spectators. However, in *Modern Painters II* for the first time Ruskin describes this privileged spectator not only as establishing a sympathetic identity with the mind of the artist, but also as participating in a process of imaginative perception which can, to some extent, be *learned*. "Imagination addresses itself to Imagination," but the imagination of the spectator now seems to Ruskin perhaps "less a peculiar gift, like that of the original seizing [by the artist], than a faculty dependent on attention and improvable by cultivation" (4.261).

As so often in Ruskin's work, the first signs of a shift in emphasis or direction appear in a volume whose major argument runs along quite different lines. The boundary between passive emotional perception and active imaginative perception is increasingly eroded in Ruskin's subsequent volumes on architecture, *Seven Lamps* and *The Stones of Venice,* until, by *Modern Painters III,* it has become virtually impossible to separate the two kinds of response. Nearly forty years later, revising *Modern Painters II,* Ruskin firmly stated the position toward which he had, in 1846, just begun to move. "The 'Imagination' spoken of is meant only to include the healthy, voluntary, and necessary action of the highest powers of the human mind," he noted—and still later he would gloss that note as meaning "that all healthy minds possess imagination, and use it at will, under fixed laws of truthful perception and memory" (4.222). The spectator's viewing is not, then, passive feeling, but active imaginative perception, as Ruskin asserted in *Modern Painters III.* What one might call the democratization of imaginative perception leads to Ruskin's growing conviction that perception is a matter not just of individual but of cultural health, that it can vary historically, and that it can be directly related to changing social and economic conditions. The new emphasis on active seeing is also accompanied by increasing attention to art and language, particularly to art as employing a variety of symbolic languages that convey meanings requiring interpretation. Reading, whether of art or of literature, becomes an explicit concern in Ruskin's criticism when he acknowledges that an intelligent response to art is not a gift but an activity that can be learned. The model for aesthetic experience is not the poet's sublime encounter but the tourist's or reader's excursive exploration.

What Ruskin sometimes saw as his long detour from landscape painting into architecture had clearly a great deal to do with the changes in his ideas of aesthetic experience between the mid-forties and

the mid-fifties. We have already seen some of the ways in which the study of architecture reshaped his criticism: the connections between architectural experience and the excursive habits of garden visitors and travelers, the associations between Gothic buildings and the picturesque, the use of travel as an approach to history and to the development of an historical self-consciousness. I want to look briefly now at two other aspects of Ruskin's architectural criticism: his recognition of the spectator's necessary activity in examining a building, and his interest in sculptural iconography addressed to the general spectator. Both concerns are already evident in *Seven Lamps* and begin to affect his attitudes toward the viewing of all art in *The Stones of Venice.*

In Ruskin's chapter on sublime architectural effects in *Seven Lamps,* the spectator's focus shifts from distant to near in the course of the chapter. Ruskin tends to adopt, by preference, an excursive rather than a sublime approach, to get at the whole through a study of its parts. In the first volume of *Stones* this shift in focus is explained differently. There Ruskin recognizes change in position and shift in focus as a necessary part of the viewing experience, concluding that one criterion of excellence in architecture must therefore be that it continue to make aesthetic sense, on some level, whether one looks at it from a great distance, a middle distance, or at very close range.[2] This description again postulates a kind of hierarchy of perception—sculptural programs and expressive handling become increasingly intelligible as one approaches a building—but here the hierarchy is a function of changes in the circumstances of viewing, not of the presence or absence of imagination or a high and sympathetic mind in the viewer.

At the same time, Ruskin begins to consider the language of architecture not as language for the few but as historical record or moral instruction for the many. *Seven Lamps* stresses the memorial function of architecture, to be achieved both directly through a usually symbolic sculpture and indirectly through the accidental age marks of the significant picturesque. Through sculptural iconography and through the picturesque, architecture is a record addressed to everyone (8.229–237). The implication that architecture uses languages everyone can read becomes explicit in *Stones*: Ruskin's first references to "symbolic language" in art which must be read occur in a book concerned with reforming the perceptions of ordinary tourists. The outstanding example of architectural language in Venice, according to

Ruskin, is the mosaics of St. Mark's—intended as a pictorial Bible for the illiterate (10.129–130). The modern tourist, like the medieval Venetian populace, can and should read the symbolic language of mosaic or sculpture. Reading architecture has become one part of the activity of looking at it. Reading no longer requires the exercise of rare gifts by the spectator.

But the artist in *Stones* is, after all, a common workman. Can the democratized response to visual language be extended from architecture to painting? At the end of *Stones* Ruskin thinks not. Tracing the rise of the English school of landscape to "a healthy effort to fill the void which the destruction of Gothic architecture has left," Ruskin finds painting less accessible to the spectator:

the void cannot thus be completely filled; no, nor filled in any considerable degree. The art of landscape-painting will never become thoroughly interesting or sufficing to the minds of men engaged in active life, or concerned principally with practical subjects. The sentiment and imagination necessary to enter fully into the romantic forms of art are chiefly the characteristics of youth; so that nearly all men as they advance in years, and some even from their childhood upwards, must be appealed to, if at all, by the direct and substantial art, brought before their daily observation and connected with their daily interests. No form of art answers these conditions so well as architecture, which, as it can receive help from every character of mind in the workman, can address every character of mind in the spectator; forcing itself into notice even in his most languid moments, and possessing this chief and peculiar advantage, that it is the property of all men. (11.226)

If painting is less accessible than architecture to seeing and reading, then architecture, not painting, must be the model for a complete, ideal art. Architecture "can address every character of mind in the spectator." This duty of all art to demand full and active perception of every spectator is assumed in the third volume of *Modern Painters* when Ruskin discusses how great art must arouse and guide the imagination of the beholder. But there it is painting, not architecture, to which he refers.

The increased emphasis on the symbolic languages of art in the later volumes of *Modern Painters* is not simply to be explained by Ruskin's original plan (to treat the simpler ideas of truth and beauty before the more complex ideas of relation). His interest in reading visual art is a

corollary to his growing conviction that all aesthetic perception is active and, to some degree, interpretive. Ruskin's program for the spectator is at first more affected by this new notion of perception than is his own approach to paintings. His study of architecture between 1845 and 1853 helps to precipitate a shift from unanalyzed practice to conscious instruction in how to see and read art. That instruction is further elaborated and extended to the reading of paintings in *Modern Painters III.* There the Victorian tourist, both reader and subject of *Stones,* is again invoked, but this time as the "eminently weariable" traveler through painted landscapes.

The imperative mood of Ruskin's "*Read* the sculpture" in *Stones* was not dictated solely by his discoveries about the nature of perception, however. His references to reading almost always suggest a real love, often felt with the force of a hunger, for multiple meaning in the visual aspects of things. The strong attraction to associative, nonlogical connections — extending from metaphor to puns — Ruskin shared with Turner (as Gage and Lindsay have emphasized),[3] but what for Turner was a secular habit of mind for Ruskin also possessed a potential religious significance. The religious significance of figural reading is particularly evident in *Stones.* Reading iconography enters Ruskin's program for the ordinary spectator in part because Ruskin was defining his own vocation as an extension of a universal religious duty to read the created and written Word.

The special character of Ruskin's approach to figurative language, as we now realize, was greatly shaped by Evangelical exegesis of allegory and typology in the Bible, a kind of reading in which he was thoroughly trained by his mother and by nineteenth-century Evangelical ministers.[4] Such reading presumed that the figurative language it interpreted was a "real" language, corresponding to a given external order. As Landow notes, Evangelicals maintained this assumption about the language of the Bible by virtue of a belief in literal inspiration.[5] Ruskin inherited from his Evangelical teachers a schizophrenic approach to language. On the one hand, most language must be considered conventional, psychological, and historical; to figuralism viewed in this light, associative readings or historical analysis would be an appropriate response. On the other hand, biblical language, literally the words of God, must be questioned for another order of knowl-

edge. Its figures could directly reveal the world from a divine perspective as opposed to a world refracted through the eyes and minds of particular cultures, periods, and individuals. The boundaries between these two kinds of language could not be neatly drawn. The Bible accustomed its believing readers to look at historical events both for their own instructive value and as types or antitypes of other events; by extension, natural objects were to be regarded for their own sakes and for their figurative significance. Reading for this kind of meaning was more than a habit; it had long been interpreted as a duty. Ruskin was quoting St. Paul, as many other Christian writers had done, when he wrote in *Stones* that "God would have us understand that this is true . . . of all things amidst which we live; that there is a deeper meaning within them than eye hath seen, or ear hath heard; and that the whole visible creation is a mere perishable symbol of things eternal and true" (II.183 [I Corinthians 2.9]).

The status of language in art and literature for an early nineteenth-century Evangelical was unclear. As a record of the world, it might impose the same interpretive obligation as the events and objects it signified. As language particularly rich in figures, the obligation might be even stronger, especially if it could be shown that artist or author employed types or figures from the Bible, or had painted or written with a desire to portray the world as typically or allegorically significant. Such reading was applied by Evangelicals to texts such as Bunyan's *Pilgrim's Progress* and Milton's *Paradise Lost.*[6] Yet by the beginning of the Victorian period it was widely recognized that any language reflected the minds of the individuals and the cultures that used it. When and to what extent should the languages of literature and art be read as a third sacred book (after the Bible and nature), and when as an expressive and historical language of the human imagination? The peculiar intensity with which Ruskin approached the interpretation of symbolic languages in art seems to come partly from the sense of urgency attached to religious exegesis, and partly from the difficulties of reconciling conflicting conceptions of language to meet the demands of dual interpretation.

Ruskin does not really face the question of the status of language in art until *The Stones of Venice,* but it is latent in *Modern Painters I* and *II.* Despite his emphasis on the expressive and associative character of great art in *Modern Painters I,* he praises it in terms of its relationship to

both the Bible and to nature considered as a divine book. Turner is a prophet of God and an angel of revelation (3.254,611,630–631); artists are like preachers commenting on the nature-Scripture (3.45n). Similarly, *Modern Painters II* explores human imagination in thoroughly romantic terms but also treats at length typical ideas of beauty and insists that art is valuable as it enables men to fulfill what is their primary function from a religious point of view, "to be the witness of the glory of God" (4.28). The conception of art as human witness to or commentary on the divine Word was, then, already in Ruskin's mind when he made his delighted discovery, in 1845, of a medieval Italian art and architecture whose subjects and iconography were directly drawn from the Bible. His excited letters to his father reflect both purely visual pleasure and the pleasure of textual recognition. From Pisa he reported: "the Campo Santo is the thing. I never believed the patriarchal history before, but I do now, for I have seen it . . . and the angels . . . it is enough to convert one to look upon them—one comes away, like the women from the Sepulchre, 'having seen a vision of angels which said that he was Alive.' "[7] He reveled in the churches "covered with holy frescoes—and gemmed gold pictures . . . all the church fronts charged with heavenly sculpture and inlaid with whole histories in marble."[8] The Italian art, even more clearly than Turner's, could be approached as a visual version of one of God's books.

As Ruskin begins to formulate his own identity as critic in the same year, he employs terms suggesting that he is thinking of the interpretation of art as a way of fulfilling the religious obligation to recognize deeper meaning in the created and written Word. He wonders, writing to his father, if his mission is really to study buildings and paintings.[9] A few years later he advises W. S. Stillman to pursue patient interpretation rather than prophecy or inspiration. His praise of religious reading suggests how much the distinction between religious exegesis and religious vision was on his mind in the period when he was making his own choice between artistic interpretation and artistic vision:

I can only imagine that by rightly understanding as much of the nature of everything as ordinary watchfulness will enable any man to perceive, we might, if we looked for it, find in everything some special moral lesson or type of particular truth, and that then one might find a language in the

whole world before unfelt like that which is forever given to the Ravens or to the lilies of the field by Christ's speaking of them . . . my advice to you would be on no account to agitate nor grieve yourself nor look for inspiration . . . but to go on doing what you are quite sure is right . . . accustoming yourself to look for the spiritual meaning of things just as easily to be seen as their natural meaning. (36.123–124)

The choice to read and interpret art is still more explicitly described as a discovery of religious vocation in retrospective accounts. In *Praeterita* Ruskin portrays 1845 as a year of discovering the power of art, beginning with the wall-scripture of Campo Santo and culminating, in Venice, with Tintoretto. His 1883 epilogue to *Modern Painters II* ties this series of revelations to a personal spiritual history. He set off for Italy, guiltily leaving his parents behind, "gloomy with penitence and ardent in purpose." In this temper of mind "the Campo Santo of Pisa was to me a veritable Palestine" (4.350). In both *Praeterita* and the 1883 epilogue, the vocabulary and structure of the accounts suggest that we are being told of a conversion experience. The final discovery of Tintoretto is its climax: Ruskin is called to criticism.

I . . . felt only that a new world was opened to me, that I had seen that day the Art of Man in its full majesty for the first time; and that there was also a strange and precious gift in myself enabling me to recognize it, and therein enobling, not crushing me. That sense of my own gift and function as interpreter strengthened as I grew older. (4.354)

The Stones of Venice is both Ruskin's first and his most sustained effort to combine religious and artistic reading in a single critical activity. The imperative *Read* embraces both religious and a more historical and psychological exegesis. Symbolic language in *Seven Lamps* and *Stones* is in fact a plural concept. Ruskin distinguishes at least four. The first is an invented symbolic language (the grotesques of sculptural or pictorial iconography, 11.182–183,205). There is also an "accidental" or "parasitical" language of the picturesque, where the marks of age record the action of the elements on human artifacts, recalling the effects of time on the most massive and enduring natural objects (effects that would be sublime) and on men themselves (8.235–237). Finally, there are two natural symbolic languages that art and architecture may also employ: the historical language of stones (the marks of

their development before they are used as human artifacts) and their theological language (II.38,41). The theological language of types is of course divine or "real"; what Ruskin calls the historical language of stones is also not a human one; it is the naturalistic basis for any real figurative language. The signs of the picturesque and the invented symbols of the grotesque are primarily human languages, however, though Ruskin has tried to bring them close to divine language. The marks of age in human artifacts resemble the historical language of stones — the signs of their natural history — but of course they depend upon the associating mind of the perceiver to function as language at all. They are conventional and associative signs, not real ones. The "symbolical grotesque" (II.178–184) is on the one hand a product of human imagination; on the other, of imagination in a state of inspiration. These symbols do not have the status of natural or biblical figures because in them meaning is refracted through the distorting glass of human perception, yet they do require religious exegesis because, though difficult and distorted, they may nonetheless be inspired vision.

When Ruskin reads Venetian Gothic in *Stones* he treats it as a thorough mixture of all these languages. Thus he points out that Venetian Gothic uses the natural grain of the marble in its designs — grain that could be read as natural history (II.38–39). It also exploits the varied colors of the stones, and color, according to Ruskin, has an allegorical meaning confirmed in the Bible (10.172–175; 7.417–419). Tourists to Italy will be especially responsive to the picturesque qualities of the buildings, the signs of age and decay, with their reminders of nobler mountain upheavals and of the endurance and suffering of the human builders — of fallen Venice.[10] The stones also possess a typical meaning, as the famous first lines of Ruskin's history point out: the fall of Venice may be a type of the future fall of England. Finally, Ruskin treats the carved stones as expressive of the minds of the workmen and of their social and economic relations with their employers. He also explicates the symbolic meaning of the figures both by comparing them to other versions (Spenser, Dante, Giotto, a selection of French manuscripts) — a procedure that stresses their historical nature — and by glossing them directly from the Bible.[11] Ruskin approaches the stones of Venice both as historical and artistic artifacts and as revelations of moral and religious truth.

The half-sacred, half-secular interpretations of visual symbolism in *Stones* are, however, firmly linked to the Christian obligation to read for figural significance. In a passage with important implications for his own criticism, Ruskin pauses in "The Vestibule" to Gothic Venice—the last chapter of volume one—to justify the work of the artist.

Is there, then, nothing to be done by man's art? Have we only to copy, and again copy, for ever, the imagery of the universe? Not so. We have work to do upon it; there is not any one of us so simple, nor so feeble, but he has work to do upon it . . . This infinite universe is unfathomable, inconceivable, in its whole; every human creature must slowly spell out, and long contemplate, such part of it as may be possible for him to reach . . . and in this he is only doing what every Christian has to do with the written, as well as the created word, "rightly *dividing* the word of truth." (9.409–410 [2 Timothy 2.15])

But art, as Ruskin describes it, goes beyond the Christian obligation to analyze the written and created word. One must not only "spell out, and long contemplate" what one sees, but also

set forth what he has learned of it for those beneath him; extricating it from infinity, as one gathers a violet out of grass; one does not improve either violet or grass in gathering it, but one makes the flower visible; and then the human being has to make its power upon his own heart visible also, and to give it the honour of the good thoughts it has raised up in him, and to write upon it the history of his own soul. And sometimes he may be able to do more than this, and to set it in strange lights, and display it in a thousand ways before unknown: ways specially directed to necessary and noble purposes, for which he had to choose instruments out of the wide armoury of God. (9.409–410)

Ruskin's everyman moves imperceptibly from seeing, reading, and explicating the significant creation to inscribing (writing the history of his own soul) and to imaginative vision (setting the flower in strange lights). When he reaches inscription and vision, Ruskin's everyman has become an artist. The critical activities implied for the spectator of this art, like the creative activities of the artist described in Ruskin's paragraph, are all embraced by the paragraph's final clause: "and in this

he is only doing what every Christian has to do with the written, as well as the created word." In fact the criticism this art implies has been extended to include the interpretation not just of divine but of human written and created words. Both art and criticism are justified by their connection with Christian exegesis. But Ruskin seems to make room, in his description, for historical and psychological dimensions of visual language which, as we have seen, very much concerned him as well.

I HAVE suggested why, apart from his original plan to defer discussion of symbolism in art, reading is a more important part of seeing in *The Stones of Venice* than it is in *Modern Painters I* or *II.* Urging every spectator to read architectural iconography was, by 1853, part of Ruskin's attempt to encourage more active, imaginative perception in the spectator-consumer as essential to cultural health. At the same time, such reading also fulfilled a religious obligation that Ruskin felt deeply, to read the divine languages of nature and the Bible, thus giving the sanction of a religious calling to his newly defined career as an art critic. In *Stones* the traditional, religious approach to symbolic meaning seems to be just what is needed to complete the reform of the modern tourist into a sensitive, historically self-conscious patron of the arts. After they have learned to look at Gothic architecture, travelers must learn to read the lessons of both carved stones and contemporary histories. In this first attempt to interpret the symbolic languages of visual art, Ruskin uses Christian exegesis as a model for all aspects of the tourist's encounter with symbolism in art.

Ruskin, however, continues to emphasize reading when he returns from his detour into architecture and history to what he later saw as his proper territory (35.372), modern painting. And in that territory the kind of reading he advocated in *Stones* seems—to twentieth-century formalists no less than it would have seemed to Hazlitt —decidedly out of place. One may read the mosaics of St. Mark's or even a Hogarth; one does not read a Turner. Imaginative modern art does not employ explicit symbolism, to be glossed by literary texts and translated into verbal interpretation, as a major part of its appeal to the spectator. "Literary" art is not good art. The judgment is very much a romantic one. Ruskin may seem at odds both with his subject, the great romantic painter, and with his own romantic criticism in *Mod-*

ern Painters I when he insists, in *Modern Painters V,* that we read Turner's paintings. But Ruskin's method of reading modern paintings can be traced to acceptable romantic responses as well as to traditional exegesis. He seems to have consciously tried, in the last two volumes of *Modern Painters,* to reconcile the two kinds of response to art on new grounds—this time thinking not just of the workman and the tourist in Gothic Venice, but of the romantic painter and his Victorian audience as well.

One can argue, though with some caution, that Ruskin's approach to Turner's painting in *Modern Painters V* has much in common with his more visual approach in *Modern Painters I.* His readings rely on the same habits of mind as his excursive and associative seeing. For example, both approaches are piecemeal methods. That is, they piece together a notion of a whole through attention to significant details. Starting from a belief in the necessary incompleteness of perception, both stress the need for constant reinterpretation from different points of view as the only way of approximating grasp of a total design. Again, neither is reductive, emphasizing instead the surplus of information in any sign. Words or images may always mean more than the sum of their figurative meanings. They have literal importance and multiple figurative significance; the two kinds of significance are overlapping but not exactly coincident. I have argued in earlier chapters that the piecemeal or excursive approach and the high valuation of unreduced visual detail in Ruskin's criticism of the visual arts owe much to a mode of seeing associated with gardens, travel, and associationist poetics. But one might also argue that these same traits, when they appear in Ruskin's readings of visual or verbal symbolism, are derived from the exegetical tradition with which he was so familiar.

The practical similarities between exegetical reading and excursive seeing may begin to suggest why and how Ruskin read Turner's paintings. Ruskin's argument for reading Turner's art as symbolic language is still more revealing. Ruskin evidently planned to conclude *Modern Painters* by showing that both Turnerian and biblical symbolism, though one was a human language and the other divine, required the same sort of reading. *Modern Painters IV* and *V* explore the physical effects of clouds on light as the natural phenomena in biblical metaphors of clouds as the veils, temples, robes, and dwelling places of God. This discussion prepares us for the final examination of Turner's

cloudy art. The term "cloudy" as applied to romantic art—by Ruskin in *Modern Painters III* and by other critics before him—describes both a major subject of that art and a technique—in painting, the use of light and color to fill space and suggest, without fully realizing, complex form. By extension, suggestive technique may also mean allusion or metaphoric suggestion to the associative imagination; hence the frequent use of mist or cloud as a figure for the imagination in the poetry of Wordsworth. When Ruskin dealt, in *Modern Painters V*, with what he rightly saw as Turner's highly metaphoric art, he used Turner's treatment of cloud, light, and color to discuss the special nature of imaginative symbolism in romantic art. But he also related that use of symbolic language, exploiting physical facts of light and color, to symbolic language in the Bible. In these last two volumes of his defense of Turner he set out, I believe, to use what he read as the biblical (and natural) metaphor for symbolic language, the clouded heavens, as his vehicle for bringing together allegorical and romantic symbolism.

Ruskin's second attempt to reconcile two approaches to symbolic language is thus an argument both from and through metaphor or, more precisely, two metaphors superimposed: the veil of allegory and the transforming mist or clouds of romantic imagination. Reading romantic art is justified not only as religious obligation but also as an appropriate *imaginative* response. But Ruskin's argument only makes sense if we look closely at the texts and paintings from which he takes his metaphors. For the biblical sense of the cloud-veil, Ruskin uses passages from Genesis and Psalm 19; for its modern meaning as a figure for imagination, he takes modern landscape painting and its poetic counterpart, typified by Scott.

In the middle of *Modern Painters IV* Ruskin starts his defense of Turner afresh, going back "to trace, with more observant patience, the ground which was marked out in the first volume" (6.104). The new treatment of the truths of nature (chapters on mountains, vegetation, and clouds) is specifically concerned with these truths as constituting a symbolic language that needs reading. These chapters explain visible aspect by detailed descriptions of physical composition and natural history, leading in each case to conclusions about the "typical signification" (6.153), "ministry to . . . man" (6.160) or "appointed" meaning (6.172) to be interpreted from natural phenomena. The section begins

and ends in the clouds—not Turnerian skies but the biblical firmament, which Ruskin interprets as a figure for the kind of symbolic language he is reading in the visible aspects of things. The section as a whole comes just before the closing section on invention in art, most of which is devoted to the discussion of painting as a "vehicle of thought" promised in the first volume. That section too begins in the clouds, the cloudy mirror of the human imagination. It comes to a climax with Ruskin's readings of two examples of Turner's cloudy symbolism. The notion of two kinds of symbolic language seems, then, to have determined the structure of these sections: one on the sacred languages of landscape, both historical and theological; followed by a second on the invented symbolism of imaginative painting. As in *The Stones of Venice,* where the two kinds of symbolic language are first recognized and distinguished, Ruskin wants not to separate them but to discover ways in which the second overlaps or coincides with the first

by examining what the real effect of the things painted—clouds, or mountains, or whatever else they may be—is, or ought to be, in general, on men's mind, showing the grounds of their beauty or impressiveness as best I can; and then examining how far Turner seems to have understood these reasons of beauty, and how far his work interprets, or can take the place of nature. (6.104)

This way of presenting his plan for ending *Modern Painters* still suggests the controlling analogy between the painter and the interpreter of nature's sacred text. The promised discussion of invented symbolism is subordinated to the duty—for both painter and critic—to interpret typical or intended natural meaning. By the time Ruskin actually writes the closing section on imaginative symbolism, that analogy has broken down. Nonetheless, Ruskin is faithful to what seems to have been his original intent: to find some means, metaphorical if necessary, for treating two kinds of symbolic language from a single critical perspective.

Ruskin's opening chapter on biblical clouds, "The Firmament," sets forth the exegetical techniques of the Evangelical sermon as the proper method for a renewed study of nature. This introductory chapter uses a reading of the opening verses of Genesis to reflect on the verbal and visual languages of God, much as Augustine, a central figure in the

earlier exegetical tradition, had used the same verses in the last three books of his *Confessions*. Ruskin is primarily interested in the created or visible Word, the divine language of Nature; Augustine, in the written Word, the divine language of the Bible. But both use the Genesis account of creation to draw an analogy between the written and the created word, and both turn their own interpretations of one or two verses into an examination of principles of reading and the nature of language applicable to created and written word alike. The comparison between the explications illuminates both what Ruskin shared with traditional patristic exegesis and where he departed from it.[12]

Both Augustine and Ruskin use the creation story not only to affirm parallels between the created and the written word, but also to elucidate a parallel structure of two different levels of truth within each divine language. Augustine distinguishes between the intellectual heaven of Genesis 1:1 and the created or visible heaven of Genesis 1:6-8, comparing the distinction to that between divine truth as it appears to the mind of God and as it is expressed in the language of the Bible.[13] The relation between the two orders of truth is that of division from the single truth to multiple, fragmented, and less perfect forms of it. This fragmented visible heaven, or readable language, imposes upon the Christian the duty of collecting and interpreting. If it is the nature of truth, in the world in which men must live and the Bible was written, to be multiple and divided, then perception and understanding are never single or complete. The only way to approach unity of comprehension is through analyzing, comparing, and gathering together many different perceptions of the "beautiful variations" of the universe or of figurative language.[14] Criticism, then, must expand and multiply meaning through "longer and more involved discussions" before it can contract it into a single whole.[15] This continual seeking and gathering together of bits and pieces of the truth—felt by Augustine as his most compelling desire and echoed much later in Milton's famous phrase[16]—could very well describe Ruskin's conception of the proper way to perceive a building or a landscape or a painting, or the right way to read a biblical text. We might also note that Augustine's attitude toward the visible creation, despite his desire to recover the undivided truth, is not reductive; the beautiful variations or many streams flowing from a single fountain[17] are a source of positive plea-

sure. Abundance and variety are highly valued in both verbal and sensible worlds. Here, too, an exegetical approach to visible things as divine language produces an attitude very similar to what we have identified as Ruskin's and traced through a secular tradition of landscape experience.

In his introductory chapter, Ruskin similarly contrasts a remote heaven, "the infinity of space inhabited by countless worlds" (6.111) or the "blackness of vacuity" in which the "intolerable and scorching circle" of the sun is set (6.113), with the nearer, finite, variable, and more easily visible aspect of the heavens described in Genesis 1:6-8, the "ordinance of clouds" (6.112). This relationship in the created world between infinite and finite, eternal and temporal, invisible or inconceivable and visible and comprehensible parallels the relationship between the whole truth of God and the divided or obscured truth of figurative language in the Bible. Ruskin's further and nearer heavens, however, realize Augustine's metaphors for their relationship as natural fact. Augustine's major metaphor, that the intellectual heaven or truth is *divided* into the created heaven or figurative language, becomes, in Ruskin's version, "by the mists of the firmament his implacable light [the sun] is divided, and its separated fierceness appeased into the soft blue that fills the depth of distance with its bloom, and the flush with which the mountains burn" (6.113).

A second common metaphor, in Augustine and allegorical tradition in general, speaks of figurative language as the veil of divine truth. In Ruskin's naturalistic interpretation of the metaphor this becomes

"In them [the clouds] hath He set a *tabernacle* for the sun" [Psalm 19:4]; whose burning ball, which without the firmament would be seen but as an intolerable and scorching circle in the blackness of vacuity, is by that firmament surrounded with gorgeous service, and tempered by mediatorial ministries . . . by the firmament of clouds the purple veil is closed at evening round the sanctuary of his rest. (6.113)

To the metaphors of dividing and tempering or veiling the truth Ruskin has added, on the authority of other scriptural passages, a third: that of housing or robing it in a gorgeous splendor of varied color, in the light-filled, colored clouds the Bible calls God's tent, temple, or tabernacle. Ruskin's cloudy heaven is both itself one of the veiled, divided, or apparelled manifestations of divine presence and a figure for divine symbolic language in general.

This figurative reference is brought out more clearly in a passage from *Modern Painters V*, the introduction to chapters on the physical nature of clouds, in which the creation is again recounted:

the heavens, also, had to be prepared for his [man's] habitation.

Between their burning light, — their deep vacuity, and man, as between the earth's gloom of iron substance, and man, a veil had to be spread of intermediate being; — which should appease the unendurable glory to the level of human feebleness, and sign the changeless motion of the heavens with a semblance of human vicissitude.

Between the earth and man arose the leaf. Between the heaven and man came the cloud. (7.133)

Here the function of the cloudy firmament is not only to veil but also specifically to "sign" — to be a language for human readers. Ruskin finds his authority for taking clouds as natural signs of divine manifestation from the Bible, citing some twenty-four passages in the course of his chapter on the cloudy heavens of Genesis 1:6-8. The effect of Ruskin's chapter, then, is to confirm, in the physical facts of nature, the literal truth of biblical figures and traditional exegetical metaphors for the relation of figurative language to divine truth. Or one might put it the other way around: he uses scripture as a guide to what aspects of the visible creation are intended to be significant. The Bible is source and authority for an explication of natural symbolism. In any case, we might note that Ruskin's chapter on the creation of the heavens diverges from Augustine's in two ways. Ruskin ties the biblical language much more closely to observed natural fact, and he also puts special emphasis on one aspect of clouds that neither Augustine nor the Bible especially brings out: their gorgeous color. The firmament as a veiled manifestation of divinity is specifically cloud through which light has been divided, appeased, and softened into color.

Like Augustine, Ruskin goes on to use his gloss on the creation story to offer rules for the right reading of biblical and of visible language. His precepts conform closely to contemporary Evangelical practice. The readings of stones or clouds or trees in the succeeding chapters follow and illustrate these precepts. Ruskin pays careful attention to discriminating signs by context, distinguishing stones of foothills from stones of high mountain peaks. He insists that we look first for details accessible to the ordinary eye. The literal — in the case

of stones, geological and physical—significance of these details is his first concern; other meanings must be consistent with physical or geological fact. Ruskin then compares the varying effects of these stone signs on human perceivers, drawing on literature and art as well as common experience for testimony. He collects multiple possibilities for symbolical meaning in stones or clouds—meanings for which the Bible, however, is the ultimate guiding text.[18] Here, as in *Stones,* Ruskin's exegetical practice is consistent with his excursive and associative habits and with his concern for detail.

Ruskin's stress on a naturalistic basis for biblical metaphors constitutes an argument for a *coincidence* of biblical and natural symbolism. As such it is a departure from the usual argument for God's two parallel, but separate, books, as made either in traditional patristic exegesis or by nineteenth-century Evangelicals. The departure is most evident in Ruskin's explication of Psalm 19, with which he concludes his section on natural symbolism (7.193-199). That psalm, as has long been recognized, breaks into two equal parts, the first in praise of the creation, the second in praise of God's law. It was often read as moving from a lesser to a greater revelation, but among Puritans or Evangelicals from the seventeenth to the nineteenth centuries, it was quite commonly interpreted as praise for the two equal books of God.[19] For example, C. H. Spurgeon, whose sermons Ruskin frequently attended in the late fifties and early sixties, begins his commentary by reaffirming the parallel revelations of the two books:

In his earliest days the psalmist, while keeping his father's flock, had devoted himself to the study of God's two great books—nature and Scripture; and he had so thoroughly entered into the spirit of these two only volumes in his library that he was able with a devout criticism to compare and contrast them, magnifying the excellency of the Author as seen in both. How foolish and wicked are those who instead of accepting the two sacred tomes, and delighting to behold the same divine hand in each, spend all their wits in endeavouring to find discrepancies and contradictions. We may rest assured that the true "Vestiges of Creation" will never contradict Genesis, nor will a correct "Cosmos" be found at variance with the narrative of Moses. He is wisest who reads both the world-book and the Word-book as two volumes of the same work, and feels concerning them, "My Father wrote them both."[20]

Spurgeon's pointed warning against the dangers of using science to disprove the literal truth of the Bible should remind us that Ruskin's reading is similarly defensive. He had himself, at least as early as 1851, felt "those dreadful Hammers" of the geologists as a threat to Evangelical belief in the literal truth of the Bible (36.115). His reading of Genesis and of Psalm 19 is likewise addressed to this threat.

But Ruskin's explication of Psalm 19 goes beyond Spurgeon's concerns to show that nature and revelation, of equal value, do not contradict each other. His reading seems intended to justify the figurative language of the Bible, not by showing that scientific natural history and the divine history of the Bible are compatible, but by showing how the biblical figures make precise and detailed reference to the physical facts of the natural world.[21] Ruskin seems to be arguing, in other words, not that the content of the two books is compatible or identical, but that they use the same language or symbolism, translated into different media. According to this view, nature and the Bible would be a closely related text and picture, to be considered or interpreted side by side—works in two media by the same author sharing a common symbolism and intended to be looked at together.

Ruskin reads Psalm 19 with a peculiar intensity and ingenuity not found in other commentaries. The psalm begins "The heavens declare the glory of God. And the firmament sheweth His handiwork" and moves to a description of the sun running through the course of the heavens, tabernacled in the cloud. Verses 7-14 praise the law in six terms: as law, commandment, testimony, fear, statute, and judgment. Neither Augustine nor anyone else that I have found attempts to distinguish between heavens and firmament in Psalm 19, much less to carry that distinction, as Ruskin does, into a reading of two kinds of verbal revelation in the second half of the psalm. Ruskin sees in the first part of the psalm a distinction between two manners in which the heavens or created things speak to men: as "the great vault or void, with all its planets, and stars, and ceaseless march of orbs innumerable," especially the sun; and as the firmament or "ordinance of clouds" (7.196). The former declare; the latter show, instruct, teach, or guide. The former are eternal, the latter variable, changing according to present circumstance in the world of the perceiver. Ruskin then goes on to find the same distinction running through the sec-

ond part of the psalm, between an eternal, fixed law (testimony, statute) that is simply declared and the word of God as it is modified to instruct men of varying capacities for understanding in a changing present. Commandment, fear, and judgment describe the law in its temporal or mediated form: addressed to the specific needs and acts of men of limited perception. Visible properties of sun and cloud are invoked to gloss this double-natured word. The gloss strongly implies that the second form of that word is figurative, or at least that it requires interpretation on the part of the reader. The law is fixed and clear; commandment is "often mysterious enough, and through the cloud" (7.198). Whereas the traditional reading of the psalm simply states that both the created world and the written word are the books of God, Ruskin's reading makes the psalm speak of the *nature* of divine language or, rather, its double nature, for which there are exact equivalents in the visible world and the verbal law. Furthermore, his reading points to one of the major conclusions he would draw from this fact: that the visual text and the verbal one have to be read together, the relation of firmament to heavens elaborating the relation of figurative language to direct revelation.

We can see also that the distinction Ruskin finds in Psalm 19 is a version of what runs through his writing on the perception of landscape and visual art, a distinction between two modes of seeing or comprehending. Only one of these modes is really possible for the ordinary man: the excursive exploration of particular aspects of a larger whole, or the interpretive reading of truth veiled in figurative language. The man of inspired vision may grasp the terrible sublimity of the law or look in the face of the sun, as Turner sometimes does, but even he will be unable to convey what he has seen except through an invented symbolic language. The man of ordinary perception will have to follow the commandments in order to know God. Seeing and reading, like moral action, are ways of approaching a desired state of knowledge. Moral, perceptual, and imaginative activity must be both continual and continually guided. Viewed in this light, seeing and reading *are* forms of moral action; they are the duty of every man, distinct from the privileged vision of the artist, poet, or prophet.

Just as Ruskin's exegetical background provided religious motivation for interpretive or critical activity, so it also provided a religious explanation of imaginative perception as distinguished from imagina-

tive vision—or the beholder's and reader's as distinguished from the artist's and poet's approach to visual and verbal language. In *Modern Painters IV* and *V* Ruskin begins from but alters traditional readings of biblical texts so that they describe two modes of revelation—direct and figurative—both of which may be found in nature or the Bible, but best understood when verbal and visual versions are considered together. His readings also imply two corresponding responses, but strongly suggest that cloudy revelation or figurative language will necessarily be the central concern of every reader and perceiver. His scriptural readings seem quite deliberately to lay the groundwork for a final discussion of Turner's cloudy art.

We can now see, I think, how Ruskin might have concluded *Modern Painters* by arguing that Turner's art was a faithful use of divine figurative language drawn from nature and the Bible. Turner's love of complex allusion (including the use of texts to accompany his pictures), his use of a naturalistic mythological symbolism, and the importance of colored clouds and a cloudy technique to his symbolic visual statements might all indicate that he was using the figurative language described—by Ruskin's reading—in Genesis and Psalm 19. Indeed, just before he explicates the psalm Ruskin points to Turner's paired engravings *Salisbury* and *Stonehenge* (ills. 14, 15) as examples, respectively, of the beneficent and fearful aspects of the divine language of clouds. Before we look further at Ruskin's readings of Turner in *Modern Painters V*, however, I want to go back to some of Ruskin's earlier comments on color and clouds in romantic painting and poetry. Ruskin had already in *Modern Painters I* extended to painting the romantic preference for an incompleteness or deliberate lack of finish which would demand imaginative participation from an audience. This suggestive incompleteness, taken as both sign of and stimulus to imagination, had been associated with mist and cloud in a long line of criticism and poetry, from Burke through Wordsworth and Shelley. Ruskin's characterization of modern art and literature as cloudy in *Modern Painters III* exploits this usual association with imagination and points out, in addition, that this art is both literally full of clouds and excessively gloomy (5.317-319,320-322). *Modern Painters III* considers romantic cloudiness in its most negative aspect. The defense of Turner that Ruskin begins here seems to be designed to demonstrate that romantic

cloudiness has been modified so as to avoid some of the negative aspects of modern landscape feeling and aesthetic technique.

That defense is made first with respect to Scott. As noted earlier, Ruskin calls Scott the representative romantic writer but dwells on a crucial distinction between Scott's landscape descriptions and those of other romantic poets. Like Turner, Scott does not employ pathetic fallacy. Scott is also important to Ruskin because his descriptions, again like Turner's paintings, are typically full of clouds and a slight melancholy feeling, without falling into what Ruskin views as two major weaknesses of romantic cloudiness, especially in painting: the absence of detail and the absence of color. In Scott's poetry "the love of natural history, excited by the continual attention now given to all wild landscape, heightens reciprocally the interest of that landscape, and becomes an important element in Scott's description, leading him to finish, down to the minutest speckling of breast, and slightest shade of attributed emotion, the portraiture of birds and animals" (5.350). The quotations from Scott that Ruskin chooses to illustrate his argument also demonstrate some very Turnerian effects of cloud and color, as in Scott's description of Edinburgh:

> The wandering eye could o'er it go,
> And mark the distant city glow
> With gloomy splendour red;
> For on the smoke-wreaths, huge and slow,
> That round her sable turrets flow,
> The morning beams were shed,
> And tinged them with a lustre proud,
> Like that which streaks a thunder-cloud.
> Such dusky grandeur clothed the height,
> Where the huge castle holds its state,
> And all the steep slope down,
> Whose ridgy back heaves to the sky,
> Piled deep and massy, close and high,
> Mine own romantic town!
> But northward far, with purer blaze,
> On Ochil mountains fell the rays,
> And as each heathy top they kissed,
> It gleamed a purple amethyst.
> Yonder the shores of Fife you saw,
> Here Preston Bay and Berwick Law;

> And, broad between them rolled,
> The gallant Firth the eye might note,
> Whose islands on its bosom float,
> Like emeralds chased in gold.[22]

Ruskin says nothing about the verbal skill of these lines; what he notes are the painterly habits of eye: "there is hardly any form, only smoke and colour . . . observe, the only hints at form, given throughout, are in the somewhat vague words, 'ridgy,' 'massy,' 'close,' and 'high'; the whole being still more obscured by modern mystery, in its most tangible form of smoke. But the *colours* are all definite; note the rainbow band of them—gloomy or dusky red, sable (pure black), amethyst (pure purple), green, and gold—a noble chord" (3.347-348). Such passages lead to Ruskin's praise for Scott's "colour instincts" (3.348); despite his modern cloudiness, "the love of *colour* is a leading element, his healthy mind being incapable of losing, under any modern false teaching, its joy in brilliancy of hue" (3.346).

These two differences between Scott's colorful, detailed descriptions and much romantic cloudiness are those Ruskin stresses in his discussions of Turner. Turner's lack of finish is never emptiness or absence of detail; his paintings are characterized by their abundance of visual material, presented in an incomplete and suggestive form. Ultimately his gloomy clouds become gloriously colorful. The first of these arguments for Turner's distinctive greatness we followed in some detail in *Modern Painters I*; it is also the burden of the chapters on "Finish" and "The Use of Pictures" in *Modern Painters III* and of those on "Mystery—Essential" and "Mystery—Wilful" in *Modern Painters IV*. The implications for the spectator of Turner's suggestive detail are particularly important to Ruskin. Turner's work is indeed designed to awaken imagination, but the spectator's imagination is never left free to follow its own train of visual and mental association wherever it pleases. Turner's paintings require continuous close visual attention, a prolonged and detailed exploration: like the language of scripture, the commandments of God, they are designed to guide and they must be followed, letter by letter or image by image. In his stress on the demands placed upon the spectator Ruskin is trying to correct what he considers a fault in romantic poetics. In "The Use of Pictures" he distinguishes between painting that will most please the romantic poet (Wordsworth is his example) and painting that is a significant imagi-

native achievement. The poet will prefer the splash of ink on the wall because he can use his own rich imagination to create whatever he likes out of it, but a great imaginative picture will be necessarily far more structured and detailed. It will also require the imaginative participation of the spectator—its technique will be suggestive—but the spectator's imagination will be guided, both visually and associatively. A great painting will deliver an impression of visual and imaginative unity *only* if the spectator follows its suggestions quite carefully, on the level of the smallest details of color, line, and composition.

The difficulty that Ruskin finds in romantic poetics—as I suggested in Chapter 2—is that there is no clear distinction between imagination in the poet or artist and imagination in the reader or spectator. The consequence is likely to be drastically lowered standards for poetry or art: the criterion of suggestive art can produce art that is, instead, simply vague. Ruskin saw the threat to literature as well as art—in Wordsworth's undervaluing of visual detail and separation of sight from thought, for example—but he was particularly concerned with the many inferior artists influenced by Turner and, more important, with the inability of the public to distinguish between Turner's cloudy pictures and the random splash of paint (soapsuds, flour, and spinach—as critics described Turner's late paintings).[23] It is important to realize that Ruskin is not rejecting incompleteness or suggestiveness of technique; on the contrary, his original defense of Turner in *Modern Painters I* singles out Turner's associative rendering of space and form as the major difference between his and earlier landscape art. It is also important, however, to see that Ruskin was suggesting a modification of the romantic aesthetic of incompleteness as it affected the experience of readers and spectators. His response to suggestive detail was, I think, much closer to an alert and sensitive experience of nonsublime scenery encountered in the course of travel; it was also, though, very much a characteristic of exegetical reading.

The second difference between Turnerian and romantic cloudiness is that cloudiness is associated with literal gloom or darkness in modern painting, whereas Turner, in the second half of his career, is preeminently the painter of clouds as brilliant light and color. Ruskin's objection to the gloom of modern cloud painting in *Modern Painters III* is both aesthetic and emotional or moral. He clearly values color on purely visual grounds, but he also connects attention to brilliant color

with cheerful or optimistic states of mind, and optimism and pessimism he links in turn with periods of faith and doubt. As early as *Stones* he calls color sacred and singles out the vibrant color of Venetian Gothic as a sign of religious temperament (10.172-175). With few exceptions, he finds no great colorists among modern painters. Like a small but growing number of English artists and collectors in the first half of the nineteenth century, Ruskin discovered color not only in the late Venetians — Titian had always been acknowledged as a great colorist — but also in the early Italian painters and — for Ruskin — in Venetian Gothic and illuminated manuscripts. All three kinds of highly colored art, of course, were products of an age of Christian faith. Use of color combined with religious subjects was evidently a major reason why Ruskin was drawn to the English Pre-Raphaelites. In their love of color the Pre-Ralphaelites had something in common with Turner as well as with the early Italians, but the Pre-Raphaelites and the medieval painters, as Ruskin takes care to point out, do not use the cloudy technique of Turner where color *suggests* space and form.

In 1851, when he compared Turner and the Pre-Raphaelites at length, he distinguished two ways of using color: in a technique of clear definition of detail, without modeling or depth of space; or in a technique of suggested detail with great attention to depth and fullness of space (12.359-360).[24] Ruskin leaves no doubt, in 1851, that he considers the second or cloudy technique superior because more imaginative. With their slow, painstaking method of covering a canvas detail by detail, rather than rapidly sketching in the whole design from the start, the Pre-Raphaelites would illustrate the process of attentive sight in the ordinary spectator rather than the marvelous grasp of the imaginative artist. Ruskin's attitude toward them is one of expectation and encouragement rather than of praise for achievement; he hopes that their attentiveness will be the basis of a future imaginative art. For the moment, one suspects, the Pre-Raphaelites were useful to him in his attempts to modify romantic approaches to imaginative art and literature. At least they might be useful, if he could convince his readers that Turner's cloudy paintings were based on a similar care for observed detail and for color — and demanded the same informed attention, as say, the botanical marvels in the foreground of Millais' *Ophelia*.[25]

But Ruskin saw a further link between Turner and the Pre-Raph-

aelites. They were not only colorists but interested in explicit symbolism as well. Hunt and Rossetti employed types and allegories taken directly from or modeled on the figures of scripture, as understood in exegetical tradition. Ruskin stressed in his reviews that these pictures needed to be read.[26] Use of typology made yet another link with the early Italian painters: medieval and nineteenth-century Pre-Raphaelites combined deliberate use of "that great symbolic language" of scripture and nature with great sensitivity to "the sacred element of color." Ruskin's discussions of medieval art and Pre-Raphaelitism might be read, then, as efforts to create the appropriate context for understanding how Turner's symbolic art modifies the gloom and the vagueness mistakenly assumed by critics, careless spectators, and inferior painters to be a sign of imagination in romantic art.[27] Within this context we might conclude that Turner's brilliant color and explicit symbolism indicate a kindred religious temperament, but one consciously working not in the manner of direct revelation, but rather in that figurative language "often mysterious enough, and through the cloud." The active, imaginative perception required of the romantic spectator of Turner's paintings could then be understood as a modern analogue for the moral activity of interpretation required of the reader of God's word in Psalm 19. Ruskin has considerably refined the meaning for a spectator of his first hyperbolic praise of Turner as "a prophet of God . . . standing, like the great angel of the Apocalypse, clothed with a cloud, and with a rainbow upon his head."

Ruskin's argument for reading the romantic symbolic art of Turner as one would read divine figurative language—if an argument by association and metaphor can be called an argument—depends finally on demonstration. That is, as with Ruskin's ideas about the proper visual response to paintings and landscape, metaphoric descriptions of that activity as traveling or perceiving light transmitted through cloud or as following scriptural commandment may prepare us for what Ruskin wants us to do by suggesting that certain attitudes or modes of perception will be appropriate. But the clinching argument, or the most important persuasive activity, is the experience he gives us of reading a Turner painting in his manner. *Modern Painters* begins with the stunning descriptions in which Ruskin takes his readers through Turnerian landscapes, delighting and sometimes overwhelming them

with what it means to *see* as Ruskin does. The fifth volume ends with examples of what it means to *read* romantic painting. These examples should, we expect, give experiential meaning to the cloud gazing developed so carefully in *Modern Painters III, IV,* and the first part of *V.* So they do—but the experience turns out to be an ironic version of the one we were led to expect. Before he finished his interpretations of Turner's symbolic art, Ruskin had changed his mind about both Turner's cloudy language and God's. His readings of Turner's *The Goddess of Discord in the Garden of the Hesperides* and *Apollo and Python* must be considered separately as a third attempt at a consistent approach to symbolic language.

Turner and Tradition

RUSKIN'S RETURN TO Turner at the end of *Modern Painters* pro-
duced a series of readings unlike anything that he had done before. The
painter he had celebrated as an angel of divine revelation now brought
a different message. His old master in the science of aspects had be-
come the master of a new art: the reinterpretation of traditional sym-
bolic language. This revision of language, Ruskin came to feel, was
the proper work of the imaginative artist—and also of the critic. Rus-
kin changed his methods of reading symbolic art and his conception of
his own critical role, particularly of the critic's relation to the artistic
tradition he interprets. His final word on Turner was also a final word
on the author of *Modern Painters* and an introduction to the author of
Unto This Last and *The Queen of the Air.* Behind his new understand-
ing of Turner, of reading, and of the links between art and criticism,
we can trace a third model for approaching the language of art: histori-
cal philology.

THE MAJOR development in Turner's painting style, Ruskin in-
sisted as early as *Modern Painters I,* was his increasing use of color rather
than chiaroscuro to suggest space and form (3.244-247). The pictures
Ruskin chose to explicate in *Modern Painters V* allow him, at least ini-
tially, to present the change from cloudy chiaroscuro to cloudy color
as a union of romantic technique with biblical and natural symbolism.
He sets out to show that Turner, too, was aware that the change in
technique was a triumph of moral and spiritual as well as artistic di-
mensions for the artist-hero—that Turner, too, looked on cloudy

color as the natural symbolic language of divinity. If Ruskin's readings are right, Turner dramatizes his own shift from chiaroscuro to color as the victory, first, of the god of light over a terrifying dragon of darkness (*Apollo and Python,* ill. 17) and later of the Homeric hero Ulysses over the smoky volcanic one-eyed monster (*Ulysses Deriding Polyphemus,* ill. 18), a victory again marked by the presence of Apollo as sun-god.[1]

To make his point, Ruskin begins with the earlier *Hesperides* (ill. 16), illustrating Turner's chiaroscuro style.[2] Ruskin's reading stresses the gloom of both tone and message in the painting. The garden's guardian dragon, which Ruskin identifies mythologically, using Hesiod, with storm clouds and consuming passions, appears as the literal and the figurative source of the discord that will finally burn Troy.[3] From the dragon's glacial, cloud-enveloped shape, stretched across the cliffs in the background, spread an overhanging gloom and the dark river that divides the garden and threatens to overwhelm its nymphs, the Hesperides. Ruskin identifies them as Aeglé (Brightness), Erytheia (Blushing), and Arethusa (the Ministering); in Turner's naturalistic terms, "light in the midst of a cloud," or sunset color. *Hesperides* suggests to Ruskin that for Turner cloudy gloom can function symbolically to indicate the inevitable consequences of consuming passions —a dark message coming from a terrible divinity, the ambiguous guardian dragon, who seems to be himself both source and punisher of evil.

In the second picture Ruskin discusses (ill. 17), the bright figure of Apollo slays a vaporous serpent who writhes downward into a pool of darkness. Ruskin points to the color in the clouds behind Apollo as a new element in Turner's work, a harbinger of the colored clouds that increasingly dominate his later compositions. He notes also that the association between Apollo and colored clouds occurs again in *Ulysses,* another painting about a heroic victory over a monster of darkness (7.411-412). Given the long traditions connecting Apollo with wisdom, purity, and healing, and his serpentine foe with physical and moral corruption, Ruskin concludes that Turner has associated his own artistic mastery of color and suggestive technique with the spiritual and moral victories embodied in the myths. And Ruskin finds Turner's association justified by the biblical symbolism of rainbow-colored clouds in Genesis 9:13.

The cloud, or firmament, as we have seen, signifies the ministration of the heavens to man. That ministration may be in judgment or mercy—in the lightning, or the dew. But the bow, or colour of the cloud, signifies always mercy, the sparing of life; such ministry of the heaven as shall feed and prolong life. And as the sunlight, undivided, is the type of the wisdom and righteousness of God, so divided, and softened into colour by means of the firmamental ministry, fitted to every need of man, as to every delight, and becoming one chief source of human beauty, by being made part of the flesh of man;—thus divided, the sunlight is the type of the wisdom of God, becoming sanctification and redemption. Various in work—various in beauty—various in power.

Colour is, therefore, in brief terms, the type of love. (7.418-419)

This passage recalls those earlier portions of *Modern Painters IV* and *V* that we have already examined. Ruskin invokes modern theories of light and perception to give a new, naturalistic basis to Augustine's reading of the created heavens. Those heavens, as atmosphere or clouds, act as a prism to divide sunlight into varied color. Ruskin translates Augustine's emphasis on the varied *forms* of creation into terms that suit romantic, and particularly Turnerian, art: the beauty of the visible divine creation is the varied color of space and cloud. Color is then the type of a merciful, redemptive divine symbolic language; and clouds, or cloudy and suggestive technique, are the means by which both color and significance are produced. In *Apollo,* the purifying significance of the colored cloud is indicated through a naturalistic rendering of myth, just as in *Hesperides* naturalized mythology indicated a terrifying divinity speaking through the dark storm cloud. In these two paintings, as in *Salisbury* and *Stonehenge* (ills. 14, 15), Turner's language and message coincide with scripture and nature. The triumph of light and colored cloud is the triumph of a loving divinity as it ministers—and speaks—to men.

Here, then, is the framework for a conclusion to *Modern Painters.* The hyperbolic description of Turner in *Modern Painters I* can, after all, be justified. The artist who turned from gloomy to colored cloud took up God's language to announce that the natural world did testify to the victory of light and love over monstrous powers of darkness and discord. Ruskin's reading of *Apollo* completes the metaphorical link he set out to create between Turner's brilliant art of clouds and the cloudy revelation of nature and the Bible.

But Ruskin's reading does not end here. Out of the dying Python, he points out, crawls a small serpent, identical with the small snakes that Turner repeatedly uses to signify the presence of some ominous evil in an otherwise paradisical landscape. In *The Bay of Baiae*, the serpent is a reminder that Apollo's gift of all-but-immortal life to the beautiful Sibyl was flawed—he did not grant her immortal youth. In *The Golden Bough* (ill. 25) the serpent is a reminder of the dark powers the hero Aeneas—who is shown arriving at his promised paradise, Italy, and being greeted by the same beautiful Sibyl—must confront when she conducts him on a Ulyssean journey to the underworld. Adding up the evidence of these pictures, Ruskin laments "Alas, for Turner! . . . In the midst of all the power and beauty of nature, he still saw this death-worm writhing among the weeds . . . He was without hope" (7.420-421). In the space of a few paragraphs, Ruskin completely reverses the reading toward which he seemed to be moving. Turner's color cannot, Ruskin goes on, be read as the type of a beneficent and purifying love, a divine promise manifested in the beauty of the natural world. Whatever symbolic associations the colored clouds may carry are, he concludes, simultaneously questioned by the continued power of darkness and death suggested in the paintings. For Ruskin's Turner the Hesperid Aeglé, sunset color, is literally a child of Night, sister of "Censure, and Sorrow,—and the Destinies" (7.421). The rose-tinted clouds of Turner's *Apollo* may very well anticipate his new use of color, but if so they anticipate not only his association of brilliantly colored landscapes with the triumph of beauty and love, but also his association of that beauty with delusion, betrayed hopes, and eventual death.[4] The central "fallacy of hope" (Turner's title for his poetry) for Turner, Ruskin came to believe, was the fallacious promise of light and color themselves—the subject of *Apollo, The Bay of Baiae,* and the terrifying *The Angel Standing in the Sun.* This is the revised interpretation of Turnerian cloudy symbolism with which Ruskin actually concludes *Modern Painters.* "What, for us, his work yet may be, I know not. But let not the real nature of it be misunderstood any more" (7.421).

The "Alas, for Turner" is an "Alas" for Ruskin too. In the concluding chapters he largely shares what he reads as Turner's highly pessimistic vision. Turner's paintings seem ironically to *reverse* the biblical or

Christian visions he once thought they so gloriously confirmed. This sense of ironic reversal marks Ruskin's own view of what happens to traditional symbols used to express contemporary values. The structure of the *Apollo* chapter, where the reading turns completely around on a single detail, is one example of a pattern of shocking or ironic about-face which Ruskin uses repeatedly in his social criticism from *The Stones of Venice* on — here applied for the first time to Turner.[5] Turner has, in a sense, become Ruskin's ally as much as his subject in these pages, his ally as a contemporary social and cultural critic.

I shall come back to Ruskin's new methods of reading, but I want to look first at some passages where what is happening is not so much interpretation as assimilation. In these passages, at the ends of chapters after the critical work on Turner has been completed, Ruskin draws on Turner where he would once have used the Bible. Or rather, Ruskin's figurative language is both biblical (and Greek) and Turnerian; but it is Turner's reinterpretation of traditional symbolism, frequently carrying with it an ironic sense of distance and change, which Ruskin now adapts to his own uses. His chapter on *Hesperides* ends with an extended allusion to Turner's painting by means of which Ruskin expresses his own equally pessimistic thoughts — his sense of the disintegration of modern faith and the destructive influence of modern work. In a sequence of contrasts (not a reconstruction of historical influence) Ruskin juxtaposes, first, Perugino's paradises of clear light and color, presided over by Madonnas, with the modern British "paradise of smoke" in *Hesperides*, presided over by a gloom-spreading dragon wrapped in a sulfurous halo. The second juxtaposition, also Ruskin's and not Turner's, puts Dürer's celebration of the hopeful strength of sorrowful labor, his *Melancholia* "with eagle's wings, and . . . crowned with fair leafage of spring" (7.314), next to a modern celebration of the spirit of work, for which Ruskin again takes Turner's gloomy false guardian, the dragon "crowned with fire, and with the wings of the bat" (7.408). In Ruskin's paragraphs Turner's dragon is used as an emblem of consuming as opposed to productive labor, a destructive deity — the perversion of Carlylian work-as-worship which has usurped all other faiths in contemporary England. This concluding passage, where Turner's painting has become part of Ruskin's own symbolic vocabulary, should not be confused with Ruskin's reading of

Turner's painting; it is instead a deliberate extension of interpretation for the purposes of cultural criticism.

The most important of Ruskin's appropriations of Turner's symbolism in *Modern Painters V* is his use of *The Angel Standing in the Sun* (ill. 19) in the concluding paragraphs of "The Two Boyhoods." I want to look at it in some detail because it provides such striking evidence of Ruskin's new understanding not only of Turner but of his own role as a critic interpreting and reusing the symbolic language of art. The angel in Turner's painting may well be the artist himself; the painting may be Turner's ironic response to the criticism of his late works, including both hostile comments on his blinding color (the figures in the foreground flee the angel standing in the midst of what is indeed a blinding yellow-white sun) and Ruskin's own hyperbolic praise of Turner as an angelic prophet of revelation through sun, cloud, and rainbow.[6] Ruskin, at any rate, seems to take the painting as an accurate emblem of Turner's vision. His allusion to it in *Modern Painters V* indicates that he now believes that that vision can in no way be equated with the ecstatic revelation of God's beautiful world for which he had once praised Turner.

Ruskin's reference to the artist-angel standing in the sun depends in part on an earlier chapter, "The Dark Mirror" (the first chapter of his concluding section on symbolic meaning in landscape art). The dark mirror of the title is the human imagination, as it had been in the discussion of grotesque symbolism in *The Stones of Venice*. Mirror and cloud are cognate metaphors; both transmit light from a source outside themselves to viewers, but with some alteration of the transmitted light (dimming, distorting, dividing, refracting, reflecting). In the earlier work the action of the mind-mirror was closely parallel to the action of the created and written word, the cloud of *Modern Painters IV*.

Most men's minds are dim mirrors, in which all truth is seen, as St. Paul tells us, darkly . . . so that if we do not sweep the mist laboriously away, it will take no image. But, even so far as we are able to do this, we have still the distortion to fear . . . And the fallen human soul, at its best, must be as a diminishing glass, and that a broken one, to the mighty truths of the universe round it . . . so far as the truth . . . is narrowed and broken by the in-

consistencies of the human capacity, it becomes grotesque; and it would seem to be rare that any very exalted truth should be impressed on the imagination without some grotesqueness; in its aspect, proportioned to the degree of *diminution of breadth* in the grasp which is given of it. (II.180-181)

In *Modern Painters III* Ruskin extended the dimmed and distorted grotesque imagery to include "nearly the whole range of symbolical and allegorical art and painting" (5.132).

Despite the "inconsistencies of the human capacity," Ruskin was confident, in *Stones* and *Modern Painters III*, that the mirror-mind could convey sacred truth (5.134). Grotesque symbolism could be read. As he explained in *Stones*, the mist (associated both with obscuring "passions of the heart" and with an equally obscuring "dulness of heart") we can sweep laboriously away while we can "allow for the distortion of an image" (II.179-181). Interpreting symbolic vision in art was not only parallel to interpreting the created and written word, but dependent on it: holding fast to the Bible as revealed truth we can gauge the extent of the distortion in imaginative vision and allow for it in our reading. In *Modern Painters V*, however, the dark mirror of the human mind is our *only* access to sacred light.

"But this poor miserable Me! [Ruskin's imaginary reader objects] Is *this*, then, all the book I have got to read about God in?" Yes, truly so. No other book, nor fragment of book, than that, will you ever find; no velvet-bound missal, nor frankincensed manuscript; — nothing hieroglyphic nor cuneiform; papyrus and pyramid are alike silent on this matter; — nothing in the clouds above, nor in the earth beneath. That flesh-bound volume is the only revelation that is, that was, or that can be. In that is the image of God painted; in that is the law of God written; in that is the promise of God revealed. Know thyself; for through thyself only thou canst know God.

Through the glass, darkly. But, except through the glass, in nowise . . . through such purity as you can win for those dark waves, must all the light of the risen Sun of Righteousness be bent down, by faint refraction. (7.261-262)

Denying the Bible and nature as revealed truth, as Ruskin does here, will drastically alter the reading of "broken truth" or symbolic meaning in imaginative art. The sacred truth transmitted in symbolical visions can no longer be reconstructed with any certainty.

Ruskin does not deny that the symbolism of human art can convey absolute religious truth; quite the contrary, he goes out of his way to reaffirm his belief that "the soul of man is still a mirror, wherein may be seen, darkly, the image of the mind of God" (7.260), and that great imaginative vision in particular is divinely inspired (19.309). But from the point of view of the reader, it looks as if he might just as well dispense with mirror and cloud metaphors altogether. The symbolic meaning in art or literature may be divine, but it cannot be interpreted. At the end of "The Dark Mirror" it seems that the cloud-mirror has in fact disappeared: "Therefore it is that all the power of nature depends on subjection to the human soul. Man is the sun of the world; more than the real sun. The fire of his wonderful heart is the only light and heat worth gauge or measure. Where he is, are the tropics; where he is not, the ice-world" (7.262). This looks like a perfect case of mirror turned lamp, Ruskin having finally adopted a wholly romantic and expressionist theory of art — or perhaps, given his wider concern with the nature of perception, arrived by one leap in the twentieth century as a full-fledged phenomenologist. But that is surely not Ruskin's position, and mirror and cloud metaphors (and myths) for a symbolic language that is both human and divine are not gone for good from Ruskin's writing.

If we look somewhat more closely at this passage and the one just before it ("But this poor miserable Me . . . by faint refraction"), we can see that the shift from mind-as-dark-glass to mind-as-sun is not a reversal of position but a shift in point of view. To the beholder of landscapes or the reader of landscape literature and art, man "is the sun of the world; more than the real sun" —

all true landscape, whether simple or exalted, depends primarily for its interest on connection with humanity, or with spiritual powers. Banish your heroes and nymphs from the classical landscape — its laurel shades will move you no more. Show that the dark clefts of the most romantic mountain are uninhabited and untraversed; it will cease to be romantic. (7.255)

This is in fact a restatement of the role of association in perception, as Ruskin had asserted it in *Modern Painters III*. In the case of landscape art, the human associations that give landscape meaning come not only from figures or buildings in the landscape, but from our sense that the

composition is itself a reflection of mental process—the sun that illuminates landscape in art is the mind of the beholder, which is in turn guided by the mind of the artist.

But as Ruskin goes on to point out in the next chapters of *Modern Painters V*, he does not mean to imply that the mind-sun is its own landscape: "[man] cannot, in a right state of thought, take delight in anything else, otherwise than through himself. Through himself, however, as the sun of creation, not as *the* creation. In himself, as the light of the world. Not as being the world" (7.263). As in *Modern Painters III* the perception of an object was inseparable from the garland of associated thoughts through which it was seen, so here the mind cannot really grasp and enjoy the world except as the mind itself illuminates it. But there, as here, what we see is not simply the garland or the light of our own sun-minds. Despite Ruskin's romantic interest in the role of associative imagination, he always insists that perception is obtaining information about a world out there.[7] To forget this, and adopt a wholly phenomenological model of vision, is to pervert the function of sight. Sight must establish the "due relation" of man "to other creatures, and to inanimate things." When man no longer uses perception to gain information about a world beyond himself, "instead of being the light of the world, he is a sun in space—a fiery ball, spotted with storm" (7.263).

Ruskin, then, adopts the sun metaphor for imaginative perception—quite possibly Turner's own—only with reservations. He retains cloud and mirror metaphors, apparently to express what has ceased to be firm belief (demonstrable by reference to the Bible) and become only undemonstrable hope: that the associations and the symbols in which "information" about the outside world is embedded have also a source outside the individual mind; that the mind reflects or refracts a light it cannot see. For beholders who are interested, as beholders for the most part should be, in information about the world in which they live, the mind is its sun—the beholder's mind and the mind of the artist who shows the world in a different light. But for beholders who want to ask metaphysical questions—and readers of symbolic art will no doubt be faced with such questions whether they like it or not—Ruskin would prefer to keep the cloud or mirror figure for the mind. Without it, after all, it is no longer possible in the world that Ruskin now describes to discover any images of divinity. There is

no divine authority for the symbolic language of nature, such as the Bible once provided: natural or typical symbolism is all regarded as a product of human imaginative perception. (Natural facts themselves are not imagined, but the symbolical meanings of those facts are.) If the light of the human mind is not a reflection or division or refraction of some higher intelligence, then there can be *no* language to tell us about divinity.

The sun and the cloud-mirror: Ruskin's terms for alternative ways of viewing the function of art and the artist. The sun-mind illuminates the world by its own imaginative perception; the cloud or mirror-mind transmits the light of sacred truth. Ruskin seems deliberately to pose alternatives, and here one must, I think, see the choice as first of all a compelling personal one. Is he to concentrate on seeing the world (in the increasingly frightening vision of a Turner) or on discovering the transmitted light, the image of divinity? The terms in which Ruskin conceived art before 1859 did not force this choice. To look at the world in nature or in art was then to see images of divinity, imagery easily read against the parallel text of the Bible. In *Modern Painters V* the two aims are incompatible. Ruskin chooses "to stoop to the horror, and let the sky, for the present, take care of its own clouds" (7.271).[8]

In this context we can better understand Ruskin's renewed depiction of Turner as an angel in the sun—this time not as a prophet of merciful revelation, but as the outsize figure with the raised sword (an angel of death, according to the accompanying verses[9]) standing in the blinding glare of a sun that has all but usurped the canvas. Apart from angel and sun, Turner's painting contains only a few foreground figures fleeing through no clearly recognizable space. How does Ruskin take this angel as his emblem of Turner? First of all, we can note that the allusion to *The Angel Standing in the Sun* comes at the end of a chapter contrasting Turner with Giorgione. In that contrast the two painters' manners of showing natural light in outdoor scenes is an important element and acquires, not unexpectedly, a figurative meaning. The Venetians, as Ruskin often pointed out, did not actually paint the sun in the sky; to introduce the sun into painting was Claude's great achievement. Giorgione sees Venice under "the limitless light of arched heaven and circling sea" (7.375), with no single source of light specified. The illumination may be read as natural, human, or

divine; Ruskin implies that for Giorgione, living in an age of faith, there is no distinction among the three. The light of the mind and the light of nature *are* the divine light. No sense of loss or mystery requires the artist to paint an intervening medium or to locate the source of light. Turner, Ruskin notes, at first follows Claude and the Dutch painter Cuyp, placing the sun visibly in the sky along with the clouds, but painting the sunlight as a golden glow diffused through air or cloud and mist (7.410–411). The young Turner sees a hazy London through fog or dusty sunbeams, loving the diffused light as much as the sun itself, but apparently accepting the visible light as an altered and diminished version of the original sunlight (7.376).

Turner later changes his treatment of sun and cloud, and here Ruskin's *Modern Painters V* version differs from his early version of the significance of this change. The later Turner abandons the golden glow of sun through cloud for a sun that fires surrounding clouds — and eventually land and sea and even shadows — pure scarlet (7.411–413). In *Modern Painters I* Ruskin interprets this sun as the light of divine revelation, with Turner himself as the revealing angel. Clouds serve to glorify this light, and sun, clouds, and rainbow color are all given into Turner's hands to celebrate the beauty of God's world. The clouds are neither divine veils nor human mirrors or mists; they simply enhance, without obstructing, the glory of the sun. In *Modern Painters V* Ruskin reads the victory of light and colored cloud over obscuring mist not as a return to an older faith, but as a statement of the power of the artist's vision: artist and sun are closely identified in *Apollo* and *Ulysses*. The triumph of the sun, Ruskin believes, is Turner's statement about the triumph of the artist as hero, not the artist as the servant of God.

There is a change not only in what Ruskin identifies as the source of illumination in Turner's late paintings, but also in what he sees that light as illuminating. In *Modern Painters I*, when Ruskin stands on the mountain top with Turner, he sees a magnificent natural world with no human inhabitants (3.415–419). In *Modern Painters V*, when he looks at what the Apollo-artist's vision illuminates, he discovers that it shows us as much about the nature of darkness — death, disease, and moral evil — as about the triumphant power of light. The bright Apollo reveals the small serpent reborn. *Ulysses* shows us the interaction of water and underground fire which produces volcanic action: the Polyphemus-volcano is about to erupt as the giant hurls a rock at

the departing Ulysses. We know from Homer that later the sea god Poseidon, invoked by the volcanic Polyphemus, will produce the storm that wrecks Ulysses. The Apollo-artist's victory still gives new life to the Python; the hero Ulysses' victory rouses the storm that will destroy his companions.

Turner's two late paintings, *Light and Colour: Goethe's Theory. The Morning after the Deluge. Moses Writing the Book of Genesis* (1843) and *The Angel Standing in the Sun* (1846), use an iconography similar to that of *Apollo* and *Ulysses*.[10] Both depict overwhelming suns associated with figures that probably stand for the artist; both also illuminate a world in which an expected purge of evil has not, after all, occurred. Moses records the events illuminated by the blinding sun in which he sits. Those events are represented through the bubble faces rising from the receding flood waters — bubbles that may reflect both the drowned population of the old world (gas released from their decomposing bodies by the sun) and the future population of the purified world. The new life is not only identical with the old; Turner's bubble symbolism, made explicit in the accompanying lines of his poetry, assures us that anything hopeful about the new life will be as ephemeral as the old.[11] Death, decay, and moral corruption are still part of the postdiluvian universe. In *The Angel Standing in the Sun* the angel seems to be simultaneously the angel of the fiery sword driving Adam and Eve (who look in horror on Cain and Abel, revealed to them by sun and angel) out of Eden, and the angel who calls the vultures to "the feast of God" to dine on his enemies, presumably the fleeing wrongdoers in the foreground. In Milton and the Bible, there is another side to the judgment of God in both Genesis and Revelation: the promise of a future salvation. That promise is not revealed by Turner's angel, whose blinding light shows us only a long series of murders.

The defeat of hope on which we are made to look in all of these paintings becomes progressively more terrible as the triumph of light and color — the triumph of the artist — becomes more overwhelming. In the last two pictures we can hardly look at the sun. We are almost forced, like the people fleeing the angel in the last painting, to look away. Here in fact the sun for the first time has not created and filled space but abolished it: the sun is pure color, paint without depth or mystery, pushing to the front plane of the canvas until it nearly crowds the fleeing figures out of the picture. They are still there — but

they are all that is left of the world of natural beauty, the receding spaces filled with various form and color that Ruskin celebrated in Turner's greatest paintings as the creation of the sun-artist working through the atmosphere. As Ruskin saw it, Turner's sun, the sun of the artist's mind, was finally turned implacably on the facts of life in this world. Ruskin had argued at length in the preceding chapters that such moral realism had been a characteristic of art in all the greatest periods, including classical Greece and the late middle ages and early Renaissance. In most of his work Turner had been the painter of a dynamic natural beauty and power surrounding, at times engulfing, human labor, sorrow, and death. But in *The Angel* the world of natural beauty has disappeared. Turner's vision, Ruskin suggests, is a modern version of the fully humane but pessimistic vision of Homer or Tintoretto or Dürer, a vision of a universe of death:

the English death—the European death of the nineteenth century—was of another range and power; more terrible a thousand-fold in its merely physical grasp and grief; more terrible, incalculably, in its mystery and shame . . . [Turner] was eighteen years old when Napoleon came down on Arcola. Look on the map of Europe and count the blood-stains on it, between Arcola and Waterloo.

Not alone those blood-stains on the Alpine snow, and the blue of the Lombard plain. The English death was before his eyes also . . . life trampled out in the slime of the street, crushed to dust amidst the roaring of the wheel, tossed countlessly away into howling winter wind along five hundred leagues of rock-fanged shore. Or, worst of all, rotted down to forgotten graves through years of ignorant patience, and vain seeking for help from man, for hope in God—infirm, imperfect yearning, as of motherless infants starving at the dawn; oppressed royalties of captive thought, vague ague-fits of bleak, amazed despair.

A goodly landscape this, for the lad to paint, and under a goodly light. Wide enough the light was, and clear; no more Salvator's lurid chasm on jagged horizon, nor Dürer's spotted rest of sunny gleam on hedgerow and field; but light over all the world. Full shone now its awful globe, one pallid charnel-house,—a ball strewn bright with human ashes, glaring in poised sway beneath the sun, all blinding-white with death from pole to pole,—death, not of myriads of poor bodies only, but of will, and mercy, and conscience; death, not once inflicted on the flesh, but daily fastening on the spirit; death, not silent or patient, waiting his appointed hour, but voice-

ful, venomous; death with the taunting word, and burning grasp, and in-
fixed sting. (7.387–388)

Although Ruskin makes no mention of Turner's painting by name in
this description, both are apocalyptic visions of a world of death, lit by
a blinding light and presided over by a figure of death. In the follow-
ing paragraph Ruskin goes on, in fact, to address the reaping angel of
Revelation.

Ruskin, I have suggested, would have had a number of reasons for
alluding to this painting in constructing his own emblem of Turner's
vision. It most fully exemplifies his new view of Turner as a painter of
the sorrow of human life and death. It was, moreover, part of a dia-
logue with Turner begun with Ruskin's description of him in *Modern
Painters I*, to which Turner's painting must have seemed, by the late
fifties, a deservedly severe reply. Casting the artist as this different
angel, Ruskin could accept—too late for Turner to know—the correc-
tion and acknowledge his former misreading of Turner's mind and art;
"let not the real nature of it be misunderstood any more." At the same
time, this picture of a cloudless, all-powerful sun, turned full on hu-
man misery and death, is a fitting emblem for the choice that Ruskin,
too, makes in *Modern Painters V*: to abandon the attempt to read a
hopeful divine message in the cloudy language of natural types or the
Bible and to use, instead, the sun of the human mind "to stoop to the
horror, and let the sky, for the present, take care of its own clouds."

There were also reasons why Ruskin might prefer not to invoke
Turner's painting by name. Although it could serve very well as an
emblem of Turner's last vision, the painting was not, Ruskin believed,
a good one[12]—in part probably because Turner abandons the represen-
tation of naturalistic space. Furthermore, Ruskin is here not interested
in giving a critical account—descriptive or interpretive—of Turner's
painting, but rather in using Turner's imagery as part of his own vo-
cabulary, to say something about Turner—and, directly or indirectly,
about himself. To refer to the painting by name would only lead his
readers to judge the passage by the accuracy of its description or inter-
pretation, not the issue here.

In technique these paragraphs recall the passage in *Modern Painters I*
where Ruskin describes what the Turnerian artist sees from a moun-

tain top. As his notes there indicate, that vision is woven together from a composite of Turner's own paintings and, probably, Ruskin's kindred visions. Here too Ruskin uses his own imagery joined to imagery from more than one Turner (the blood-stained Alpine snow surely comes from Turner's *Hannibal*, with its allusions to Napoleon; the winter wind and rock-fanged coast recall any number of Turner's early sea paintings).[13] Yet both the imagery and the effects are different. In *Modern Painters I* the paintings of the artist and the descriptions of the critic are virtually indistinguishable, with the result that the critic seems almost to be competing with his artist as a man of high imaginative vision. Ruskin's understanding of Turner changed as he moved from describing paintings to interpreting them; his understanding of what he himself was doing changed no less radically. His sense of himself as critic—critic of art, of perception, of culture, of society—in *The Stones of Venice* and the intervening volumes of *Modern Painters* at first serves to create a critical distance between Turner and Ruskin which was not present in the first volume. There are no more passages, like that at the end of "The Truth of Clouds," in which the painter and his critic see with the same eyes and speak with the same voice.

With Ruskin's description of "the English death" at the end of *Modern Painters V*, artist and critic come together again. The grounds of their shared vision have greatly altered. In the first place, the power Ruskin assimilates from Turner in this passage is a critical power, not of revealing and rejoicing in what is eternally right and beautiful and true in the natural world, but of pointing out what is wrong in the contemporary human world, an historical world. This is, of course, an identity that Ruskin has already made his own before this second meeting with Turner. Turner's critical method becomes Ruskin's: to use familiar symbolic imagery in a contemporary context, producing a sense of distance and irony as well as of familiarity.

There is a second conjunction between critic and critical artist in this passage. In *Modern Painters I* Ruskin's prose translates a primarily visual experience. His words add energy, cinematic sweep, a temporal dimension, and occasionally a supratemporal reference to recognizably Turnerian landscapes. The Turnerian paragraphs of *Modern Painters V* combine images to produce a complex symbol that no one will confuse with a real landscape. Furthermore, the imagery is as much verbal as

visual. The blood-stained snow, bodies crushed to dust, or rock-fanged coast can be visualized, and have been by Turner, but "infirm, imperfect yearning," "oppressed royalties of captive thought," and "vague ague-fits of bleak, amazed despair" are Ruskin's and they cannot be visualized. Ruskin's prose here is no longer descriptive. He is, in a sense, creating a text to go with Turner's images, a text that incorporates and extends and interprets them. The two kinds of imagery are deliberately brought together in a single symbolic statement. For this new use of his visual sensibility and verbal virtuosity, Turner's own practice could of course have served as model. Ruskin had recently reencountered Turner when he set out to read as well as look at his art. That reencounter—which must have taken place over a period of time, probably between 1856, when he began work on the Turner bequest, and the winter of 1859–60, when he wrote the last sections of *Modern Painters V*—had as profound an effect on Ruskin's writing as the first encounter, reflected in *Modern Painters I*.

Artist and critic are not, however, so closely identified in *Modern Painters V* as they were in *I*. After Ruskin describes Turner's vision of the "pallid charnel house," he explicitly separates his own vision of a modern universe of death from Turner's. Turner identifies his figure in the sun as an angel of the last judgment. Ruskin, after quoting a line from the prophet Joel (3.13) which might appropriately be addressed to that angel, "Put ye in the sickle, for the harvest is ripe," continues:

The word is spoken in our ears continually to other reapers than the angels,—to the busy skeletons that never tire for stooping. When the measure of iniquity is full, and it seems that another day might bring repentance and redemption,—"Put ye in the sickle." When the young life has been wasted all away, and the eyes are just opening upon the tracks of ruin, and faint resolution rising in the heart for nobler things,—"Put ye in the sickle." When the roughest blows of fortune have been borne long and bravely, and the hand is just stretched to grasp its goal,—"Put ye in the sickle." And when there are but a few in the midst of a nation, to save it, or to teach, or to cherish; and all its life is bound up in those few golden ears,—"Put ye in the sickle, pale reapers, and pour hemlock for your feast of harvest home." (7.388)

In Turner's version, the figure bringing death to the murderers is both the angel of the last judgment and, probably, the artist; in both cases

the death he brings is deserved. But Ruskin substitutes an unjust, untimely death. This, he insists, is what the modern English death really looks like. Turner's vision is bleak enough, and critical enough of his contemporaries, but Ruskin's is bleaker and more critical yet.

It should not be surprising that Ruskin finished *Modern Painters V* in a state of deep depression. In the Turner paintings he read in these last chapters—from *Apollo* to *The Angel*—Ruskin was tracing a series of what he saw as self-conceptions by Turner. The series begins with the almost triumphant artist and goes on to show a gradual transformation of artist into critic. There is a shift of focus from the depictions of the triumphant artist and the darkness he (almost) vanquishes (*Apollo* and *Ulysses*) to, finally, *The Angel* in which the artist-critic is himself dwarfed by the unbearable sun of his own powers. The ties between Ruskin and Turner in this last section of *Modern Painters* are extremely close. Ruskin uses the occasion of his reinterpretation of Turner as a pessimist and a social critic to announce, though somewhat indirectly, his own decision to turn from art to social criticism. He surely saw that the pictures he chose might also serve as emblems for changes in the views of the author of *Modern Painters*.

To see this, however, would have been to tread on very dangerous ground, for Ruskin also believed that by 1846, when Turner painted *The Angel*, he had lost full control of his art and his mind—had ceased to produce great art, under the unbearable pressure of that vision of the world as "one pallid charnel house—a ball strewn bright with human ashes."[14] Ruskin seems to have imagined Turner burned up, as it were, by the power of his own critical vision. One remembers that Ruskin, earlier in this last section, warns against the solipsistic vision in which the sun usurps the world:

Let him stand in his due relation to other creatures, and to inanimate things —know them all and love them, as made for him, and he for them;—and he becomes himself the greatest and holiest of them. But let him cast off this relation, despise and forget the less creation round him, and instead of being the light of the world, he is a sun in space—a fiery ball spotted with storm.

All the diseases of mind leading to fatalest ruin consist primarily in this isolation. (7.263)

This diseased, usurping sun is very nearly, once again, the sun of Turner's painting. Ruskin did indeed mistrust the apocalyptic critical vi-

sion he saw here, but already by 1860 he comes very close to sharing it. Turning away from Turner and art criticism in the following decade was, I suspect, more than simply following Turner's example by leaving cloudy romantic art for the horror of the real world. Ruskin was also turning away—though only temporarily, as it turned out—from the apocalyptic mode exemplified for him by *The Angel Standing in the Sun*, where social and moral realism is finally warped by the very horror of what it contemplates.

Ruskin is already pulling back from Turner's apocalyptic criticism in these last chapters. Despite passages like that at the end of "The Two Boyhoods" where Turner's vision and Ruskin's are close, Ruskin for the most part writes as a reader or interpreter of Turner's paintings and not as a social critic. I want now to examine his interpretive methods more closely, comparing them both with those he had employed reading nature and the Bible a few years before and with other kinds of reading, Victorian and twentieth-century, to which they may be related. I shall focus on what seems to be the single greatest change in Ruskin's methods of reading, his use of a collection of historical texts rather than a single authoritative text to interpret the symbolism of visual art. We shall not have much to do, for once, with clouds and sun, but I may as well point out that Ruskin did in fact integrate his new critical method into the old cloud metaphor for imaginative and symbolic creation. Putting aside the ambiguous triumph of human imagination that he associated with the sun-mind of Turner, together with the unsolvable question of whether or not that vision could also be thought of as a mirror-mind transmitting divine light, Ruskin explored instead what he could describe as another function of the cloud or mirror-mind, the reflections between "minds of the same mirror-temper, in succeeding ages" (19.310). The concept of an historical imaginative tradition, developed in *Modern Painters V* and *The Queen of the Air*, is consonant with Ruskin's ideas about the uses of history for criticism developed in *The Stones of Venice*. This special form of historical criticism is Ruskin's alternative to Turner's last apocalyptic vision and, at the same time, the context and justification for Ruskin's own occasional ventures into that mode.

To begin, however, with specifics: How does Ruskin approach

Turner's symbolic paintings? In *Modern Painters V* he looks less at visual richness than at selected signs, visual and verbal. He considers these signs not so much as statements of meaning in themselves but as clues or guides to the way landscape and formal elements are to be experienced. The interpretive procedure is worked out in his 1857 catalogue of oil paintings from the Turner bequest. There for the first time he was concerned with reading Turner's work:

There is something very strange and sorrowful in the way Turner used to hint only at these under meanings of his; leaving us to find them out, helplessly; and if we did *not* find them out, no word more ever came from him. Down to the grave he went, silent. "You cannot read me; you do not care for me; let it all pass; go your ways." (13.109)

Turner had, nonetheless, left three kinds of hints, words, or, as Ruskin elsewhere refers to them, clues to his "under meanings": his titles, the texts he appended to the listings of his pictures in the Royal Academy exhibition catalogues, and the figures he put in his landscapes. Ruskin's readings of Turner's paintings, in both the 1857 catalogue and the last volume of *Modern Painters*, almost always begin from the title and frequently make a special point of directing attention to texts and figures. Thus Ruskin notes, "The course of [Turner's] mind may be traced through the . . . poetical readings very clearly" (13.125), and the choice of subject in his manuscript poem "The Fallacies of Hope" is "a clue to all his compositions" (13.159). He often treats Turner's figures as equally textual, pointing out that they are rendered with Hogarthian realism in his early work and become increasingly schematic in later works (13.109, 151–157).[15] Regardless of period, Ruskin finds, "in almost every one of Turner's subjects there is some affecting or instructive relation to [the landscape] in the figures . . . the incident he introduces is rarely shallow in thought" (13.152).

Ruskin's reading of *The Bay of Baiae* is representative (13.131–135). He begins with the appended text, "Waft me to sunny Baiae's shore," noting the "spirit of exultation" as typical of Turner's delight in highly colored Italian landscapes at this period. But going on to describe the painted landscape, he points to an apparently discordant element: it is a landscape of ruins whose appearance is treated with such delight. The decisive clue to Turner's meaning he finds in the figures:

"If, however, we examine who these two figures in the foreground are, we shall presently accept this beautiful desolation of landscape with better understanding." Identifying the figures as Apollo and the Sibyl (information, he notes, provided in the full title of the painting), Ruskin uses the mythical story to gloss the puzzling aspect of the scene ("We are rightly led to think of her [the Sibyl] here, as the type of the ruined beauty of Italy") — concluding his reading by pointing to a related painting, *The Golden Bough*, in which the same Sibyl (this time accompanied by a snake) indicates again the "terror, or temptation, which is associated with the lovely landscapes" in Turner's mind.

Ruskin characteristically moves back and forth between texts (including figures) and the landscape, with the final emphasis always on the latter. There is no absolute division between a purely representational landscape and a symbolic language of mythological figures or verbal tags. The tags instead act as additional glosses, hints, or signs to an under meaning to be read in the landscape itself. Thus Ruskin frequently points to ways in which Turner has translated the mythical figures or actions into purely naturalistic terms. The glacial form of the dragon in *Hesperides* expresses the physical and moral significance of the dragon suggested in Hesiod's genealogy.

Two aspects of Ruskin's procedure need stressing. First, reading, as illustrated by Ruskin's interpretation, is different from but not a substitute for the active seeing exemplified by his descriptions. Titles, texts, or painted hieroglyphs always point back to landscape. They serve as a guide to one of the most difficult problems of reading a visual work, that of deciding what visual marks are significant. Ruskin seems to assume that both the first and last experience of a landscape painting should be the kind of looking he had urged in earlier works.[16] By beginning and ending with expectations of careful seeing, he implies that, though not all visual elements are symbolic, no detail fails to contribute to a reading of the painting. In the second place, Ruskin is quite careful to begin his interpretations from the specific signs provided by Turner. He has a firm sense of where those additional, textual clues are to be found, suggesting a sequence of interpretation specific to Turner's work. (He makes no claim that titles, texts, and figures will be the guides to meaning in all painting.)

The interpretive procedure worked out for Turner is in many ways closely parallel to the reading of sacred texts with which Ruskin was

concerned in the preceding section of *Modern Painters*. There Ruskin took the written text of the Bible as his guide to reading the created world. Scripture suggested what aspects of the visible world could be significant and provided an authoritative guide to the under meaning of those significant aspects as well. With Turner's painting, as with divine symbolic language, Ruskin's interpretive procedure is to juxtapose two different kinds of meaningful creations, one visual, the other verbal or hieroglyphic (in either case a more explicit sign) and to use the latter as guide to reading the former. The process is actually more complex, of course—the interpretation of the words or signs itself involves comparison of different passages (from the Bible, or from Turner's other poems or paintings, or from his reading); further, the written or hieroglyphic texts are themselves illuminated by the painted or created landscapes. The two kinds of creations, textual and visual, are in each case related (they are by the same author and have been put together by the same author) but not identical. The visual creation in particular cannot be reduced to textual signs. There is always a surplus of information. It is these visual nuances and details, which cannot be specified by hieroglyphs or words, which may in turn enrich understanding of the texts. The exegesis of written and created word *together* seems to provide a pattern for Ruskin's reading of Turner's paintings. Visual and verbal elements are considered to work together like the two mutually illuminating creations; they are deliberately set in relationship to one another by their author. In Ruskin's verbal-visual reading, as in his purely visual explorations, overall structure is not a primary concern.

There are, however, some significant differences between Ruskin's readings before 1856 and his readings in *Modern Painters V* and afterwards. The most obvious change is that there is no single authoritative text to place beside Turner's paintings. Not only does Turner himself use a variety of textual materials, but these in turn need explication from yet other texts, not all by Turner, not all specifically alluded to by Turner, not all even definitely known to have been read or used by Turner. In this almost infinitely expansive process of interpretation there is no ultimate written text comparable to the Evangelical's Bible. Ruskin had of course been using multiple texts to read the symbolism of human art ever since *The Stones of Venice*. For the capitals on the Ducal Palace he turns not only to their inscriptions but also to Spenser,

Dante, Bunyan, and Giotto. But in these earlier readings there is always a final text, and that text is always from the Bible. Ruskin's procedure in *Modern Painters III* is typical of his approach before 1859: he examines the significance of fields or grass in medieval art and literature by moving back and forth between Dante and various manuscript illuminations, contrasting these with Homer, but he concludes his reading by appealing first to his readers' perception of actual grass, as the authority for all visual representations or descriptions, and second, to the meaning of grass as established in a collection of passages from the Bible (5.284–293). When Ruskin reads Turner's *Hesperides*, he uses, besides Turner's title and the figures of dragon and goddesses in the painting, the following additional texts (I give them in the order cited): Smith's *Dictionary of Greek and Roman Geography*, Diodorus Siculus, Hesiod, Matthew, Euripides, Apollodorus, Genesis, Psalm 74, Exodus, Dante, Lucian, Milton, Job, Coleridge, Homer, Virgil, and Spenser. Job, Matthew, and Genesis have as much illuminating value as any other of the texts Ruskin cites, but no more. Experience is still the final authority for truth of representation, but Ruskin does not refer symbolic meaning to the Bible as a privileged text. For that single, divine text he substitutes a cumulative historical tradition in which the Bible itself is included. The procedure is put forward as a principle of interpretation ten years later in Ruskin's lecture on myth, *The Queen of the Air*, using, as I have already indicated, a mirror metaphor: "its [a myth's] fulness is developed and manifested more and more by the reverberation of it from minds of the same mirror-temper, in succeeding ages. You will understand Homer better by seeing his reflection in Dante, as you may trace new forms and softer colours in a hillside, redoubled by a lake" (19.310).

Ruskin's new reliance on secular tradition as the underlying text against which to read symbolic meaning in art is, of course, immediately related to a major change in his religious views. Between 1856 and the winter of 1859–60 he had given up his old belief in the Bible as the direct word of God, a divine symbolic language.[17] The problem with which he had been wrestling—of two kinds of symbolic language and the degree to which these might coincide in great art—did not disappear; we have noted that he continued to inquire whether imaginative inspiration might not be at times equivalent to divine inspiration. But practically speaking, Ruskin was no longer faced with

two different methods of reading symbolism, the one historical and psychological (against artistic and literary tradition), the other ahistorical (against a divine text).

Ruskin's use of historical tradition to establish meaning for the symbolic imagery of a particular painting or text is nonetheless rather different from the historical approach to iconography taken in this century by Irwin Panofsky and others. Ruskin's tradition is not constructed on the principle of historical development and influence, whether from individual to individual or within the shared context of a common culture. What counts for him is not the illumination of a particular picture or phrase, but our understanding of the image or figure itself, whose meaning is greater than and independent of any particular picture or text in which it occurs. Thus the critic constructs a tradition in order to multiply and enlarge the potential meaning of image or metaphor or myth, not simply in order to specify its meaning in a given text by selecting only those uses of the figure that author or artist could have known. The procedure is by no means completely unselective; context in the work in question puts limits on what examples of the image or figure will be relevant. Ruskin gives some attention to historical and cultural probability, but he is much less rigorous than a modern historical scholar with different intentions. Furthermore, Ruskin is able to cite many more examples than are directly appropriate historically, culturally, or contextually, because he cites them to differentiate nuances of meaning rather than to point to identities. Again, the value of a tradition, in Ruskin's approach, is not to prove a line of historical development or influence, but to enrich the potential meaning of image or figure by discovering connections between its meaning in different works without reducing or conflating the individual variations.

Ruskin's tradition is probably closer to that of nineteenth-century poets like Blake, Baudelaire, and particularly Swinburne.[18] Swinburne envisions the relation of one poet to another within an historical tradition in an image very close to Ruskin's:

> And one light risen since theirs [the Jacobean tragedians] to run
> such race
> Thou hast seen, O Phosphor [Marlowe], from thy pride of place,

Thou hast seen Shelley, him that was to thee
As light to fire or dawn to lightning; me,
Me likewise, O our Brother, shall thou see,
And I behold thee, face to glorious face?[19]

The image of varied forms of the same light to describe the brother-
hood of imaginative poets is no doubt Shelley's ("thy light, / Imagina-
tion! which . . . / As from a thousand prisms and mirrors, fills / The
Universe with glorious beams"[20]), but it acquires in Swinburne's
hands, as in Ruskin's, an historical meaning, describing relationships
across time. As used by both Ruskin and Swinburne, the image sug-
gests that the later poet's reflection of a song or image is not viewed as
part of a causal sequence of development (from which an original poet
might feel obligated to escape) but as a variation on a common light, a
variation that adds to something all the poets have in common.[21] The
emphasis falls on the multiplication and variation of light, not on the
degree of resemblance or difference or of progressive development be-
tween successive versions of a similar image. For Swinburne or Rus-
kin, songs or images are still alive, ready for use and reuse, but con-
stantly changing each time they are reused.[22] Swinburne explicitly
describes the historical series of great singers as a living tradition; he
delights to proclaim the kinship of such singers, regardless of their his-
torical knowledge of one another:

But the life that lives for ever in the work of all great poets has in it the sap,
the blood, the seed, derived from the living and everlasting word of their fa-
thers who were before them. From Aeschylus to Shakespeare and from
Shakespeare to Hugo the transmission of inheritance, direct or indirect, con-
scious or unconscious, is as certain and as traceable as if Shakespeare could
have read Aeschylus and Hugo could have read Shakespeare in the original
Greek or the original English.[23]

In that living tradition individual poets do not speak the same lan-
guage. They are culturally and historically distinct. Yet each nonethe-
less is fully present, in his individual historical particularity, for his
successors who will repeat, but not exactly, what he has said. For
Swinburne as for Ruskin this relationship holds not only between a
poet and his predecessors but also between a critic and the poetical tra-

dition he traces. The move from interpretation to reuse is a natural one for both poet and critic.

These attitudes toward artistic tradition might be compared to the philological approach to meaning represented by the modern historical dictionary, whose origin, in England at least, dates to just this period, the second half of the nineteenth century. Historical quotations, chronologically ordered, are used to build up a range of meanings for a word. The value of historical quotations is to create a "text" that is read together with the single instance in a reciprocal process of interpretation. We read a contemporary instance of "cloud" in light of the varying historical uses of "cloud" in the dictionary's collection of quotations, just as Ruskin reads Turner's Hesperidean dragon in light of the dragons in Hesiod, Dante, Revelation, and so forth. At the same time, we reread the whole conception of cloud or dragon in light of the present writer's or Turner's version of it. The goal is not simply an historical record of the word "cloud" or the image "dragon" but, more importantly for most readers, an expanded sense of the word or symbol approached as an element in a living language, a word we might want to use ourselves. The modern historical dictionary fosters an historical consciousness in the current user, while making available accumulated nuances of meaning; the record of different meanings need not be used merely to trace a line of development or to interpret the meaning of some past instance of the word. Ruskin's *The Stones of Venice,* intended for the use of contemporary patrons of architecture, presents the history of Byzantine, Gothic, and Renaissance styles with the same double aim: to reinforce historical consciousness of both past and present moments, while making some parts of that past available as a living tradition for reuse in the present.

The analogy with the historical dictionary has a more direct relevance to Ruskin's interpretations of symbolic painting in *Modern Painters V.* The *Oxford English Dictionary,* the great example of the historical dictionary, was conceived in the late 1850s; through its founders Ruskin was first exposed to the new philological methods. His fascination with historical philology is widely evident for the first time in the last volume of *Modern Painters.* When, for example, Ruskin interprets "heavens" in Psalm 19 (a passage probably composed in 1856 but revised in 1859), he begins by tracing the various meanings of the He-

brew, Roman, and Greek words for "heavens" and their relation to the English term (7.195–196). That Ruskin became interested in contemporary philology at the same time that he began to gloss the symbolism of Turner's paintings from an historical collection of texts is not accidental.

There is external as well as internal evidence that Ruskin turned to the philological methods of F. J. Furnivall, F. D. Maurice, and particularly R. C. Trench sometime in the late 1850s. Ruskin knew their work earlier; in 1851, and again as late as 1854, he had disagreed strongly with their historical approach to language, especially biblical language. The three men rejected much of the literal content of the Bible, using historical arguments about its language to support interpretation of many passages as poetic, mythic, or figural expressions that were not to be taken as literally true. Before 1858 or 1859, this approach was not acceptable to Ruskin. In 1854, he records in *Praeterita,* he was shocked to hear Maurice during a Bible lesson tell his listeners that they should ignore the literal example of Jael as morally anachronistic; in reply to a question from Ruskin about how one should then take the praise of Jael (who pierces the head of Sisera with a nail) by the prophet Deborah, Maurice replied, again to Ruskin's "sorrow and astonishment," that Deborah's speech was (in Ruskin's words) "a merely rhythmic storm of battle-rage, no more to be listened to with edification or faith than the Norman's sword-song at the battle of Hastings" (35.486–487). The issue between Maurice and Ruskin had been joined three years before, in a three-way correspondence mediated by Ruskin's friend Furnivall, over Ruskin's literal reading of St. Paul in his pamphlet *On the Construction of Sheepfolds* (1851). In reply to objections from Maurice and Furnivall, Ruskin admitted that he did not consider the "etymological force" of the terms in question, but vigorously defended ignoring evidence of historical changes in meaning on the grounds that the Bible was intended to speak directly to simple people at all times—in other words, that it should be taken as the literal word of God and not as a human text written in an historically changing language. The differences between himself and Maurice and Furnivall, he wrote to the latter, came down to "the endless question of Authority of Scripture, into which it is vain to enter. I say only this—If the Bible does not speak plain English enough to define the articles of saving faith, burn it, and write another, but don't talk of *Interpreting* it" (12.570).

Two years later, in 1853, Furnivall sent Ruskin a copy of R. C. Trench's *Study of Words* (1851), to which Ruskin replied: "I am afraid it will not convert me" (36.146). But some time between 1856 and 1864 Ruskin seems to have changed his mind, writing again to Furnivall:

as it happens, I am just now profiting not a little by help you gave me long ago; you know how you used to find fault with me for speaking ill of philology, and how you, in alliance with the Dean of Westminster [Trench], first showed me the true vital interest of language. While I have not one whit slacked in my old hatred of all science which dwelt or dwells in words *instead* of things, I have been led by you to investigations of words as interpreters of things, which have been very fruitful to me; and so amusing, that now a word-hunt is to me as exciting as, I suppose, a fox-hunt could be to anybody else. (38.332)

Furnivall and Trench were together chiefly responsible for the Philological Society's ambitious project, begun between 1857 and 1859, for a new English dictionary combining full etymologies with extensive historical and literary illustrations of changing usage. No longer, after 1858, resisting the historical approach to language, Ruskin not only learned from them the gleeful pleasures of the word hunt, but also, I think, took over from them the practice of collecting historical examples of a word in context—took over and applied to the task of interpreting the meaning of symbolical images and of myths.

The dictionary example seems to me not only relevant, given Ruskin's connections with philology through Furnivall and Trench, but also helpful in explaining the peculiar kind of tradition or history of an image that Ruskin assembled. As with the dictionary, so in Ruskin's collections of texts for interpreting a given image, the collection itself may be historical (historically significant instances of usage where clear variations in meaning can be differentiated), but the use to which one puts the historical information need not be. What a word means depends finally on how it is used in a particular context, and that use may draw on any or all of the past and hence potential meanings of the word. Its reuse will then become part of its meaning, as presented by the dictionary to the reader and writer. The difference between iconological criticism like Panofsky's and Ruskin's, then, is partly the difference between compiling a dictionary of a dead language, which cannot

be addressed to a potential user, and compiling an historical dictionary of a still living language. Traditional iconography *has* perhaps become more or less a dead language in an age of nonrepresentational art, but both traditional visual symbolism and myth were very much alive, or at least capable of being resuscitated, for Ruskin.[24]

The emphasis on recovering possibilities of meaning, rather than constructing a history, is characteristic of Trench's *Study of Words* and is much more explicit there than in the *OED* itself. Language for Trench, too, is very much alive. Words are "not merely arbitrary signs, but living powers."[25] They have a life of their own which fascinates Trench much as the life of the nonhuman natural world does Ruskin. Trench justifies the historical study of language on three grounds: language preserves a record, first, of various historical changes—social, political, intellectual; second, of imaginative insights; and third, of moral insights. In only the first sense is the meaning of a word historically limited and particular, of no immediate interest to a current user. Insofar as words at different periods reflect imaginative or moral insights, however, these meanings are never really outdated; if they are not now current, this does not prevent them from functioning as part of the potential meaning of the word. Indeed, Trench implies an obligation to revive such lost meanings: "Where use and custom have worn away the significance of words, we too may recall and issue them afresh."[26] The "we," in this case, are the students at the Training School for teachers in church-supported schools, and the recalling and reissuing of words—the comparison is with worn coins—is specifically a recommendation as to "how we may usefully bring our etymologies and our other notices of words to bear on the religious teaching which we would impart in our schools." As Trench makes clear, historical philology does not primarily tell him that the same word has meant different things at different times, and hence that meaning is relative, but rather that every word has "one central meaning," variously developed, altered, or forgotten. To get at that meaning is to recover an insight whose validity does not change. Regarded as "fossil poetry," a word may "be found to rest on some deep analogy of things natural and things spiritual"; alternatively, language may be "fossil ethics": in using it "men are continually uttering deeper things than they know, asserting mighty principles, it may be asserting them against themselves, in words that to them may seem nothing more than the current coin of society."[27]

Ruskin's conception of significant images, symbols, and myths seems to be formed by analogy with Trench's conception of language. Myths, he asserts in *The Queen of the Air,* are words in a literally and historically living language of natural things: "words of the forming power" (19.378). Myths have their roots either in "actual historical events, represented by the fancy under figures personifying them," or in "natural phenomena similarly endowed with life by the imaginative power, usually more or less under the influence of terror" (19.299). Ruskin is even less interested than Trench in myths as they reflect historical events or situations; he concentrates on myths that originate in some imaginative perception of natural phenomena. These too have a history. The development of a myth, or of mythical names or images, can be used to trace out or exemplify a history of consciousness, of religious or ethical thinking, of aesthetic or intellectual changes in a culture. But all myths, and especially those originally referring to natural phenomena, are more than historical artifacts ("fossil history"). They preserve, as words do for Trench, "true imaginative vision" that "perceives, however darkly, things which are for all ages true" and "moral significance . . . which is in all the great myths eternally and beneficently true" (19.309,310,300),

and it is this veracity of vision that could not be refused, and of moral that could not be foreseen, which in modern historical inquiry has been left wholly out of account: being indeed the thing which no merely historical investigator can understand, or even believe. (19.309)

The task of the philologist, Ruskin tells his readers at the beginning of his lecture on myths, is to account for the errors of antiquity; his own, by contrast, is to read the thoughts of these men (19.296). That reading, like Trench's, ultimately requires the reader to issue afresh the worn words or myths he examines.

I think the reader, by help even of the imperfect indications already given to him [in the preceding two lectures], will be able to follow, with a continually increasing security, the vestiges of the Myth of Athena; *and to reanimate its almost evanescent shade,* by connecting it with the now recognized facts of existent nature, which it, more or less dimly, reflected and foretold. (19.385; my italics)

The limitations of philology or "modern historical inquiry" to which Ruskin refers point not to Trench but to the leading exponent in England of the philological school of comparative mythology. F. Max Müller lectured at Oxford throughout the fifties and gave two series of popular lectures on language in London in the early sixties. Ruskin refers to these in his own lecture on language and books ("Of Kings' Treasuries," 1864) and his lectures on Greek myth (*The Queen of the Air*). Müller combined word hunts with myth hunts, tracking down the origins of mythical thinking through various Indo-European languages back to Sanscrit. But where Trench and Ruskin tried to *recover* the meaning of words or myths in order to restore them to language, Müller saw myth as an accident, a mistake: myths arose to explain metaphorical words whose original reference had been forgotten or distorted. Hence myth, far from being a potential living power, was, in Müller's famous phrase, a disease of language.[28] By implication, the historical philologian's task was not to restore meaning to myth, but to demythologize language, to reduce its metaphorical terms to rational perceptions. (Müller tended to regard these perceptions as, in any case, primitive and unscientific, of historical interest only.) Ruskin drew heavily on Müller's word hunts because they frequently connected mythical beings with perceptions about nature (most of Müller's deities turn out to be descriptions of the sun or other elements). But Ruskin, like Trench and unlike Müller, looked to metaphoric language and myth for continually valid imaginative and moral perceptions — and indeed for scientifically accurate *physical* perceptions as well.

On this last point Trench and Ruskin differ. Though Trench collects texts to show significant variations in usage in order finally to recover a fuller meaning for current use, he continues to take the Bible, however liberally read and interpreted, as *the* authoritative moral and spiritual text against which the insights stored up in words can be evaluated. The truths of the Bible story — that man is of "a divine birth and stock," "fallen, and deeply fallen, from the heights of his original creation," but elevated and redeemed by Christ — he finds reflected and confirmed in the histories of words.[29] Furthermore, it is his readers' knowledge of, and belief in, the truths of scripture which will enable them to understand and restore to use the worn or forgotten moral insights preserved in language. Because "we" — his audience of Anglican

teachers-in-training—believe in the revealed truth of the Bible, "we only rejoice at each new homage which [philological] Science pays to revealed Truth, being sure that at the last she will stand in her service altogether."[30] This is very close to Ruskin's attitude toward the results of his own historical science applied to the symbolic language of stones in *The Stones of Venice.*

In *Modern Painters V* or *The Queen of the Air*, however, what enables us to reanimate myth and symbol, once we have assembled the cumulative tradition in which meaning is expanded and expressed, is not belief in the biblical revelation but accurate, imaginative perception of the concrete phenomena to which myth or symbol originally or literally refer. Müller was interested in this literal reference of words and myths though he regarded the perceptions on which literal meaning was based as outdated or unscientific. Trench was not much interested in the value of original literal reference at all. For Ruskin, we can only understand the true vision, moral and imaginative, developed and elaborated in myth "so far as we have some perception of the same truth" (19.310). In the case of Turner's myths and the Greek myths that Ruskin treats in *The Queen of the Air*, that perception is a perception of nature:

If it [the myth] first arose among a people who dwelt under stainless skies, and measured their journeys by ascending and declining stars, we certainly cannot read their story, if we have never seen anything above us in the day but smoke; nor anything round us in the night but candles . . . we can only understand the story of the human-hearted things, in so far as we ourselves take pleasure in the perfectness of visible form . . . we shall be able to follow them into this last circle of their faith only in the degree in which the better parts of our own beings have been also stirred by the aspects of nature, or strengthened by her laws. It may be easy to prove that the ascent of Apollo in his chariot signifies nothing but the rising of the sun. But what does the sunrise itself signify to us? . . . if the sun itself is an influence, to us also, of spiritual good . . . [it] becomes thus in reality, not in imagination, to us also, a spiritual power . . . [and we may] rise with the Greek to the thought of an angel who rejoiced as a strong man to run his course, whose voice, calling to life and to labour, rang round the earth, and whose going forth was to the ends of heaven. (19.302–303)

Ruskin's last lines paraphrase no Greek source but verses five and six of Psalm 19. Like the Greek myth, he implies, the Hebrew symbolism

cannot be reanimated unless it can be refounded in an attitude toward nature which sounds very much like the modern landscape feeling he described in *Modern Painters III*: clear perception, pleasure in visible form, a nonpathetic emotional responsiveness to the aspects of nature, especially to signs of the alien life in natural things. Ruskin is still in agreement with Trench when he says that collecting evidence of historical changes in language and myth, as Müller does, is not enough. Words must be reissued for present use, their moral and imaginative insights restored. But Trench or Maurice or Furnivall would hardly recognize Ruskin's method of restoring meaning to symbolic language by referring all of it—including the Bible—to the accurate, imaginative visual exploration of nature. Ruskin was in his interpretations refusing to follow the lead of Turner's last symbolic paintings—refusing to abandon naturalistic reference and the landscape feeling as the basis of a symbolic language fitted for current critical use.

This last move requires some additional comment. The landscape experience to which Ruskin returned included the discoveries of contemporary natural scientists, specifically in *The Queen of the Air*, Darwin and Tyndall. The appeal to experience serves to give the imaginative tradition currency, a function performed by the Bible for Trench but no longer for Ruskin. Still the experience of nature to which Ruskin appeals is not quite the same as that of *Modern Painters I, II*, or *III*. What Ruskin had noted tentatively in *Modern Painters III* as "no definite religious feeling" but "an instinctive awe, mixed with delight; an indefinable thrill, such as we sometimes imagine to indicate the presence of a disembodied spirit" (5.366,367) becomes in *Modern Painters V* and *The Queen of the Air* animistic thinking about nature, which Ruskin now feels is at the root of even the modern landscape experience. Natural phenomena are "words of a forming power." This sense of a forming power in the beautiful variations of nature increasingly fascinates Ruskin in the 1860s.[31]

George Landow has argued that the appeal to a shared experience of natural phenomena as words in *The Queen of the Air* is really another version of the theories of beauty put forward in *Modern Painters II*, with Ruskin once again reading the divine symbolic language of God's second book.[32] This is, I think, to blur essential differences. In the first place, the natural language of types in no way implies an animistic feeling about natural phenomena. In the second place, God's second book is

language by virtue of God's first book; the two could never be read separately. The living words or myths of cloud or bird or serpent in *The Queen of the Air* are not dependent even on the (itself uncertain) text provided by iconographical tradition. Knowledge of the tradition assuredly helps to expand and multiply the possible meanings of image or myth, but a collection of past uses does not itself select out "true" meaning from contradictory and fanciful elaborations. Similarly, though the shared response all men feel to, say, the serpent, *may* be a better guide than the full imaginative tradition, still the single perceptions that form the root of any mythical tradition will be far less significant:

the first narrow thought . . . indeed, contains the germ of the accomplished tradition; but only as the seed contains the flower. As the intelligence and passion of the race develop, they cling to and nourish their beloved and sacred legend; leaf by leaf, it expands, under the touch of more pure affections, and more delicate imagination, until at last the perfect fable burgeons out into symmetry of milky stem, and honeyed bell. (19.301)

In *The Queen of the Air* the return to landscape experience as a basis for reading art acquires a much more problematic relation to reading with reference to tradition. There is little trace of the happy juxtaposition of written and created word that we find as late as *Modern Painters IV*. Even in *Modern Painters V,* though the tradition cannot provide the kind of authority for individual readings of nature the Bible once promised, perception of nature and symbolic tradition are mutually dependent. But the second lecture of *The Queen of the Air* appears to reconsider the relation between common perception—the experience of the beholder of nature—and imaginative perception. There is a tentative suggestion that the two may not be so closely related as Ruskin has been arguing. The structure of *The Queen of the Air* itself suggests this. The first lecture provides a far fuller explanation of the value of art and art criticism through the concept of imaginative tradition than Ruskin suggests in *Modern Painters V*. The second lecture, however, focuses on the instinctive sense of life and meaning in nature and suggests that the "natural and invariable" myths to be found in this way are more important to the beholder than the "human and variable" ones elaborated in artistic or literary tradition (19.361). There is a shift

in metaphor that reinforces the structural suggestion of a split between imaginative, primarily visual perception and moral or sympathetic perception: the clouds that function as mirrors or prisms in *Modern Painters* become breath or wind, momentarily visible but fundamentally a force or power to be felt, not seen. If imaginative perception (embodied in artistic or literary creation) and moral perception (accessible through immediate landscape experience) are indeed separate—and Ruskin does not seem fully to decide, in *The Queen of the Air,* that they must be—then the interpretation of art and literature will become at best a luxury, at worst a criminal distraction from the serious business of improving the quality of human life.

Though the later parts of *The Queen of the Air* are ambivalent about the value of past imaginative art for present perceptual health, Ruskin himself continues to use his readings of symbolic art and literature to illuminate contemporary experience—even in works that stick to social and economic criticism, such as *Unto This Last* and *Munera Pulveris.* I have suggested that the relation of past art to present practice in Ruskin's concept of a figurative tradition parallels the relation of past to present first worked out in his history of Venetian architecture. We can now elaborate that parallel as it bears on Ruskin's use of history for criticism. Ruskin's method in *Stones,* as noted earlier, is close to Carlyle's—to describe the past with sufficient immediacy that present readers or viewers seem to see and understand what had before been distant and incomprehensible. Current readers and viewers are re-formed so that, in effect, the difference between past and present seems to be abolished, and they can grasp the meaning of "that great symbolic language," now forgotten. The distance never completely disappears or, rather, Ruskin and Carlyle repeatedly shock readers into remembering the gulf that separates them and try to force consciousness of, in Ruskin's case, the peculiarly modern modes of perceiving and understanding which can never really be put aside.

Similarly, Ruskin's readings of Turner in *Modern Painters V* reconstruct a long history of mythological and symbolical thinking about clouds and serpents until those images in the paintings begin to resonate with significance. But at some point in the discussion of each painting there is a turn—in *Hesperides,* not until the final paragraphs where the dragon becomes "the British Madonna," in *Apollo,* much

sooner, when the small serpent crawls out of the belly of the slain Python. At this point readers are confronted with the distance—an ironic distance—between modern dragon protection or python slaying and its traditional meaning. The break between past and present is emphasized, not the continuity of symbolical thinking. In *Modern Painters V* as in *The Stones of Venice,* the gap between past and present is the point at which history becomes contemporary criticism, or the point at which the old symbol provides a means of reflecting on or expressing the different situation of the present. Its meaning then is both dependent on past usage and yet sharply different from it, because it is made to refer to contemporary situations and events. In the case of *Hesperides,* the reinterpretation of the image with contemporary reference does not actually occur in the painting. Turner is not the contemporary critic. It is Ruskin who, after he has completed his reading, uses the image anew, this time to provide the sense of ironic contrast, which is where his criticism begins. In the case of *Apollo,* Ruskin suggests that Turner himself functions as critic, giving the symbol a new twist and a contemporary application (as, it could be argued, he does in paintings like *Hannibal* or *The Angel Standing in the Sun*). In the first instance interpretation and contemporary cultural criticism will be to a certain extent separate acts. In the second instance the two procedures are not really separable. For Ruskin, it is important to note, both are equally valid uses of history.

I would suggest, then, that beginning with *Modern Painters V* Ruskin uses his readings of symbolism in art for much the same purpose that he used description and analysis of the visible aspects of Gothic architecture in *Stones*: history is a mode of contemporary criticism. This represents a change from the use to which he put his interpretive readings of symbolism in earlier volumes of *Modern Painters* and in *Stones* itself. In *Stones* he was interested in reading first as an extension of seeing—of the active perception necessary to cultural health—and, second, as the fulfillment of the religious obligation to read the divine symbolic language reflected in art. By the conclusion of *Modern Painters* Ruskin is interested in reading because through reading one learns, recovers, and recreates a symbolic language for present use—specifically for use not just by the artist, but by the contemporary critic. His readings from this point on almost always occur as the preludes to passages in which he himself uses the phrase or

image explicated in a new and contemporary context. There is a real shift of emphasis, in the later volumes of *Modern Painters,* from seeing and describing to reading and interpreting. That shift is finally not just to reading, but to writing and speaking: reinterpreting the imaginative tradition by using it to comment on Victorian culture and society.

I began this chapter with the changes in Turner that Ruskin traced at the end of *Modern Painters*: the emergence of the heroic artist, from *Hesperides* to *Apollo,* and the transformation of that heroic artist into the mad, despairing critic of *The Angel Standing in the Sun.* Turner's evolution formed a model both feared and followed by Ruskin himself. But Ruskin had other models, most importantly Carlyle, already his second master and eventually a second father, too. Unlike Turner, Carlyle and Ruskin continued to teach as well as denounce their audience. Beginning with the last volume of *Modern Painters,* Ruskin's prose is increasingly directed to educating his readers not only to see but to read, write, and speak critically themselves. If Ruskin, by the end of *Modern Painters III,* had created the romantic spectator of painting, one might say that by the last volume he had undertaken a new task: to turn both the romantic spectator and the romantic reader into Victorian critics.

The Critic's Art

W HEN MATTHEW ARNOLD attacked Ruskin's prose, he gave two examples. One was a passage of landscape description; the second was a paragraph on the significance of Shakespeare's names. Arnold quoted the first passage as an instance of genius—the genius of a poet mistakenly working in prose. In the second, however, he found the marks of an immoderate, ill-proportioned, and "provincial" criticism. With the deflating voice of common sense he remarked, "Now, really, what a piece of extravagance all that is!"[1] A century later Northrop Frye called Arnold the provincial for entertaining an idea of criticism that extended no further than the history of taste. Ruskin's second passage, he suggested, is the real example of a genuine and systematic criticism.[2]

Arnold may not be a systematic critic, but his ear is good. To Ruskin's early distinctive way of writing, poetic and painterly description, he had indeed by 1864 added a second, different style. Arnold's selection is illustrative of that style, but it does not suggest what Ruskin could do with it. The passage Arnold takes is only a footnote. The same weaving together of related verbal or visual forms into a representative figure characterizes Ruskin's paragraphs on Turner as angel in the sun. There is nothing like this kind of writing before *Modern Painters V*. Passages as obscure as the footnote on Shakespeare's names, and others as formally and rhetorically prominent as the conclusion to "The Two Boyhoods," are everywhere in Ruskin's prose after 1859.

Arnold is misleading, however, when he judges Ruskin's first style as prose poetry and his second as prose criticism. Just as the prose descriptions serve an educative end—to demonstrate excursive seeing,

the beholder's art—so one might argue that the reconstruction of words or significant images is also both critical and creative, an art of myth or emblem making. Frye is right: Ruskin's word and image hunting is a criticism more systematic than Arnold imagined. The new attitudes toward language evident in Ruskin's readings of Turner lie behind his invention of an emblematic prose to promote perceptual and linguistic reform. But Ruskin's myth and emblem making is also highly artful, at least as artful as his descriptive prose. Oddly enough, it is often *the* organizing feature of Ruskin's later writing. Oddly, because for Arnold such writing was an instance of the lack of order and measure, a fatal flaw in the critic. For Ruskin, however, it became the means of imposing order and form on excursive criticism. In most of Ruskin's later prose, beginning with the last volume of *Modern Painters,* excursive looking, describing, and explaining are employed to create symbolic names or images. These emblems constitute the critic's art.

R USKIN'S titles provide the clearest indication of a change in his way of writing. Beginning with some of the most important chapters in *Modern Painters V,* titles begin to serve not as guides to reading but as cryptic, summary expressions of a chapter's major themes, as worked out in what is primarily a metaphorical structure. In *Modern Painters I* Ruskin used titles to clarify contents and give prospective readers an immediate idea of what they would find: "Definition of Greatness in Art," "General Principles Respecting Ideas of Power," "Of Truth of Colour." Chapters were further organized under sections and sections under parts; the chapters themselves were broken down into numbered paragraphs, for each of which a marginal summary was provided. The elaborate system of headings and subheadings was also conveniently brought together at the beginning of the work as a "synopsis of contents." As Ruskin's editors point out, this naming and ordering of the parts of a book reflects the education of the "Graduate of Oxford"—strongly Aristotelian, with more immediate influences, appropriately for a writer on aesthetics, from Locke (3.xix). The second volume of *Modern Painters* follows this format, but in the third volume there are changes. Ruskin sheds some of the elaborate subdivisions and all of the paragraph summaries. His explanation of

the change acknowledges a disjunction between the orderly structure implied by the titles and his own principles and practice (5.13). Giving up the effort to maintain "constructive symmetry," Ruskin makes the whole volume a single undivided part and calls it "Of Many Things."

Although symmetrical subordination gives way to mere sequence, the titles of the chapters are still a straightforward indication of their contents. But by *Modern Painters IV* these too have begun to change. Ruskin now uses some titles that can be read metaphorically as well as literally. "The Firmament" and "The Mountain Gloom," like "The Foundations" (or like *The Stones of Venice* and *Seven Lamps of Architecture*) suggest some of Ruskin's preoccupation with meaning and expression as well as with geological and architectural description. The added resonance to Ruskin's titling brings the table of contents closer to the text it introduces. The disappearance of logical structures makes it impossible to foresee Ruskin's argument, but his texts had never really conformed to the preliminary diagram in any case. Metaphorical suggestion had always played an important role. The titles in *Seven Lamps*, *Stones*, and some of the chapters in *Modern Painters IV* alert the reader from the beginning to the role that metaphor plays in the text. There is even a correspondence between the kind of title and the nature of the text from chapter to chapter in *Modern Painters IV*: in the second section, which deals with the geology of mountains, the introductory chapters on "The Firmament" and "The Dry Land" are wholly concerned with biblical symbolism, while "Of the Materials of Mountains—First Compact Crystallines" is primarily devoted to geological analysis.

The metaphorical titles in *Seven Lamps* or *Stones* or *Modern Painters IV* are not obscure. Many of those in *Modern Painters V* are distinctly puzzling. "Firmament" and "dry land" as the Genesis terms for the heavens and the earth would be readily recognized, certainly by a Bible-reading Victorian audience. But to what does "The Angel of the Sea," the last chapter of Part VII, refer? The metaphor is neither familiar nor transparent. The first sentence of the chapter tells us that Ruskin's subject is rain clouds. It is not until we are several pages into the chapter that he identifies these rain clouds with the angel of his title. The rest of the chapter might be read as an explanation of that metaphoric coupling, an account of how the figurative name for the physical fact was constructed. "Construction" is the right term, for Ruskin

has not found the figure ready-made in the Bible or any other single text. He begins with an account of the aspect of rain clouds which employs many of the descriptive techniques familiar to readers of *Modern Painters*. This description presents, through an accumulation of intensely perceived details, a moss-land landscape and then evokes the intermittent passage of rain over that landscape, as a beneficial, "renovating and purifying" natural presence (7.178). The rain clouds themselves appear soft, like wings drooping with dew; we see the "shadows of their plumes" passing over the hills. The evocation of physical aspect reaches quite naturally to metaphor. If the metaphorical comparisons of Ruskin's descriptive passage are convincing, then we will have acknowledged the basis in perceptual experience for Ruskin's figurative identification of rain as the angel of the sea.

Ruskin does not base his figure solely on perceptual experience. This appeal is only the first part of his explication. The major part of the chapter constructs a myth or symbol on these experiential foundations by incorporating mythical or metaphorical interpretations of rain clouds found in widely scattered texts, both biblical and classical. Ruskin wants to "gather" (7.181, 184) these various names, epithets, and stories together. He has "traced" the elaboration of an animate figure (7.188) through what he sees as an accumulated tradition of imaginative response to the single natural phenomenon of rain. Ostensibly the end of this gathering and tracing is to explicate Turner's treatment of rain clouds, both their physical aspect and their secret meaning. But the whole is more than the sum of the parts. Ruskin's Angel of the Sea is not really Turner's, but a figure built out of perceptual experience and the imaginative tradition to which Turner's paintings are the latest contribution. The procedure is the same as that which occurs in Ruskin's chapters on Turner's *Hesperides* or his *Apollo*, with the difference that those chapters end with several paragraphs of allusive prose in which he actually evokes the mythical figure or symbolic landscape he has labored to construct. "The Angel of the Sea" ends not with a passage of emblem-making prose, but with the explication of Psalm 19 we have earlier examined. Only in the title of Ruskin's chapter—his name for his mythical figure—is she fully present.

That title is not comprehensible until the reader has finished the chapter—until, that is, the literal reference has been not only identified but realized through description, and until the various metaphorical

and mythical meanings embodied in the name have been gathered together. The chapter title cannot serve at first as a guide to the reader. It appears rather as a puzzle or mystery: the object to be seen and explained. Rhetorically it must work to challenge or intrigue; it cannot communicate. This kind of chapter title has a retrospective function that is almost as important as its prospective function, however. It brings together the sometimes fantastically unexpected associations gathered and traced in the course of the chapter in a single, naming phrase or word, conferring a unity—though only retrospectively—on what might otherwise appear hopelessly diverse. The chapter is organized around a single, elaborated metaphor or figure rather than structured as a logical argument. In one sense, the chapter exists for the sake of its title: to create a meaningful word, phrase, image, or mythical figure—an emblem.[3] Once the chapter is mastered, the figure named in the title becomes part of a vocabulary Ruskin can use again. The mythical figure of the Angel of the Sea, a spirit of wind and cloud both terrible and beneficent, is directly or indirectly present in "The Nereid's Guard" and "Hesperid Aeglé," and still more powerfully in Ruskin's lectures a decade later, "The Mystery of Life and Its Arts" and *The Queen of the Air*.

She is also a dominant presence, though not directly evoked, in the coda of the chapter to which she gives the title. We looked at Ruskin's reading of Psalm 19 earlier without relating it to the chapter in which it appears. Out of local context it serves as part of Ruskin's effort to assimilate Turner's romantic technique and imagery to a divine language of clouds. If we read his explication of the psalm as the conclusion to "The Angel of the Sea," however, its implications are subtly altered. The biblical message acquires a more personal messenger. It is delivered *by* the animate spirit of the half-Greek, half-biblical Angel of rain clouds, not simply *in* the veiled language of the cloudy firmament. Where before we found Ruskin assimilating the historical language of imagination to the divine language of nature and the Bible, now the passage suggests the reverse. The cloudy veil of the Bible is yet another guise of Ruskin's Angel. Turner's clouds, too, belong to this tradition: "To him, as to the Greek, the storm-clouds seemed messengers of fate" (see ills. 14, 15). Ruskin ends what he has begun, in *Modern Painters IV*, as a plea for the religious reading of art and nature by adopting the closing prayer of Psalm 19: "Cleanse Thou me

from secret faults . . . So shall I be undefiled, and innocent . . . my Strength, and my Redeemer"(7.199). The myth making of the chapter suggests that we should recognize in the cleansing Redeemer to whom this prayer is addressed Ruskin's "great renovating and purifying" Angel of the Sea.

It is quite probable that this alteration of meaning actually occurred in the course of Ruskin's successive treatments of his material. "The Angel of the Sea" is the last chapter in the part of the volume that was first written in 1855–56, but in title, structure, and the use of etymological word and myth hunts it resembles the second part of the volume, written in 1859–60. The explication of Psalm 19 balances the opening chapter, "The Firmament," but the emblem-making title and constructive text are the first examples of what were to become characteristic features of Ruskin's work in the next three decades. Five chapters in the second half of *Modern Painters V* employ this method of naming and structuring chapters: "The Dark Mirror," "The Lance of Pallas," "The Wings of the Lion," "The Nereid's Guard," and "Hesperid Aeglé." The titles of books alone in the sixties, seventies, and eighties suggest the same cryptic naming: *Munera Pulveris*, *The Cestus of Aglaia*, *Sesame and Lilies*, *The Crown of Wild Olive*, *The Queen of the Air*, *Ariadne Florentina*, *Aratra Penteleci*, *Proserpina*, *Deucalion*, *Fors Clavigera*, *Praeterita*. With the possible exception of *The Queen of the Air* (and here the subtitles are more enigmatic: Athena Chalinitis, Athena Keramitis, Athena Ergane), none of these titles, even to a good classicist, is very revealing of its contents. Ruskin insisted that "I am not fantastic in these titles, as is often said; but try shortly to mark my chief purpose in the book by them" (22.315). Such titles name myths or images that are constructed and explained within the works they name, and provide a unifying network of metaphor and allusion within those works.

Ruskin's titles apparently change to accommodate his views of language as these alter between 1856 and 1859. In the later chapters and books, as in the explication of Psalm 19 when read in the context of the rest of the chapter, a human, historical language of myth or metaphor is the dominant if not the only language with which Ruskin is concerned. Biblical language never regains the absolute privilege it once possessed for Ruskin as a language both real and symbolic. The significance of the cloudy firmament, and of the message of "judgment

and commandment" figured by it, is reinterpreted by looking at that cloud symbolism as part of a cumulative imaginative tradition about a spirit of cloud and wind. Ruskin's title for this chapter is not the biblical "Firmament" but an epithet of his own devising that will subsume the biblical meaning together with the long history of cultural association behind it.

THE EMBLEMATIC naming that begins in "The Angel of the Sea" becomes one of the characteristic features not just of Ruskin's titles but of his prose generally in the next three decades. Examples of word and image hunting, leading to the construction of emblems or the redefining of words, are found throughout the texts (and liberally in the notes) of all Ruskin's later work, from *Unto This Last* through *Praeterita*. The meanings Ruskin gathers and assigns to existing words and images, or the epithets, words, and myths he constructs, often appear eccentric if not wildly unlikely. These are exercises in the creation of language, as Ruskin understood language in 1859 and after. This language in the first place corresponds to the science of aspects. As the language of accurate perception, however, it is not really new in Ruskin's work. His prose as early as *Modern Painters I* expands and reshapes the vocabulary of landscape description to meet the demands of accurate, excursive seeing.[4] Much of this expansion is effected through new or unexpected similes, analogies, or metaphorical epithets. The difference between this kind of language shaping and the extravagant acts of renaming of his later work is not merely the degree of fantasy or strangeness of the associative comparisons. Once the Bible loses its supreme authority for Ruskin as a real language, human language has to do more than express accurate perception. It must also suggest its own authority by recalling its history. Ruskin's new word and myth making is not Adamic naming. Rather, it is the discovery, or recovery, of terms that will suggest both natural history — aspects as they appear to a perceptive observer — *and* cultural history — the record of the imaginative associations attached to a perceived natural fact in successive works of art and literature.

This change is most evident if we compare Ruskin's revisions of scientific nomenclature at two points in his career. Early in *Modern Painters V* (in a chapter probably written in 1855–56), he discusses the inade-

quacy of scientific classification and announces his intention to devise and name his own botanical orders. His intention is to underline differences in natural history: in the organic development of different orders of plants. His contributions to scientific nomenclature are the terms "builders" and "tent-dwellers" and, in this last group, "earth plants" and "pillar-plants" (7.20–22). Ruskin's builders (or toilers) are the trees, who build "monuments," their trunks. His tent-dwellers include both the bush and creeping plants (earth plants) and the endogens or "false trees" who send up shoots (pillars) that are not built up into true barked trunks. This kind of metaphoric naming is characteristic of Ruskin's earlier experiments in extending language. He wants to reflect accurate perception more precisely. The resulting terms or epithets do not strike the reader as terribly difficult to understand. They are based on comparisons with familiar objects that serve to bring out some visible expression of natural history.

We can contrast these additions to scientific nomenclature with the revisions Ruskin attempted in the seventies and eighties in his "grammars" of botany, ornithology, and geology—*Proserpina*, *Love's Meine*, and *Deucalion*.[5] In *Proserpina*, for example, he keeps the name "Papaver Rhoeas" for the English poppy, but he then proceeds to attach to "Rhoeas" an elaborate complex of visual and expressive meanings by gathering together a series of symbolic uses of "papaver rhoeas" in literature and decorative art. The paragraphs that trace associations for the poppy make up the body of Ruskin's chapter, following an initial analysis of the flower's visual structure. Through etymology, quotation, and visual example Ruskin works to establish in the minds of his readers three different lines of association for the name he preserves: the drooping head of the flower with the lost pride of the fallen warrior, its multiple seed head with fullness of life, and its common presence in field mixtures of weeds and corn with a healthy relation of "the adverse powers of nature to the beneficent ones" (25.275–279). At the end of his chapter Ruskin's name will recall for his reader both natural history—the drooping head, multiple seed, and field mixtures—and the history of what the human imagination has made of the poppy.

These are the two purposes that Ruskin articulates later in *Proserpina*, in a chapter defending his apparently fanciful nomenclature: "my own method . . . consists essentially in fastening the thoughts of the pupil on the special character of the plant, in the place where he is

likely to see it; and therefore, in expressing the power of its race and order in the wider world, rather by reference to mythological associations than to botanical structure" (25.340). In *Modern Painters V* Ruskin sought terms to express only the "special character of a plant, in the place where [the observer] is likely to see it." He found metaphors based on visual similarities adequate. In *Proserpina* he wishes also to express "the power of its race and order in the wider world"—its imaginative power traced through the history of European art and literature. Both special character and power in the wider world, he maintains, can best be expressed "rather by reference to mythological associations than to botanical structure." The position is derived, as we saw in the last chapter, from Max Müller's belief that myths are decayed metaphors and that those metaphors originally expressed some perception about natural phenomena. Names taken from myths, or symbolic imagery, then, can recall both cultural history—the evolution of myths and symbols—and the perception of natural history in which those myths originated. Hence Ruskin's new preference for names that are not immediately descriptive, directly or metaphorically, of visual aspect. Hence, too, his preference for Greek or Latin words in his titles: they immediately suggest the importance of western European cultural tradition.

But the critic must gather and trace for the reader these forgotten cultural associations, and fasten them again to names and images. The names Ruskin rejects, or those whose meanings he reconstructs ("papaver rhoeas," or "value," "wealth," and "economy" in *Unto This Last*), are names that have ceased to fulfill their linguistic function. That is, they no longer convey either the results of perception or—the important addition—the results of imaginative vision as these have accumulated over time. It would be more accurate to say that Ruskin's prose reforms language rather than creates it. In his eyes, naming is a critical rather than an artistic endeavor. It is what Trench described as the reminting of words—for Ruskin a process that needs to be performed for symbolic visual imagery as well. As such, his myth-making prose, however fantastic and apparently idiosyncratic its associations, works very much like his purely descriptive prose. His descriptions are structured to teach his audience how to see, by leading them on excursions through landscapes. His prose conveys the precision of visual observation and the excitement it can generate. Similarly, his myth-

making prose is structured to teach his audience how to read verbal or visual language, by leading them through a representative experience of recollecting meaning. The experience begins with the naming, in title or text, of the word or image to be read and proceeds first through description, then by explication (the gathering of cultural associaions), and concludes either with a simple return to the name in title or text or with a short evocative passage weaving together associations established in the chapter to form an emblematic verbal and visual image. Both descriptive and myth-making writing encourage active participation, offering the reader the opportunity to learn by doing.

There are a number of passages in Ruskin's criticism, especially in "Of Kings' Treasuries," *The Queen of the Air*, and *Fors Clavigera*, which support this interpretation of the critical function of Ruskin's myth-making prose. "Of Kings' Treasuries"—a lecture on the value of good books and right reading—is the most explicit instance. Ruskin insists first of all on the necessary labor and difficulty of reading: "be sure, also, if the author is worth anything, that you will not get at his meaning all at once;—nay, that at his whole meaning you will not for a long time arrive in any wise. Not that he does not say what he means, and in strong words too; but he cannot say it all; and what is more strange, *will* not, but in a hidden way and in parables, in order that he may be sure you want it" (18.63). Such reading Ruskin calls "mining" for meaning. (The same point is made in *The Queen of the Air*, where he demonstrates mining for the meaning of Greek myth.) "Of Kings' Treasuries" offers instruction in the reading of words and metaphors. Ruskin is concerned both with precision of meaning and with the history of meaning.

And, therefore, first of all, I tell you earnestly and authoritatively (I *know* I am right in this,) you must get into the habit of looking intensely at words, and assuring yourself of their meaning, syllable by syllable—nay, letter by letter . . . The entire difference between education and non-education (as regards the merely intellectual part of it), consists in this accuracy. A well-educated gentleman may not know many languages,—may not be able to speak any but his own,—may have read very few books. But whatever language he knows, he knows precisely; whatever word he pronounces, he pronounces rightly; above all, he is learned in the *peerage* of words; knows the words of true descent and ancient blood, at a glance, from words of modern canaille;

remembers all their ancestry—their intermarriages, distant relationships, and the extent to which they were admitted, and offices they held, among the national noblesse of words at any time, and in any country. (18.64–65)

Despite the repetitive assertions of authority with which this passage begins ("I tell you . . . authoritatively . . . I *know* I am right"), its persuasive power rests with the example of right reading that immediately follows: the justly famous explication of twenty-two lines from *Lycidas*. Ruskin's reading focuses, as he says we must, on key words or phrases—words that at first appear odd, perhaps simply "picturesque" excrescences. For example, Milton's St. Peter reproves delinquent clergy:

> Of other care they little reckoning make,
> Than how to scramble at the shearers' feast,
>
> . . .
>
> *Blind mouths*—[6]

Ruskin comments:

I pause again, for this is a strange expression; a broken metaphor, one might think, careless and unscholarly.

Not so: its very audacity and pithiness are intended to make us look close at the phrase and remember it. Those two monosyllables express the precisely accurate contraries of right character, in the two great offices of the Church —those of bishop and pastor.

A "Bishop" means "a person who sees."

A "Pastor" means "a person who feeds."

The most unbishoply character a man can have is therefore to be Blind.

The most unpastoral is, instead of feeding, to want to be fed,—to be a Mouth.

Take the two reverses together, and you have "blind mouths." (18.72).

Ruskin presents this passage as an instance of right reading, but the following paragraphs suggest that the explication of Milton is part of a reconstruction of meaning for the word "bishop," not the reverse. Ruskin goes on to illustrate modern bishoply blindness, suggesting that bishops who do not oversee the Bills and Nancys of their Dickensian urban parishes are not true bishops. To his audience's supposed objection, "But that's not our idea of a bishop," he answers, "Perhaps

not; but it was St. Paul's; and it was Milton's." This is the crucial conclusion to the example of close reading: the recovery of meaning both more precise and more suggestive for the word "bishop," by means of an excursion into literary texts. As Ruskin reminded his audience at the beginning of his second lecture, "Of Queens' Gardens," "The questions specially proposed to you in the first, namely, How and What to Read, rose out of a far deeper one, which it was my endeavour to make you propose earnestly to yourselves, namely, *Why* to Read" (18.109). We should read, Ruskin suggests, to acquire the wisdom to guide action, wisdom hidden in the forgotten meanings of words.

In the second lecture Ruskin goes on to answer this deeper question directly: "I wish you to see that both well-directed moral training and well-chosen reading lead to the possession of a power over the ill-guided and illiterate, which is, according to the measure of it, in the truest sense, *kingly*" (18.109). Words guide action, especially acts of leadership. The most immediate form of kingly power (and it is described in political as well as moral terms in both lectures) is the power of language itself. In the passage quoted earlier Ruskin asserts that to know a language precisely, to know the history of words, is both to *be* a gentleman and to *know* a gentleman. It is to be able to distinguish nobility from vulgarity, the nobleman from the mob. The educated gentleman knows the place of words "among the national noblesse of words," knows "the words of true descent and ancient blood, at a glance, from words of modern canaille." Those ill-descended words, Ruskin implies, are the imprecise language of the modern mob. He plays here with the snobbery and the social ambitions of his middle-class audience. (He had begun his lecture by reproaching them for desiring education only as "advancement in life.") This sort of play continues when he describes the dangers of words without precise meanings or adequate histories by likening them to skulking, cloaked, and masked revolutionaries (18.66). Such words are the agents provocateurs working on the mob or "modern canaille." Ruskin's prolonged metaphor might be a technique borrowed from Carlyle's writing in the 1830s. He is not only goading his middle-class audience by means of their ambitions to be gentlemen, but also threatening them with the specter of a revolutionary mob (notably French).

This politicization of the power over language is maintained

throughout both lectures and has an increasingly serious point. The first part of Ruskin's lecture on reading stresses the importance of mining for meaning as the way to reconstruct words and thus possess the power of language. The second part urges the importance of sympathy or true passion in reading great books. Here too the requirements for power over language are presented as identical with the requirements for social and political power. To lack passion, or to feel it only erratically and uncontrollably, is to be incapable of comprehending a great book. It is also to be vulgar, not gentle. "For as in nothing is a gentleman better to be discerned from a vulgar person, so in nothing is a gentle nation (such nations have been) better to be discerned from a mob, than in this, — that their feelings are constant and just, results of due contemplation, and of equal thought" (18.81). Insensitivity (as Ruskin defines vulgarity) to language, like ignorance of the history and meaning of words, reduces us to the condition of the mob. Sensitivity and knowledge of language are routes to social advancement and power — "kingly power." No sooner has Ruskin established these equations than he turns on his audience and tells them that *they* are indeed a mob.

My friends, I do not know why any of us should talk about reading. We want some sharper discipline than that of reading; but, at all events, be assured, we cannot read. No reading is possible for a people with its mind in this state . . . No nation can last, which has made a mob of itself, however generous at heart. It must discipline its passions, and direct them, or they will discipline *it*, one day, with scorpion whips. Above all, a nation cannot last as a money-making mob: it cannot with impunity, — it cannot with existence, — go on despising literature, despising science, despising art, despising nature, despising compassion, and concentrating its soul on Pence. (18.83–84)

Power over language is only one form of the power the English lack. Ruskin is by no means always sure that linguistic reform is the most crying need in contemporary England. But if social and economic reforms are more immediately pressing, linguistic reform is finally inseparable from them. Language is an index to perception, and perception, as Ruskin maintained in *The Stones of Venice*, is strongly influenced by social and economic forms. The connection between linguistic reform and the reforms Ruskin urges is all the more inescapable

because, despite the recurring analogies, he is not primarily interested in political or social power but in moral power. There is political danger and social irresponsibility in the misreading and misuse of language, but the gentleness or kingly power to be achieved through right reading and speaking is more a quality of mind and activity than a social or political position. Ruskin exhorts his audience as kings and queens or rages at them as a mob, according as he addresses himself to their capacities for seeing, speaking, and acting humanely—or despairs at their incapacity.

As with seeing, Ruskin's strategy for improving his audience's skill at reading and speaking is to try to make them do it: to demand active and even difficult reading and seeing. His own prose is an important tool in this process. Thus his lecture on reading includes more than exhortations to right reading and an exercise in word hunting. It also presents readers with a demand for such reading: the puzzling and emblematic titles and the epigraph (in Greek) from Job. Ruskin weaves all of these together in his closing paragraphs into a final complicated emblem for the true wisdom of books. Titles, epigraph, and closing emblematic paragraphs cannot be "got at" without some strenuous application of the laws of reading; those laws—an improved corn law—will provide a more sustaining bread or—as Ruskin shifts the metaphor—protect a different grain, the "sesame" that will open the doors of kings' treasuries. Such treasuries, in turn, are not just books, but also the streets of cities, paved no longer with dust or even with gold dust but with the crystal of the new world announced in Revelation. The power of language attained by the reader's efforts here is finally not a worldly power, any more than are its bread, its gold, or its cities.

Ruskin's books in the sixties, seventies, and eighties take, simultaneously, two different approaches to the teaching of reading or the proper use of language. On the one hand, careful explication—describing and gathering and explaining texts, as in "The Angel of the Sea" or "Papaver Rhoeas" or "Of Kings' Treasuries." On the other hand, the deliberate challenge—as in the initial titles of all three works and the closing paragraphs of the last. This double approach can create a difficulty, which we can see most clearly in *Fors Clavigera*. In *Fors* too education in seeing and reading is frequently equated with social posi-

tion and political power. Ruskin's ostensible audience, however, is different. *Fors* is addressed not to would-be gentlemen, kings, and queens who have made themselves a mob, but to the real mob, or at least the ambitious working members of it. Ruskin's letters keep referring to what must have been a common accusation, that he had "written to you of things you were little likely to care for, in words which it was difficult for you to understand" (27.79).[7] Ruskin's response to the real or imagined accusation was both to explain words, texts, and pictures—and to refuse to explain.

I write of things you little care for, knowing that what you least care for is, at this juncture, of the greatest moment to you.

And I write in words you are little likely to understand, because I have no wish (rather the contrary) to tell you anything that you can understand without taking trouble. You usually read so fast that you can catch nothing but the echo of your own opinions, which, of course, you are pleased to see in print. I neither wish to please, nor displease you; but to provoke you to think; to lead you to think accurately; and help you to form, perhaps, some different opinions from those you have now. (27.98–99)

Ruskin's stated intentions are no different from those he ascribed to great books and followed himself in "Of Kings' Treasuries," *The Queen of the Air*, or any of his emblematic writing beginning with *Modern Painters V*. As he had repeatedly warned, "if the author is worth anything . . . you will not get at his meaning all at once"; it "is withheld on purpose, and close-locked that you may not get at it till you have forged the key of it in a furnace of your own heating" (19.308–309). But both Ruskin's carefully leading explications and his refusals to explain take on unwanted connotations of condescension and arrogance if one remembers that these are *Letters to the Workmen and Labourers of Great Britain*. Ruskin's writing, in the best of circumstances, is not free of these connotations. The problem is exacerbated with the apparent change in audience. The difficulty is partly that whereas in "Of Kings' Treasuries" he could use the inducement to become gentle or the fear of becoming vulgar to support his arguments for education, in *Fors* he is still urging education with the promise of social or political power explicitly withdrawn. It is moral power only — improvement in the quality of their lives and their actions — that linguistic and perceptual reform can offer to the workers of England. In-

sofar as *Fors*, despite its named audience, is really spoken to and read by Ruskin's usual middle-class audience, the problem is not so great. From his working-class audience, however, he asks a conservative acceptance of the status quo. Though at times Ruskin does seem to be addressing "Workmen and Labourers" as a classless category of all those who participate in humane activity, *Fors* is not a classless work. Radical economic, social, linguistic, and perceptual reforms are here most clearly linked to political conservatism.

Linked to—and perhaps undercut by. Though Ruskin wrote that "someday" his audience would understand what he was saying and the way he said it, it is clear that he perceived the distance between himself and those he addressed to be much greater than in his other works. One consequence is the uncertainties and shifts of tone I have noted; another is the still looser and often more whimsical links between subjects in any single number of *Fors*. Tracing these links, the patterns in what Ruskin himself called a mosaic or a heap of loose stones, not the many-towered building he intended (27.669, 26.96), is as stimulating an exercise in active reading as Ruskin ever designed. But as Ruskin increasingly accepts his isolation from his audience, his myth- and emblem-making prose seems more and more to be a response to private need and not to public responsibilities. As early as Letter Six he defends his difficult style as designed to make them think and read more carefully—and as something he cannot help. "But I *can* only write of things in my own way and as they come into my head; and of the things I care for, whether you care for them or not, as yet" (27.101).[8] The associative prose of *Fors* exhibits a freedom Ruskin did not allow himself in "Of Kings' Treasuries." It gives his writing an intimacy both marvelous and frightening. As Cardinal Manning wrote, reading *Fors* is like listening to one's own heart beating in a nightmare.[9] But part of that sense of intimacy comes from Ruskin's growing conviction that while he is talking no one is listening. He is not addressing his old audience—has perhaps lost it—but the new audience cannot yet understand him. This gives him a liberty to talk more freely, even recklessly; to assume, at times, a mask of madness that is uncomfortably close to the truth.[10] But it also undercuts the educative function of his criticism and destroys the ties between critic and audience on which his rhetoric had been based. We are no longer certain that his emblems *are* readable, his associations worth tracing out. Might they

not have only a private meaning that we are not ever meant to understand? There are accommodations to this change of audience which I shall not trace here. My point is simply that the critical function of Ruskin's emblem making is diminished in parts of *Fors*, as it is in some parts of earlier works where his attention is apparently distracted from the needs of his audience to the exigencies of self-expression. This does not necessarily mean that his emblem making is less powerful. The achievement of *Praeterita* is enough to contradict that assumption. And the diminished critical function of Ruskin's emblem making may encourage us to consider his prose as art.

RUSKIN stopped writing poems and painting Turnerian watercolors before he was thirty. He fitted his descriptive and myth-making prose to critical and educative ends. Yet neither description nor myth is always clearly educative and explanatory. Moreover, the affinity between these two kinds of prose and the work of romantic landscape poets and artists remains, in some passages, very strong. The Ruskin of *The Queen of the Air*, like the Ruskin of *Modern Painters I*, is the apologist and critic of English landscape feeling, but he is also a contributor to its art. He is rightly seen in the company of Turner and Wordsworth and, in his myth-making prose, of Shelley. I began by examining the artfulness of Ruskin's word painting in *Modern Painters I* and the tension between art and criticism unwittingly generated there. I would like to conclude by looking at the artfulness of Ruskin's later pictorial style. To what extent is criticism again at odds with art?

The obviously artful passages of Ruskin's later prose are apt to come at endings, emblematic last paragraphs like those evoking Turner's Angel at the end of "The Two Boyhoods." There are occasional exceptions, however, where what is usually explanatory myth making — description and the gathering of texts — becomes something more. One of the most compelling passages of Ruskin's later prose is his presentation of Athena's serpent in *The Queen of the Air*. The passage occurs in the middle of the lecture, at a point where we would normally expect an educative exercise, not the encounter with sublimity that Ruskin gives us.

The passage is structurally similar to the explanatory myth-making sections of "The Angel of the Sea." Ruskin follows the same sequence,

description and a survey of literary and artistic tradition. But in *The Queen of the Air* mythological perception is not analyzed into its parts by dramatizing a progression from fact to metaphor to myth. Ruskin presents us from the beginning with a mythologized perception of the serpent. The gliding snake is already a mystery. The metaphor for its motion, the running brook, is inseparable from the emotion of horror it arouses in the perceiver. As Ruskin points out, "that horror is of the myth, not of the creature" (19.362). He makes a brief attempt to de-mythologize the snake: "There is more poison in an ill-kept drain, —in a pool of dish-washings at a cottage door, —than in the deadliest asp of Nile." But the attempt is not successful and serves only to dem-onstrate the hold of the myth. The description of the visible aspect of the snake repeats and expands, but does not analyze or explain, Ruskin's first phrase. His repetitions amplify the suggestions of an un-natural power perceived in the frightening contradiction between form and motion. The apparently formless and inanimate brook horri-fies because its running is that of an animate and self-willed being.

That rivulet of smooth silver—how does it flow, think you? It literally rows on the earth, with every scale for an oar; it bites the dust with the ridges of its body. Watch it, when it moves slowly:—A wave, but without wind! a current, but with no fall! all the body moving at the same instant, yet some of it to one side, some to another, or some forward, and the rest of the coil backwards; but all with the same calm will and equal way—no contraction, no extension; one soundless, causeless march of sequent rings, and spectral procession of spotted dust, with dissolution in its fangs, dislocation in its coils. Startle it;—the winding stream will become a twisted arrow;—the wave of poisoned life will lash through the grass like a cast lance. It scarcely breathes with its one lung (the other shrivelled and abortive); it is passive to the sun and shade, and is cold or hot like a stone; yet, "it can outclimb the monkey, outswim the fish, outleap the jerboa, outwrestle the athlete, and crush the tiger." It is a divine hieroglyph of the demoniac power of the earth,—of the entire earthly nature. As the bird is the clothed power of the air, so this is the clothed power of the dust; as the bird is the symbol of the spirit of life, so this of the grasp and sting of death. (19.362–363)

Ruskin's description circles in fascination about the serpent's terrifying paradox. His evocation cannot be taken as an explanation of its power or a demonstration of how its myth can be read. The mystery is no less

for being articulated. This passage works very differently from "The Angel of the Sea," where description makes an obscure epithet comprehensible by demonstrating the separate contributions of natural fact, of metaphor employed to describe a sympathetically perceived natural phenomenon, and of cultural association. Here the snake is and remains a thing of mystery and horror. There is no possibility, according to the evidence of Ruskin's paragraph, of reducing it to visible fact in order to make it comprehensible to the reader.

The verbal rhythms of this passage are remarkably suggestive. In Ruskin's descriptions, the impression of energy we receive from the prose can be identified both with that of the objects described and with that of the perceiver—the excursive eye and responsive mind of the beholder. So too in this passage, though the beholder is not a moving spectator but a stayed traveler, articulating in repetitive metaphors his broken vision of the symbolical grotesque. Ruskin's passage does not lead us piecemeal to a comprehension of the terrible, but presents us with a fractured and irreducible whole we will have to grasp for ourselves.

The discussion of mythological perception coming just before this passage prepares us to find in the description a perceptual energy that is not excursive. Mythological perception, Ruskin says, springs from a recognized kinship between the creative energy that shapes matter into animate form in plants and animals and our own spirit or life. The energy, spirit, or life to which he refers is specifically creative: a "formative force" or shaping power visible in the natural forms it creates (19.353–59). The perceiver who sees in the serpent a "natural myth" is responding as a creature who possesses a similar shaping and animating power. Articulating that perception, he becomes one of those who elaborate natural myths into "the human and variable myths" of imaginative tradition, for others to read (19.361). The mute tongue of the serpent acquires a voice that both is and is not its own, the drawn-out hiss of Ruskin's words, themselves half alive with the same horrifying animation they describe: "one soundless, causeless march of sequent rings, and spectral procession of spotted dust, with dissolution in its fangs, dislocation in its coils." We feel both that the characteristic energy of Ruskin's prose is taken over here by the strange life of the serpent, and that this energy is assimilated to Ruskin's own—the formative force of his verbal creation.

The author of this passage is a Wordsworth who has been in Gondo

Gorge, not one of the wanderers from *The Excursion*. He does not simply join his voice to nature's. Nor does he here, as he does usually, instruct his fellow creatures how to make inarticulate nature speak to social reason's inner sense, of itself and of human history. There is a struggle to comprehend and master an alien natural power. Ruskin does not want to recognize in the snake a life like his own. Its life, because so alien, is perceived as actively hostile. It is a living negation of life, death perceived as an animate power. Like Wordsworth in Gondo Gorge confronting the destructive power of nature and of God (those types and symbols of eternity), Ruskin confronts the reduced sublimity of the grotesque, which is no less terrifying. By articulating his experience, he masters it, at least temporarily. The serpent's alien power is taken to serve Ruskin's creative one.

Wordsworth, turning such an experience into language, at the same time celebrates the triumph of his imagination, until we can almost read the "characters of the apocalypse" as his own writing inscribed on the scene of his confrontation with the natural sublime. Ruskin makes no such announcement of imaginative victory. Instead his passage continues, joining his perception of the natural myth of the serpent to all those others elaborated in cultural tradition, from Apollo's Python through Aesclepius' healing snake to the serpents of the phallic and death cults discovered by comparative anthropologists. The impulse to inscribe, to commemorate his own imaginative encounter with the serpent, is much less strong in Ruskin than in Wordsworth.

Yet it has not fully disappeared. Serpent and bird are introduced at the beginning of Ruskin's passage as emblems of the shaping power mythologized as Athena. The title of Ruskin's lecture, "Athena Keramitis," can be roughly paraphrased, Athena Spirit of Air as she is capable of working together with earth to create and shape living forms.[11] The serpent exemplifies the terrifying aspects of this meeting of life and death, of the vital spirit of air with the strong, deadly power of inanimate earth. Ruskin conducts these lectures as if Athena and her emblems were the products of the Greek mind, or of the accumulated thoughts of a long cultural history. But he also tells us, in a note to his title, that "Athena Keramitis" is a phrase of his own invention (19.351). We must see that note, I think, as Ruskin's version of the Wordsworthian impulse to inscribe. Athena's emblem is Ruskin's own grotesque vision.

Against this initial indication that he has turned his encounter into

language for art, however, we have to put the rest of Ruskin's passage. After he has placed his own perception in imaginative tradition, he reflects on the darker side of that tradition, the worship of death as life and sexual power as death, recorded in Ferguson's anthropological discoveries. He invokes his powerful grotesque to characterize a bleak vision of human progress, his version of Darwinian evolution.

And truly, it seems to me, as I gather in my mind the evidences of insane religion, degraded art, merciless war, sullen toil, detestable pleasure, and vain or vile hope, in which the nations of the world have lived since they could bear record of themselves—it seems to me, I say, as if the race itself were still half-serpent, not extricated yet from its clay: a lacertine breed of bitterness— the glory of it emaciate with cruel hunger, and blotted with venomous stain: and the track of it, on the leaf a glittering slime, and in the sand a useless furrow. (19.365)

Ruskin's "lacertine breed of bitterness" is his emblem, built on mythical perception assimilated to imaginative tradition. It is an emblem made accessible to his readers by what has come before, in Ruskin's experience and others'. But Ruskin's art in this passage is a critical art once again. The bitter commentary of the last paragraph alters the meaning of the preceding encounter with the grotesque sublime. The passages of myth making become, in retrospect, not a victorious imaginative confrontation yielding language for art, but the necessary though terrible imaginative perception that creates a new vocabulary for criticism.

I N THE SERPENT passage of *The Queen of the Air* the central myth making is closer to what Ruskin elsewhere defines as the artist's or poet's experience; the final use of that myth as emblem returns to the critic's reforming concerns and less conspicuous display of his own imaginative encounter. In most of Ruskin's later prose, however, the reverse is true: myth making is critical and explanatory, while emblematic titles and conclusions extend education into artful making for its own sake. Before we ask what effect this emblem-making art has on Ruskin's criticism, we need to look more closely at the kind of art it is.

In one respect, despite the fact that Turner's genius was as a painter,

Ruskin's, Wordsworth's, and Shelley's as writers, Turner is the romantic model for Ruskin's art. It is not just Turner's vision that links Ruskin's art to his, but Turner's conception of a poetry of painting. Turner steeped himself in literary as well as visual tradition and deliberately set out to create works of art with both verbal and visual components. He created paintings and verses to be considered together; he introduced symbolic figures and multiple literary allusions into his visual compositions; he used titles that were themselves compressed verbal complements and clues to his paintings. Like Turner, Ruskin saw the visual and literary traditions as one. He set out to master both media—to see and draw as well as to read and write. Ruskin's genius was also unequal in the two media he attempted, but he nonetheless continued to work in both. He urged his audience to acquire rudimentary drawing skills just as they learned to write, and he taught that visual culture was as important as literary culture, and never independent of it. But he went further. Like Turner, Ruskin experimented with new ways of combining picture and text in a double or composite art.[12] His emblematic prose is an example of such art—sometimes working as the literary complement to pictures, at other times embodying in itself the interplay of visual and verbal form. The double art of *Modern Painters I* may not have been deliberate; that of *Modern Painters V* is elaborate and self-conscious. It is of central artistic importance to Ruskin's finest later writing, from the great lectures of the sixties through *Praeterita*.

The tradition of English double art is substantial, with roots in Renaissance emblem making and a particular flowering, coincident with the general decline of sister-arts theory, in the late eighteenth and the nineteenth centuries. Ruskin belongs in this tradition, though he would hardly want to separate it from the rest of English and European culture. (He, after all, defined both imaginative literature and painting as, simply, poetry.) Yet Ruskin felt special affinities with English masters of a double-art tradition. His closest acknowledged ties were always with Turner. With Turner he persistently associated Blake, once singling them out as the only two modern English geniuses.[13] Another of nineteenth-century England's double artists, Blake's admirer, was Ruskin's difficult younger friend Dante Gabriel Rossetti, the Pre-Raphaelite from whom for a while he hoped most. Ruskin's constant favorite among earlier English poets is more

strongly linked to the Renaissance emblem tradition than any other major writer—George Herbert.

Ruskin himself evoked the same recognition of special kinship among the major English poets and artists interested in combining verbal and visual form in the second half of the century. Besides Rossetti, Ruskin's art was enthusiastically received by William Morris and Edward Burne-Jones, who pursued the interplay between texts and the decorative arts. Holman Hunt, another early admirer of *Modern Painters*, wanted to create a visual symbolic language with roots in literary and biblical tradition. Hopkins—a Ruskinian observer who both drew and described natural objects—invented a new and emblematic version of landscape poetry. The English double art after Ruskin, however, also takes a different form under his influence. With Swinburne and Pater the conjunction of text and picture resulted in a deliberately artful treatment of prose, whose inheritor, himself once an art critic, was Henry James. In this century, art criticism became one half of a *de facto* composite art, the verbal complement to abstract expressionist painting. One might, I think, argue that the art criticism of the last century is a new kind of double art, whose founding father, however reluctant both he and some of his descendants might be to acknowledge it, was Ruskin.

The most developed form of Ruskin's composite art was his myth making, specifically the compressed or emblematic results of the descriptive and constructive process. But Ruskin's work before 1860, which had probably more influence on the next generation of poets and artists, also experiments with various relations between picture and text. The famous descriptive passages of *Modern Painters I* can be read as verbal complements to particular paintings. The relationship may be one of satire (the parodic description of Claude's *Il Mulino*), of contrast (Ruskin's versions of La Riccia or the Campagna), or of apparently direct imitation (the descriptions of Turner's *Snowstorm* and *The Slave Ship*). Even with the Turners, however, picture and text are not actually parallel. Ruskin's physical perspective is always different. He gives us the moving spectator's experience of a Turner translated back into actual landscape. He may also, as at the end of his clouds chapter, compose his own Turnerian painting out of a composite of Turnerian and Ruskinian views. Even when he is directly describing a single painting, as with *The Slave Ship*, Ruskin's metaphorical lan-

guage brings out moral meanings or literary and historical references, as Turner himself did in his titles and accompanying verses. Ruskin's passage on *The Slave Ship* refers us to the actual painting as a necessary completion of the visual experience; Ruskin's suppression of Turner's texts in his description, moreover, suggests that his own text is a substitute for the verbal part of Turner's art. At the same time, the lavishness of Ruskin's description suggests that his passage itself aspires to the condition of a composite art: a blend of precisely rendered visual detail and brilliant color with metaphoric suggestion supplied through language, where natural and perceptual motion are translated into verbal rhythms.

Ruskin also used plates and woodcuts, mostly drawn by himself, in *Seven Lamps*, *Stones*, and the last three volumes of *Modern Painters*. But the kind of double work he thus created is not what we might expect from the descriptive art of *Modern Painters I*. He rarely illustrates his most elaborate and extensive descriptions and, when he does, he does not use plates that can claim an equal importance as art. Instead, the plates in the volumes before *Modern Painters V* fall generally into three classes. There are picturesque and often very beautiful drawings of architectural details or of rocks, mountain forms, leaves, flowers, branches, or clouds (ill. 10); and there are simplified or schematized drawings of the same things, sometimes taken from his own and sometimes from other artists' work (ill. 20). Often both picturesque and simplified drawings are placed several to a single plate to illustrate some point of comparative or progressive form. These two classes of illustration, sometimes used in combination, account for most of Ruskin's plates. They generally relate to particular analytical points made in the text and are directly referred to at the appropriate place. Both text and plate titles (which Ruskin begins to use after *Seven Lamps*) are straightforwardly descriptive, directing the reader to those aspects of the pictures relevant to the passages they illustrate. In *Seven Lamps* and *Stones*, all of the plates have this localized, explanatory function; Ruskin does not even use frontispieces. In a third and much smaller class of plates, beginning in *Stones*, pictures are also tied to a particular point in the text, but those points have a wider thematic significance and may be elaborated in more ambitious descriptive prose—the double plate of the true and false griffins (5.140), for example, or that of surface and Turnerian picturesque (ill. 9). These plates, like the texts they il-

lustrate, are types as well as examples. They are, however, still illustrative of and subordinate to the text. We are not encouraged to regard any one of these kinds of illustration as distinctive but coequal statements in a different medium, parts of a composite work of art.

We might also take the illustrated volume as a whole as a composite work of art. Quite possibly the example of Ruskin's careful designs for plates and bindings as well as descriptive prose inspired Morris and Burne-Jones, though there were other author-designed Victorian illustrated books. But Ruskin did not pay nearly so much attention to the correspondence between the physical aspect of the whole book and its literary form and style as to the expository function of individual plates and prose passages.[14]

Ruskin's drawings, considered separately from the illustrations he chose for his books, suggest one reason why he did not combine them with his descriptive prose to create a true double art. The changes in his drawing style between the early forties and the mid-fifties bring his modes of visual and verbal presentation steadily closer together. The culmination of this development is the Swiss drawings Ruskin made between 1854 and 1866, especially those intended for his unrealized project, a history of Swiss towns. He wanted to demonstrate the importance of the walls and bridges and towers of the Swiss towns as sources of the cultural associations that formed an essential part of the European experience of landscape. To this he later added a second purpose, to illustrate the differences between the beholder's art (his own drawings) and the imaginative artist's (Turner's versions of the same scenes).

Ruskin's drawings for this project, then, were intended to illustrate the excursive and associative seeing that his descriptive prose also exemplifies. As Paul Walton, the closest student of Ruskin's visual art, points out, in these drawings Ruskin achieves a new freedom from the burden of imposing imaginative and compositional unity, a freedom greater, in fact, than that of the "delight drawings" of Turner he originally took as his model.[15] In a long, wandering trail of walls and towers across a page (ill. 21), passages of fine detail emerge suddenly from large areas of white, to fade again, as the eye follows the trailing forms, into a less defined vision. The uneven realization and the wandering forms suggest the freely changing focus and perspective permissible in a record of an eye moving through what it sees. Or again, in

the mazelike appearance of the top-viewed streets in Fribourg (ill. 22) where there is no orienting horizon line at all, lurching houses, twisted streets, and unexpected shifts from fine to hazy detail force a dizzying sense of changing perceptual involvement which bears little relation to Turner (though perhaps a good deal to the later experiments of Cezanne). If there is a visual counterpart to Ruskin's progressive descriptive style, it is these Swiss drawings. But exact visual and verbal counterparts are not composite art. If the changes in Ruskin's drawing style between *Modern Painters I* and *V* are seen as an increasing freedom of organization culminating in the Swiss drawings, then it is not surprising that Ruskin should have kept his prose descriptions and his drawings of this kind separate. He was developing parallel expressions in visual and verbal form of his beholder's art — not the deliberate interplay of forms that might create a double art.

In *Modern Painters V*, however, just as there are passages of new, emblematic pictorial prose, so there are also plates with a new emblematic relationship to Ruskin's text. Early in the volume three plates have titles that suggest their new function: "The Dryad's Toil," "The Dryad's Crown," and "The Dryad's Waywardness." The mythologizing of trees into dryads does not take place in the text at all. The prose refers to the plates merely to illustrate local points about leaf and branch form. Nor are the actual drawings markedly different from earlier illustrations. It is only the titles to the plates that indicate a larger, emblematic meaning for each plate, expressed in a mythological figure.

In the last third of the volume, emblematic text and plates combine to form a composite art. Ruskin had used frontispieces for the first time in *Modern Painters III* and *IV* — one a landscape drawing of his own, never referred to in the text; the other Turner's *Pass of St. Gotthard*, which is discussed in several different places. In *Modern Painters V* Ruskin uses a frontispiece whose meaning seems to exceed its designated illustrative function.[16] Moreover, he adds separate headplates for each of the last three chapters, in which again the plates do not really seem to illustrate the texts. That for "The Nereid's Guard," for example, shows Turner's dragon, copied by Ruskin from *Hesperides* (ill. 23). The dragon, as Ruskin redraws him out of his original setting, reveals features not easily visible in the full painting: a skeletal form, batlike wings, a nimbus of flame-shaped clouds. Ruskin's black and white drawing also makes the ridges of the ground on which the dragon lies

appear as extensions of its clawlike feet, so that the dragon itself merges into the rock structure (or glacial structure) of the mountain top. All these features Ruskin's text attributes to Turner's dragon, but the drawing that singles them out for clearer representation is no longer Turner's vision, but Ruskin's. The plate is not titled *Turner's Hesperidean Dragon* but *Quivi Trovammo.* The dragon of the drawing is the dragon of Ruskin's closing emblematic paragraphs.

The visual image and the emblematic prose are equally compelling, but they are complementary rather than parallel in style. The prose presents a succession of allusions and comparisons arranged for maximum ironic effect: Turner's dragon and St. George's; the presiding images of Pallas Athena, the Virgin, and the Dragon; Dürer's Melancholia, crowned with laurel and eagle's wings, and Turner's dragon, "Crowned with fire, and with the wings of a bat." The drawing makes all these into a single image and includes in that image other details from earlier in the chapter, which link it more firmly with Hesiod and Turner. The title of the plate is from Dante: the "There we found . . ." that announces the discovery of "il gran nemico," which Ruskin earlier associated with the Hesperidean dragon (7.401). The drawing is a summary view of what "we have found," without the irony of the prose but with the more unified impact of the single visual image. On the other hand, the conjunction of text and picture means that the picture can also be read as a complex symbolic statement, full of definite allusions; similarly, the text can be envisioned as a multilayered pictorial image, with related visual figures superimposed to show their likeness in difference. The plate, the two titles, the concluding paragraphs, and the chapter itself work together to form a composite structure very much like a Renaissance emblem: a picture that needs to be read, followed by cryptic mottos in a mixture of languages (*Quivi Trovammo*; "The Nereid's Guard"), paired with a prose-poem that uses a great deal of verbal metaphor to enrich the texture of readable meanings, and finally—if we include the body of the chapter—further explained in a prose essay or amplification.[17]

Ruskin's dragon emblem bears at least a superficial resemblance to Turner's, as indicated in both plate and title. In his "Hesperid Aeglé" neither picture nor title (the same for both picture and chapter) is directly illustrative of the Turner painting that is his ostensible subject. In that painting (*Apollo and Python,* ill. 17) the Hesperides do not, of

course, appear. Ruskin's plate (ill. 24) shows a Giorgione fresco of a half-nude woman (not one of the Hesperides); there is no female figure in Turner's painting. The only possible relationships between picture or title and the chapter they preface are symbolic or emblematic. In this case, the meaning of plate and title is only made clear in the closing paragraph; similarly, the female figure of Ruskin's plate is essential for comprehending the elaborate visual allusions of that paragraph. Here plate and prose passage are different realizations of the same figure which cannot be comprehended except together.

The opening pages of the chapter directly discuss *Apollo*: the flawed victory of light and color over darkness, of Apollo over the Python, of the artist over his medium and material. The rest of the chapter is a more general characterization of Turner's mind and work as a mixture of the rose and the worm: a vision of incredible natural beauty, joined to a pessimistic view of human labor, sorrow, and death. At the end of that discussion Ruskin points out Turner's fascination with the historical examples of Carthage, Rome, and Venice: Carthage (and the nearby Garden of the Hesperides) "showing the death which attends the vain pursuit of wealth; Rome showing the death which attends the vain pursuit of power; Venice, the death which attends the vain pursuit of beauty" (7.437). Ruskin notes that Turner's late Venetian paintings, whose beautiful colors so quickly deteriorated,[18] are "strangely significative" examples of Turner's theme. The chapter then concludes:

Vain beauty; yet not all in vain. Unlike in birth, how like in their labour, and their power over the future, these masters of England and Venice—Turner and Giorgione. But ten years ago, I saw the last traces of the greatest works of Giorgione yet glowing like a scarlet cloud, on the Fondaco de' Tedeschi. And though that scarlet cloud . . . may, indeed, melt away into paleness of night, and Venice herself waste from her islands as a wreath of wind-driven foam fades from their weedy beach;—that which she won of faithful light and truth shall never pass away. Deiphobe of the sea,—the Sun God measures her immortality to her by its sand. Flushed, above the Avernus of the Adrian Lake, her spirit is still seen holding the golden bough; from the lips of the Sea Sibyl men shall learn for ages yet to come what is most noble and most fair; and, far away, as the whisper in the coils of the shell, withdrawn through the deep hearts of nations, shall sound for ever the enchanted voice of Venice. (7.438–440)

This may be Ruskin's most complex and cryptic emblem, at once the culmination of experiments with verbal and visual language in *Stones* and *Modern Painters* and the beginning of a new prose style. Turner's art and Giorgione's are two superimposed images, distinct yet akin, exemplifying the historical connections between two artists working in the same tradition. The fading scarlet cloud that both men have left is Giorgione's fresco, represented in the plate, of which all that remains (according to Ruskin's note) is the scarlet outline. It is also the fading color in Turner's late Venetian oils and watercolors. That scarlet cloud is again the real Venice, wasting like wind-driven foam from its islands as the brightly colored buildings crumble, following its political and cultural decline. It is a particular sunset cloud, subject of many of Turner's Venetian watercolors—what Ruskin elsewhere calls the flush of "second twilight," the last rosy flush of color in the sky after the sun has set (13.212). That last sunset color is what Ruskin had, in the previous chapter, identified as the natural phenomenon represented by the mythic maidens of the Hesperides, which is the reason for the title of the chapter and for Ruskin's renaming of Giorgione's woman. Extensive footnotes earlier in the chapter expand the symbolic meaning of the color red, both as biblical language—for love, especially as purification and redemption—and as Turnerian language, where (according to Ruskin) it suggests beauty linked to blood and death. The scarlet cloud is thus the rose that Ruskin has used as a metaphor for Turner's pessimistic vision of natural beauty throughout the chapter. The *Quivi Trovammo* becomes, in retrospect, an emblem of the worm.

We have only begun. The female figure is as important as her color. The Sea Sibyl, or Deiphobe of the Sea, is again Venice, this time associated with the Sibyl who appears in four of Turner's paintings (mentioned by Ruskin earlier in the chapter).[19] She is the Sibyl whom Apollo loved and promised, at her request, that she would live as many years as the grains of sand in the handful she held. The Sibyl denied Apollo and, like Tennyson's Tithonus, failed to gain perpetual youth along with her all but eternal life. As Ruskin earlier explained, writing of Turner's *The Bay of Baiae,* she "wasted into the long ages; known at last only by her voice" (13.132). The fading beauty of Venice, Giorgione's fresco, and Turner's paintings are all figured in the Sibyl's story. The same Sibyl carrying the golden bough guided Aeneas to the underworld by Lake Avernus. The allusion to the Sibyl in Rus-

kin's passage intentionally recalls a visual figure as well as a mythic story. In Turner's three paintings of the Sibyl and the golden bough (at least two of which were known to Ruskin)[20] the Sibyl holds aloft the golden bough much as the Statue of Liberty holds her torch; but his Sibyl is a diminutive figure almost overwhelmed in a larger land-scape, like the thin shimmering line of Venice on the water in Turner's paintings. In Turner's *The Golden Bough* (ill. 25) the Sibyl is half draped in almost exactly the same fashion as Giorgione's fresco, which like the Sibyl holds something in her left hand. (In Ruskin's plate, the dark hatched background stops slightly above her cupped hand, so that she seems to hold light itself.) Giorgione's woman, in Ruskin's plate, is the visual image uniting the Sibyl with the golden bough and Venice itself—with the insubstantial form of crumbling buildings still holding the incredible Venetian light. All three images, mythically and visually related, are fused in a single emblem for the continuing but nonethe-less fading beauty and power of art—a rose that is Giorgione's, Venice's, and Turner's.[21]

Ruskin's emblem making in these last chapters of *Modern Painters* creates new figures by bringing together related images, voices, and myths drawn from perceptual experience and cultural tradition. This gathering may be a slow and carefully presented sequence of description and explication, as in the body of each chapter, or a rapid and al-lusive piling up of visual and verbal forms into a multilayered emblem, as in their concluding paragraphs and the complementary plates. In both the leisurely exploratory and the rapid emblematic sections, the allusions bring together very different kinds of phenomena and endow them with equivalent linguistic value. Giorgione's fresco, *Hesperid Aeglé,* the myth of the Sibyl, Turner's late Venetian paintings, the last flush of twilight sky, Venice itself—these are equally effective signifiers, each, as it emerges from Ruskin's paragraph and plate, capa-ble of recalling the whole intricate texture of reference he has estab-lished. Nowhere, either in his reconstructions of cultural history or in his compressed final paragraphs, does he try to reduce these different orders of phenomena to one signifier. The movement is quite the other way: from the single name or image to the complex of significant ob-jects. As he warned readers of *Proserpina,* "No single classification can possibly be perfect, or anything *like* perfect. It must be, at its best, a ground, or *warp* of arrangement only, through which, or over which,

the cross threads of another, — yes, and of many others, — must be woven in our minds" (25.359–360). Ruskin's myth-making prose works toward linguistic pluralism: especially, though not exclusively, a pluralism that embraces the complex images of natural landscapes and of visual art together with the stories, myths, and names of verbal language.

In this sense Ruskin's myth-making prose, and particularly the more compressed and allusive writing like that of the closing paragraph of "Hesperid Aeglé," creates a double art even without the physical presence of a readable picture. The use of both plate and title is arguably redundant. Either Giorgione's fresco or the name "Hesperid Aeglé" would do as the points from which to begin the multiplication of sign and significance. Ruskin does not, in fact, continue to use both. The lectures of the sixties are almost all organized as expansions of emblematic titles, but they were not published with illustrations. Only a few of the emblemizing chapters of *Praeterita* were issued with plates — though these few illustrations do work emblematically. The monthly letters of *Fors* use emblematic illustrations less than half the time. Ruskin's commitment to the ideal of a composite art, a poetry using visual and verbal language together, is no less evident in these later examples of his prose.

The "art" of this later prose, although full of difficulty for the reader, nonetheless possesses a more intelligible relationship to the critical works of which it is a part than the purple passages of his early prose. The difficulties should not be underestimated. Ruskin's descriptive art is more accessible, even though more apt to mislead when it is admired as art. Emblematic titles, plates, and conclusions require an interpretive labor that readers may not be willing to undertake. It is all too often true that either the more expansive passages of explication or the more compressed passages of emblemizing seem self-indulgent — the emblems contracting unintelligibly; the excursive prose ranging too far for too long, so that author or reader cannot get back. Yet the artful aspects of Ruskin's later writing have a clear formal as well as critical function.

Emblematic titles or plates and the cryptic paragraphs to which they refer provide a way of imposing formal limits and formal unity — a beginning and an end — on what might otherwise be an infinitely expansive and digressive flow. The cryptic naming and figuring and the

rapid layering of related names and figures is the counterpart to an excursive prose. The latter leads; the former makes. Education begins with, concludes with, and is shaped by poetic making. No single prose passage attempts both, a source of potential confusion for the readers of *Modern Painters I*. Both emblematic art and excursive instruction have separate functions, but they cooperate to form a larger prose structure. Such cooperation is consistent with Ruskin's new ideas about the relation of the critic to the imaginative languages whose history he reconstructs. The critic treats such human languages as living, and when he has reconstructed the potential meanings of words or images, he uses them. That using is itself a further extension of meaning. In the reinterpretation of a living tradition, criticism passes naturally into creation.

My description of the prose artist Ruskin became in his last three decades as a critical writer may seem to stress surprisingly unromantic qualities. I have suggested that his composite art is an art of making emblems—emblems that control and shape the beholder's activities of excursive seeing and associative reading, and that constitute the end to which those activities lead. What has happened to the natural expressive landscapes with which Ruskin began? Mental process and natural form seem no longer to meet in these emblematic forms. They do, compellingly, in the reanimated myth of Athena's serpent as Ruskin first presents it, "the running brook of horror on the ground." But the Athena passage is exceptional. Even there in his completed emblem the energy of perception and the energy of nature are compressed into significant forms, an intricate texture of readable images and words. The "lacertine breed of bitterness" is an emblem for the deathful power of a still uncivilized human race, but it lacks the immediacy of his horrified glimpse of the living serpent. One might be tempted to conclude that Ruskin, in the second half of his career, reversed the direction of a century of English landscape art as he moved from an expressive to an emblematic art.

This would be an inaccurate conclusion. Ruskin does revise the landscape art of the romantic poets, but he does not return to the seventeenth-century emblematic art Shaftesbury attacked.[22] Ruskin's emblems reassert the continuing importance of perceptible objects as affective language. For Ruskin the imagination does not, as for Wordsworth in "Tintern Abbey," dissolve the details of real land-

scapes and substitute for them its own mnemonic signs, to be later converted into the more expressive characters of verbal language. In Ruskin's version of Wordsworth's poem, cliffs and hedgerows and hermit smoke would all remain after memory and imagination had done their work: an emblematic image infused with meaning, the warp on which a woof of related images and stories had been woven but which yet could stand, in all its perceived complexity of sensible form, as the representative, significant design. Still, Ruskin would certainly have agreed with Shaftesbury that the significant picture must also possess naturalistic and expressive power as the basis of its emblematic function. The emblematic landscape should convey the illusion that the artist had a single vision of nature. Its parts should appear to be related both as natural form or scene and as mental process. The wholly artificial construction of a significant sensible figure, intelligible only as allegorical language to be read, was not Ruskin's model even for his most elaborate emblems. It would be more accurate to describe Ruskin's later art as both expressive and emblematic. The combination of expression and emblem is conceived as that of an historical process by which human perceptions of nature are elaborated into emblems, increasing in linguistic complexity as the imaginative tradition grows. In Ruskin's later critical writing, the emblem shapes the perception of expressive form, but the original perception is in turn the continuing source of the emblem's linguistic power. The reform of language can still be accomplished only by returning to the beholder's art.

Ruskin was never sanguine about the prospects for reform — perceptual, linguistic, or social. Despite his passionate, idealistic commitment to improving the quality of human life, he had by temperament and religious conviction no very strong faith in the desire or ability of people, including himself, to realize his humane goals. His disbelief in his audience shows. He can never trust us to make our own judgments. He does not use the vast mass of evidence he has accumulated — for *The Stones of Venice,* say — but relies on typical or emblematic examples combined with authorial demonstrations of how to see or read. When his audience is British workingmen or philistine businessmen or women of any kind, his distrust is more obvious and, to us, distasteful, but it is characteristic of his attitude even toward those

who do not differ from him in class, culture, or sex. Ruskin's pessimism is not entirely a function of temperament, religious conviction, or unexamined prejudices about his audience. In the 1850s the spirit of reform was at a low ebb in Victorian England.[23] Ruskin's readers were not quick to take fire with his or any proposals for changing their way of life or taking social action to change life for others—even when those proposals were tied to a conservative political ideology. Ruskin's response was seldom to persuade patiently, to encourage the fiction of consensus and kinship in his audience in the hope of quietly converting them to his own values. His reaction to a national mood unreceptive to reform was to demand more while he expected less. He made beholding and reading more strenuous, and both his prose and his proposals more difficult and quixotic.[24] At the same time, he did not hide his increasingly bitter conviction that what he urged his audience would not achieve.

Ruskin's ideas about perception and the languages of art survive what he regarded as the symptomatic failure of his proposals for reform: the disappearance of landscape feeling as a major impulse toward perception and language and, with it, the alteration of the English and European landscapes he loved. To tie the validity of his aesthetic and social ideas too closely to the fate of landscape feeling is probably a mistake. It may well be true that, were Ruskin's humane vision of labor and consumption realized, we would cherish natural landscapes as guides to perception and sources of language. But as Ruskin himself realized, one begins with the conditions of labor and consumption in society and art, not with the landscape feeling.

Nonetheless, much of Ruskin's most bitter and despairing as well as his most enthusiastic writing is devoted to landscapes and landscape art. So, too, are the moving elegiac passages of his later prose: above all, the emblematic landscapes of *Praeterita*. These express Ruskin's pessimism more than his passion to reform. The pessimism, though, is muted, mixed with desire and the ever-present sense of loss. If landscape feeling has any continuing role in English or American culture, then these Ruskinian landscapes of loss will be part of the imaginative language we inherit. In his landscapes Ruskin most directly contributes to the available poetic tradition. The last landscape of *Modern Painters* is an earlier and more public version of the emblematic landscapes of paradise lost and recovered in *Praeterita*. It is also, I think, a

deliberate comment on his first reading of symbolic landscape—an emblem of the new view of the languages of nature and art presented in *Modern Painters V*.

"Hesperid Aeglé" is the conclusion to *Modern Painters*; the final chapter, "Peace," is more coda than finale. Ruskin's "rose" of perpetually fading beauty is also his private "Rose," with whom he was already hopelessly and obsessively in love. But she is equally his public Venice. Figure and landscape merge, joining the figures and the Venetian landscapes of Giorgione and Turner. Ruskin's defense of natural beauty as portrayed in Turner's paintings ends where his other major work of these two decades, *The Stones of Venice*, began: with an evocation of Venice as a real landscape and a figure of beauty, a landscape to be read and a voice to be listened to. The visual image in both passages is very nearly the same. In 1851 too Ruskin saw Venice as "a ghost upon the sands of the sea, so weak—so quiet,—so bereft of all but her loveliness" (9.17). The voice that opens *Stones*, however, is stern. Ruskin hears and conveys "the warning which seems to me to be uttered by every one of the fast-gaining waves, that beat like passing bells, against the STONES OF VENICE." The stern warning that Ruskin adopts is God's, delivering through his prophets the lesson of the fall of a great and proud sea-based civilization. Tyre is a biblical type of Venice, and England, unless it reforms, may follow Venice and Tyre.

The voice, the language, and the message Ruskin calls up at the end of *Modern Painters* are a deliberate revision of that earlier warning. The voice he hears is not beating waves but receding ones; not the tolling bell but the whisper of the seashell; not the stern warning but the "enchanted voice." The language is no longer biblical but historical and human, the language of Greek myth, of Giorgione's art and Turner's, and of Ruskin's, his figures incorporating and extending theirs. The message has also altered. It is not that England must reform or fall, but that beauty does survive, even "for ever," though only as the lovely wreck of what it once was. It fades to a scarlet glow but still keeps its whispered voice, resounding in memory: "withdrawn through the deep hearts of nations." The ghostly voice of that fading scarlet shadow, Venice, sounds here once more in Ruskin's elegiac prose—but only to remind us of what we have already lost.

NOTES

INDEX

Notes

Introduction

1. *The Complete Works of John Ruskin* (Library Edition), ed. E. T. Cook and Alexander Wedderburn (London: George Allen, 1903–1912), vol. 35, p. 14 (hereafter cited in text as 35.14).

2. Robert Hewison discusses what he calls the "dialectical" nature of Ruskin's thinking in *John Ruskin: The Argument of the Eye* (Princeton: Princeton University Press, 1976), pp. 201–208. Ruskin's characteristic approach to paintings as well as ideas, however, often involved successive considerations from multiple points of view rather than the simpler Hegelian pattern that Hewison suggests.

1. The Poet–Painter

1. *Gentleman's Magazine,* November 1843, p. 467; *Fraser's Magazine,* March 1846, p. 368. The *Church of England Quarterly* (January 1844) and the *Globe* (August 1843) also called him a poet and painter.

2. *Gentleman's Magazine,* November 1843, p. 467.

3. *Athenaeum,* February 10, 1844, p. 106; February 3, 1844, p. 133.

4. See George P. Landow, "Ruskin's Revisions of the Third Edition of *Modern Painters,* Volume I," *Victorian Newsletter,* 33 (Spring 1968), 12–16.

5. Ruskin singles out these two men by name in several letters (3.646,670). His references make it clear that he respects their historical and technical knowledge but rejects it as grounds for critical judgments. Of Waagen, for example, he notes in his diary for November 27, 1843: "Got a good deal out of Waagen, but he is an intolerable fool—good authority only in matters of tradition" (3.646).

6. That analytical looking was the major instrument of scientific investigation is clear from the works of natural history on which Ruskin was raised, such as Robert Jameson's *System of Mineralogy* and H. B. de Saussure's *Voyages dans les Alpes.* Robert Hewison discusses this point at greater length in *The Argument of the Eye,* pp. 20–22.

7. See Landow, "Ruskin's Revisions."

8. Landow points to the pairing of satiric and visionary descriptions as one of Ruskin's rhetorical techniques in his "There Began to Be a Great Talking About the

Fine Arts," in *The Mind and Art of Victorian England,* ed. Josef L. Altholz (Minneapolis: University of Minnesota Press, 1976), pp. 140-143.

9. See the survey of Victorian periodical art criticism in Landow, "There Began to Be," pp. 130-135.

10. Ruskin's description of Turner's *Snow Storm — Steam-Boat off a Harbour's Mouth* (1842), 3.569-571; of *Slavers Throwing Overboard the Dead and Dying (The Slave Ship)* (1840), 3.571-572; of the Roman Campagna compared with Claude Lorrain's version of it in *Il Mulino* or *The Marriage of Rebecca and Isaac,* 3.41-44; of La Riccia on the Campagna, compared with Gaspar Poussin's version, 3.277-280. The La Riccia and *The Slave Ship* descriptions were quoted frequently in reviews.

11. The foliage description quoted above seems to be still another version of the same scene, a detailed study of the foreground composed as a whole scene but paired with the bank of foliage in the Gaspar painting of La Riccia.

12. "Of Turnerian Topography," esp. 6.29-47.

13. John L. Bradley, ed., *Ruskin's Letters from Venice, 1851-1852* (New Haven: Yale University Press, 1955), p. 293.

14. Joan Evans and John H. Whitehouse, eds., *The Diaries of John Ruskin* (Oxford: Clarendon Press, 1956), I, 130.

15. *Diaries,* I, 216.

16. Ruskin later decided that his impulse to draw and describe was partly compensation for an inadequate memory; a great artist like Turner did not need to make extensive visual notes. See 35.75, for example, and Ruskin's 1845 comments comparing J. D. Harding's memory with his own, in *Ruskin in Italy: Letters to His Parents, 1845,* ed. Harold I. Shapiro (Oxford: Clarendon Press, 1972), pp. 192-193.

17. An unused manuscript passage for *Praeterita,* published by Cook and Wedderburn, comments on his drawing style in 1841: "How far at this time . . . I saw and enjoyed the colour I never attempted to represent, may be judged accurately from the passage of *Modern Painters* so often quoted by my shallow literary admirers — the description of sunshine after storm at La Riccia. That passage is merely the description of one of the thousand thousand sights and scenes which were then the delight of life to me — but, in the splendour and fulness of them, wholly beyond any form of painting I had reached. And I had the general sense to draw only what I could draw, already, rightly, looking forward . . \. to being able to paint such things some day or other; or if not, to be happy in seeing Turner do them, while I pleased myself and my friends enough with pencil outlines washed with cobalt and touched with Naples yellow" (35.625-626).

This is in fact the style of the La Riccia drawing, modeled on that of David Roberts, whom Ruskin cites as an important influence on him in the early 1840s. He characterizes Roberts' work as combining "precision of line" in outline drawings "completed to the pitch of shadow . . . by flat grey washes, giving the forms of shade with precision and its gradations with delicacy, and finally touched, for light, with whitish yellow" (35.625). However, Ruskin continues, "Roberts remained merely a draughtsman and oil painter in grey and yellow — he never looked for the facts of colour in anything, nor received, as far as can be judged from his work, emotion from" color. Ruskin's prose passage in *Modern Painters I,* as he points out

especially tries to capture the color and emotion omitted in his Robertsian drawing. The diary description, though it says little about the effects of light and color notable in the published version, does carefully note the presence of yellows and grays, suggesting that the diary passage was intended partly as notes for the drawing that Ruskin returned to do in March.

18. Evans and Whitehouse, *Diaries*, I, 135–136.

19. The 1841 drawing is not so reorganized either (ill. 2). It shows the foliage-covered slope with the Bernini church in La Riccia above it, against the sky and the descending road in the foreground—the factual view noted in the diary, without the conflation of La Riccia with Albano and with the distant prospect of the sea.

20. As George Landow has pointed out to me, the added similes in the published version of the description make obvious allusions to scriptural types of heaven, turning Ruskin's experience into a recognizable "Pisgah sight," or vision of the promised land. The typological allusions further reinforce the dramatic narrative structure that Ruskin has given to his original experience. See Landow's discussion of the Pisgah sight in his *Victorian Types, Victorian Shadows: Biblical Typology in Victorian Literature, Art, and Thought* (Boston: Routledge and Kegan Paul, 1980), pp. 203–231.

21. See especially *The Ethics of the Dust* (1866) and *The Queen of the Air* (1869). John Rosenberg discusses Ruskin's later animism in "The Geopoetry of John Ruskin," *Etudes Anglaises*, 22 (1969), 42–48.

22. Landow has noted the cinematic motion of Ruskin's eye ("There Began to Be," p. 139). John Dixon Hunt describes (not with reference to Ruskin) the "kinema" of eye movement as "the mysterious process of discovering what comes next to eye and mind rather than an apprehension of landscape at a distance which is surveyed rapidly by what Thomson called 'the raptured eye, / Exulting swift' " ("The Seasons: Summer," ll.1409–1410); see Hunt, *The Figure in the Landscape: Poetry, Painting, and Gardening during the Eighteenth Century* (Baltimore: Johns Hopkins University Press, 1976), p. 228. What both Landow and Hunt point to by their use of "cinematic" or "kinema" is the movement of the eye not only *over* the picture space but *through* it: the constant shifts in focus as the eye and mind travel through three-dimensional space. This is one of the essential characteristics of Ruskin's descriptions.

23. See Patricia Ball, *The Science of Aspects: The Changing Role of Fact in the Work of Coleridge, Ruskin and Hopkins* (London: Athlone Press, 1971), esp. pp. 55, 62–67, 73–74, 86–88.

24. This survey leaves out many favorite later examples of Ruskin's descriptive prose. One distinctive use of prose description—to reanimate myth or create emblems, as Ruskin does with the serpent and bird in *The Queen of the Air* (19.360–365)—has been reserved for my last chapter.

For a fuller discussion of Ruskin's use of landscape description to structure *Praeterita*, see my "Ruskin and The Poets: Alterations in Autobiography," *Modern Philology*, 75 (November 1976), 142–170; reprinted as "The Structure of Ruskin's *Praeterita*" in *Approaches to Victorian Autobiography*, ed. George P. Landow (Athens: Ohio University Press, 1979), pp. 87–108.

2. The Victorian Critic in Romantic Country

1. For the best discussion of the pathetic fallacy as aesthetic theory, see George P. Landow, *The Aesthetic and Critical Theories of John Ruskin* (Princeton: Princeton University Press, 1971), pp. 32–33, and 377–390; for the landscape-feeling chapters as a turning point in Ruskin's intellectual development, see Francis G. Townsend, *Ruskin and the Landscape Feeling: A Critical Analysis of His Thought During the Crucial Years of His Life, 1843–56* (Urbana: University of Illinois Press, 1951). Kenneth Clark assumes Ruskin's contribution to art history in his *Landscape into Art* (London: J. Murray, 1949). Townsend does point out the criticism of Wordsworth briefly (pp. 73–74), as does U. C. Knoepflmacher, "Mutations of the Wordsworthian Child of Nature," in *Nature and the Victorian Imagination*, ed. Knoepflmacher and G. B. Tennyson (Berkeley: University of California Press, 1977), pp. 409–413.

2. Ball, *The Science of Aspects*, pp. 1–3, 48–102; Harold Bloom, "Ruskin as Literary Critic," in *The Ringers in the Tower: Studies in Romantic Tradition* (Chicago: University of Chicago Press, 1971), pp. 169–183.

3. Bloom, p. 178.

4. See my "Ruskin and the Poets." Ruskin's criticism of the romantic poets in *Modern Painters III* has of course much in common with Victorian criticism of romantic subjectivity beginning in the 1830s. Arnold's are the most well-known later expressions of this critical attitude (in, for example, his "Preface," 1853; "Essay on Heine" and "The Function of Criticism," 1863; "Wordsworth," 1879; "John Keats," 1880; and "Byron," 1881). For Arnold, however, as for Sir Henry Taylor, objections to the egotism of Byron, Shelley, and Wordsworth were coupled with praise of Wordsworth's more thoughtful poetry. Ruskin, like Arthur Hallam, thought Wordsworth's reflective poetry too full of conscious thought to be highly imaginative (Taylor, preface to *Philip von Artevelde*, 1834, and essay on Wordsworth, 1841; Hallam, review of Tennyson, 1831). See R. G. Cox, "Victorian Criticism of Poetry: The Minority Tradition," *Scrutiny*, 18 (1951), 2–17; and Lawrence Poston, "Wordsworth among the Victorians: The Case of Sir Henry Taylor," *Studies in Romanticism*, 17 (1978), 293–305.

5. Eileen Tess Johnston discusses *In Memoriam*'s alterations of romantic lyric conventions in her dissertation, "The Rhetorical Design of Tennyson's Poetry" (University of Chicago, 1977).

6. See Ruskin's discussions of typical and vital beauty in *Modern Painters II*, and on this, Landow, *Aesthetic and Critical Theories*, esp. pp. 321–457.

7. Ruskin's comments on Scott may owe something to Hazlitt's *The Spirit of the Age* (London, 1825), also an attempt to define the modern temper. Hazlitt deprecates exactly what Ruskin praises about Scott, calling him "a literal, a *matter-of-fact* expounder of truth or fable" (p. 136). Scott "has found out (oh, rare discovery) that facts are better than fiction" (p. 142). Hazlitt finds mere description of facts a virtue in fiction but not in poetry. "It must be owned, there is a power in true poetry that lifts the mind from the ground of reality to a higher sphere, that penetrates the inert, scattered, incoherent materials presented to it, and by a force and inspiration of its own, melts and moulds them into sublimity and beauty. But Sir Walter . . . has not

this creative impulse" (pp. 135–136). Wordsworth, who is not merely factual or descriptive, has the true creative impulse; he is "the most original poet now living" (p. 238).

8. For a fuller discussion of Ruskin's sister-arts theory in *Modern Painters II* and its connection with Burke and Hazlitt, see Landow, pp. 43–86; on Hazlitt, Coleridge, and romantic sister-arts theory, see Roy Park, *Hazlitt and the Spirit of the Age: Abstraction and Critical Theory* (Oxford: Clarendon Press, 1971), pp. 115–137.

9. Edmund Burke, *A Philosophical Enquiry into the Origin of Our Ideas of the Sublime and Beautiful*, ed. J. T. Boulton (1958; rpt. Notre Dame: University of Notre Dame Press, 1968), pp. 175–176, 177.

10. *The Complete Works of William Hazlitt*, ed. P. P. Howe (London: J. M. Dent, 1930–1934), V, 10.

11. Hazlitt, *Works*, XII, 337.

12. *Coleridge's Shakespearean Criticism*, ed. T. M. Raysor (London: Constable, 1930), II, 93.

13. Coleridge, *Collected Letters*, ed. E. L. Griggs (Oxford: Clarendon Press, 1956), I, 511.

14. *The Prose Works of William Wordsworth*, ed. W. J. B. Owen and Jane Worthington Smyser (Oxford: Clarendon Press, 1974), III, 26 ("Preface to the Edition of 1815").

15. See Ralph Cohen's discussion of the shift in criticism of descriptive poetry from praise of the eye to praise of "the eye of the mind," in *The Art of Discrimination: Thomson's "The Seasons" and the Language of Criticism* (London: Routledge and Kegan Paul, 1964), pp. 162–173.

16. Landow, *Aesthetic and Critical Theories*, p. 78.

17. Wordsworth's version of how the mind responds to natural scenery is, as Harold Bloom has pointed out ("Ruskin as Literary Critic," pp. 176–179), ultimately more comforting than Ruskin's. Ruskin agreed with Wordsworth that the landscape feeling was most intense in youth and gradually faded, but where Wordsworth welcomed its replacement by the philosophic mind, Ruskin, tying thought and feeling to immediate visual experience, could only mourn the loss of responsiveness as total deprivation.

18. Archibald Alison, *Essays on the Nature and Principles of Taste* (1790); on Alison, see Landow, *Aesthetic and Critical Theories*, pp. 100–109. Rudolph Arnheim, *Visual Thinking* (Berkeley: University of California Press, 1969), and *Art and Visual Perception* (Berkeley: University of California Press, 1954); Ernst Gombrich, *Art and Illusion: A Study in the Psychology of Pictorial Representation* (New York: Pantheon, 1960).

19. In the hundreds of references to Wordsworth and his poetry indexed in the Library Edition, there are none to *The Prelude*. "Yew Trees" is also quoted by Coleridge (*Biographia Literaria*, chap. 22) as an example of Wordsworth's imaginative power.

20. For Ruskin on Wordsworth in the 1880s, see especially "The Storm Cloud of the Nineteenth Century" and "Fiction Fair and Foul" (vol. 34) and *Praeterita* (vol. 35).

21. I take my use of the word "traditionalist" from the term as it has been applied to Burke. J. G. A. Pocock's description of the critic of traditionalism who is radical in stance, yet reactionary in locating the values he urges in a distant past, seems to me to fit Ruskin on Wordsworth rather well. I am indebted to Pocock's *Politics, Language and Time: Essays on Political Thought and History* (New York: Atheneum, 1973), esp. pp. 233–272.

22. See 3.415–419 ("Of Truth of Skies"), 3.492–493 ("Of Truth of Earth"), and 3.569–573 ("Of Truth of Water").

23. See, for example, *The Stones of Venice III* (11.47–69), *Pre-Raphaelitism* (12.391–392), and the immediately preceding attacks on modern science in "The Moral of Landscape" (5.380–383).

24. "And men who have this habit of clustering and harmonizing their thoughts are a little too apt to look scornfully upon the harder workers who tear the bouquet to pieces to examine the stems. This was the chief narrowness of Wordsworth's mind; he could not understand that to break a rock with a hammer in search of crystal may sometimes be an act not disgraceful to human nature, and that to dissect a flower may sometimes be as proper as to dream over it; whereas all experience goes to teach us, that among men of average intellect the most useful members of society are the dissectors, not the dreamers" (5.359; also 12.392). Note that Ruskin is not criticizing Wordsworth because he dispenses with accurate observation (Wordsworth insists, in the supplemental essay of 1815, that the poet must begin with accurate looking). Nor does Ruskin disagree with Wordsworth's claim that the poet must pay attention to how natural objects strike the mind and imagination, not just to how they look (8.58; 5.358–359). Ruskin does object to Wordsworth's impatience with *analytic* observation, taking the object to pieces and examining it part by part. He suggests that the beholder must employ this progressive, analytic method, to grasp both external facts and his own associative and emotional perceptions of those facts. Only by this piecemeal method, according to Ruskin, can the beholder reconstruct the instantaneous imaginative perception of the gifted poet or artist.

3. Excursive Sight

1. Burke's *Enquiry* was the first and most important example in England. The eighteenth-century literature on the psychology of the sublime and the beautiful is discussed in Samuel H. Monk, *The Sublime: A Study of Critical Theories in XVIII-Century England* (New York: Modern Language Association, 1935), and Boulton's introduction to Burke's *Enquiry*.

2. Standard modern accounts of the picturesque are Christopher Hussey, *The Picturesque: Studies in a Point of View* (London: G. P. Putnam's Sons, 1927); Elizabeth Wheeler Manwaring, *Italian Landscape in Eighteenth-Century England* (New York: Oxford University Press, 1925); Walter J. Hipple, Jr., *The Beautiful, the Sublime, and the Picturesque in Eighteenth-Century British Aesthetic Theory* (Carbondale: Southern Illinois University Press, 1957). A brief summary of historical meanings of the term is given in Jean H. Hagstrum, *The Sister Arts: The Tradition of Literary Pictorialism and*

English Poetry from Dryden to Gray (Chicago: University of Chicago Press, 1958), pp. 157–162.

The only extensive discussion of the physical and visual habits of perception associated with the picturesque and sublime is John Dixon Hunt's *The Figure in the Landscape.* What he terms the "gardenist" mode of landscape experience is close to the way of seeing usually associated with the picturesque. Hunt's term is not a good one for discussing Ruskin and the early nineteenth century, however, because gardens had ceased to play a central role in supporting the visual and psychological habits they originally encouraged. Travel had largely replaced garden exploration as the typical experience of what Hunt describes as four-dimensional exploration. Hunt finds a sharper distinction between gardenist experience and the picturesque than I find between the traveler's mode of seeing and the picturesque, at least in the late eighteenth and early nineteenth centuries. What Hunt calls the picturesque (taking the term, as most postromantic writers do, to have a slightly derogatory sense) is probably closest to what Ruskin means by the "surface picturesque" — a rapid, purely visual exploration of a scene from which emotional and mental response is excluded, as even the eye passes over without penetrating into what it sees. However, I do not think that either for Ruskin or for the early nineteenth-century traveler picturesque experience necessarily meant rapid, distracted surveys from a fixed perspective (prospect looking), as Hunt suggests. In the landscape annuals of the thirties, for example, "picturesque" can describe both exclusively visual pleasures (as in *Jenning's Landscape Annual* for 1830, text by Thomas Roscoe) and more leisurely exploration of an unfolding countryside in which historical and literary associations deepen the significance of visual detail (as in *Heath's Picturesque Annual* for 1832, text by Leitch Ritchie). For this later period, at least, Hunt's use of "picturesque" to denote picturelike looking as opposed to progressive or gardenist exploration does not hold.

3. In fact, he had drawn the fall of the Tees from precisely the spot at which the sketcher sits — a drawing engraved for the earlier (and more picturesque) Richmondshire series of views (T. D. Whitaker, *History of Richmondshire*, 1821). See Andrew Wilton, *Turner and the Sublime* (London: British Museum Publications, 1980), p. 128; and Eric Shanes, *Turner's Picturesque Views in England and Wales, 1825–1838* (New York: Harper and Row, 1979), p. 25.

4. Andrew Wilton makes this point, both in his introduction to Shanes's *Turner's Picturesque Views* (pp. 8–9), and in *Turner and the Sublime* (pp. 79–80). In most of the pictures in the England and Wales series the ordinary man is not a traveler but a local inhabitant; *Launceston* and *The Fall of the Tees* are exceptions. The function of the figures is the same in all the plates, however: in each case figures provide a means for the beholder to enter and experience the landscape as someone in the midst of it, rather than from the more distanced and comprehensive perspective of the artist.

5. Ruskin gives an ironic account of his parents' expectations for him in *Praeterita* (35.185). Paul Walton, *The Drawings of John Ruskin* (Oxford: Clarendon Press, 1972), describes the special nature of Ruskin's training as an amateur (pp. 5–38).

6. On changes in book illustration in the early part of the century, see Gordon N. Ray, *The Illustrator and the Book in England from 1790 to 1914* (New York: Pierpont Morgan Library, 1976), and David Bland, *A History of Book Illustration: The Il-*

luminated Manuscript and the Printed Book (Cleveland: World Publishing Company, 1958). For the earlier history of illustrated travel books, see John Roland Abbey, *Travel in Aquatint and Lithography, 1770-1860* (London: privately printed at Curwen Press, 1956); on steel engraving and lithography in the thirties, Basil Hunnisett, *Steel-Engraved Book Illustration in England* (Boston: David Godine, 1980), and Michael Twyman, *Lithography, 1800-1850: The Techniques of Drawing on Stone in England and France and Their Application to Topography* (London: Oxford University Press, 1970).

7. John James Ruskin's book purchases in the 1820s and 1830s, as recorded in his account books, are published in Van Akin Burd's *The Ruskin Family Letters* (Ithaca: Cornell University Press, 1973).

8. Walton gives a thorough account of Ruskin's training in *The Drawings of John Ruskin.*

9. Though there are a number of studies of the English grand tour, there are surprisingly few of English travel literature, especially in the period 1800-1850. For the following discussion I have referred to the *New Cambridge Bibliography of English Literature* for information about the relative popularity of various kinds of travel works in 1750-1800 and 1800-1850. Charles Batten, Jr., *Pleasurable Instruction: Form and Convention in Eighteenth-Century Travel Literature* (Berkeley: University of California Press, 1978), provides a useful discussion of the narrative form of the earlier literature. My comments on the later literature are based mostly on my own reading among travel narratives, histories, guidebooks, and such, including but not limited to the books Ruskin used.

10. See Batten, *Pleasurable Instruction,* esp. pp. 47-81.

11. The edition of Rogers' *Italy* with vignettes by Turner and Thomas Stothard was published in 1830 by Thomas Cadell and Edward Moxon, and purchased by John James Ruskin in 1833; Thomas Moore's 17-volume *Works of Lord Byron,* published by J. Murray (1832-1833)with illustrations by Turner, Stanfield, Harding, and others, was also bought by J. J. Ruskin in 1833. Robert Cadell of Edinburgh published several illustrated editions of Scott including a 12-volume *Poetical Works,* beginning in 1830, with illustrations by Turner; a 28-volume *Prose Works* (1834-36), also illustrated by Turner; and a 12-volume *Waverley Novels,* with illustrations by Stanfield among others. Almost all these illustrations, except those for the Waverley Novels, were landscapes.

12. See Hunt, *Figure in the Landscape*; also Ronald Paulson, *Emblem and Expression: Meaning in English Art of the Eighteenth Century* (Cambridge: Harvard University Press, 1975), pp. 19-34, and "The Pictorial Circuit and Related Structures in Eighteenth-Century England," in Peter Hughes and David Williams, eds., *The Varied Pattern: Studies in the Eighteenth Century* (Toronto: Hakkert, 1971), pp. 165-187.

13. On prospect and descriptive-meditative landscape poetry, see Earl R. Wasserman, *The Subtler Language: Critical Readings of Neoclassical and Romantic Poems* (Baltimore: Johns Hopkins University Press, 1959); also Alan Roper, *Arnold's Poetic Landscapes* (Baltimore: Johns Hopkins University Press, 1969), and Robert A. Aubin, *Topographical Poetry in Eighteenth-Century England* (New York: Modern Language Association of America, 1936).

14. Prout's *Facsimiles of Sketches in Flanders and Germany* lured the Ruskins on

their 1833 continental tour. On their return, Ruskin's father bought Rogers' *Italy* and a guidebook by Mrs. Starke, followed the next year by William Brockedon's *Illustrations of the Passes of the Alps,* Saussure's *Voyages dans Les Alpes* (at Ruskin's request), Chateaubriand's *Souvenir d'Italie,* William Rose's *Letters from the North of Italy,* and in 1835 Joseph Forsyth's *Remarks on Antiquities of Italy.*

15. Unity of impression is almost universally ascribed to sublime experience. The beautiful generally implies unity of composition, but with more varied parts than the sublime. Thus sometimes the beautiful is taken in at a single glance, but at others it permits exploration of the parts. Picturesque is the term most often associated with the secondary pleasures of intricacy, novelty, and exploration; however, picturesque is sometimes used to mean complete, picturelike compositions, which presumably have visual unity. It is more frequently applied to parts of scenes, though — especially foregrounds in landscapes — and is meant then to point out irregularity and intricacy rather than compositional arrangement.

16. Alexander Gerard, *An Essay on Taste,* facsimile reproduction of the 1780 (3rd) edition (Gainesville: Scholars' Facsimiles and Reprints, 1963), p. 11.

17. Ibid., pp. 4–5.

18. Ibid., p. 12.

19. Henry Home, Lord Kames, *Elements of Criticism,* facsimile reproduction of the 1785 (6th) edition (New York: Garland Publishing, 1972), I, 322.

20. Joshua Reynolds, *Discourses on Art* (New York: Collier Books, 1961), esp. Discourse Four (1771).

21. Hazlitt, *Works,* VII, 169 ("On a Landscape of Nicolas Poussin"); 317–318 ("On the Picturesque and Ideal"). For Ruskin's knowledge of Hazlitt, see William C. Wright, "Hazlitt, Ruskin, and Nineteenth-Century Art Criticism," *Journal of Aesthetics and Art Criticism,* 32 (1974), 509–523.

22. William Hogarth, *The Analysis of Beauty,* facsimile reproduction of the 1753 edition (New York: Garland Publishing, 1973), pp. 24–25. Hogarth's anomalous position among the eighteenth-century aestheticians is discussed by Paulson, *Emblem and Expression,* pp. 51–57.

23. For the importance of the pleasures of pursuit to discussions of allegorical art, see Paulson, *Emblem and Expression,* p. 53; to discussions of the garden, see note 12 above. The novel most often mentioned in this respect is *Tristram Shandy*; for discussions see John Preston, *The Created Self: The Reader's Role in Eighteenth-Century Fiction* (London: Heinemann, 1970), and Wolfgang Iser, *The Implied Reader: Patterns of Communication in Prose Fiction from Bunyan to Beckett* (Baltimore: Johns Hopkins University Press, 1974). Hogarth's descriptions of the pleasures of pursuit provided by curving lines may also have reference to rococo art.

24. William Gilpin, *Three Essays: On Picturesque Beauty; On Picturesque Travel; and On Sketching Landscape; with a Poem, On Landscape Painting,* 3rd ed. (London, 1808), pp. 47–48. Landow, *Aesthetic and Critical Theories,* pp. 222–223, summarizes the evidence of Ruskin's knowledge of Price, Knight, and Gilpin: none, for Gilpin; an undated notebook reference to Price; no indications for Knight on the picturesque, but Ruskin read his book on mythology later. The text of *The Poetry of Architecture* seems, however, to indicate that Ruskin was familiar, at least indirectly, with

the sort of discussions of the picturesque of gardens and tours which these three writers conducted.

25. Gilpin, *Three Essays*, pp. 48–50.

26. Uvedale Price, *An Essay on the Picturesque, as Compared with the Sublime and the Beautiful; and on the Use of Studying of Pictures, for the Purpose of Improving Real Landscape* (1794) in *Sir Uvedale Price on the Picturesque*, ed. Sir Thomas Dick Lauder (Edinburgh, 1842), p. 98.

27. Richard Payne Knight, *An Analytical Inquiry into the Principles of Taste*, 4th ed. (London, 1808). Describing Gothic architecture, for example (pp. 177–178), Knight stresses that "there was no point, from which the eye could see the whole of it at one glance; so that, though much was seen, something still remained to be seen, which the imagination measured from the scale of the rest." Knight found imaginative extension of parts and the following out of hidden intricacies to be the best route to the sublime impression of vastness (see also p. 410). Price too thought the Gothic could become sublime, but he recommended that Gothic intricacy be combined with the dark massiveness of the medieval castle to ensure a simultaneous impression of a single powerful whole (*Price on the Picturesque*, pp. 334–340); Knight preferred to reach sublime conceptions simply through progressive visual and imaginative discovery.

28. William Wordsworth, *A Guide Through the District of the Lakes in the North of England, with a Description of the Scenery, etc., for the Use of Tourists and Residents* (1810; repr. New York: Greenwood Press, 1968), p. 141.

29. James Beattie, "The Minstrel; or, The Progress of Genius," I. lviii.

30. Ibid., II. lviii,lv.

31. In 12.365–366 (1851), for example.

32. For instance, *The Glacier des Bois* or *Amboise* (2.170, 224); see also Ruskin's *Amalfi*, a watercolor begun in 1841–42 though not finished until 1844. Walton suggests Turner's *Mercury and Argus* (one of the oils Ruskin defended as wildly imaginative in 1836) as a model for the *Amboise; The Drawings of John Ruskin*, p. 45.

33. "A Walk in Chamouni," "The Alps (Seen from Marengo)," "Mont Blanc Revisited," "The Arve at Cluse," "Mont Blanc," "Written Among the Basses Alpes," and "The Glacier" (2.222,232–240).

34. Geoffrey Hartman discusses the *siste viator* topos in *Wordsworth's Poetry, 1787–1814* (New Haven: Yale University Press, 1964), pp. 3–30; and the spirit of place in "Romantic Poetry and the Genius Loci," *Beyond Formalism: Literary Essays, 1958–1970* (New Haven: Yale University Press, 1970), pp. 311–336.

35. Shapiro, *Ruskin in Italy*, p. 168.

36. Ibid., pp. 144, 85; also p. 197.

37. Ibid., pp. 54, 107.

38. Including 4.29, 5.28, 16.154, 17.105, 22.505, 26.338, 27.90,156, 28.255,656, 33.292, 35.297.

39. Coleridge in the *Biographia Literaria*, Hazlitt in *The Spirit of the Age*.

40. Owen and Smyser, *Wordsworth's Prose*, I, 126.

41. Ibid., I, 128.

42. Ibid., I, 126.

43. Ibid., III, 81.

44. Ibid., III, 83.

45. According to Cook and Wedderburn's index (vol. 39), *The Excursion* is the single poem to which Ruskin referred or from which he quoted most often.

46. In this letter Ruskin wrote: "Coleridge may be the greater poet, but surely it admits of no question which is the greatest *man* . . . I believe Coleridge has very little moral influence on the world; his writings are those of a benevolent man in a fever. Wordsworth may be trusted as a guide in everything, he feels nothing but what we ought all to feel—what every mind in pure moral health *must* feel, he says nothing but what we all ought to believe—what all strong intellects *must* believe" (4.392). Surveying Wordsworth's poetry he concludes with "the magnificent comprehension—faultless majesty of the 'Excursion,' to crown all" (4.393).

47. In *The Prelude,* these are lines 556–572 from Book VI (1805 version).

48. Thomas Weiskel notes that they do not really contribute to a *perceptual* unity. The unity is already abstract. The balance is linguistic, not visual or aural. This is, I think, accurate: what counts here is the desire to present the experience as one of unity. Weiskel, *The Romantic Sublime: Studies in the Structure and Psychology of Transcendence* (Baltimore: Johns Hopkins University, 1976), pp. 197–198.

49. Owen and Smyser, *Wordsworth's Prose,* II, 353–354.

50. Ibid., II, 351–352.

51. Ibid., II, 357.

52. James Chandler points to the disappearing visual details of the Tintern Abbey description, in "Wordsworth and the Sway of Habit" (diss., University of Chicago, 1978), pp. 208–209. Again, in Book VII of *The Prelude,* when the poet encounters the visual and oral confusion of a London crowd scene, we are told (though we do not witness it) that the poet can nonetheless exercise a composing power learned from "the influence habitual" of such unified natural impressions as the Simplon or Tintern Abbey. He retains "among least things / An under-sense of greatest; sees the parts / As parts, but with a feeling of the whole" (VII.721,710–712 [1805]).

53. I.471–472 (1850).

54. XII.237–238, 241–245 (1850).

55. See also the episode of the blind man in Book VII. As with the gibbet scene, Wordsworth is struck by the appearance of actual letters, though here he has a clearer grasp of why they are important, as a sign of mental power face to face with natural power.

56. Owen and Smyser, *Wordsworth's Prose,* II, 56–60.

57. Ibid., 88, 93, 84, 56, 76, 83.

58. Ibid., 59.

59. Ibid., 58.

60. Book VI.595 (1850); see also Book XIV (the ascent of Snowdon), and the *Guide,* in Owen and Smyser, *Wordsworth's Prose,* I, esp. 190–191.

61. Owen and Smyser, *Wordsworth's Prose,* II, 58, 81.

62. One could argue, as Thomas Weiskel does, that the characters in the Simplon passage and the first spot of time are signs not of the poet's own imaginative

power, but of an alien power manifesting itself through a universal, divine, symbolic language (*The Romantic Sublime*, pp. 197–204). Wordsworth's response, Weiskel suggests, is to run in terror from this manifestation of a power always associated by him with death, a power that will subdue his conscious mind and overpower his own attempts at poetry. I would agree that the legible messages of the visible characters in Wordsworth's writing are not the messages that count for the reader, not the fruits of poetic creation. Weiskel may also be right that Wordsworth's first reading of those visible characters—the types and symbols, the name of the murderer, the epitaph on the tombstone—is not an experience of exaltation but of terror. But these visible characters are nonetheless an important part of the extraordinary sublime or imaginative experience in "The Simplon Pass," the "Essay on Epitaphs," and *The Prelude* because through them Wordsworth arrives at poetic creation. See also Geoffrey Hartman, "Wordsworth, Inscriptions, and Romantic Nature Poetry," in *Beyond Formalism*, pp. 206–230.

63. Wordsworth first pares down the lengthy series of views recounted in *Descriptive Sketches* (an earlier poetic record of the same tour) and then organizes these few into the recurrent pattern noted by Hartman (*Wordsworth's Poetry*, pp. 39–41): expectation is interrupted by the disappointment of expectation and followed by a particularly moving experience. The twenty-four line apostrophe to Imagination which divides the first disappointment from the sublime experience—an apostrophe returning us to the present tense and the moment of composition—provides a further interruption of the narrative sequence of travel, disrupting even the pattern of expectation-disappointment-moving experience, and further isolating the sublime moment. Wordsworth does give us the sublime moment as part of an excursive experience, but he also contrives to disrupt his narrative so severely that we sense the discontinuity he implied when he published the passage as a separate fragment-poem.

64. This discussion of Book I as a reform of picturesque seeing is indebted to James Chandler's "The Sway of Habit," pp. 201–223.

65. See the Addendum to MS.B in E. de Selincourt and Helen Darbishire, *The Poetical Works of William Wordsworth* (Oxford: Clarendon Press, 1949), V, 400–404.

66. Coleridge, *Biographia Literaria*, ed. J. Shawcross (Oxford: Clarendon Press, 1907), II, 96, 124.

67. Ibid., 101–109.

68. Ibid., 102.

4. The Ruskinian Sublime

1. *Childe Harold's Pilgrimage*, III. 62.

2. Weiskel, *The Romantic Sublime*, pp. 22–62, makes this distinction. I have drawn on his analysis of the concept in the following discussion, though my account of possible resolutions to the sublime challenge does not entirely follow his.

3. Weiskel gives this interpretation of the passage in *The Romantic Sublime*, pp.

194–204. See also Hartman, *Wordsworth's Poetry*, pp. 16–18.

4. Byron's piecemeal method is not presented as exclusively a *beholder's* sublime. The status of the speaker of *Childe Harold* is somewhat unclear. On the one hand, he is a traveler and not a professional poet; on the other hand he is, by Canto IV, not a separate dramatic character (Childe Harold disappears), and his poetic ambitions are increasingly a subject of reflection.

5. Evans and Whitehouse, *Diaries*, I, 116–117, 119–122, 124, 129, 132–133, 169, 170, 175.

6. Landow, *Aesthetic and Critical Theories*, pp. 183–187.

7. See, for example, Francis Hutcheson, *Inquiry into the Original of Our Ideas of Beauty and Virtue* (1725): absolute beauty springs from "Uniformity amidst Variety," pp. 15–16; or Alexander Gerard, *Essay on Taste*, pp. 30–33.

8. John Rosenberg, *The Darkening Glass: A Portrait of Ruskin's Genius* (New York: Columbia University Press, 1961), pp. 19–20.

9. Landow, *Aesthetic and Critical Theories*, p. 112.

10. Weiskel, *The Romantic Sublime*, p. 201.

11. Ibid., p. 204.

12. In 1883 Ruskin noted the "insolence of these abrupt and unhesitating theological assertions, now become extremely painful to me, and much repented of" (4.199).

13. Bradley, *Ruskin's Letters from Venice*, pp. 244–245, pp. 246–248.

14. Burke, *Enquiry*, p. 64.

15. MS published posthumously in Ireland's *Hogarth's Illustrated*; quoted in Arthur Clayborough, *The Grotesque in English Literature* (Oxford: Clarendon Press, 1965), p. 6.

16. See Wolfgang Kayser's discussion of Schlegel and Richter in *The Grotesque in Art and Literature*, tr. Ulrich Weisstein (Bloomington: Indiana University Press, 1963), pp. 48–56.

17. Hugo, Preface to *Cromwell* (1827); see Kayser, *The Grotesque*, pp. 56–59.

18. Walter Scott, "The Novels of Ernest Theodore Hoffman," *Foreign Review*, I (July 1827).

19. Ruskin showed special interest not only in visionary and Gothic grotesques but also in fantasy art and literature, from Shakespeare and Scott to children's fairy tales. Himself the author of a fairy tale, (*The King of the Golden River*, 1841), Ruskin also discussed the importance of fantasy as a healthy exercise of imagination in his *Modern Painters III* chapter on the grotesque and in a late lecture, "Fairy Land," in *The Art of England* (1884). Landow draws attention to "Ruskin's valuable perception that fantastic art and literature form part of a continuum which includes sublime, symbolic, grotesque, and satirical works"—"And the World Became Strange: Realms of Literary Fantasy," in Diana L. Johnson, *Fantastic Illustration and Design in Britain*, 1850–1930 (Providence: Museum of Art, Rhode Island School of Design, 1979), p. 36.

20. Walter Benjamin, *Illuminations*, ed. Hannah Arendt (New York: Harcourt, Brace and World, 1968), "The Work of Art in the Age of Mechanical Reproduction," p. 221.

5. History as Criticism

1. Studies of nineteenth-century history have most frequently omitted Ruskin altogether, from G. P. Gooch's *History and Historians in the Nineteenth Century* (London: Longmans, 1952) through Peter Dale's *The Victorian Critic and the Idea of History* (Cambridge: Harvard University Press, 1977). In discussions of art history Ruskin is more likely to appear, but there too the tendency to assume that criticism and modern history are mutually exclusive is evident. Wallace K. Ferguson, in *The Renaissance in Historical Thought: Five Centuries of Interpretation* (Boston: Houghton Mifflin, 1948), p. 145, distinguishes a group of romantic art "critics" (including Rio and Ruskin) from art historians (such as Rumohr and Burkhardt).

Ruskin scholars, puzzled about what kind of history *The Stones of Venice* might be, have generally focused on Ruskin's criticism of contemporary society. Exceptions include John Rosenberg, who, however, suggests "Christian epic," "moral drama," or "the chronicle of a Gothic paradise lost" as more appropriate terms for Ruskin's "archetypal cultural history" (*The Darkening Glass*, pp. 85–87). James Sherburne, in *John Ruskin, or the Ambiguities of Abundance: A Study in Social and Economic Criticism* (Cambridge: Harvard University Press, 1972), p. 41, also describes the book as "an original form of cultural history," but though he investigates Ruskin's antecedents in social criticism, he has virtually nothing to say about his relation to nineteenth-century histories.

Treatments of Ruskin as an historical thinker are few and far between. R. G. Collingwood, in a pamphlet on *Ruskin's Philosophy* (Kendal: Titus Wilson, 1922), characterizes Ruskin as an "historicist" rather than a "logicist" thinker. Collingwood's views are closer to very recent descriptions of historicism than to most twentieth-century definitions, according to which Ruskin is the least objective or historicist of writers. John G. Speise takes this orthodox view in his dissertation, "John Ruskin as a Writer of History" (Pennsylvania State, 1968). Much the best consideration of Ruskin as an historical thinker is Gerard Bruns's brief discussion in "The Formal Nature of Victorian Thinking," *PMLA*, 90 (1975), 904–918. Bruns makes a strong assertion of Ruskin's commitment to the primacy of historical knowledge in his works, beginning with *The Stones of Venice*. He puts the shift in Ruskin's critical focus from a romantic, transcendental language of nature to a fully historical language of nature and human events too early, I think, but he is surely right that between *Modern Painters II* and *Stones* Ruskin's thinking underwent a transformation with respect to the importance of historical context.

2. For example, Rosenberg, Landow, Sherburne, and Hewison.

3. Ruskin planned but never completed a major work on the history of Swiss towns. His later works include many historical chapters (the four chapters in *Modern Painters III* on the history of landscape representation, for example) or fragments (*Our Fathers Have Told Us: Sketches of the History of Christendom for Boys and Girls Who Have Been Held at the Font*); *Stones* is his only major historical work, however. There are, of course, some earlier stirrings of interest in history: the defense of architecture as historical record in *Seven Lamps*; the rudimentary historical sketch of painting and architecture that swelled the chapter "The Foregoing Principles" in the third edition (1846) of *Modern Painters I*. Ruskin also continued to write for the tourist

trade, often incorporating historical information (though never again so fully fusing the history with the guidebook). He produced a number of guides to the churches and museums of Florence and Venice over the next four decades.

4. Ruskin was, of course, not alone among the Victorians in using historical inquiry to encourage cultural self-consciousness. Arnold and Carlyle share his interest in discerning historical patterns and in relating events to social institutions and religious beliefs. Historical pattern and the genetic approach to history—important concerns of philosophical and romantic historians at the turn of the century—serve all three critics primarily as a means of locating and interpreting a present that at first seems radically discontinuous with the past. Peter Dale (*The Victorian Critic and the Idea of History*) traces this process in Carlyle, Arnold, and Pater. This double focus, on the past and the present that observes it, is also central to the dramatic monologue, especially in Browning. Critics and poet alike take historical events or periods or personalities, but as only half of their subject. They are interested in the contemporary response to the past: movements of attraction, repulsion, and judgment in the reader of "My Last Duchess," *Past and Present*, "Empedocles on Etna," or *The Stones of Venice*. Jerome Buckley, among others, has explored such Victorian uses of the past, *The Triumph of Time* (Cambridge: Harvard University Press, 1966). The connections between history and the dramatic monologue or between history and Arnold's criticism, however, are not formally or rhetorically the same as those between history and Ruskin's critical prose.

5. For example, Karl R. Popper, *The Poverty of Historicism* (London: Routledge, 1961), and Hans-Georg Gadamer, *Truth and Method* (New York: Seabury Press, 1975).

6. P. Selvatico, *Sulla Architettura e sulla scultura in Venezia, dal medio evo sino ai nostri giorni* (Venice, 1847). For Ruskin's use of it see *Works* 9.4.

7. *Handbook for Travellers in Northern Italy* (London, 1842), pp. xix, xxii. Ruskin used this edition in 1845.

8. Kugler, *Handbook of Painting: The Italian Schools*, 4th ed. (London, 1874), p. iii.

9. Rio, *The Poetry of Christian Art* (London, 1854), p. vi.

10. Batten, *Pleasurable Instruction*, has a lengthy discussion of personal narrative as the dominant form of these books, esp. pp. 47–81.

11. Ronald Paulson's description of the eighteenth-century poetic garden (*Emblem and Expression*, pp. 19–34) could stand, with few changes, as an account of the English traveler's experience abroad, especially after 1750. See also Hunt, *Figure in the Landscape*.

12. C. P. Brand, *Italy and the English Romantics: The Italianate Fashion in Early Nineteenth-Century England* (Cambridge, Eng.: Cambridge University Press, 1957), notes the increased interest in history, especially medieval and Renaissance, for travelers to Italy. Otherwise the rather thin literature on early nineteenth-century travel writing does not explore this phenomenon.

13. Samuel Rogers, *Poetical Works* (Philadelphia, 1868) pp. 221, 402.

14. As I have noted, however, Ruskin began to share the current interest in travel as history only slowly, despite his imitations of both Rogers (1833–34) and Byron (see Chapter 3).

15. Anna Jameson, *Sacred and Legendary Art*, 5th ed. (London, 1866), p. 8.

16. Bradley, *Ruskin's Letters from Venice*, pp. 40–41.

17. See Batten, *Pleasurable Instruction*, pp. 32–35.

18. In Edward Gibbon, *The History of the Decline and Fall of the Roman Empire* (London, 1776–1788).

19. Alexander William Crawford [Lord Lindsay] *Sketches of the History of Christian Art*, 2nd ed. (London, 1885), pp. 1–2 (my italics).

20. See, for example, Shapiro, *Ruskin in Italy*, p. 157.

21. For example, 9.4–5 (para. 2) or 9.5–6 (para. 3).

22. Horace Bénédict de Saussure, *Voyages dans les Alpes. Précédés d'un Essai sur l'Histoire Naturelle des environs de Genève* (Neuchatel, 1779), 4 vols., I, xiii–xiv.

23. Byron, *Childe Harold's Pilgrimage*, IV, 1. 155; Rogers, *Italy*, "Venice," l. 1; l. 72.

24. English interest in ruins as signs of an historical pattern was of course widespread in the late eighteenth and early nineteenth centuries. From Gibbon and Goldsmith and Thomson through a host of minor travel narratives and poems, meditations on the decline and fall of Rome, Carthage, Tyre, Venice, and other ancient cities was a commonplace for both historian and traveler. Comparisons with contemporary England were not infrequently implied, or even explicitly drawn. But reflections on the modern Englishman's habits of perception were far less common than references to England's present political or economic position. Laurence Goldstein traces the literary expression of ruin sentiment in England from the Renaissance through Wordsworth in *Ruins and Empire: The Evolution of a Theme in Augustan and Romantic Literature* (Pittsburgh: University of Pittsburgh Press, 1977).

25. *The Works of Thomas Carlyle* (Centenary Edition; London, 1897), X, 2. Further references to *Past and Present* will be given by page number in the text.

26. See, for example, 12.507, 5.427, 37.320.

27. *Works*, XXVII, 2 ("On History"). George Landow has suggested that this presentational aspect of both Carlyle's and Ruskin's histories may derive from Evangelical practices of biblical meditation that required the believer to place himself in recreated historical events, experiencing all the phenomena of those events, including their landscape, colors, etc. For discussion of this practice, see Landow, *Victorian Types, Victorian Shadows*, esp. pp. 52–54.

28. *Works*, VI, 1, 9.

29. In chapters two and four of volume two (10.17–35, 69–142).

30. *Works*, VI, 12.

31. "Dry-rubbish" echoes through *Past and Present*; "DryasDust" is a character in a number of Carlyle's books (borrowed from Scott), including *Cromwell*; "The Paper Age" is the title of Book II of *The French Revolution*.

32. *Works*, VI, 5.

33. *Works*, II, 27.

6. The Romantic Reader and the Visual Arts

1. Letter to W. S. Williams (of Smith, Elder, and Co.) printed in *Macmillan's Magazine*, 64 (1891), 280; quoted 3.xxxix.

2. The term "reading" can be used to refer to just about everything one does when one looks analytically at a work of art, from basic perception (especially of figures and space in representational art) through formal analysis to iconographical interpretation. All three of these activities are part of Ruskin's way of looking at art. I consider these different kinds of looking together in this section to the extent that each presumes that art is in some sense a language, and each can be related to a particular contemporary approach to written texts.

Among twentieth-century critics who have considered all or part of the spectrum of reading visual art, I have found most useful Gombrich, on the psychology of perception (*Art and Illusion* especially), and Erwin Panofsky on iconographical interpretation (*Meaning in the Visual Arts*, Garden City: Doubleday, 1955). On the problem of how we pass from the reading of images to the reading of symbols, I have found Nelson Goodman's distinctions between articulateness and density, attenuation and repleteness especially helpful in distinguishing between the reading of verbal and visual symbolism (*Languages of Art*, Indianapolis: Hackett Publishing, 1976, esp. chaps. 4 and 6). Roland Barthes makes an interesting, though not finally successful, attempt to describe how all levels of reading from simple perception to elaborate symbolical interpretation work together when the spectator confronts the picture, "Rhetoric of the Image," *Image, Music, Text*, trans. Stephen Heath (New York: Hill and Wang, 1977), pp. 32–51.

3. John Unrau, *Looking at Architecture with Ruskin* (Toronto: University of Toronto Press, 1978), p. 64.

4. Jonathan Richardson, *Two Discourses: I. The Connoisseur. An Essay on the Whole Art of Criticism as it relates to Painting. II. An Argument in behalf of the Science of a Connoisseur* (London, 1719), II.17.

5. Leonardo da Vinci, *Paragone: A Comparison of the Arts*, trans. Irma A. Richter (London: Oxford University Press, 1949), p. 49.

6. Ideas derived from the mind's self-conscious reflection on its own processes ("Ideas of Reflection") combine with "Ideas of Sensation" in Locke's model. See *An Essay Concerning Human Understanding*, esp. Books I and II.

7. Ruskin's ideas on this subject subsequently changed at least twice. Already in *Modern Painters II* he began to admit, hesitantly, a symbolic *manner* of representation (abstract, exaggerated, and so on) in certain kinds of art, particularly architectural sculpture (4.299–313). By the late fifties he seemed to be willing to admit this manner into painting as well, to a limited extent (see the chapter on the "Grotesque Ideal" in *Modern Painters III*, 5.130–148). But in the seventies and eighties he returned to his first position, or indeed to a still firmer insistence that all good art should resemble real objects as closely as possible. See Ruskin's note, of about 1884, to a passage in *Modern Painters III* calling for "truth so presented that it will need the help of the imagination to make it real"; the note says "I go beyond this now and say perfect reality" (5.185).

8. Richardson, *Two Discourses*, II.38–39.

9. On the declining tolerance for elaborate emblems and the new stress on immediacy in painting, see Paulson, *Emblem to Expression*, pp. 51–57; and Hagstrum, *The Sister Arts*, pp. 139–140, 159–162. In the second passage, Hagstrum quite unhistorically uses the term picturesque to refer to the attempt to make literature imitate

the "at one blow" immediacy of painting. But this overlooks the difference between picture-like unity and associative (literary) unity which most of the writers Hagstrum cites do not forget.

10. Richardson, *Two Discourses*, II, 17.

11. Of the pleasures of imagination in general, Addison writes that they "have this advantage above those of the understanding, that they are more obvious, and more easy to be acquired. It is but opening the eye, and the scene enters. The colours paint themselves on the fancy, with very little attention of thought or application of mind in the beholder. We are struck, we know not how, with the symmetry of any thing we see, and immediately assent to the beauty of an object without inquiring into the particular causes and occasions of it" (*Spectator* No. 411). Addison seems to have in mind the immediate visual effects such as derive from nature rather than art; the visual pleasures of art he later describes as closer to those of literature (the secondary pleasures of imagination), requiring mental comparison of ideas and thus somewhat less immediate. But it is interesting that Addison describes immediacy of effect by reference to painting ("the colours paint themselves on the fancy"). Addison is also careful to recommend against overly obscure allegories, emblems, or allusions that may detract from a more immediate, accessible impression (*Spectator* No. 421).

12. Anthony, Earl of Shaftesbury, *Second Characters or the Language of Forms*, ed. Benjamin Rand (Cambridge, Eng.: Cambridge University Press, 1914), pp. 55, 56 (from Treatise II, on the Judgment of Hercules, chap. 5).

13. Joshua Reynolds, *Discourses on Art* (New York: Collier Books, 1961), p. 129 (from Discourse 8).

14. Landow, *Aesthetic and Critical Theories*, pp. 43–48. Landow does not explicitly make a claim for Ruskin's precedence, but he does point out that his most important predecessor among English writers on art, Hazlitt, continued to hold an imitative theory of art. Roy Park notes two earlier objections to classing art as imitative only, Benjamin Haydon in *The Diary of B. R. Haydon*, ed. W. B. Pope, (Cambridge: Harvard University Press, 1960–63), I, 57, and Sir William Jones in "On the Arts Commonly Called Imitative," 1772 (Park, *Hazlitt and the Spirit of the Age*, p. 121n). Jones's essay is not quite so clear, however: he says simply that while much of painting is imitative, the most effective works are those that express passion and move viewers by sympathy. Jones's essay is reprinted in *Eighteenth-Century Critical Essays*, ed. Scott Elledge (Ithaca: Cornell University Press, 1961), II, 872–881.

15. The quoted phrases are from the titles of Richardson's *Two Discourses*.

16. See Hazlitt's essay, "On the Pleasure of Painting" (*Table Talk*, 1821).

17. My comments on Hazlitt's reputation as an art critic draw on Wright, "Hazlitt, Ruskin, and Nineteenth-Century Art Criticism," and on James A. Houck's useful *William Hazlitt: A Reference Guide* (Boston: G. K. Hall, 1977), a descriptive bibliography of writings on Hazlitt that covers the early nineteenth-century period. *Tait's*, 10 (April 1843), 268–70.

18. Jonathan Richardson, Senior and Junior, *An Account of Some of the Statues, Bas-reliefs, Drawings and Pictures in Italy, etc. with Remarks* (London, 1722), pp. 234–237. For the Richardsons' expressed intention to avoid mere cataloguing, see the preface to the *Account*.

19. Ibid., 69.

20. Ibid., preface (unnumbered).

21. Hazlitt, *Works*, VIII, 168–169.

22. Ibid., 170.

23. Ibid., 173.

24. Ibid., 169, 173.

25. Coleridge, *Biographia Literaria*, II, 6; *Shakespearean Criticism*, I, 129–130.

26. But even Ruskin objected to some of Turner's paintings as too full of detail: "and he erred finally, and chiefly, in *quantity*, because, in his enthusiastic perception of the fulness of nature, he did not allow for the narrowness of the human heart; he saw, indeed, that there were no limits to creation, but forgot that there were many to reception; he thus spoiled his most careful works by the very richness of invention they contained, and concentrated the materials of twenty noble pictures into a single failure" (13.129–130). Ruskin was speaking of Turner's Italian landscapes, chiefly from the 1830s, including *The Bay of Baiae* (3.241–243, 13.133–134), *The Departure of Regulus, Ancient Italy, Cicero's Villa*, and *Caligula's Bridge* (3.241–243).

27. Charles Lamb, "On the Tragedies of Shakespeare, considered with reference to their fitness for stage representation" (1812), in *The Works of Charles Lamb*, ed. William MacDonald (London: J. M. Dent, 1903), III, 19, 31, 34.

28. Coleridge, *Shakespearean Criticism*, I, 132.

29. Hazlitt, *Works*, V, 234. See also Walter Scott, "Essay on Drama" (1819): "it may remain a doubtful question, whether . . . minds of a high poetic temperature may not receive a more lively impression from the solitary perusal, than from the representation, of one of Shakespeare's plays," in *The Prose Works of Sir Walter Scott*, ed. Robert Cadell (Edinburgh, 1834), VI, 310–311.

30. Coleridge, *Shakespearean Criticism*, II, 273. I give the wording used by Hartley Coleridge in the *Literary Remains.* Raysor points out that Coleridge is quoting Kant's definition of the sublime here.

31. Archibald Alison, *Essays on the Nature and Principles of Taste* (Hartford, 1821), p. 103. Associationist literary theory has a long history before Alison, succinctly presented in Ralph Cohen's "Association of Ideas and Poetic Unity," *Philological Quarterly*, 36 (October 1957), 465–474. Among the most important works of literary associationist theory in the half century preceding Alison are those by David Hume (1748), Lord Kames (1762), Walter Whiter (1764), Abraham Tucker (1768), Alexander Gerard (1774), and James Beattie (1783). Not all of these consider the reader's or spectator's response from an associationist viewpoint, however; Gerard's earlier *Essay on Taste* (1759), Kames's *Elements of Criticism*, and Alison's *Essays* do. Cohen points out that the associationist theory of poetic unity was applied to literary works only—not to paintings or musical compositions.

32. Burke, *Enquiry*, 166–172.

33. Hazlitt, *Works*, V, 10. The same distinction is found in Alison, *Essays on Taste*, pp. 87–88.

34. Alison, *Essays on Taste*, pp. 88–89.

35. See Hazlitt, *Works*, XI, 165–166. Park discusses this subject in *Hazlitt and the Spirit of the Age*, pp. 104–114.

36. See Helene Roberts, "Trains of Fascinating and of Endless Imagery': Associationist Art Criticism before 1850," *Victorian Periodicals Newsletter*, 10 (1977), 91–105.

37. Kames, *Elements of Criticism*, I, 30–31; Alison, *Essays on Taste*, pp. 80–89; Coleridge, see "On Poesy or Art" (1818); for Hazlitt there is no single passage that exhibits the spectrum, but the range of his attitudes may be perhaps best gathered from his review of Schlegel's *Course of Lectures on Dramatic Art and Literature*, which appeared in the *Edinburgh Review* for 1815 (*Works*, XVI, 63–64). Hazlitt and Coleridge both liked Schlegel's comparison of modern literature of association, feeling, and suggestion to painting rather than to sculpture (which classical literature more nearly resembles). The implied spectrum of imaginative, associative art extends from modern poetry through painting to classical drama and, finally, sculpture. On Hazlitt and Coleridge see Park, *Hazlitt and the Spirit of the Age*, pp. 127–130.

38. Hazlitt, *Works*, VIII, 171.

39. Lamb, "On the Genius and Character of Hogarth," *Works*, III, 106.

40. Ibid., p. 126.

41. Ibid., p. 110.

42. Ibid., p. 111.

43. Hazlitt, *Works*, VI, 146, 147.

44. Ruskin uses the terms "specific character" and "expression" constantly in the second preface to *Modern Painters I*; they occur with equal frequency in Alison. See Ruskin's definition of poetry (5.28) as suggestion by the imagination.

45. See Section II, "Of General Truths" (chapters on truth of color, chiaroscuro, and space). I have drawn on the last of these particularly in the discussion that follows. For some interesting arguments about the historicity of Renaissance perspective, see Erwin Panofsky, "Die Perspektive als 'Symbolische Form,' " *Vorträge der Bibliothek Warburg* (1924–25), pp. 258ff; Joel Snyder, "Picturing Vision," *Critical Inquiry*, 6 (1980), 499–526; Peter Galassi, *Before Photography: Painting and the Invention of Photography* (New York: Museum of Modern Art, 1981); Goodman, *Languages of Art*, pp. 10–19. Gombrich, *Art and Illusion*, pp. 250–257, argues against seeing perspective as an historical convention or a symbolic form.

46. Ruskin is actually describing a picture by Copley Fielding which employs Turner's discovery of the effect of the unfocused foreground.

47. W. J. T. Mitchell discusses some of the implications of Turner's vortices as representations of bifocal vision in his "Metamorphoses of the Vortex from Rococo to Romanticism," in *Relations of the Arts, 1660–1800*, ed. Richard Wendorf (Minneapolis: University of Minnesota Press, 1982).

48. George Berkeley, *An Essay Towards a New Theory of Vision*. Turner would have been at least indirectly familiar with Berkeley's theory through Price, Goethe, and others.

49. Price, "Dialogue" in *Price on the Picturesque*, pp. 506–507; J. W. von Goethe, *Theory of Colours*, trans. C. L. Eastlake (London, 1840).

50. In 1847 Ruskin comments extensively on Berkeley's paper on religion (*Guardian* No. 55), with which he disagrees; Evans and Whitehouse, *Diaries*, I, 353–354.

51. "New Theory," in *Berkeley: Essay, Principles, Dialogues*, ed. Mary W. Calkins (New York: Charles Scribner's Sons, 1929), p. 92.

52. This is not to say, of course, that Ruskin accepted Alison's associationist theory of beauty. In *Modern Painters II* particularly, he was anxious to deny that the emotion of beauty *depends* on associations in the mind of the perceiver. Even in *Modern Painters III* — after he had acknowledged that association played a larger role than he had thought in the emotion of beauty — he continued to insist that the train or cluster of associated ideas that make up imaginative perception has as center a seen object that can itself be beautiful or not (see Landow, *Aesthetic and Critical Theories*, pp. 101-105). Still, Ruskin's objections to association in *Modern Painters II* must be taken together with the evidence of *Modern Painters I*. Alison's influence is more pervasive on the Ruskin of *Modern Painters I* and even *II* than Landow implies.

7. Symbolic Language

1. Unrau, *Looking at Architecture*, esp. chaps. 3 and 4.

2. Chap. 21. Unrau quotes and discusses this passage at length, *Looking at Architecture*, pp. 66–88.

3. Jack Lindsay, *J. M. W. Turner: His Life and Work* (London: Cory, Adams and Mackay, 1966). Lindsay believes that while "Ruskin never consciously grasped the nature of Turner's imagery," "perhaps there was an intuitive response of some kind" (p. 250). John Gage, *Color in Turner: Poetry and Truth* (New York: Praeger, 1969), makes a similar point much more positively: "Ruskin's elaborate interpretations of Turner's symbolism have sometimes been attacked . . . But although in the letter there is much that must remain debatable, the spirit of Ruskin's emphasis shows an awareness of the nature of Turner's imagination that is absolutely right" (pp. 133–134). Gage gives several examples of Ruskin's instinctive associative responses to Turner paintings which can be confirmed by outside evidence as closely parallel to Turner's own associative thinking.

4. See Landow, *Aesthetic and Critical Theories*, pp. 329–356. The discussion of early Victorian attitudes toward real and historical languages which follows draws on Landow and also on Murray Cohen, *Sensible Words: Linguistic Practice in England, 1640–1785* (Baltimore: Johns Hopkins University Press, 1977), and Hans Arsleff, *The Study of Language in England, 1780–1860* (Princeton: Princeton University Press, 1967).

5. Landow, *Aesthetic and Critical Theories*, pp. 352–354.

6. See Landow's discussion of Ruskin's childhood reading, ibid., pp. 356–370.

7. Shapiro, *Ruskin in Venice*, pp. 67–68.

8. Ibid., p. 51.

9. Ibid., p. 157.

10. The opening pages of volume two first exploit and then criticize this susceptibility of the Victorian tourist — as Ruskin also does in "The Nature of Gothic."

11. See the readings in the last two chapters of volume two ("Gothic Palaces" and "The Ducal Palace"); the treatment of stones as expressive of the minds of the workmen occurs in "The Nature of Gothic."

12. I have no certain evidence that the parallels between Ruskin's chapter and the *Confessions* are intentional, though that would not be impossible. Ruskin refers to Augustine's *Confessions* as early as *Modern Painters II* (4.114). According to his wife, Ruskin was reading the church fathers and puzzling over problems of biblical interpretation in Venice in 1852—*Millais and the Ruskins*, ed. Mary Luytens (London: J. Murray, 1967), p. 17. Ruskin seems to have gone to the Latin fathers for help in using evangelical methods because he was having increasing difficulty with his Bible reading at this time (see Bradley, *Ruskin's Letters from Venice*, pp. 244–247). During this period of concern with the reading of biblical language, Ruskin began an extensive commentary on the Book of Job. The conjunction of difficulties of reading divine language with Job's difficulties of faith, and with the God of Job who manifests himself in the heavens and speaks out of the whirlwind, creates a suggestive parallel between Ruskin's concerns in 1852 and the subjects of the *Modern Painters* chapters on clouds and exegesis. If Augustine was among the church fathers whom Ruskin read in 1852, then it would not be surprising if Ruskin had him in mind too when he returned to these concerns in *Modern Painters IV*. For my purposes, however, the comparison is useful whether or not Ruskin intentionally modeled his chapter on Augustine's readings of Genesis.

13. *The Confessions of St. Augustine*, trans. John K. Ryan (Garden City: Doubleday, 1960), pp. 305–333 (Book 12).

14. Ibid., p. 329 (Book 12, chap. 28); see also chaps. 27–32, and Books 10, 11, and 13.

15. Ibid., p. 328 (Book 12, chap. 27).

16. *Areopagitica*, in *Complete Poems and Major Prose*, ed. Merritt Hughes (New York: Odyssey Press, 1957), p. 742.

17. *Confessions*, pp. 328–329 (Book 12, chaps. 27–28).

18. For Ruskin's emphasis on accessible meaning, belief in multiple possible meanings, and two-step interpretive procedure, see Landow, *Aesthetic and Critical Theories*, pp. 329–356; and parallels in both Henry Melvill, *Sermons*, ed. C. P. McIlvaine (New York, 1851), esp. II, 60–71; and Augustine, *On Christian Doctrine*, trans. D. W. Robertson (New York: Liberal Arts Press, 1958).

19. See the collection of commentaries assembled by C. H. Spurgeon, *The Treasury of David, containing an original exposition of the Book of Psalms; a collection of illustrative extracts from the whole range of literature; a series of homilectical hints upon almost every verse; and lists of writers upon each psalm* (New York, 1882), I, pp. 311–337.

20. Ibid., 304.

21. In fact Ruskin offers in *Modern Painters IV* a discussion of geological change not inconsistent with evolution (see especially 6.177–181), which suggests that the "dreadful Hammers" perhaps bothered him less by 1856. Other problems than those of geological history probably contributed more to his final unconversion—particularly, I suspect, the status of biblical language, the very point addressed here.

22. Scott, *Marmion*, IV.30 (ll. 604–627).

23. For example, *Blackwood's* (Rev. John Eagles) on *Juliet and Her Nurse* (1836); or the remark that Turner's *Snowstorm* was "soapsuds and whitewash," which Ruskin quotes Turner as repeating (24.584). The *Athenaeum* review of *Snowstorm*

(May 14, 1842) was of the same sort: Turner paints with "cream, or chocolate, yolk of egg, or currant jelly, — here he uses his whole array of kitchen stuff."

24. This distinction is worked out in much greater detail in the Oxford "Lectures on Landscape," delivered in 1871. There the Pre-Raphaelites are said to belong to the school of crystal, which is the Gothic school (22.49), whose use of color is like "the sharp separations and prismatic harmonies of coloured glass"; their method is "trenchantly formal and clear" (22.50); they have "Gothic sharpness of crystalline colour and acuteness of angle" (22.51). Ruskin relates this way of using color — unblended, sharp, clear — to the sacred meaning of color, as described in *Modern Painters V*: color as light divided by cloud. "By being studious of colour, they are studious of division; and while the chiaroscurist devotes himself to the representation of degrees of force in one thing — unseparated light, the colourists have for their function the attainment of beauty by arrangement of the divisions of light" (22.51). These Gothic and Pre-Raphaelite colorists are opposed to Turner, who is described (in 1871) as a chiaroscurist who is also a colorist. The characteristic sign of his color is not crystal or prism but cloud and flame.

25. The attention demanded by the clear, highly detailed naturalism of Pre-Raphaelite work in the early fifties makes these works well suited to the kind of viewing Ruskin had been urging. As various critics have pointed out, the absence of tonal harmony or of a unifying use of chiaroscuro, together with the unrelenting sharp focus on detail, makes it difficult for viewers accustomed to conventions of keeping, recession, and composition to grasp these works as unified wholes. See, for example, Allen Staley, *The Pre-Raphaelite Landscape* (Oxford: Clarendon Press, 1973); W. F. Axton, "Victorian Landscape Painting: A Change in Outlook," in *Nature and the Victorian Imagination*, esp. pp. 301–306. For different reasons, both Turner's suggestive technique and Pre-Raphaelite clarity of detail and local color require a more active participation by the spectator to make sense — visually or figuratively — of their compositions.

26. See especially Ruskin's letters to the *Times* on Hunt's *The Light of the World* and *The Awakening Conscience* in 1854 (12.328–335). On Rossetti's use of symbolism, see the second of Ruskin's two papers in *Nineteenth Century*, called "The Three Colours of Pre-Raphaelitism" (1878), in which he classes Rossetti together with Hunt as members of a learned school, singling out Rossetti's *The Passover* (1856). The "symbolical meaning" of this work he again praised in the Oxford lectures for May 1883 (34.167–168, 33.288).

27. Landow argues that Hunt's pictures of 1854 first awakened Ruskin to the linguistic and symbolic potential of a modern naturalistic art — " 'Your Good Influence on Me': The Correspondence of John Ruskin and William Holman Hunt," *Bulletin of the John Rylands University Library of Manchester*, 59 (1976, 1977), 10. Since Ruskin's earlier (1851) comments on Pre-Raphaelite work make little mention of symbolism, and since his work on Turner's symbolism postdates the 1854 letters to the *Times*, the hypothesis is plausible. However, as I have argued, his attention to linguistic and symbolic elements in art generally increases in the late forties and early fifties; if Hunt's use of typological symbolism in realistic modern painting suggested to Ruskin the importance of reading modern art, that suggestion fell on well-prepared ground.

8. Turner and Tradition

1. In Ruskin's 1857 catalogue to Turner's paintings he gives a fuller interpretation of *Ulysses* (1829) as the central picture in his career, "in some sort a type of his own destiny" (13.136-137). He focuses on two aspects of the painting: Turner's shift to a higher key of color and to a more fully naturalistic symbolism. Light, color, clouds, water, and darkness themselves take the place of mythological figures. In the *Ulysses*, we see Apollo's horses in scarlet outline against the sun, but "The god himself is formless, he *is* the sun." Ruskin reads the painting as a statement of the artist's triumphant control of the language of nature. The artist, like Ulysses defying "one-eyed people" (imperceptive critics), heads into the rising sun, province of the God of Light. (Gage, following Ruskin, takes the picture as central with respect to Turner's development of a "symbolic scientism"; see *Color in Turner*, pp. 128-132, 142-147.) In *Modern Painters V*, Ruskin reads the *Apollo* as an earlier version of the same statement of artistic heroism, the mastery of a naturalistic mythology through an art of light and color.

2. *Hesperides* is explicated in "The Nereid's Guard," 7.389-408; *Apollo* in "The Hesperid Aeglé," 7.409-440. For other interpretations of Ruskin's mythological readings, see Landow, *Aesthetic and Critical Theories*, pp. 420-432, and Hewison, *Argument of the Eye*, pp. 81-84, 117-118.

3. The subject of the painting, elaborated in Turner's verses on the same topic, is the entry of the Goddess of Discord into the garden to take a golden apple—the apple Paris will award to Aphrodite, provoking the Trojan War. For Turner's verses, see Jack Lindsay, ed., *The Sunset Ship: The Poems of J. M. W. Turner* (London: Scorpion Press, 1966), p. 103.

In Hesiod's *Theogony*, the Hesperidean dragon is the grandchild of Nereus, the god of the sea. Ruskin extends Hesiod's identification of Nereus with a natural phenomenon to Nereus' children and grandchildren, and adds a moral or psychological interpretation to that description of the birth of different kinds of clouds from the sea. This assumption that Hesiod's mythological figures embody unconscious thinking about both natural phenomena and human emotions is characteristic of mid-Victorian approaches to mythology. See James Kissane, "Victorian Mythology," *Victorian Studies,* 6 (1962), 5-28.

4. Throughout this chapter and its extensive footnotes Ruskin pursues a complex of associations with the color red (the most abstract and hence symbolic color, according to 7.414), both in literary and artistic tradition and as a central feature of Turner's work. For his comments on the role of red, scarlet, and "the rose"—both as color and as the beauty of art or landscape generally—in Turner's work, see especially 7.422-431. Ruskin's final conclusion is that the rose in Turner's work is inseparable from the worm—deception, corruption, and death, whose presence is sometimes indicated by a serpent or by gloomy serpentine clouds in the paintings.

5. See my discussion of how Ruskin's descriptions employ a pattern of shocking or ironic reversal, at the end of Chapter 1.

6. Charles F. Stuckey, "Turner, Masaniello and the Angel," *Jahrbuch der Berliner Museum*, 18 (1976), 155-175, takes the allusions to both Ruskin and the hostile critics (especially Rev. Eagles of *Blackwood's*) as definite.

7. J. J. Gibson's information theory of perception would not have been wholly uncongenial to Ruskin. See J. J. Gibson, *The Senses Considered as Perceptual Systems* (Boston: Houghton Mifflin, 1966).

8. Ruskin does not, of course, stick to his decision. He returns to clouds, cloudy art, and to the possibilities of divine symbolic language in both nature and art on many occasions. See, for example, "The Mystery of Life and Its Arts" (1868) and *The Queen of the Air* (1869). In the seventies and eighties he balances art work (the Oxford lectures) against social criticism (*Fors Clavigera*).

9. The verses (from Revelation 19:17,18) are: "And I saw an angel standing in the sun; and he cried with a loud voice, saying to all the fowls that fly in the midst of heaven, Come and gather your selves together unto the supper of the great God; That ye may eat the flesh of kings, and the flesh of captains and the flesh of mighty men, and the flesh of horses, and of them that sit on them, both free and bond, both small and great." For purposes of convenient comparison, I give here the two passages from Revelation which Ruskin refers to when he associates Turner with an apocalyptic angel, first in *Modern Painters I* and then in *V*. The first is from Revelation 10:1: "And I saw another mighty angel come down from heaven, clothed with a cloud: and a rainbow was upon his head, and his face was as it were the sun, and his feet as pillars of fire." This angel carries an open book that the prophet John is instructed to eat so that he may prophesy. The second passage, referred to when Ruskin associated Turner with his own *The Angel Standing in the Sun*, is not the passage Turner quotes but this one from Revelation 14:14–16: "And I looked, and behold a white cloud, and upon the cloud one sat like unto the Son of Man, having on his head a golden crown, and in his hand a sharp sickle. And another angel came out of the temple, crying with a loud voice to him that sat on the cloud, Thrust in Thy sickle, and reap: for the time is come for Thee to reap; for the harvest of the earth is ripe. And he that sat on the cloud thrust in his sickle on the earth; and the earth was reaped." It is, I think, important that neither Turner's angel nor Ruskin's second angel are the same as the first angel to whom Ruskin compared Turner (Stuckey's statement on this, "Turner, Masaniello and the Angel," p. 161, is incorrect). Ruskin's first angel is an angel of prophecy; the other two are angels of death.

10. Lindsay suggests that Moses is a figure for the artist in *Turner*, p. 213. Stuckey argues the same for the Angel in "Turner, Masaniello and the Angel," pp. 161, 172–175.

11. Turner's verses: "The ark stood firm on Ararat; th'returning Sun / Exhaled earth's humid bubbles, and emulous of light, / Reflected her lost forms, each in prismatic guise / Hope's harbinger, ephemeral as the summer fly / Which rises, flits, expands, and dies." Gage suggests that the bubbles may be marsh gas escaping from the decomposing bodies, quoting Shelley's "Bubbles, which the enchantment of the sun / Sucks from the pale faint water-flowers, that pave / The oozy bottom of clear lakes and pools" (*Prometheus Unbound*, II.2); *Color in Turner*, p. 186.

12. In 1857 Ruskin wrote: "I shall take no notice of the three pictures painted in the period of decline. It was ill-judged to exhibit them." (13.167). The pictures in question were *The Angel, Undine Giving the Ring to Masaniello* (1846), and *The Hero of a Hundred Fights* (1847).

13. Some of the images Ruskin apparently takes from Turner were already

(before 1859) his own. The lines about the "pallid charnel house . . . blinding white with death from pole to pole" were first written as part of an attempt to describe his own idea of the horrible sublime (4.376, quoted in Chapter 4). In the manuscript passage there is nothing to suggest that Ruskin has Turner's painting consciously in mind.

14. When refusing to write about *The Angel* in 1857 he said that it showed "*distinctive* characters in the execution, indicative of mental disease"; "these characters are so trenchant that the time of fatal change may be brought within a limit of three or four months, towards the close of the year 1845" (13.167).

15. Ronald Paulson neatly terms these schematic, textual figures "Turner's graffiti"; see "Turner's Graffiti: The Sun and Its Glosses," in *Images of Romanticism: Verbal and Visual Affinities*, ed. Karl Kroeber and William Walling (New Haven: Yale University Press, 1978), pp. 167–188. I do not agree with Paulson that Turner's figures and texts work against his visual structures.

16. Ruskin had already described *Hesperides* at length in the 1857 catalogue (13.113–119), for example.

17. See the two retrospective accounts of his "unconversion" at Turin in the summer of 1858 (29.89 and 35.495) and the discussion of them in Landow, *Aesthetic and Critical Theories*, pp. 281–286. To Landow's list of nine factors contributing to the loss of his belief, I would add one more: the loss of faith in the truth of scripture seems to have been influenced not only by Ruskin's interest in the discoveries of geology but also by his exposure to historicist views of language in the fifties.

18. Blake's ideas of the relations between himself and his great predecessor Milton are in many respects similar both to the kind of tradition Baudelaire compares to a series of answering artistic beacons ("Les Phares") and to Swinburne's felt kinship with previous poets like Sappho (see especially "On the Cliffs"). Jerome J. McGann discusses Swinburne's concept of tradition, habits of pastiche and imitation, and methods of translation or interpretation in *Swinburne: An Experiment in Criticism* (Chicago: University of Chicago Press, 1972), pp. 74–88, where he quotes the Shelley and the Swinburne verse passages I quote. Among recent myth critics, the closest analogue to the Ruskin-Swinburne model is probably Robert Graves.

19. Swinburne, "In the Bay," stanza 26.

20. Shelley, "Epipsychidion," ll.163–164, 166–167.

21. This conception of poetic tradition is very different from that described by Harold Bloom in *The Anxiety of Influence: A Theory of Poetry* (New York: Oxford University Press, 1973).

22. See "On the Cliffs," especially. McGann, discussing Swinburne's modern translations or imitations of old ballads, notes: "if Swinburne tinkered at ballad forms in order to construct elaborate symbolic songs, thereby bestowing a 'finished' quality upon an original design which could only have suggested such structures to him by fits and starts, he would have seen himself merely performing his poet's duty: to reveal to others the hidden and sometimes arcane knowledge of the 'interpreters' who went before him . . . He meant to make his voice heard in his ballads in order that the voices of all his ballad forebears might be understood everywhere as distinctly as Swinburne felt he understood them" (*Swinburne*, p. 87). This description

might well fit Ruskin's idea of the artist's or the critic's relationship to predecessors who have used the same myth or image. But for Ruskin, at least, the distinct voices of historical tradition would have greater reality than the single, ahistorical voice that one might imagine behind them—the song of Apollo of which, McGann thinks, Sappho's or Swinburne's voices would be, according to Swinburne, each a different version. The shift of emphasis from a single, transcendent truth or image or language to an historical tradition is the major change in Ruskin's thinking I wish to point out.

23. Cecil Lang, ed., *New Writings by Swinburne* (Syracuse: Syracuse University Press, 1964), pp. 70–71.

24. The evolutionary view of language history, embodied in Trench and Furnivall's *OED*, had also affected Victorian attitudes toward mythology, as Kissane ("Victorian Mythology") points out. Ruskin would have found in such familiar works as George Grote's *History of Greece* (1846) the view that myths, like the philologist's language, were continually changing; their later history in the hands of poets and artists was felt to be as important as their original meaning. Mythology thus formed what was, in effect, a living literary (or artistic) tradition to which the nineteenth-century poet might contribute. Ruskin's references to myths as words, together with the evidence of his strong new interest in historical philology in the late fifties, suggest that he recognized parallels between the evolutionary view of myth and the philologists' ideas of language, and owed a special debt to the latter. For a discussion of the new philology and the founding of the *OED*, see Hans Arsleff, *The Study of Language in England,* esp. chap. 6.

25. R. C. Trench, *On the Study of Words* (London: J. M. Dent, 1927), p. 23.

26. Ibid., p. 133.

27. Ibid., pp. 121–122, 11–12, 14.

28. Müller expresses this view quite consistently in his work on myth and language. See, for instance, "Comparative Mythology," 1856, and "Greek Legends," 1867; both reprinted in *Selected Essays on Language, Mythology, and Religion,* vol. 1 (London, 1881). In the latter essay he speaks of mythology as "an infantine disease" of language (p. 471), in the former as "petrified relics" of language (p. 389).

29. Trench, *Study of Words,* pp. 25–29.

30. Ibid., p. 45.

31. See Rosenberg, "The Geopoetry of John Ruskin."

32. Landow, *Critical and Aesthetic Theories,* pp. 413–415.

9. The Critic's Art

1. Matthew Arnold, *Lectures and Essays in Criticism*, ed. R. H. Super (Ann Arbor: University of Michigan Press, 1962), pp. 251–252 ("The Literary Influence of Academies"). Arnold quotes part of Ruskin's eulogy of grass, from *Modern Painters III* (5.289), and a footnote from *Munera Pulveris,* essays on economics (17.257–258).

2. Northrop Frye, *Anatomy of Criticism: Four Essays* (Princeton: Princeton University Press, 1957), pp. 9–10.

3. Apparently Ruskin often invented his titles before he wrote his texts. See

17.lxiv–lxviii and the list of chapter titles for the unfinished parts of *Praeterita,* 35.633–634.

4. Patricia Ball discusses Ruskin's expansion of the vocabulary of natural description, *The Science of Aspects,* pp. 88–102.

5. Ruskin's word, 28.647. Frederick Kirchhoff's essay on scientific nomenclature in *Proserpina* is suggestive: "A Science Against Sciences: Ruskin's Floral Mythology," in *Nature and the Victorian Imagination,* pp. 246–258.

6. Lines 116–117, 119 (Ruskin omits a line; his italics).

7. The earlier *Time and Tide* (1867), also addressed to an artisan audience, has similar rhetorical problems.

8. There are earlier indications that Ruskin regarded his myth-making prose— whether explanatory or emblematic—as the way of writing most closely approximating the movements of his mind. For example, his description of the very loose, associative style of the latter parts of *The Queen of the Air* as "my third way of writing": "to say all that comes into my head for my own pleasure, in the first words that come, retouching them afterwards into (approximate) grammar" (19.408). His first two ways of writing, according to this passage, involve more omission and rearrangement; his third style is less "affected." Much of the myth-making writing I am describing seems to belong to this third style.

9. See 36.lxxxvi and Rosenberg, *The Darkening Glass,* p. 187.

10. See 28.201 and ibid., p. 191.

11. "Athena in the Earth" is Ruskin's English version of his title. He translates "keramitis," a term used in conjunction with the word for clay, as "fit for being made into pottery."

12. I take the first term from Mary Wynn Ainsworth, *Dante Gabriel Rossetti and the Double Work of Art* (New Haven: Yale University Art Gallery, 1976). The second is W. J. Thomas Mitchell's, *Blake's Composite Art: A Study of the Illuminated Poetry* (Princeton: Princeton University Press, 1978). Like Ainsworth and Mitchell, I use the terms to indicate a pairing of text and picture in which the two elements are more or less equal but interdependent, are designed to be considered together, and are complementary rather than parallel in style and content.

13. See 8.256. Ruskin also links Blake with Turner on 19.56, 19.133, and 22.470. Ruskin's comments on Blake almost always depict him as the genius driven by isolation into partial insanity—which he also saw as Turner's fate, at least at the end of his life. For praise of Blake as "an English prophet," "a man of power," "a great and wise mind," a "magnificent and mighty" genius, see 29.36, 19.115, 8.256; on Blake's isolation and insanity, 5.323, 8.256, 19.56, 19.133.

14. Probably for this reason his illustrated books are often not included in surveys of English book illustration in the nineteenth century. Gordon N. Ray, for example, puts no work of Ruskin's on his list of "100 Outstanding Illustrated Books Published in England between 1790 and 1914" because Ruskin's illustrations in any one book are "too miscellaneous" (*The Illustrator and the Book,* pp. xxiii–xxiv). Ray notes that Ruskin's mixtures of steel engravings, mezzotints, woodcuts, and (in the early books) lithographs are determined by "exposition, not visual delight" (p. 25). Ruari McLean points to the "typographic feebleness" of *Seven Lamps,* though he praises Ruskin's design for bindings, in *Victorian Book Design and Color Printing*

(Berkeley: University of California Press, 1972), p. 116. Ruskin did, however, contribute to two outstanding illustrated books: *The King of the Golden River* (1851), his fairy tale, illustrated by Richard Doyle; and *The Harbors of England* (1856), twelve mezzotints by Thomas Lupton from drawings by Turner, which Ruskin published with a descriptive text of his own. Though artist and author are not the same person in these books, the relationship between picture and text is that of the true double or composite work of art.

15. Walton, *The Drawings of John Ruskin*, pp. 87-93, regards the Swiss drawings as Ruskin's best and most expressive work. His characterization of Ruskin's style first suggested to me the parallel with the excursive prose. "Delight drawings" was Ruskin's term for Turner's sketches, mostly watercolor, done for his "own pleasure, in remembrance of scenes or effects that interested him; or else with a view to future use, but not finished beyond the point necessary to secure such remembrance or service, and not intended for sale or sight" (13.236).

16. The frontispiece is a drawing from a Fra Angelico annunciation cited in the text as an illustration of the art of the Purist school. The drawing of the Madonna, titled *Ancilla Domine*, seems to serve as an emblem for the religious role of art generally—and hence to be an effort by Ruskin to dedicate even this last volume of *Modern Painters* to the service of God, despite gloomy conclusions on the possibility of definite faith which fill the last part of the volume. It must be noted, however, that Ruskin decided to use this plate as frontispiece rather than illustration at the last minute, perhaps when the intended frontispiece did not work out (7.lxxii).

17. My model Renaissance emblem is admittedly a composite. Most of the English emblem books did not exhibit all these possible parts. On the English Renaissance emblem, see Rosemary Freeman, *English Emblem Books* (New York: Octagon Books, 1966, 1st pub. 1948). Robert J. Clements offers a general discussion of the sister-arts theories in Renaissance emblematic art (European as well as English) in *Picta Poesis: Literary and Humanistic Theory in Renaissance Emblem Books* (Rome: Edizione di Storia e Letteratura, 1960). Ernest B. Gilman argues convincingly that the Protestant English emblem tradition, unlike the European, reveals a radical distrust of the visual image—"Word and Image in Quarles' *Emblemes*," *Critical Inquiry*, 6 (1980), 385-410. Despite his Protestantism, Ruskin does not share the anti-image bias of the English emblem writers.

18. Though they did not suffer as much as Ruskin thought, it is true that a number of the late Venetian paintings (which include some sixteen exhibited and eight unexhibited oils, the latter known to Ruskin from the Turner bequest) are today described as in bad condition. See Martin Butlin and Evelyn Joll, *The Paintings of J. M. W. Turner* (New Haven: Yale University Press, 1977). Ruskin had also catalogued (in 1856–57) twenty late Venetian watercolors from the bequest and examined many more. His evocation of Turner's Venice here was surely made under the impact of the many spectacular studies of Venice that Turner made, in both oil and watercolor, in the 1840s.

19. Turner's four paintings on the Sibyl are *Aeneas and Sibyl, Lake Avernus* (c. 1798), *Lake Avernus: Aeneas and the Sibyl* (1814–15), *The Bay of Baiae, with Apollo and the Sibyl* (1823), and *The Golden Bough* (1834).

20. Ruskin refers to *The Golden Bough* earlier in the chapter; the 1798 painting

was part of the Turner bequest, so he had undoubtedly seen it. *The Bay of Baiae* (without the golden bough) he discusses in 13.131–135.

21. That rose is also, by a verbal allusion, Ruskin's: Rose La Touche, another image for Ruskin of wasted, hopeless beauty. Rose's presence here strongly suggests what Andrew Wilton and others have insisted upon, that the pessimistic vision of natural beauty Ruskin attributes to Turner is Ruskin's own. See Wilton, *Turner and the Sublime.* The last plate in *Modern Painters V* (ill. 26) again makes Turner's sunsets a part of Ruskin's emblem. It is titled *Monte Rosa. Sunset.* Paul L. Sawyer briefly sketches the meaning of Ruskin's *Hesperid Aeglé,* though he does not refer to Ruskin's plate, in "Ruskin and St. George: The Dragon-Killing Myth in 'Fors Clavigera,' " *Victorian Studies,* 23 (1979), 8.

22. *Second Characters* ("A Notion of the Historical Draught of Hercules").

23. Patrick Brantlinger's useful study traces the decline of reform enthusiasm in the 1850s and 1860s: *The Spirit of Reform: British Literature and Politics, 1832–1867* (Cambridge: Harvard University Press, 1977).

24. Ruskin found the comedy of *Don Quixote* unbearable. He identified too strongly with Cervantes' knight to take his projects other than completely seriously. See 37.12,17.

Index

Abbey, J. R., 312n6
Addison, Joseph, 170
Ainsworth, Mary Wynn, 332n12
Alison, Archibald, 56–57, 184–186, 189, 199, 323n33, 325n52
Angelico, Fra, 333n16
Architecture: "The Poetry of Architecture," 80–85; sublime and picturesque of, 130–133; histories of and travel, 140–142, 143–146, 150–153; Victorian patrons of, 152–153; "The Nature of Gothic," 158–163; reshaping Ruskin's criticism, 206–208; on interpreting iconography of, 201–202, 207–208, 211, 212–215. *See also Stones of Venice*
Arnheim, Rudolph, 56–57
Arnold, Matthew, 4, 43, 268–269, 308n4, 319n4
Arsleff, Hans, 325n4, 331n24
Association of ideas, 5, 230; in romantic poetics and criticism, 54–57, 178, 182–186; Ruskin's revision of romantic uses of, 54–57, 188–190, 196–200; and excursive sight, compared with biblical exegesis, 216–217; in *Modern Painters V*, 239–240; and prose emblems, 299; in 18th century literary theory, 323n31; Ruskin's use of Alison on, 325n52
Aubin, Robert A., 312n13
Augustine, St., 218–220, 221, 223, 234, 326n18; Ruskin's knowledge of, 326n12
Axton, W. F., 327n25

Ball, Patricia, 42–43, 307n23, 308n2, 332n4
Barthes, Roland, 321n2
Batten, Charles, Jr., 312nn9–10, 319n10, 320n17
Baudelaire, Charles, 254, 330n18
Beattie, James, 86, 323n31
Beautiful, the, 116–117, 126, 205, 308n6, 313n15
Benjamin, Walter, 138
Berkeley, George, 194–196
Bible: Ruskin's childhood reading of, 1, 2,

209; Evangelical reading of, 209–211, 253–254, 307n27; and medieval iconography, 211, 213, 215, 252–253; Ruskin and Augustine on, 217–225; and reading Turner, 252–253; Ruskin's difficulties with, 253, 326n12; Maurice and Furnivall on, 257; Trench on, 261–263. *See also* Genesis; Job; Psalm 19; Revelation
Blake, William, 254, 330n18; Ruskin on, 289, 332n13
Bland, David, 311n6
Bloom, Harold, 42–43, 308nn2–3, 309n17, 330n21
Boswell, James, 147, 156
Brand, C.P., 319n12
Brantlinger, Patrick, 334n23
Brockedon, William, 76, 143, 313n14
Browning, Robert, 43, 319n4
Bruns, Gerard, 318n1
Buckely, Jerome, 319n4
Bunyan, John, 210
Burke, Edmund: on language vs. visual imagery, 50–53; on the sublime, 81, 113, 116, 120, 122, 310nl; on the sublime and grotesque, 126
Byron, George Gordon: as "perceptive" poet, 50, 57; as seer, 60; and the sublime, 112, 114–116, 139; and history, 143, 153–154, 158; *Childe Harold*, 67, 76–78, 79, 112, 114–116, 143, 145; *Don Juan*, 79

Carlyle, Thomas, 60; as historian-critic, 140, 141, 142, 153–158, 265, 319n4; *Cromwell*, 154, 155, 320n31; *Past and Present*, 154–158; "On History," 155; *The French Revolution*, 157, 320n31
Cervantes, Miguel de, 334n24
Chandler, James, 315n52, 316n64
Chateaubriand, François-René de, 313n14
Clark, Kenneth, 308n1
Claude Lorrain, 16, 18, 22, 23, 28, 36, 88, 141, 199; depiction of space, 190, 193–194; Ruskin's criticism of, 196–198